Recycled Re·Seen:

Folk Art from the Global Scrap Heap

Recycled Re·Seen:

Folk Art from the Global Scrap Heap

Charlene Cerny and
Suzanne Seriff, Editors

Studio photography by
John Bigelow Taylor

Harry N. Abrams, Inc., Publishers,
New York, in association with
the Museum of International
Folk Art, Santa Fe, a unit of the
Museum of New Mexico

In honor of my parents, Albert J. and Charlotte A. Cerny – C. C.

In honor of my mother, Kay B. Seriff, and in loving memory of my father, Aaron J. Seriff – S. S.

Recycled, Re-Seen: Folk Art from the Global Scrap Heap accompanies the exhibition of the same name, which originated at the Museum of International Folk Art, a unit of the Museum of New Mexico, Santa Fe.

Harry N. Abrams, Inc.:
Editor: Elisa Urbanelli
Designer: Judith Hudson

Front cover photograph by
John Bigelow Taylor

Museum of International Folk Art:
Joyce Ice, Barbara Mauldin,
Judith Chiba Smith, Nora Pickens

Library of Congress Cataloging-in-Publication Data:
Recycled, re-seen : folk art from the Global Scrap Heap / Charlene Cerny and Suzanne Seriff, editors; studio photography by John Bigelow Taylor.
p. cm.
Includes bibliographical references and index.
ISBN 0-8109-2666-0 (Abrams: pbk.)
ISBN 0-8109-2696-2 (Mus. pbk.)
1. Folk art—History. 2. Outsider art—History. 3. Found objects (Art)—History. I. Cerny, Charlene. II. Seriff, Suzanne.
NK600.R4 1996
700' .9—dc20 95-52751

Photograph credits
All studio photography is the work of John Bigelow Taylor, New York, except where noted. The following individuals and organizations have supplied photographs:
(José Azel)/AURORA, 10–11; BBC Photo, 137; Courtesy of the Bemis Bag Company, 34; Charlene Cerny, 40, 41 bottom, 87; © Martha Cooper, 19 top, 171; Donald Cosentino, 168, 173, 174 top, 178, 179; photograph by Joanne Cubbs, Sept. 1989, 56; © Angela Fisher, 154 left; Ron Gordon, 51, 55; Grey Gundaker, 73, 74, 75, 76, 77, 78, 80; Edward Hellmich, courtesy of Christina Hellmich Behrmann, 157; Julius S. Kassovic, 104, 108, 109, 111, 116, 117; © Joanna Kirkpatrick, 1987, 120; © Frank J. Korom, 125, 127; Herbert Lang, courtesy of Library Services, American Museum of Natural History, 155; Daniel Leahy, courtesy of Kathleen Leahy Murray and the National Library of Australia, 158; Michael Leahy, courtesy of Kathleen Leahy Murray and the National Library of Australia, 11 top; Barbara Mauldin, 134, 141, 145, 147, 149; Ricardo Muratorio, 144; National Museum of American Art, Smithsonian Institution. Gift of Herbert Waide Hemphill, Jr., and museum purchase made possible by Ralph Cross Johnson, 42 left; National Museum of Canada, photograph courtesy of San Diego Museum of Man, 13 bottom; Steve Ohrn, State Historical Society of Iowa, 31; Paria Publishing Co., Ltd., 131, 132, from a postcard copyrighted by V. De Lima & Company Limited; Donna K. Pido, 163, 164, 165; Louis Psihoyos/Contact Press Images, 16, 38;

Chantal Regnault, 173; Herb Ritts, 167, Courtesy of *Playboy* magazine. Copyright © 1985 by Playboy; Allen F. Roberts, 86, 95, 98, 101, 181; Allen F. Roberts and Mary Nooter Roberts, 89, 91, 94; © Seymour Rosen/ Courtesy SPACES, 7, 39; Doran Ross, 174 bottom; Kay Turner, 61, 63, 65, 66, 68, 69

Contents

Suzanne Seriff is a folklorist, writer, curator, and lecturer at the University of Texas in Austin, Texas.

Charlene Cerny is Director of the Museum of International Folk Art in Santa Fe, New Mexico.

Joanne Cubbs is Curator of Folk Art at the High Museum in Atlanta, Georgia.

Eugene W. Metcalf, Jr., is Professor in the School of Interdisciplinary Studies at Miami University in Oxford, Ohio.

Kay Turner is a folklorist, writer, and curator living in Austin, Texas.

Grey Gundaker is Assistant Professor of American Culture at the College of William and Mary in Williamsburg, Virginia.

Julius Stephen Kassovic is an independent scholar and entrepreneur currently living in the Slovak Republic.

Allen F. Roberts is Professor of Anthropology and Director of the African Studies Program at the University of Iowa in Iowa City, Iowa.

Frank J. Korom is Curator of Asian and Middle Eastern Collections at the Museum of International Folk Art in Santa Fe, New Mexico.

John Nunley is Curator of the Arts of Africa, Oceania, and the Americas at the St. Louis Art Museum in St. Louis, Missouri.

Barbara Mauldin is Curator of Latin American Folk Art at the Museum of International Folk Art in Santa Fe, New Mexico.

Enid Schildkrout is Curator of Anthropology at the American Museum of Natural History in New York.

Donna Klumpp Pido is an independent scholar, gallery owner, and curator living in Nairobi, Kenya.

Donald Cosentino is Professor of Folklore and Director of the Folklore and Mythology Program at the University of California in Los Angeles.

Robert Farris Thompson is Professor of the History of Art and Master of Timothy Dwight College at Yale University in New Haven, Connecticut.

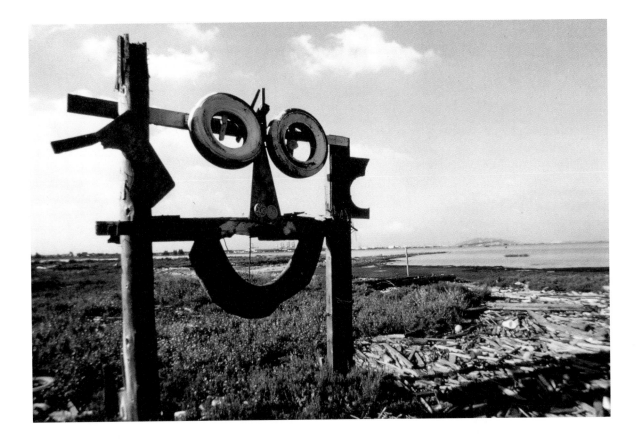

The Museum of International Folk Art wishes to gratefully acknowledge the support of the following generous donors

Major support was provided by the LILA WALLACE-READER'S DIGEST FUND, which seeks to enhance cultural communities and to make the arts and culture an active part of everyday lives through support of programs in the performing, visual, literary and folk arts, adult literacy, and urban parks.

Additional support provided by

National Endowment for the Humanities, a federal agency

The Rockefeller Foundation

International Folk Art Foundation

Museum of New Mexico Foundation

Marshall L. and Perrine D. McCune Charitable Foundation

Folk Art from the Global Scrap Heap: The Place of Irony in the Politics of Poverty

Suzanne Seriff

Picture this opening scene from the quirky, multicultural box-office hit *The Gods Must Be Crazy:* An American pilot, flying over the wide open expanse of Africa's Kalahari Desert, innocently tosses an empty Coke bottle out the window of his moving plane. It drops a few thousand feet into the hands of a puzzled Kalahari "Bushman"[1] – a scantily clad African "native," or so the documentarian tells us – whose peaceful nomadic community has heretofore managed to escape the ravages – or advantages – of modern history: capitalism, mass production, popular culture, literacy, and everything else that is symbolized for us in the shape, logo, and substance of a disposable Coca-Cola bottle.

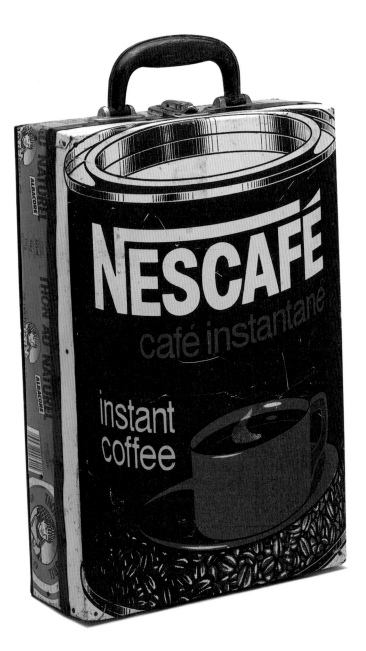

I.1

Nescafé Briefcase. Maker un-
known, Dakar, Senegal. c. 1980.
Misprinted factory-milled metal
sheeting for tin cans, scrap
wood, manufactured hardware,
color comics on newsprint used
for lining. H 16 1/2 x W 9 1/2 x
D 3 1/4" (41.9 x 24.1 x 8.2 cm).
International Folk Art Founda-
tion Collection, Museum of
International Folk Art, Santa Fe.

Suitcases made from recycled
tin cans or scrap-metal sheeting
were originally made for local
use, but the chic irony of recy-
cling (transforming Heineken
beer cans into a lawyer's brief-
case, for example) has attracted
new clients among resident
expatriates and foreign tourists.

So what do the Khoisan man and his fellow tribespeople do with this hard, cool, green "gift from the gods?" Why, they do with it exactly what we Westerners have come to expect of such "noble savages" in first contact with such a revered symbol of modernity:[2] the kids toss it back and forth and make a game of it; the men blow on its lip to extract music from it; the women carry water in it, pound tubers with it, and weave material around it to emphasize its status as a sacred missive.

In a word – or in *our* word – they *recycle* it. They artfully transform it, from its most recent state as a piece of Westerner's trash, to a new status of tribal treasure. At least that's the way we see it. For the Kalahari Bushmen, the process appears to be one not so much of reusing but of creating anew; not so much transforming, as inventing. They are not concerned with – or even aware of – the mysterious receptacle's previous "life" as America's No. 1 soft-drink container. Rather, the found object's power, or so we are told, comes from its perceived value as an unexplained gift from the gods.[3] And like most things that carry such power, it contains within it both the promise of immediate pleasure and the seeds of profound discontent. (Indeed, in an ironic twist, the "natives" ultimately decide that their newly acquired treasure is so controversial that the best thing they can do with it is ceremoniously "throw it away.") What was for the Westerner an object of imminent disposability becomes transformed for this Kalahari community into an object of imminent desire and profound social consequence.

The story this film tells, about a commonly discarded consumer by-product and its complicated transformation into a new life halfway around the world, is also the subject of this collection of essays on intercultural recycling. It is intended as a companion volume to a traveling exhibition of the same title, which was organized by and first mounted at the Museum of International Folk Art in Santa Fe, New Mexico, in May of 1996. Like many such volumes, this collection of essays is designed to complement and expand upon the themes presented in the exhibition, and its arrangement into sections corresponds closely, although not exactly, with the exhibition's organization on the gallery floor. Both presentations

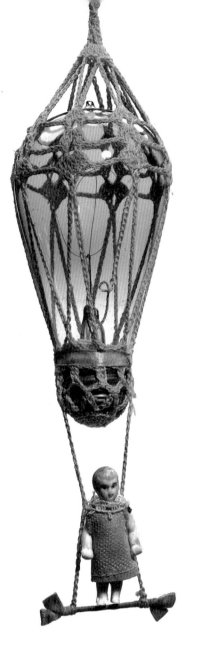

tell a story about an aesthetic and cross-cultural process – as well as an economic and political one – which is defined by the act of recovering and transforming the detritus of the industrial age into handmade objects of renewed meaning, utility, devotion, and sometimes arresting beauty.

While the heart of this story is the process of transformation itself, the end result is a category of hybrid objects that bear the mark of at least two distinct domains, each with its own material, meaning, makers, and users. Some of these objects are strictly utilitarian: a dustpan is constructed from an out-of-date license plate. Others are created to be ornamental: a delicate china doll's hot-air balloon is created from a macramé-wrapped electric lightbulb (plate 1.2). Yet whatever their ultimate function, each of these objects contains within itself a visual, material, and conceptual reference to multiple technologies, histories, and temporalities. As one commentator notes about these refabricated objects,

Like collage in art or quotation in literature, the recycled object carries a kind of "memory" of its prior existence. Recycling always implies a stance toward time – between the past and present – and often a perspective on cultures – one's own and others. (Jacknis 1992)[4]

On a more philosophical level, this volume explores the socially constructed nature of these objects and their possession, the effects they have on us, and the way we act toward them. It is based on the premise that the same object can – and frequently does – have one meaning for one community or culture and another meaning or series of meanings for another. The further fact that different objects have different life spans – different degrees of permanence or disposability – and that these life spans are socially constituted is also an integral part of this story about the value that gets conferred upon objects – or drained from them – as they shift and slide across the

1.2

Lightbulb Hot-Air Balloon. Maker unknown, Mexico. c. 1900. Lightbulb, string, porcelain figurine. H 9 3/4 x W 2 3/4" (24.5 x 6.5 cm). International Folk Art Foundation Collection, Museum of International Folk Art, Santa Fe.

This delicate whimsy from prerevolutionary Mexico resembles the finest of handblown Spanish Colonial glassware of the nineteenth century. The irony stems from the fact that the glass balloon is not handblown at all, but rather a commercial discard from the days of early industrialism and electric power in Mexico.

1.3

One step away from meltdown, briquettes of compacted metal still bear witness to their previous lives as beer cans, aluminum foil, brass planters, heater cores, and wire.

geographic and socioeconomic boundaries of class, caste, and culture throughout the world. But most important, it is a story about people – about the women, men, and children who ingeniously and persistently negotiate those boundaries through the material transformation of one person's trash into another's treasure.

The process of refabrication explored here is not to be confused with the kind of industrial strength recycling to which we in the West are most accustomed. When we think of recycling in America and other industrialized nations we imagine an automated sequence beginning with the curbside disposal of aluminum cans, plastic bottles, and old newspapers. These postconsumer items are then systematically collected and transformed at giant recycling centers where they are smelted and de-inked and returned to the industrial process (plate 1.3). Solid waste management, global greening, and ecological awareness are the buzzwords that guide and motivate consumers and industries to engage in this process of secondary and postconsumer waste recycling.

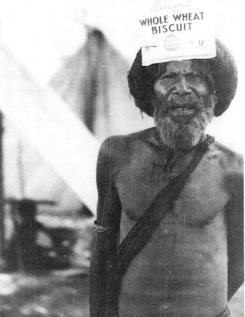

1.4
Renowned early-twentieth-century anthropologist Michael Leahy encountered this Wabag man from Papua New Guinea wearing an aluminum whole wheat biscuit tin on his head. In the symbol system of this culture, large, bright, and shiny ornaments connote health, well-being, sexual attractiveness, and the approval of the ancestors.

The essays in this book are designed to explore an altogether different kind of recycling that is small-scale, hand done, and local – a kind of recycling in which yesterday's newspapers are transformed by hand into tin trunk liners; empty food cans become kerosene lanterns; and old tires are refashioned into spouted water vessels or bracelets for bodily adornment. In some cases, the raw materials are commonly discarded items that individual consumers have saved rather than thrown away – old spark plugs, run pantyhose, used horseshoes, or metal juice cans. These are generally saved by the original consumer with the intention that some day they will be refabricated into something new and entirely different from their originally intended use. In other cases, the broken or discarded objects are scavenged by people who have little or no contact with those who first possessed them, and may neither know nor care about their originally intended function. This is the case depicted in the satirical cinematic exposé on Western colonialism described at the beginning of this introduction. It is also the case depicted in the "real life" photographs taken by anthropologist Michael Leahy which document his first colonial contact with New Guinean Highlanders in the 1930s (Connoly and Anderson 1987, 128) (plate 1.4).[5]

Because we are dealing specifically with industrially produced consumer discards and their subsequent transformation, these essays are necessarily situated

in a particular time, place, and sensibility: the consumer culture of the late twentieth century. In its most basic form, I refer to a consumer culture as one "in which the activities and ethics of a society are determined by patterns of consumption" rather than production (Mamiya 1992, 2).[6] While consumption has provided a foundation for the transnational capitalist system and thus has a much longer history than the last fifty years, the essays in this book focus on the more recent historical period because it is during this time that the patterns of conspicuous consumption and disposability can be said to define a truly global, as opposed to a Western, or "first world" sensibility.[7] As one commentator glibly observed, the last half of the twentieth century has seen the rise of a global epidemic "of galloping consumptionitis." (Sahlins 1992, 13)

This juncture, while materially defined in terms of the by-products of a consumer mentality, is not limited either by geography, gender, or nationality. The process of retrieving and transforming a consumer package or product that someone else has thrown away is a phenomenon that is taking place in the largest metropolises of urban America as well as the remotest corners of the Amazonian rain forest.

To frame a discussion that incorporates an understanding of such diverse locations, objects, and peoples is to claim links between material processes that originate under vastly different social, economic, environmental, and political circumstances.

The most obvious link are the raw materials themselves: the packaging, broken pieces, or discarded by-products of mass-produced, mass-circulated Western-based consumer goods. Tin cans, plastic bottles, tires, cigarette packs, bread wrappers, cereal boxes, pop-tops, lightbulbs, plastic toys, watch parts, and used auto and electronic parts are the raw materials that give shape to a kaleidoscopic array of ingeniously transformed objects and environments, from "flip-flop" sandal toys (plate 1.5) to plastic-coated telephone wire baskets (plate 1.6).

What is immediately apparent is that these recycled objects signal the ubiquitous intrusion of material modernity in even the remotest corners of the globe. We in the West are quick to recognize from the realms of advertising, retail, and mass media the snippets of transformed products and logos that form the body of an Inuit's handmade violin (plate 1.7) or the graceful curves of an ornamental bowl molded from a heated phonograph record, made in India.

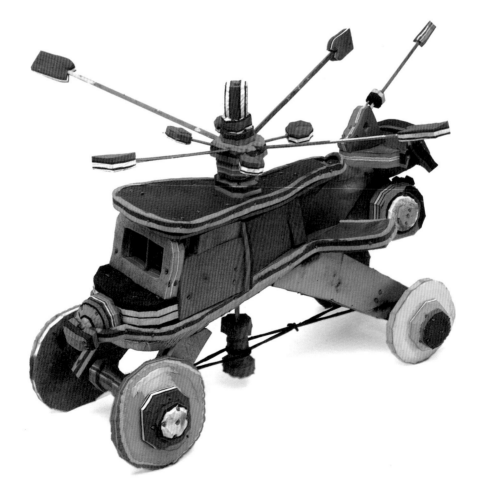

1.5
This toy helicopter, made almost entirely from the colorful soles of old "flip-flop" sandals, was created by itinerant toy maker Saarenald T. S. Yaawaisan of Monrovia, Liberia. When Mr. Yaawaisan first began making his signature "flip-flop" vehicles, he scavenged for abandoned sandals along the beaches near his home. Later he began getting the sandals directly from a nearby sandal factory, a steadier source of raw materials.

These clues provide visible proof that we are living in an age, as social commentators are quick to remind us, "where what is local can no longer be separated from what is 'global'" (Brett 1986) – where "groups are no longer tightly territorialized, spatially bounded, historically unselfconscious, or culturally homogeneous." (Appadurai 1991, 191) And where the material signs of Western affluence are by no means limited to the market of "first world" capitalist consumers.[8] Perhaps more to the point, we are living in an age in which the mass-marketed and globally advertised corporate sponsors of these products – Levi Strauss, Seiko, Coca-Cola, and Reebok, to name a few – enjoy a tremendous iconic recognizability and popularity on the international cultural landscape. Bottles of Coca-Cola may not only be dropping like flies into the Kalahari Desert, they are probably being manufactured in locally franchised bottling plants, advertised by satellite on locally owned broadcasting stations, and sold at the nearest franchised McDonald's.

The question that needs to be raised at this point is not whether and to what extent these material symbols of Western capitalist culture have penetrated the developing corners of the so-called fourth world,[9]

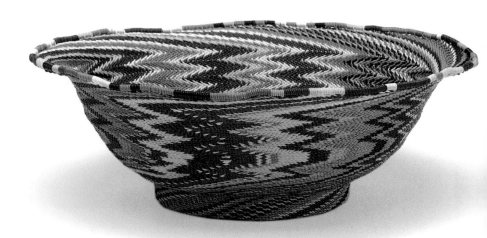

I.6
Telephone Wire Basket. Unknown Zulu maker, South Africa. 1994. Telephone wire. H 4 x Diam 11 3/4" (10 x 30 cm). Collection of Diane and Sandy Besser, Little Rock, Arkansas.
 The fine, even texture and variety of colors of telephone wire are used in this basket to produce an intricate, swirling design. The techniques and aesthetic of traditional grass basketweaving have been beautifully adapted by contemporary Zulu artisans to this readily available scrap material.

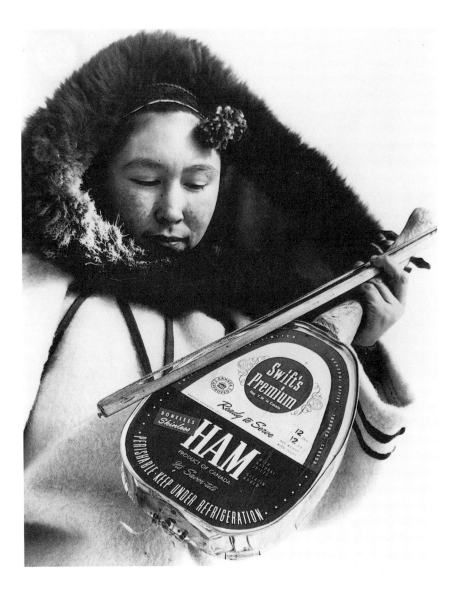

I.7
This 1958 photograph shows a young Inuit woman examining a violin made by her grandfather from a Swift's Premium Ham can. The young woman learned to play this handmade violin at Resolute Bay, Cornwallis, Northwest Territories, Canada.

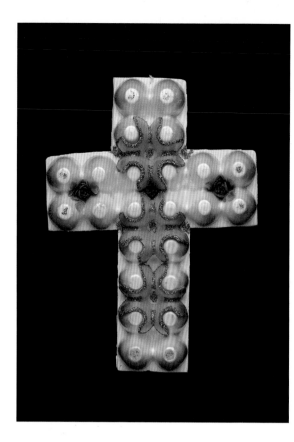

but what the responses to this penetration have been. Although such responses can be chronicled on a wide variety of popular levels – even in the realm of material expression – let's stick, for a moment, to the subject at hand: what one observer calls, "the indigenization of Western objects." (Sahlins, 16) Do these hybrid objects, as many Western critics might assume, point to a passive acceptance of a homogenized consumer culture in the service of Western capitalist expansion, or, even worse, a sense of want and deprivation when confronted with "our riches?"[10] Or might they point to some other kind of cultural dynamic – one in which local peoples take responsibility for what is being inflicted on them? Describing the way New Guineans have coped with the onslaught of capitalism over the last century, anthropologist Marshall Sahlins provides a clue to this dynamic when he states: "The first commercial impulse of the local people is not to become just like us, but more like themselves. They do not necessarily despise our commodities. But they are selective in their demands and transformative of their uses of such things." (Sahlins, 13)

This "transformative" response provides the second link between the disparate objects, peoples, and processes which are explored in these pages. It is a reaction, remarks Sahlins, "of peoples the world over to the so-called benefits of so-called civilization." (Sahlins, 15) What unites each of these transforming artisans is an ability to perceive in Western things certain possibilities of human value that the manufacturers never envisioned (plate 1.8). It suggests a self-confidence and intellectual authority that allows local peoples to encompass Western goods in their own meanings, literally "in their own scheme of things." (Ibid.)

This process of creatively "misusing" the detritus of the industrial age has been described by some Western theorists as inherently "ironic."[11] The irony is often embodied both visually, in the recycled product itself, and conceptually, in the process of its transformation. Irony, according to the *Oxford English Dictionary*, can be "a condition of affairs or events of a character opposite of what was, or might naturally be, expected."[12] As Allan Rodway has written about such double vision, irony is "not merely a matter of seeing a 'true' meaning beneath a 'false'; but of seeing a *double* exposure on one plate." (Rodway 1963, 113) We speak colloquially of "making something from nothing," or turning "trash into treasure," yet we rarely stop and examine the ironic kernel inherent in this transformative process: taking an idea or an object that is considered worthless to one person – a burned-out electric lightbulb, for example – and transforming it into something of value – a reservoir for a kerosene lamp – by someone else (plate 1.9). And even fewer of us take the further conceptual leap to contemplate the historically determined socioeconomic ironies embodied in an example such as this one in which an icon of high energy consumption (and of modern urban life) is adopted for an alternate energy source by someone

who is probably without the benefits of electricity in the home (Roberts 1992, 62–3).

While such multiple ironies of juxtaposed materials, out-of-sync audiences, and conflicting cultures occasioned by these types of refabrications are taken up in more detail by several of the authors in this volume, I want to focus for a moment on the specific subversion involved when the trash of those who "have" becomes treasure for those who "have not." In the words of one leading theorist on the subject of trash, "It is clear that one man's rubbish can be another man's desirable object; that rubbish, like beauty, is in the eye of the beholder." (Thompson 1979, 97)[13]

The Power of Rubbish

When an object is discarded it is perceived as being no longer of value to the person or society that once possessed it. Once a newspaper is read, or a bottle of soda pop consumed, its initial function is fulfilled and it is intended to be thrown out as trash. Rubbish is, by definition, an object that is not, or is no longer, owned by anyone, that falls outside all categories of economics, culture, and social control. As one of many things on the garbage heap, a discarded object even tends to take on a negative value as something unsanitary, dangerous, dank, and disorderly. The socially constructed value of the object has shifted over time from its finite life span of usefulness and meaning to a timeless and valueless state of socially sanctioned rubbish.

The remarkable thing about many of these objects – especially those produced in the last half of the twentieth century – is that they were specifically designed to end up on the garbage heap. They were designed to *decrease* in value over time – to be used once, or twice, or twenty times, and then to be thrown away. This applies not only to packaging – designed containers that protect and promote products[14] – but to an ever expanding list of products themselves. In the latter half of the twentieth century

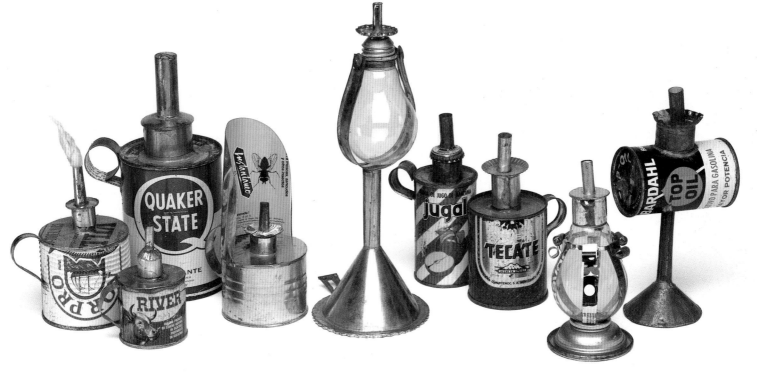

I.9

Group of Tin Lanterns. Makers unknown. From left: Brazil, Ethiopia, Mexico, Guatemala, Brazil, Mexico, Mexico, Togo, Mexico. 1990–93. Fifth from left: H 10 1/2 x Diam 3 3/4" (26.6 x 9.5 cm). From left: first, fourth, fifth, and eighth, International Folk Art Foundation Collection, Museum of International Folk Art, Santa Fe; second, Museum of International Folk Art, Santa Fe; third, sixth, seventh, and ninth, Collection Julius S. Kassovic.

One of the most ingenious utilitarian objects made from discarded materials is the tin kerosene lantern. In many parts of the world where electrification is absent and natural gas unavailable, kerosene is used for both light and cooking. The forms shown here are traditional to Latin America, Asia, and Africa. A couple of these lanterns incorporate a visual irony: a burned-out electric lightbulb (a symbol of modern human inventiveness) transformed into the base of an oil lamp – one of the earliest forms of artificial light.

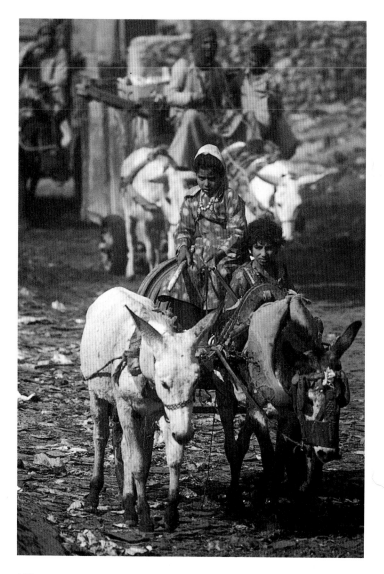

I.10
Cairo's traditional garbage collectors, the *zabaleen,* return home to the city's trash heap each evening, their donkey carts overflowing with trash. As happens in many developing countries, these rural immigrants, mostly members of Egypt's Coptic Christian minority, accepted the lowly task of urban scavenging for a livelihood.

"planned obsolescence" has become the mantra for an entire generation of corporate producers and advertisers who have shaped not only the nature of the commercial product, but the mental attitude of the consumer as well.[15]

This "throwaway spirit" – a term appropriately coined by American sociologist Vance Packard as early as 1960[16] – goes hand in hand with an economic and cultural affluence enjoyed by a relatively small yet privileged subset of the world population. It goes without saying that poor people do not waste as much as rich people do because they cannot afford to. In an interesting discourse on the nature of cultural and natural recycling, noted natural historian Stephen Jay Gould has observed: "In our world of material wealth, where so many broken items are thrown away, rather than mended...we forget that most of the world fixes everything and discards nothing." (Gould 1989, 8)

The flip side of this paradigm is that a person's wealth has become measured not only in how much he or she can afford to consume, but in how much he or she can afford to throw away. Even today, when popular invectives on the virtues of recycling have begun to dampen this blatant enthusiasm for disposability, Americans still manage to throw away more than 200 million tons of garbage every year (Grove 1994). And what we no longer throw in our own backyards, we have found ways to package and ship to farther frontiers on the other side of our nation's boundaries. Major American industries, while promoting their domestic recycling campaigns, have partially circumvented domestic regulations on solid waste management by exporting their plastics, metals, and other industrial scraps to less industrialized and environmentally regulated countries around the world (Leonard 1993).

Although America is still the undisputed leader of this cycle of conspicuous consumption and waste production, the trend has clearly infected both the global economy and the consumer culture of the entire industrialized world. The message conveyed in distinct yet consonant ways throughout this culture of consumption is that waste is not merely acceptable but essential to progress and prosperity (Hine 1995, 439–40). And the physical signs of this "prosperity" – antimonuments such as Staten Island's Fresh Kills landfill,[17] and Manila's "Smokey Mountain" trash

heap – are overflowing with both the material and physical consequences of our transnational waste making.

While most waste ends up in these unsanitary and unsightly landfills, some small percentage is reincorporated – or recycled – back into the economic and cultural system of the local population. Indeed, this is the power of rubbish as a category of possessable objects: it has within itself the potential of being discovered, retrieved, and transformed back into an object of greater or lesser durability. The United Nations estimates that two percent of the people in cities in nonindustrialized countries make a living from the refuse discarded by the richest ten to twenty percent (Germer 1991).

In Jakarta, Indonesia, for example, women work in the intense ninety-degree heat sorting through huge piles of liquid soap bottles, food wrappers, disposable diapers, and other plastic waste – most with familiar Western logos – to sell back to industrial recyclers. In Medellín, Colombia, workers pick through what they call the "third mountain" – five hundred tons of refuse from which they retrieve thirty tons of things to sell. And the city dump of Cairo is home to over thirty thousand Christian migrants from southern Egypt known as *zabaleen,* who collect, sort, and sell metal, glass, paper, and plastics to local middlemen, who in turn resell these materials to industrial and individual recyclers (plate 1.10).[18]

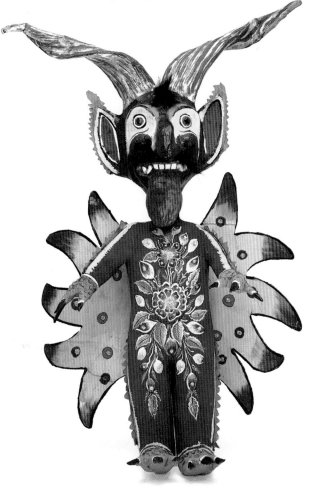

I.11
This papier-mâché devil figure – made entirely of moistened strips of paper torn from discarded cement bags – plays a part in the folk-Catholic festivities surrounding Holy Week in central Mexico. Known as a "Judas figure," it is designed to be strung with fireworks and exploded in commemoration of the death of Judas Iscariot, Jesus's betrayer. This figure was made by Bernardino Lemus and his family of Celaya, Guanajuato.

The Nature of Trash Transformed

The point at which these materials are picked up by individual artisans – local metalworkers, blacksmiths, woodworkers, papier-mâché makers, costume makers, quilters, furniture makers, and the like – is the point at which they reenter the cultural arena as raw materials for local expression. It is a dynamic point of entry that not only tolerates this incorporation of "nontraditional" materials and technologies, but in some cases depends, and even thrives, on it.

Egyptian craftspeople turn reclaimed metal into cooking utensils and coffepots or teapots. Broken glass bottles are melted down and reblown into glasses and pitchers and sold in local markets (Germer, 38). In Cairo as well as many other urban locales throughout the "third world," an entire class of blacksmiths, welders, cutters, hammerers, and painters has come to depend on the detritus of the modern automobile and food packaging industries to create household utensils, shoes, and lanterns from discarded motor oil and food cans, rubber tires, plastics, and scrap metals. In the urban city of Celaya, Guanajuato, in central Mexico, another kind of intercultural recycling has developed along with the booming industrial market. In traditional artisan *barrios,* second- and third-generation festival toy makers have come to rely on the discarded cement bags from local tile manufacturing plants to make their papier-mâché piñatas, masks, Judas figures, and other festival forms throughout the year (plate 1.11). Even in the celebrated heartland of industrialized America, hundreds of individuals – farmers, ranchers, quilters, homemakers, mechanics, carpenters, and heavy equipment operators – have responded to the massive proliferation of scrapped materials in their midst by transforming their environment into bold displays of refabricated quilts, toys, furniture, fences, whirligigs, gardens, yard displays, shop signs, and other creations of beauty, whimsy, utility, protest, or devotion.

These and other individual refabricators are the protagonists of this collection of essays on the nature and meaning of intercultural recycling. While each of these artisans has managed to find new uses and meanings in the detritus of the industrialized world, it is important to emphasize that their motivations –

and their audiences – are as varied and far reaching as the material creations themselves. If they use materials that have their origins in a world or an economy other than their own, this is ultimately not as important as the local meanings that they manage to ascribe to those materials. It is perhaps more accurate to say, then, that the people who are presented in these pages do not recycle; they create. And what is critical is that they create in ways that tell us as much about the communities from which they come, as about the industrialized sectors from which their mass-produced raw materials are descended.

Marcel Duchamp, Andy Warhol, and other modernist artists have taught us to see urinals as fountains, soup cans as paintings, and cheeseburgers as sculptures – thus making it easy for Western audiences to appreciate consumer products as recycled into art. The mass appeal and easy commodification of these Pop images, it could be argued, have even accustomed us to appreciate "fourth-world" recyclia as exotic fantasies or copies of a particularly dominant American aesthetic. When we view an African briefcase made from a recycled Nescafé can (plate 1.1) or a Haitian cardboard Christmas ornament in the shape of a television set (plate 1.12), we respond to the object as inherently understandable, "whimsical," perhaps ironic, yet ultimately devoid of any further cultural, critical, or ideological meaning.[19] We are trained to "read" the image of consumerism in a billboard-flashing millisecond; and what is more insidious, we are ultimately trained – dare I say seduced –

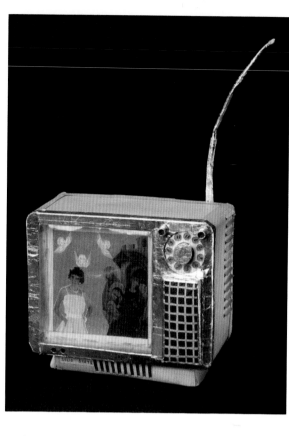

1.12
Cardboard Christmas Lantern. Maker unknown, Port-au-Prince, Haiti. c. 1985. Cardboard dry cleaner's shirt box, foil, magazine pages. H 9 3/4 x W 12 1/4" (24.5 x 31 cm). Collection Marilyn Houlberg, Chicago, Illinois.

Originally patterned after "gingerbread" houses in Port-au-Prince, these freestanding cardboard Christmas lanterns made from dry cleaners' boxes have become popular lawn decorations during the holiday season in the capital's wealthier neighborhoods. Today, the more traditional architectural forms compete with images of mass media and popular culture, such as radio "boom boxes" and television sets like the one seen here.

to desire the product behind the label, even if it is in a language or a lettering we do not understand. This desire smacks of what cultural critic Susan Vogel has referred to as our "narcissistic Western fascination with Western things recast amusingly or incongruously, to Western eyes, in exotic settings." (Vogel 1989) While we think we can read the intent, if not the actual words, of both the consumer product and the object recycled from it, I would argue that most of us are verging on illiterate when it comes to "reading" the culturally embedded meanings that might lie behind the consumer-based raw material or transformed product we immediately recognize.

Yet this is exactly what these essays challenge us to do. In fact, they start from the premise that even those recycled objects that take the theme of mass production or mass media as their explicit subject matter must be seen to carry a meaning different from that of their Western "art" counterparts (plate 1.13). And this meaning, they maintain, is readable only if we are willing to contextualize the objects within the often distressing realities of the political economies from which they come.

Take, for example, one of the most globally ubiquitous, and seemingly straightforward, categories of refabricated objects: the children's toy.[20] Every one of us experiences pleasure in seeing the way a child transforms waste tin or wire into a plane, boat, or transistor radio (plate 1.14). As one observer remarks, "In their economy of statement, elegance, the way the idea of a 'car' or 'helicopter' can be communi-

cated without the pedestrian realism, they have a true aesthetic sense." (Brett, 108) Yet few of us look beyond the whimsical elegance of the toys themselves to understand the multiple meanings behind their blatant appropriation of the materials and icons of the modern world. At the very least, we must assume that they reflect a paradoxical relationship to modern materials and traditional values. "On the one hand children are fascinated by the latest inventions, which awaken universal desires. On the other hand they do not relate to them as consumers. They want to appropriate them in the fullest sense, to produce them." (Ibid.) On a more ideological level, the para-doxical relationship might be situated between a world where, on the one hand, the real-life counter-parts of their fancy toy cars, radios, and motorcycles are seemingly well beyond their reach (plates 1.15, 1.16, 1.17) and, on the other, the life-size counter-parts to their toy tanks, helicopters, and weapons of war are sometimes all too frightfully present in their daily lives.

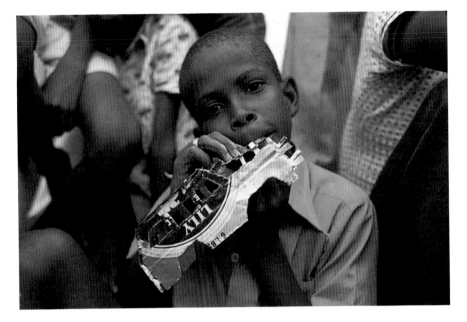

I.14
From ancient times children have been fascinated by vehi-cles. Greek and Roman boys played with miniature carts they made by hand. And not surpris-ingly, mechanized transport still fascinates and stirs the cre-ativity of children throughout the world who manipulate their urban and rural found environments to create planes, buses, bikes, trucks, tractors, cars, and canoes. This young boy from Haiti puts a finishing crimp in his tin-can car, using his teeth for pliers. (Photograph © Martha Cooper)

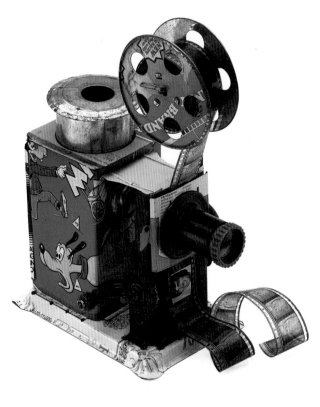

I.13
Toy Projector. Maker unknown, Pakistan. 1983. Metal cans, cogs, plastic scrap, and optical lenses. H 11 1/5 x W 8 1/4" (28.44 x 20.95 cm). International Folk Art Foundation Collection, Museum of International Folk Art, Santa Fe.

The most popular toys reflect the things that are of greatest interest to children – radios, cars, bicycles, trucks, trains, airplanes, animals, rockets, and spaceships – objects that they see on tele-vision and in movies. The film medium itself is an object of fascination. This toy projector is representative of a type found throughout South Asia and Africa. Recently, hand-made recycled ocular machines have become difficult to find because cheaper, more durable plastic ones are replacing them.

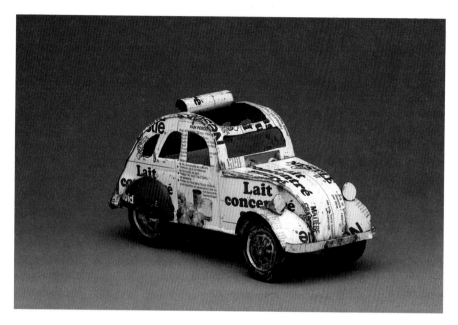

I.15

Toy "Deux Chevaux" Car. Maker unknown, Johannesburg, South Africa. 1994. Misprinted sheet metal from cans. H 4 1/2 x W 8 x D 3 1/2" (11.4 x 20.3 x 8.8 cm). International Folk Art Foundation Collection,

Museum of International Folk Art, Santa Fe.

The sunroof and jaunty shape of the classic Citroën "Deux Chevaux" make this toy popular with both adults and children.

If it is ultimately romantic to speak of these toys (or any other modern-day recyclia) in the language of resistance (by which I mean self-conscious political opposition), I would agree with Marshall Sahlins's assertion that

whether or not it comes to this [resistance], the indigenous mode of response to imperialism is always culturally subversive, insofar as the people must need to interpret the experience, and they can do so only according to their own principles of existence. (Sahlins 1992, 16)

As we prepare to enter the twenty-first century, we find ourselves at a historical crossroads where migration, urbanization, and culture contact have permanently altered the face of the international landscape. "The world is full of multinational companies, global agencies and affluent world travellers at the same time as it sees national diasporas, desperate waves of refugees and unstable patterns of migrant labor." (Wollen 1993, 205) In this context, mass-mediated images, technologies, and commercial products collide and intersect with local materials, communities, and customs on a daily basis. The refabricated material forms that result from this collision represent an elegant example of newly emergent

I.16

Toy Bicycle. Maker unknown, Mali. 1993. Cans, electric wire, tape. H 9 3/4 x L 19 1/4" (24.5 x 49 cm). International Folk Art Foundation Collection, Museum of International Folk Art, Santa Fe.

Children in many parts of the world use discarded metal cans and wire to create toys. As their creative and technical

skills develop, they pride themselves on making the most exacting miniatures of "the real thing." This toy bicycle sports every accessorized detail of a fancy touring bike – including a Coca-Cola can seat, plastic water bottle and air pump, telephone wire hand brakes, and a flashbulb brake light.

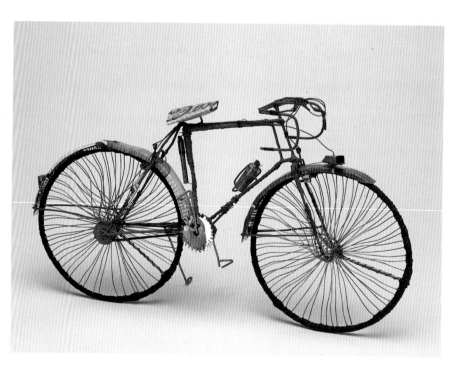

hybridity on a visual/material basis. They are signs whose semiotic richness stems from the necessarily subversive nature of their existence: each recycled object contains within it a reference to two or more distinct times, technologies, and meaning systems of which the former, and usually dominant, has been artfully subverted by its incorporation into the latter.

Social theorist Dick Hebdidge refers to this type of transformative process as a kind of "subcultural style" – a level of appearance, he observes, in which the most normalized of commodity forms are symbolically repossessed in everyday life and endowed with implicitly oppositional meanings (plate 1.18). These "humble objects," he says, "can be magically appropriated; stolen by subordinate groups and made to carry 'secret' meanings: meanings which express, in code, a form of resistance to the order which guarantees their continued subordination." (Hebdidge 1979, 18)

Folk Art from the Global Scrap Heap

In exploring the topic of folk recycling as a form of cultural creolization, the authors in this volume join a growing number of scholars and curators who have challenged the definitions of folk and tribal art in the late twentieth century.[21] In particular, these essays confront commonly held Western presuppositions about folk and tribal arts – i.e., that they are, by definition, nonindustrial, premodern, unchanging, nontechnological, communal, rural, primitive, and timeless – and dispute the conclusion that these art forms are fast degenerating, or indeed disappearing, in the contemporary world of culture contact and globalization. Because the recycled arts featured in this discussion necessarily involve a "grafting" of distinct technologies, materials, and sensibilities, they provide an ideal case for exploring the socially constructed nature of authenticity, traditionality, and material value itself.

Whatever their ultimate design or destination, these recycled artifacts are, by definition, "impure," "inauthentic" products of past and present, here and there, "us" and "them" (Clifford 1992). They fall into the category of all expressive activities that celebrate, in the words of the famed exiled novelist

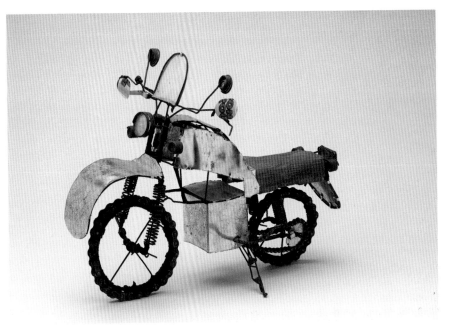

1.17

Toy Motorcycle. Maker unknown, Burkina Faso. 1990. Used tin cans, copper wire, bicycle chain, fabric, plastic. H 13 1/2 x L 17 1/2 x W 9 3/4" (34.5 x 44.5 x 24.3 cm). International Folk Art Foundation Collection, Museum of International Folk Art, Santa Fe.

Created from the cheapest of found materials, this miniature motorcycle is rich in detail and design. Note the carefully worked accessories, including tin-can rear mirrors, red plastic lights, rear flap, red tape–wrapped wire kickstand, and bike chain wheels.

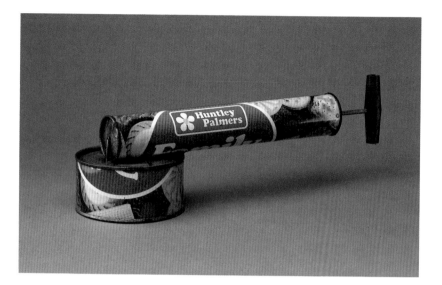

I.18

Insecticide Spray Gun. Maker unknown, Pakistan. 1983. Scrap metal, used cookie tin can, solder. H 3 1/2 x L 13 x W 4" (9 x 33 x 10 cm). International Folk Art Foundation Collection, Museum of International Folk Art, Santa Fe.

If recycling is a necessary art, it is also sometimes a dangerous one. Environmentally sophisti-cated consumers now recognize the danger in using cooking utensils recycled from American insecticide cans, or impover-ished children playing with toys made from Raid cans. In this handmade spray gun from Pakistan, the irony is reversed: a gun used to kill unwanted bugs is fabricated from an apparently innocent cookie tin.

Salman Rushdie, "hybridity, impurity, intermingling, the transformation that comes of new and unex-pected combinations of human beings, cultures, ideas, politics, movies, songs."[22] And like all such newly emergent hybrid forms, they have much to teach us about the powerfully creative ways people respond to conditions of change and upheaval – sociocultural, political, economic, and environmental – affecting us all in a postindustrial world.

Because this intermingling will necessarily take many different forms, inflected by different types and pressures of culture contact, by different patterns of consumption, and by different matrices of the ver-nacular and the industrial, it is necessary to always return to specific geographic, artisanal, or presenta-tional contexts to understand the true nature and meaning of the process of intercultural recycling. It is for this reason that we have structured the following collection of essays into four discrete sections – each featuring a different geographic locale, recycling pro-cess, or context of use – in order to introduce the reader to a broad range of motivating factors and aesthetic sensibilities that influence how, why, and for whom these refabricated objects are produced and consumed.

Seeing and Being Seen: The All-American Art of Conspicuous Recycling

While cases of recycling virtuosity can be found throughout the world, the first section of the book invites readers to focus for a moment on the United States – the self-proclaimed hub of the industrialized world – as an extraordinary site for the bold, and decidedly cross-cultural, display of conspicuous recy-cling. For some Americans, this display might be a proud and public statement of personal or occupa-tional virtuosity, identity, and patriotic devotion. For others, it might be an ironic commentary on American "junk" and its transformation by those, like African-American scrap figure maker Charlie Lucas, who feel that they, too, have been "cast off . . . beat up, broken, down at the bottom." (Lampell and Lampell 1989, 220) Yet whatever the motivating factor or contextualized significance, each of the recyclers dis-cussed in this section takes the site of America (its popular icons, images, symbols, products, people, or

scale) as a literal or figurative reference point for his or her conspicuous display of recycled arts and environments (plate 1.19).

In the introductory essay of this section, Charlene Cerny provides a provocative historical framework for understanding the proliferation and meaning of American folk objects and environments made from recycled industrial discards in the twentieth century. As shareholders in the last three decades of this century, she notes, we're often overwhelmed by the clutter of our throwaway American culture. Much of this clutter is made of plastic, tin, and paper – leftovers from the packaging industry, in which they served as containers of food, toiletries, sundries, and sprays. Ironically, this most tangible outgrowth of our disposable society is increasingly finding its way out of the trash heaps and onto the decorated fence posts, rag rugs, whirligigs, and yard sculptures of both the urban and rural landscape. These objects, Cerny maintains, provide an ironic testament to a contemporary consumer culture that has largely replaced the early American ethic of frugality and resourcefulness with media-driven planned obsolescence.

Joanne Cubbs and Eugene Metcalf, Jr., pick up where Cerny leaves off by focusing on the work and aesthetic sensibilities of two self-taught American artists who have created significant artifacts and environments from recycled objects. "Mr. Imagination" is an African-American environmental artist from Chicago who has created bottle-cap thrones, paintbrush people, cast-off totems, and other pieces salvaged from his life as a performing street artist. Tom Every, a retired salvager and industrial wrecker, patterns himself after a nineteenth-century fictional scientist named "Dr. Evermor" to create sprawling assemblages of giant machine parts. Despite vast differences in their socioeconomic, racial, and artistic identities, both of these self-taught artists shed light on the nature of creativity and consumption in postmodern American culture.

Kay Turner and Grey Gundaker shift the focus from the psychosocial motivations of individual artists to the culturally embedded forces of particular ethnicities: the Mexican-American and African-American communities, respectively.

In her exploration of the yard art of the Texas-Mexican community, Turner suggests that an aesthetic

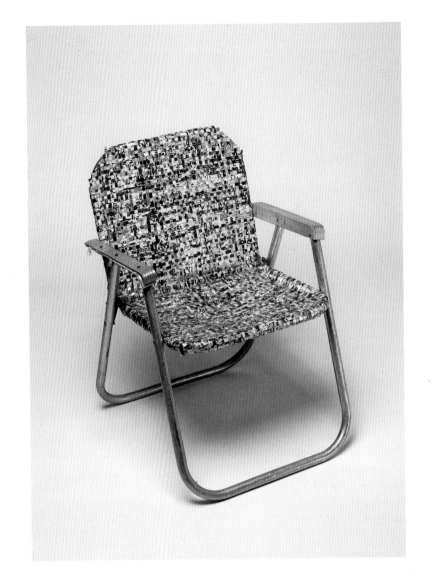

1.19

Lawn Chair. Svein "Slim" Sirnes. Goldfield, Nevada. 1992. Aluminum chair frame, aluminum beverage can strips. H 30 x W 22 1/2" (76.3 x 57.2 cm). International Folk Art Foundation Collection, Museum of International Folk Art, Santa Fe.

While traveling around the country, often following the trail of environmental concerns, journalist, inventor, and environmentalist "Slim" Sirnes passes the time by weaving aluminum fabric or mats from strips of discarded beer and soft drink cans. The resulting pieces, including this lawn chair, are examples of one-of-a-kind craft projects that make use of disposable materials and disposable time, of excess and leisure. A literal American icon – a lawn chair intended for leisure use – it provides a self-reflexive commentary on the disposable culture of late-twentieth-century American life.

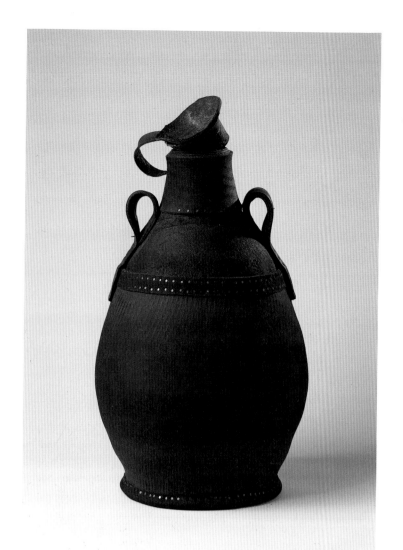

I.20

Water Carrier. Maker unknown, Marrakech, Morocco. 1993. Tires, nails. H 27 1/2 x Diam 16 1/2" (69.8 x 41.9 cm). International Folk Art Foundation Collection, Museum of International Folk Art, Santa Fe.

This elegant water carrier is made from one of the most inexpensive and widely available recycled materials – used tires. It is almost identical in size and shape to more costly ones made in riveted copper.

of bold display is at work in these everyday recycled arts. Images, objects, and ornamentation are not absorbed into environments, she says, but rather pushed to the forefront to catch the eye and to carry meaning. Turner provides a provocative framework for interpreting the seemingly disparate activities and artifacts seen in the domestic, yard, and commercial spaces of the Mexican-American *barrio* (where automobile tires are used as planters, porcelain bathtubs are converted into sacred grottoes, and discarded tin cans are elaborated as flower pots). The refabrication of other people's throwaways, she maintains, must be seen, first of all, as a strategy of resourcefulness in an economically difficult environment. Yet it must be recognized also as a proud aesthetic stance, or attitude, that represents the community's sense of itself in a changing and often troubling world.

Gundaker's essay on the yard displays of the African-American community provides an illuminating counterpart to Turner's exploration of subcultural style. According to this author, African-American yard displays throughout the United States – as created in widely divergent geographic locales, and by people of different socioeconomic classes, genders, and ages – can be said to follow a cyclical principle of rebirth and renewal. A creolization of Christian and Afro-Caribbean belief systems, this "what goes around comes around" philosophy is visually represented by a variety of material castoffs including old clock faces, wheels, compasses, rotary fans, whirligigs, and diagrams of solar movement. This cyclical process of rebirth and renewal is not only represented by cast-off materials, but the process itself can be seen as a metaphor for recycling.

Recycling and the Global Marketplace

A central theme addressed in the second section of the book involves the importance of recycling as an economic strategy of survival in developing countries and marginalized communities throughout the world. It is set, appropriately enough, against the vivid, dynamic backdrop of the open-air marketplace where many of these objects are both made and sold. Based on their in-depth field research in Africa, Mexico, and India, respectively, anthropologists Allen F.

Roberts, Julius Kassovic, and Frank Korom examine the nature and meaning of recycling in these countries as a form of creative production that is motivated, primarily, by adverse conditions of economic necessity. Economic survival and adaptation are influential factors for both the makers, who build informal businesses on the making and selling of recycled goods, and the local consumers, for whom the market for affordable, utilitarian goods is devised.

In each case study, the recycling process involves the appropriation and transformation of worn-out and/or discarded, industrially produced products for primarily utilitarian or recreational functions. While economic adversity is the principle motivating factor in this type of artisanal activity, each of the authors emphasizes the artisans' clear commitment to "making do" according to an aesthetic sensibility and technological style that are distinctly their own. In Morocco, the fluid grace of a hand-turned copper pot is mirrored in its refabricated tire counterpart (plate 1.20); in Senegal, the love of pattern and color reflected in native craft traditions is reflected in the kaleidoscopic cases made from the cut and soldered sheets of locally produced tomato-paste tins.

In "The Ironies of System D," Roberts draws on the activist political model of the Surrealists to illuminate the process of "culture-building" among the sometimes oppressive political economies of African metropolises. What the Surrealists referred to as "extraordinary realities" can be seen in the unexpected juxtapositions which result when African "technology brokers" recycle materials, images, and ideas from one domain of their social and economic life into another. Recycling in Africa becomes a necessary art, Roberts maintains, and such ironic "misuse" of objects reflects nothing short of adaptive brilliance. Incorporating two separate case studies – one from the tin-can recycling artisans of Dakar, Senegal, the other chronicling the transformation of chrome car bumpers and other scrap pieces into sacred grave ornaments in Bénin – his provocative article explores the nature and meaning of recycling as an ironic act. In both Senegal and Bénin, the recycling artisans are guided by spiritual saints or gods whose narratives of transformation and innovation inspire the ironic collages affected in the finished products.

In his essay on folk recycling in Mexico, Kassovic provides a framework for understanding the junk refabrication process on both the household and small workshop levels. Using examples from his extensive field travels throughout the country, Kassovic makes explicit the technological and motivational distinctions between the large-scale industrial recycling with which most of us are familiar – where masses of products are systematically reduced to their basic component materials – and the tradition practiced by poor people in Mexico and the world over. On the folk level, junked items are not merely recycled, but are "refabricated" to produce new items performing altered functions. This process, according to Kassovic, can be classified in terms of the degree to which the junked item has been modified: "minimal modification" describes the simple process of transforming a tin can into a flower pot; "radical modification" is the term he uses for defining the complicated refabrication involved in transforming a tin can into something with a completely altered shape and function, such as a fluted bird cage.

Placing the recycling arts of India within a context of Hindu cosmology, philosophy, and ideology, Korom explores the anthropological notions of pollution and purity as they pertain to the production and use of recycled objects in India. He illustrates these binary principles through a case study of one artist whose social status is challenged by his involvement in the recycling industry. Whereas the handling and transformation of polluted discards is usually reserved for the lowliest caste in India, the featured artist is a high-caste Brahman who defies the rules of conduct to create objects of renewed beauty and utility out of his scavanged collection of other people's throwaways. In so doing, he sheds light on the socially constructed value of objects within Indian society and on the meaning of waste and its transformation.

Recycling in the Streets: The Arena of Ceremony and Celebration

The ironic manipulation of Western discards is also a central element of the third section of the book, which focuses on recycled arts in a festival or ceremonial context. The two essays in this section point

out significant ways in which industrial discards have altered the appearance, meaning, and/or function of festival-related forms, sounds, and practices. The first focuses on the development of the steel drum bands in Trinidad and Tobago, and the second highlights the elaborate Corpus Christi Festival headdresses of Ecuador's Central Highlands. Each represents a distinct domain of festival expression that has incorporated Western products and materials into its traditional structure. In each case, the creators and performers have been empowered by both the process and the products of ritual appropriations, and the appropriated materials themselves have acquired new meanings – mythical, autobiographical, historical, sometimes political – in the context of their festival reuse.

In "The Beat Goes On," John Nunley explores the historical development of an entirely new musical tradition created from the detritus of the industrial age. By recycling discarded fifty-five-gallon oil barrels into percussive instruments, the people of the Caribbean country of Trinidad and Tobago have developed a

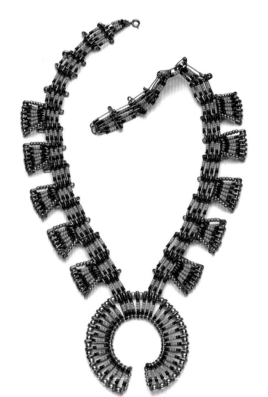

I.21

"Squash Blossom" Necklace. Maker unknown, New Mexico. c.1970s. Safety pins, plastic beads. L 15 x W 3 1/4" (38.1 x 8.3 cm). International Folk Art Foundation Collection, Museum of International Folk Art, Santa Fe.

Safety pin "squash blossom" necklaces were popular tourist items in the 1970s. Based on the traditional Native-American design of that name (usually made of turquoise and coral on silver) made by Navajo silversmiths, these more affordable "souvenirs" reflect the complex multicultural junctures where diverse materials, symbols, and peoples meet on common ground.

national sound that symbolizes the island culture and contributes to a national identity that is recognized and celebrated worldwide. The history of the oil drum–defined steel band, or "pan" as it is called, can be traced to emancipation from slavery, when people of African descent appropriated the upper-class Carnival tradition and substituted their own music based on the percussive sounds from their homeland. Despite government restrictions and even explicit bans on the use of drums in the late nineteenth century, a grassroots movement of young, marginally employed men kept the music alive, first with bamboo cylinder drums, and later with metal vehicle parts, garbage can lids, salt boxes, tin kettles, biscuit tins, paint cans, and other found objects.

Soon after World War II, fifty-five-gallon oil barrels became the raw material of choice for the drums that today musically define this island nation. The barrels – large, well made, and widely available – soon replaced all other materials. Musicians turned over the oil drums and pounded the bottom into forms that created a wide range of notes, enabling the instruments to be tuned to imitate everything from calypso to Western classics. Like the biting lyrics and eclectic style of calypso music itself, the refabricated oil drum instruments are a product of, and continuing visual commentary on, the dynamic cultural, social, and musical juxtapositions defining the Afro-Caribbean experience.

Barbara Mauldin's essay moves from the expressive arena of festival music to that of festival dance and, more specifically, the material domain of dance costumery. Based on her fieldwork in the Central Highlands of Ecuador, Mauldin explores the contemporary production of large costume headdresses for the indigenous and mestizo dancers who perform in honor of the Corpus Christi Feast Day in this Andean region. Historical records of these headdresses from previous centuries show them encrusted with jewels, gold bands, and other precious materials. The contemporary headdresses are adorned with a wide range of broken, secondhand, or salvaged commodities such as clocks, watchbands, sunglasses, zippers, hospital syringes, and metal automobile company logos, as well as plastic baby dolls, old lightbulbs, and cheap costume jewelry. Her case study explores not only the creation and maintenance of these

ornate headdresses, but also their public presentation. She concludes that the bold pastiche of popularly appropriated Western "riches" reflects a dynamic cultural merging of the aethetic traditions of European-Catholic Baroque ornamentation, indigenous Andean motifs and religio-decorative practices, and the mass-mediated images of contemporary popular culture.

Wearing the Other, Transforming the Self: The Flip Sides of Cultural Appropriations

The final section of the book locates the practice of recycling squarely within the "global ethnoscape"[23] where personal style becomes the arena of cross-cultural encounter and appropriation. In this section, the reader follows the recycling trail into the last decades of the twentieth century with a look at two kinds of recycling practices that encapsulate the ironic juxtapositions and multicultural exchanges characteristic of global modernity. In the first instance, Enid Schildkrout and Donna Klumpp Pido explore the conscious and conspicuous transformation of Western discards – by non-Western peoples – for decorative use in their own indigenous adornment. In the second case, Donald Cosentino takes a provocative look at the transformation of folk-Catholic imagery – by Western peoples – into accessories of personal or household adornment for consumption by a sophisticated urban Western audience. Both sets of objects proudly display the appropriated symbols of a disparate time or place recast into a familiar form. They are mirror statements of culture contact and conquest, reflecting each other in an ironic commentary on the late-twentieth-century global village where industrial products and indigenous customs share a common fertile ground.

The proud and public display of plastic pen caps in armbands worn by the Maasai of Kenya and Kellogg's biscuit-tin labels in New Guinean tribal headgear (see plate 1.4) are two of the types of bodily adornment discussed in Schildkrout and Pido's essay on appropriated style in the non-Western world. While focusing their attention on the ornament and dress of the indigenous African peoples with whom they have worked for more than twenty years, the authors also address the creolized couture of other

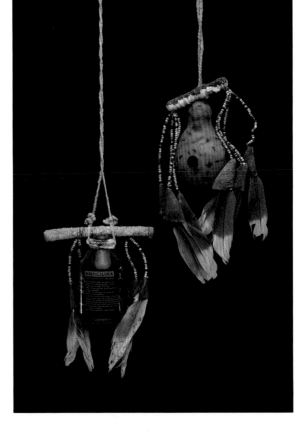

portions of the globe, including such items as Wodaabe safety pin tunics, Kefiristani robes decorated with nonfunctional zippers and buttons, and Native-American thimble vests and "squash blossom" necklaces made from safety pins (plate 1.21). Discussion of these pieces is framed in terms of the specific contexts of their creation and use, encouraging an understanding of these stylistic adaptations not as the indigenous wearer's poignant "misapprehension" of the Western world, but as self-conscious and culturally embedded statements of local style, global awareness, and cultural reversal (plate 1.22).

In "Madonna's Earrings," Cosentino explores the recent Euro-American fashion fad for Latino-derived folk Catholic imagery. Focusing on the phenomenon of "Catholic kitsch" recycling in contemporary American popular culture, and the patterns of urban elite consumption that support it, the author analyzes the marketing appeal of a growing product line which includes everything from rosary bead belts to decoupaged bottle-cap earrings and matching hair clips emblazoned with the Virgin of Guadalupe. Arguing that this type of "recycling" of Catholic images and icons has actually been going on since ancient times, Cosentino provides a fascinating framework for understanding the MTV-popular-culture intersection of religion and recycling in this hip, hybrid fashion phenomenon, which one vendor refers to as "pop-modern-Catholic-folk-like art and stuff."

Like the Kellogg's cereal box woven into the hair design of a New Guinean man, these examples of

1.22
Gourd and Medicine Bottle Pendants. Unknown Xavante maker, Mato Grosso, Brazil. c. 1984. Cord, wood sticks, seed beads, deer hooves, feathers, gourd, glass medicine bottle. Bottle, H 3 1/4" (8 cm). Collection Laura Graham, Iowa City, Iowa.

Cultural contact between dominant and minority peoples often leads to fertile new forms of adornment, by taking some ideas, materials, or techniques from industrial society and applying them in new ways to the needs of the indigenous culture. In this example of a ceremonial pendant worn by the Xavante, an indigenous group in Brazil, a discarded medicine bottle from a nearby regional hospital substitutes for a traditional gourd, which is similar in color, shape, and capacity.

kitsch reuse have as much to teach us about ourselves as about the peoples whose images we have so self-consciously appropriated. And it is these lessons about the self and the other that await our discovery in the radically heterogeneous mix of materials, ideas, and technologies that define the popular arts of recycling.

Some Concluding Thoughts: Trash Chic Comes to Texas

In Austin, Texas, where I live, a new Mexican restaurant has sprung up along the freeway feeder street in the rapidly expanding north side of town. The restaurant, which caters almost exclusively to a middle-class Anglo clientele, draws the cosmopolitan Austin crowd for nightly rounds of "ethnic chic" cuisine: in this case, Tex-Mex margaritas, enchiladas, rice, beans, tacos, and homemade salsa. It is one of dozens of such trendy renditions of Mexican cooking that flood the urban Texas restaurant scene every year; this one, in fact, is a transplanted clone of a successful chain that began as a storefront mom-and-pop business in a rough-and-tumble *mexicano* neighborhood of east Houston.

The restaurant's decor is also part of the draw. Where ten years ago popular Mexican restaurants in Texas were decorated with gaudy, brightly colored Mexican border crafts – oversized gold-trimmed sombreros and handwoven serapes – which were meant to evoke the nostalgic color and icon saturation associated with that culture, this hip establishment of the '90s takes the concept of "border aesthetic" one step further. It is not decoration, per se, they're marketing; it's ambiance. The entire building *is* the decoration, and it is designed to give the customer the manufactured grit and feel of a Mexican border or *barrio* experience – a "vicarious sensibility," if you will, of life on the edge, at the border of another world – where danger and excitement lurk behind rough-hewn adobe walls topped with jagged cement-embedded bottle shards, and the exotic lure of the Mexican *cantina* is suggested in hand-hewn packing-crate shelves lined with empty bottles of Mexican beer.

A few miles away, in another Anglo-dominated neighborhood of north Austin, another Mexican restaurant has recently completed a similarly post-modern face-lift on its turquoise-washed adobe building. Gone are the brightly painted clay decorations and neon signs that once graced the pastel facade of this family-owned Austin restaurant chain. In a clearly self-conscious attempt to draw a hip new clientele with the proper and acquired taste for tackiness, this restaurant has literally peppered its facade with hundreds of empty rusted chile-pepper-cans-turned-flower-pots – just like one might see fronting the brick or adobe facades along the unpaved streets of a dusty Mexican border town.

Recycling becomes "kitsch" in this sensibility, when the very necessary practice of "making do" along the Texas-Mexican border is transformed into a parodic act of making exotic. The shard-embedded walls and packing-crate shelves reproduced in the first restaurant decor are not functional; indeed, they are very clearly designed as icons of the real thing. The decor is a stage set that capitalizes on what one postmodern theorist refers to as "a camp sensibility, a perspective wherein appreciation of the 'ugly' conveys to the spectator an aura of refined decadence, an ironic enjoyment from a position of enlightened superiority." (Olalquiaga 1994, 45)

In both these examples, the most threatening and "ugly" products of industrialized recycling – broken bottle shards and rusted tin cans – have been reappropriated and transformed as exotic foreign icons to ornament the urban American "culturescape." They have been divorced from their original points of referentiality – as ingenious solutions to real problems of economic and aesthetic impact – and reascribed new meanings in a system of pure consumption. "Such a distanced reception," says Celeste Olalquiaga, "is best described as a vicarious sensibility . . . one where experience is lived indirectly, through the intercession of a third party, so to speak, that acts as both its catalyst and its buffer." (1994, xix)

"Vicarious sensibility," according to this critic and others, is what drives the contemporary Western market in its production of trash chic decoration and decor like that fronting the Tex-Mex restaurants in my neighborhood. License-plate bustiers, bottle-cap-studded seat belts, tin-can disco bags, Rubber Necker tire ties, and African kente cloth suspenders are other examples of refashioned products that are targeted

for both the "enviro-conscious" and the "exotic wannabes" (plate 1.23). With these eclectic recyclables, we have come full circle in the discourse on creative recycling from the kind of transformation of an industrial discard – remember the Coca-Cola bottle? – depicted in the cinematic spoof on Western colonialism with which I began this essay. Note, in fact, how a recent *Esquire* review of a trendy SoHo gallery specializing in "Afrocentric chic" appropriates that same image to locate its postmodern subject:
Drop a Coca-Cola bottle among the Bushmen of the Kalahari and you get the culture shock depicted in The Gods Must Be Crazy – *a film, its video jacket tells us, "that shows us (westerners) just how crazy we are." But drop Coca-Cola cans – or 7-Up or Heineken – into Senegal or Burkina Faso, and you get them back – flattened out and made into briefcases, the logos proudly displayed, the insides lined with French comic books, shipped to the West for sale.* (Patton 1992, 52)

Both of these commercial recastings of "The Real Thing" – the trendy cinematic parody and the hip Afrocentric suitcases – seem to offer a profound commentary on modern culture. They both hold up a mirror, as one critic suggests, "to the wastefulnesss of the West" and at the same time "demonstrate a virtuosity of hand that shames the mechanical uniformity of mass production." (Patton, 53) And both ends of the spectrum – from the culture shock of the "noble savage" first confronted with the bottle of Coke, to the savvy appropriation and commercialization of the transformed Coke-in-a-can – are part of the multiple and complicated "mixed blessings"[24] that define the postmodern landscape. They celebrate a historical vision that makes space for specific and disparate paths through modernity, not one that sees the world as populated by endangered authenticities – what James Clifford, borrowing a line from famed American poet William Carlos Williams, refers to as "pure products always going crazy." (Clifford 1988, 5)

It is in this spirit that I invite you to expore the hybrid and subversive forms of cultural representation presented by the essays in this book – "recycled," "impure," "inauthentic" forms, every one, which provide a metaphor for multiculturalism in the gloriously complicated world in which we all live.

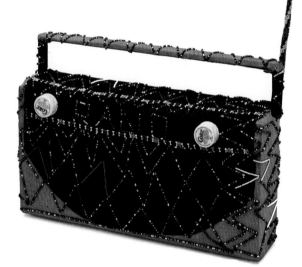

1.23

Beaded Fabric Radio. Unknown Zulu maker, South Africa. 1993. Old plastic radio, fabric, beads, thread, plastic Coca-Cola bottle caps. H 13 x L 14 1/2 x W 4 1/4" (33 x 37 x 10.5 cm). International Folk Art Foundation Collection, Museum of International Folk Art, Santa Fe.

A discarded plastic radio is the foundation for this toy icon of popular culture that may have been made for sale to tourists in South Africa. The basic form is covered in black fabric and decorated with a traditional diamond pattern of multicolored seed beads; a more formal Zulu aesthetic is reflected in the antenna's spire of orange, green, and yellow beads. The signs of Western culture are inscribed by the beaded word "RADIO" written across the top and the plastic knobs fashioned from the familiar red and white plastic caps of America's No. 1 soft drink.

American Adhocism: Wasting, Saving, and the Aesthetics of Conspicuous Recycling

Charlene Cerny

If I seem to be over-interested in junk, it is because I am, and I have a lot of it, too – half a garage full of bits and broken pieces. I use these things for repairing other things. . . . But it can be seen that I do have a genuine and almost miserly interest in worthless objects. My excuse is that in this era of planned obsolescence, when a thing breaks I can usually find something in my collection to repair it – a toilet, or a motor, or a lawn mower. But I guess the truth is that I simply like junk.

– John Steinbeck,
Travels with Charley, 1962

"Recycled" folk arts in America reveal a great deal about the nation's traditional character. Embodying the old-fashioned value of thrift and resourcefulness, but using as their primary media the leftovers of our throwaway society, they are powerful signifiers of a peculiarly American ambivalence toward thrift and waste. Often they celebrate rugged individualism in a conspicuously bold way – all the while reminding us that this is an art born not only in studios, but in sewing rooms, front yards (plate 1.1), garages, and prison cells. These recycled works thumb their noses at artistic hierarchies, and do so with considerable glee. With their sometimes quirky, can-do inventiveness, they provide us with meaningful glimpses into the American psyche – and the phantoms of Benjamin Franklin, Sarah Hale, Henry Ford, Rube Goldberg, and Heloise that inhabit it. Often resulting from acts of improvisational bravado and technical mastery, this art from the scrap heap is rife with complex cultural messages about, among other things, thrift and waste, consumption and value, and marginalization and personal identity.

Thrift and Waste

"Waste Not, Want Not." "Every little makes a mickle." "When the well's dry, we know the worth of water." Many if not most Americans have heard some version of these homilies, whether spoken in English, Spanish, Yiddish, or some other language. Such aphorisms – all too often uttered by an elder in hopes of producing a desired behavior and instilling "proper" values – are far from being merely simple clichés. They express the long-standing and implicit value placed on thrift and frugality, one that has especially deep roots in America.

Historically, we can look to our ever-so-practical forefather Benjamin Franklin as one of thrift's most active proponents. The sayings he popularized in his immensely successful *Poor Richard's Almanack*, grafted onto the already strong principles of Puritan asceticism practiced by the early colonists, had a monumental influence on pre-Revolutionary ideas about thrift, waste, and the value of purposeful work. At a time when the Bible and the newspaper were still unattainable luxuries for most (Sagendorph 1970, 32), the almanac was often the *only* printed matter to be found in

many colonial homes (Van Doren 1941, 106–7). So we can be reasonably certain that Poor Richard's list of "Thirteen Virtues," in which "Frugality" ranks fifth and "Industry" sixth, were internalized by many of our forebears.

Later, in the nineteenth century, the principle of thrift merged with good housewifery, for which in part we can thank the prodigious writer and editor Sarah Hale. Hale edited *Godey's Lady's Book* and Boston's *Ladies' Magazine* between 1828 and 1878. She was famous in her day, not only as an editor and popular novelist, but as composer of the verse "Mary Had a Little Lamb" (1830), and even as leader of the campaign to establish Thanksgiving as a national holiday. Thus, Hale exerted enormous influence over her female contemporaries.

Hale's writings were suffused with lectures about the importance of thrift, industry, and womanly self-sacrifice (Tucker 1991, 25–37). For example, she railed against the "fashion victims" of her day who wore imported fabrics and extravagant accessories such as ribbon and gauze, thereby impoverishing their families

1.1
Plate View. Kinross, Iowa. 1993. The entire exterior of this two-story house in the rural farming community of Kinross has been covered with Iowa license plates. Hubcaps are used as accents.

and their nation with their "frippery." To the wealthy she counseled:

An extravagant woman can never be an amiable or lovable one . . . no amount of wealth excuses indolence, or renders it attractive. (*Godey's Lady's Book,* February 1856, 177)

To those less fortunate, she preached

in our country, where every family wishes to appear "respectable," it is essential to know how to make the most of small means. (*Godey's Lady's Book,* June 1843, 293)

Hale particularly encouraged the teaching and development of needlework skills to women of all classes in society, counseling that a woman could not be considered educated – no matter how many instruments she might play nor languages she might speak – if she were not also a competent needlewoman.

With a *Godey's* readership alone of half a million women, Sarah Hale's themes of thrift and economy persisted not only for the three generations who read her, but well into this century.[1] In fact, Hale's essential message of thrift and making do still persists today in such popular writings as "Heloise's Hints," the nationally syndicated column that provides homemakers with earnest tips on how to transform useless discards into household gadgets and labor-saving devices.

Despite the admonitions of Franklin and Hale, and their allies in frugality, there have been strong countervailing attitudes to thrift in America. Histori-

cally, it has been said, we are a nation of wasters.[2] Frederick Jackson Turner's seminal and much-argued "frontier hypothesis" characterized the American pioneer as a ruthless exploiter of his newfound land. Subduing nature to meet human demands and needs, the American pioneer ravished the land and, once it was no longer productive, simply moved on (Turner 1920, 22–3). Such an experience, it is reasoned, has led our society to take abundance – and wasting – for granted; indeed, to regard them as a privilege. Arthur Schlesinger commented in 1942 that a tradition of wastefulness created by

an environment of abundance, had fastened itself on the American character, disposing men to condone extravagance in public as well as private life. . . . In their personal lives Americans were improvident of riches that another people would have saved or frugally used. (Schlesinger 1942–43, 235)

In the days when "progress" was still an uncontroversial concept, and no one was concerned about a "solid waste crisis," even the material evidence of waste was regarded positively. In 1930, Julius Klein, a key official in Herbert Hoover's Department of Commerce, wrote that "heaps of junk" were merely "the visible evidence of our willingness to shake off archaic traditions, methods and equipment." (Quoted in Lears, 403)

Yet wasting also represents the dark side of our consumption,[3] and is often associated with pollution, disease, and death. On the one hand, we deplore waste

1.2
Stampwork Picture. Benjamin E. Ulmer (1864–1942), Middletown, Pennsylvania. c. 1900. Canceled postage stamps. H 13 1/2 x W 20" (35.5 x 51 cm). International Folk Art Foundation Collection, Museum of International Folk Art, Santa Fe.

This unusual stamp collage predates even Picasso's use of found materials in his collages.

and are embarrassed by it. Our own human waste is carried safely out of sight in underground pipes. Our trash is put out for euphemistically named "sanitation workers," who suffer low social status for performing the unseemly task of handling polluted goods.[4] Is there anything most Americans would protest more vocally than the prospect of a new waste disposal site near their home? Our language, too, reveals our biases: vandals "trash" our cities; marginalized people are referred to as "outcasts," "dregs," "scum," or even "white trash." The toxicity of the Love Canal, the physical wasting that plagues AIDS victims, and graffiti-covered subway cars are all images that many people find repellent.

But what repels also attracts. Many people experience a kind of perverse pleasure in the destructive sight of a raging fire or the demolition of a building as the big, seemingly all-powerful, wrecking ball pounds into its abandoned walls. Why else the classic car chase, a staple of our grade-B movies, which inevitably ends in wanton destruction of a car or two?[5]

Then, too, there is an attraction in the redolent beauty of the trash heap. It is a place free of restraint, rich with possibilities, laden with discovery, layered with old meanings and associations, and tinged with voyeurism. For many twentieth-century artists these associations have proven a fertile ground for artistic exploration. In her comprehensive study *Collage, Assemblage and the Found Object,* Diane Waldman

comments that Picasso and Braque introduced into their papiers-collés objects that were "already soaked with humanity." (Waldman 1992, chapter 1, note 8) She notes that the use of found materials

layers into a work of art several levels of meaning: the original identity of the fragment or object and all of the history it brings with it; the new meaning it gains in association with other objects or elements; and the meaning it acquires as the result of its metamorphosis into a new entity. (Waldman, 11)

Folk artists also apparently responded to these same qualities. As early as the late nineteenth century "found objects" were sometimes incorporated into their works, thus adumbrating twentieth-century developments in fine art.[6] For example, there are a pair of handsome pictures made around 1900 that are a collage of canceled postage stamps (plate 1.2). Inscribed on the back, "B.E. Ulmer, Middletown, PA," we now know that these were made by one Benjamin E. Ulmer (1864–1942), who lived and died in the town of Middletown, Dauphin County, Pennsylvania, not far from Harrisburg. While the Ulmer family is of Pennsylvania-German ancestry, these stamp collages are not typical of any recognized Pennsylvania-German folk art tradition. Finely and lovingly executed, they are masterful in their use of the stamps' color and texture to create complex – and charming – compositions.[7]

Another more typical, popular form of American recycled art is that of the "memory vessel" (plate 1.3), a type of late Victorian decorative object that served as a kind of three-dimensional scrapbook. Here, bottles, vases, and jugs form the backdrop for an eclectic array of objects – a scissors, a spring, a spoon, a framed mirror, a thimble, nuts and bolts, a fish charm. While we know that the makers of such jugs were a diverse group racially, ethnically, and in gender,[8] little has been published that reveals the true nature of these fascinating objects. Were these mementos of loved ones and happy times, paeans to the dearly departed,

1.3

Memory Jar. Maker unknown, United States. Early 20th century. Glass jar covered with composition dough embedded with metal, plastic, glass, and wood objects, gilt with gold paint. H 8 1/4 x Diam 5 1/2" (21 x 14 cm). International Folk Art Foundation Collection, Museum of International Folk Art, Santa Fe.

"Memory vessels" from the late Victorian era are compelling decorative objects that serve as three-dimensional scrapbooks for their makers.

1.4

"Tobacco Sacks" Quilt. Maker
unknown, United States. 1920s–
1930s. Dyed tobacco sacks,
cotton filling, thread. H 83 x
W 42 1/2" (212.9 x 184 cm).
Collection Shelly Zegart, Louis-
ville, Kentucky.

Loose tobacco used to be
sold in small cotton sacks that

were sometimes exploited by
quilt makers. They removed
the bags' stitching, washed and
dyed the cotton rectangles,
and used them to piece simple
patterns. In this unusual exam-
ple, the dyed bags have been
arranged to spell out their
origin.

or merely glittery knickknacks meant to grace the
parlor? Whatever functions they served, today they
provide us still with a nostalgic glimpse into the
hearts and lives of the individuals who made them,
while demonstrating that the power of the recycled
manufactured object was recognized early on.[9]

The two World Wars and the Great Depression
dictated that thrift and resourcefulness, of necessity,
would continue to figure large in American life. Dur-
ing those decades, many American housewives, for
example, had little choice but to provide handmade
clothing and bedding for their families. Women com-
petent in needleworking (they would have made
Sarah Hale proud), particularly rural women, contin-
ued the tradition of creating pieced quilts – perhaps
the quintessential American recycled folk art – as
well as less-celebrated sack clothing.[10] Increasingly,
though, the scraps came from sources other than
the family sewing basket, such as pancake, flour, and
tobacco sacks (plate 1.4). By the 1940s, when such
recycling sported the patina of patriotism as well as
thriftiness, flour sack manufacturers and millers were
intentionally marketing feed sacks made from fabric
suitable for clothing and other uses (plate 1.5). No
longer did housewives have to struggle to remove the
product labeling either – although some chose to
utilize it in their design (plate 1.6). Farm women even
organized "Sack and Snack Clubs," which combined
pot luck and sack-swapping parties, in hopes of get-
ting enough identical bags to complete a garment
(Connolly 1992, 23).

The make-do sensibility is still in evidence, albeit
in a somewhat more self-conscious form. Late-twen-
tieth-century quilts made from such disparate items
as bank cash bags, men's neckties, blue jean pockets,
underwear labels, and overalls, not to mention the
ubiquitous hippie skirts made from recycled blue
jeans in the 1960s, all suggest that the "throwaway
spirit" has not totally eradicated the desire to trans-
form trash into treasure.

1.5

*Advertisement for Bemis Bag
Company.* San Francisco, Cali-
fornia. December 1949. Recycled
feed sacks printed with decora-
tive patterns were popular for
making clothing, as these
mother-and-daughter fashions
show. Bags made by the Bemis
Company alone were available
in at least one thousand differ-
ent patterns, to appeal to all
tastes.

1.6

"Aunt Jemima" Sack Quilt.
Maker unknown, Texas. 1940s.
Cotton fabrics, including printed
labels from Aunt Jemima
Cornmeal bags, cotton filling,
thread. H 79 x W 71" (200.6 x
184 cm). Collection Shelly
Zegart, Louisville, Kentucky.

Made in the 1940s, this quilt
features the repeated portrait
of "Aunt Jemima," an image
that has aroused controversy
since the 1960s, when civil rights
activists began to object to its
physical and occupational stereo-
typing of African-American
women. Although the image
has been "updated," Aunt
Jemima remains on company
packaging.

The *New* Poor Richard: "When in Doubt, Throw It Out"

While we often think of consumerism as a post–World War II phenomenon, even by the turn of the twentieth century a majority of Americans rated the Sears catalogue as their favorite book after the Bible (Panati 1991, 51). Already, the newly primed factories churned out goods that a hundred years earlier could not even have been fathomed. And in the rural United States, once a stronghold in the production of handmade goods, farm families could now emulate their city cousins with the latest fads – or, being cash-poor, could at least learn to yearn for them.

The slow shift from home-based resourcefulness to consumer convenience had begun to occur. Disposable items such as toilet paper, introduced in the U.S. in 1857, at first met considerable consumer resistance. At that time, a majority of Americans could not *comprehend wasting money on perfectly clean paper when their bathrooms and outhouses were amply stocked with last year's department store catalogues, yesterday's newspapers, and sundry fliers, pamphlets and advertisements, which also provided reading material.* (Panati 1987, 204–5)

1.8

Grape Trivets. Maker unknown, probably Denver, Colorado. 1920s–50s. Crochet-covered bottle caps. Largest H 13 x W 7 3/4" (33 x 19.3 cm). International Folk Art Foundation Collection, Museum of International Folk Art, Santa Fe.

A popular reuse for bottle caps was to crochet them together, sometimes covering the cap with foil, to make trivets, place mats, and decorative household items.

1.7

Chest. Maker unknown, probably Missouri. c. 1930s. Wood trunk covered with cloth and bottle caps. H 16 1/2 x W 29 x D 14" (42 x 73.8 x 35.6 cm). International Folk Art Foundation Collection, Museum of International Folk Art, Santa Fe.

The bottle caps on this trunk are almost all from soft drink distributors in St. Joseph and St. Louis; the caps date from the 1920s and 1930s.

It took the full-scale introduction of indoor plumbing, the invention of perforated rolls, and the business acumen of Edward and Clarence Scott to finally persuade consumers that toilet paper was a worthwhile product. By 1907, their business a success, the Scott brothers introduced America's first commercially packaged, tear-off paper towels, the Sani-towel. Again consumers balked: "Why pay for a towel that was used once and discarded, when a cloth towel could be washed and reused indefinitely?" (Panati 1987, 206) Reuse, closely tied to thrift, had been a traditional expectation. But as prices fell, so did consumer resistance.

The profitability of disposable items was clearly not lost on businessmen who followed in the Scott brothers' footsteps. It was a short step from paper towels and Dixie cups to Five-Day Deodorant Pads ("Use them once and then throw them away") and Bic shavers, pens, and lighters; most recently we find Acuvue contact lenses with their trademark slogan: "Wear them a day then throw them away." Now, disposability and convenience are watchwords for American consumers and the potential for a product's reuse is of little concern to us, if at all. The ultimate fate of the things we so eagerly consume seems to be beside the point.

A potent combination of factors fueled the relentless growth of this consumer society and, as a consequence, its landfills. Starting with the successful introduction of the automated assembly line by Henry Ford and his fellow industrialists, Americans came to expect that the flow of goods would be affordable and endless. In addition to the revolutionary technological innovations of mass production, the development of synthetics, alloys, and plastics had a radical impact on the proliferation of consumer goods and altered the way goods were packaged and marketed. Big business also invented the concept of "planned obsolescence," a term only whispered in 1950s corporate boardrooms but which by now requires no explanation.[11] Yet the net result of this capitalistic principle, widely accepted by industry and consumers alike, means that so-called durable goods, purposely designed to be cheap to buy – but difficult or too expensive to repair once broken – quickly wind up in the landfill, along with all the disposable packaging that leads an even shorter useful life.

1.9
"Caparena" Figures. Clarence and Grace Woolsey, Lincoln, Iowa. 1961–72. Bottle caps, wood, wire. H 16 1/2 x W 20 1/2 x D 10" (42 x 52.1 x 25.4 cm). Collection Shelly Zegart and The Four Corporation.

Starting with a gallon container of bottle caps, a snow-bound evening, and the question, "What could we make out of the caps?" Clarence and Grace Woolsey created "Caparena," an environment of over four hundred figures, animals, houses, and vehicles.

By mid-century, bankers would extend "easy credit," facilitating the process of acquisition and consumption. And soon the burgeoning advertising industry helped to ensure that fashion, with its endlessly shifting objects of desire, reigned. We became accustomed to the enticing campaigns and seductive packaging that masterfully serve to separate us from our money. Packaging gave us bottles, caps and corks, cans, pop-tops, plastic jugs and lids, cartons, juice boxes, and hubcaps. Such packaging leftovers, so readily available in multiples, have inspired folk artists and hobbyists by the thousands to hoard them, thinking "this must be good for something," and then to challenge themselves to find such a use.

The bottle cap has been perhaps the most ubiquitous. After its invention in 1891, the colorful "crown cap" found its way into a variety of forms (Hartigan 1990, 126–7), ranging from simple ropes to whimsical animals, to functional but decorative furniture (plate 1.7) and other household items (plate 1.8). It took Clarence and Grace Woolsey of Lincoln, Iowa, though, to create the ultimate bottle-cap piece, "Caparena." The term, coined by the artists to mean "caps in an arena," once featured more than four hundred bottle-cap constructions, everything from a full-size bicycle to a schoolhouse fashioned from thirty thousand caps, a wishing well, and numerous animals and figures (plate 1.9), all of which recently captured the hearts (and wallets) of folk art collectors nationwide when Caparena was disassembled

and auctioned off (Johnson, 1993). For the Woolseys as well as others, the lowly bottle cap – so unnecessary once removed – provided the color, texture, and the "conversation piece" quality that, in so many recycled works, calls attention to the cleverness of the maker.

The Woolseys and other recycling artists may save, salvage, and hoard packaging by-products for artful reuse, but such activities are hardly indicative of a trend away from wastefulness. Indeed, Americans measurably and persistently generate more trash and garbage than any other nation (plate 1.10). We produce 200 million tons per year, or nineteen percent of the entire world's garbage (that's 3.6 pounds each, on average, every day). Next in line is Japan at a mere 4.4 percent. In addition, fully thirty percent of our garbage now consists of packaging material alone (Motavalli 1995, 28). In a single hour, to give but one chilling example, Americans go through two and a half million plastic bottles (Bronstein 1991, 13).

Is it any wonder that "Reduce, Recycle, Reuse" is now the battle cry of millions of school-age environmentalists? As my own children are only too quick to inform me, *they* are the generation that will have no choice but to cope with the wasteful excesses of their elders.

"Retrieval Adhocism" in America: Conspicuous Recycling

Folk art that makes conspicuous use of recycled goods, regardless of the maker's intent, can inspire us to reconsider our own role in the production of solid waste. Reuse is recognized as one positive environmental alternative to simply "throwing it away" when "away" is an increasingly relative term. Most Americans, seeing recycled arts for the first time, view them through a "green" filter. And indeed, this is one legitimate avenue toward an appreciation of them.

But, for me, the power of recycled arts lies in their ability to make manifest the power of transformation and of personal transcendence, meanings that are rooted in the very process itself. Some would say that is a romantic notion. But could it not be that the very concept of metamorphosis is inherently interesting to the human intellect? That to witness "something" made from "nothing" is to find wholeness arising from fragmentation, and order from chaos, a kind of metaphor for human consciousness? Recycled works are compelling because they suggest the triumph of human creativity over circumstance, and divergent thinking at its best. At times, these works do appear to us pathetic – either because the circumstance of

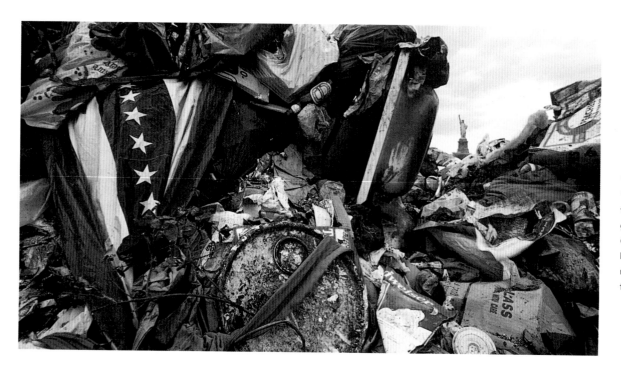

1.10
"Star-spangled refuse" reads the caption to this 1983 photograph featured in *National Geographic*. Garbage is brought by barge to Staten Island's notorious Fresh Kills landfill, not far from the Statue of Liberty.

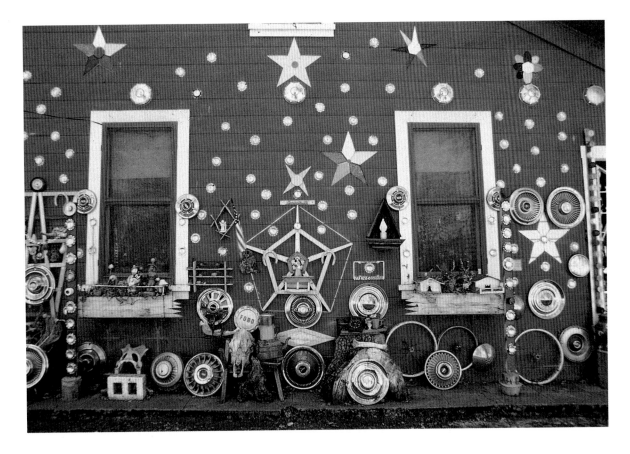

1.11

Hubcap Ranch. Emanuel (Litto) Damonte, Pope Valley, Napa County, California. c. 1976. Litto, the self-proclaimed "Pope Valley Hubcap King," started his environment one day in 1957 by hanging just a few hubcaps on the wall; he was inspired by the sight of hubcaps sparkling in the sun.

manufacture suggests abject poverty (in "our" own terms) or because they are so unselfconsciously unsophisticated.[12]

Whatever the intended or received meaning of these works, however, it remains a fact that there exist people who, armed only with our collective trash and their ingenuity and willing labor, stubbornly assert their humanity and personal identity in an increasingly faceless society, through acts of recycling and transformation (plate 1.11). And in so doing, they employ a process that has been termed "retrieval adhocism."

The term "adhocism" (drawn from the Latin expression "ad hoc," meaning "for this" specific need or purpose) was coined in 1968 by architectural critic Charles Jencks. Soon after, Jencks and colleague Nathan Silver devoted an entire volume (now rarely cited, it seems[13]) to this postmodern concept. They characterize adhocism as a principle of action having context or purpose; as employing the notion of adding on and assembly; as involving chance or serendipity; as being subversive, improvisational, approximate, hybrid, fragmentary (using pieces as parts); and often expressing time/money constraints. It is fixing things instead of buying new; it is getting things done "by hook or by crook." It is also, according to Jencks and Silver (1973 passim), a means by which "the individual sustains and transcends himself."

"Retrieval" adhocism further describes such activities when the process involves finding new uses

for leftovers – the very subject of this entire volume. It is my contention that retrieval adhocism in the American context results in an aesthetic that is intentionally conspicuous and self-referential. Tomás Ybarra-Frausto, describing the attitude and aesthetic of *rasquachismo* in the Chicano community, says it well: *Limited resources means mending, re-fixing and reusing everything. Things are not thrown away but saved and recycled, often in different context. . . . This constant making do, the grit and obstinacy of survival played out against a relish for surface display and flash creates a florid milieu of admixtures and recombinations.* (Ybarra-Frausto 1989, 6)

Another term that has been applied to this Chicano sensibility is the "aesthetic of bold display" (cf. Turner, this volume).

Adhocism also "insists upon attention, if only (or precisely) because it has been ignored and despised." (Jencks and Silver, 143) The very process – additive, visible, generative – calls attention to itself.[14] Couple this process with junk – a raw material that is already multilayered, evocative of past memories, and ripe with new possibilities – and you have an aesthetic that speaks in a very loud voice. One not for shrinking violets.

Take Italian-born Emanuel (Litto) Damonte (1892–1985), who created the "Hubcap Ranch" in the hills north of San Francisco. There he covered his red house, his garage, his shed, and a few hundred yards

of fence with more than three thousand hubcaps (plate 1.11). A retired concrete contractor, Litto started one day in 1957 to amuse himself by hanging just a few hubcaps on the wall. He saw how the hubcaps sparkled in the sun and admired them; he collected more. Soon people began to bring him their old hubcaps, and other trash, and he hung those. Finally he erected an arch over the driveway that said "Litto, the Pope Valley Hubcap King." Why? When pressed for motives in an interview conducted when he was ninety-one years old, he said: "I just did it. I'm Litto, I'm here." And then, with obvious pride: "This is my place; Litto's place. It's nobody's but mine. You can travel all you want, you don't see no hubcap ranch, no hubcap king all over the world." (Crease and Mann 1983, 83)

Another, even more well known, recycler from California is Tressa, or "Grandma," Prisbrey (1896–1988), who created the famed Bottle Village in Simi Valley. Beginning in 1955, Prisbrey constructed an entire compound of buildings on her third-of-an-acre lot, all built from courses of concrete and scavenged

1.12
Pop-top recycler Ray Cyrek used thousands of aluminum tabs to make a shimmering environment at his home in Homosassa Springs, Florida.

bottles. She enhanced these with paving that is a mosaic of broken crockery, tile, license plates, and pot lids; with planters outlined in automobile headlights; and with a fence made from discarded television picture tubes. Initially conceived as a way to house her collection of seventeen thousand pencils, the Bottle Village became both a refuge and a memorial for members of her family, as well as a tourist stop. She said, regarding her monumental effort: *Anyone can do anything with a million dollars – look at Disney. But it takes more than money to make something out of nothing, and look at the fun I have doing it.* (Greenfield 1986, 73)
Tressa Prisbrey reminds us that the element of play is an essential part of artmaking, and seems to be a leitmotiv of the recycler's art in particular.

Fred Smith, who lived and tended bar in the fifteen-hundred-person town of Phillips, Wisconsin, expressed a similar sensibility. Smith, over a fifteen-year period (1949–64), built Concrete Park, replete with 203 larger-than-life figures and animals: men and riders, a fifteen-foot-tall Paul Bunyan, farmers, a pioneer family with their cattle, a feather bedecked Native American, participants in a double wedding, an attentive dog. All were built of concrete encrusted with bits of glass, much of it broken glassware from Smith's own Rock Garden Tavern. Interviewed at the age of eighty-nine, Fred Smith said with a glint in his eye: "Nobody knows why I made them, not even me." He also proudly proclaimed, it's "the best God-damn decoration on Highway 13 in the country." Told of an impending exhibition that would include his work he said: "Put my picture right in there and make a big thing of it." (Hoos and Blasdel 1974, 53) Smith in his candor reveals to us one motive shared by many of the retrieval adhocists who attempt these ambitious works: recognition, or even fame, that most elusive of American status symbols. Steeped in the *Guinness-Book-of-World-Records*-pop-cultural appreciation of things grand and noteworthy, many of these artists seek validation for their extraordinary talents and efforts.

The late Ray Cyrek was one. A gruff and crusty, hard-working Polish-American man (plate 1.12), Ray lived in the fisherman's enclave of Homosassa Springs, Florida, about two hours north of Tampa. Having retired to Florida from Buffalo, New York,

twenty-two years ago, Ray soon found he was not one for leisure time. So one day, surrounded by his fishing buddies and fourteen cases of beer, he posed a challenge: would they drink enough beer to make a chain of pop-tops long enough to stretch past the carport? They did. Discovering his medium, Ray devised new ways to connect the pop-tops, and the chain evolved into a series of lawn ornaments for his double-wide trailer. By 1989, Ray's creations engulfed his entire property. Glittering in the sun, the 4 million pop-tops were, well, dazzling. Lit at Christmas with sixteen thousand hand-colored lights, Ray's place was simply magic (plate 1.13) – a kind of obsessive monument to the machine age and human ingenuity all rolled into one. Or, as one journalist described it, "a cross between a glittering amusement park and a recycler's nightmare." (Woodward 1987)

Before his 1995 move to another home, Ray's environment featured a silvery fence enclosing a lawn filled with densely woven pop-top figures in the forms of a snowman, Santa and reindeer, angels, butterflies, the letters of the name "Ray Cyrek," a turkey, a

1.14
Heart. Ray Cyrek, Homosassa Springs, Florida. 1993. Pop-tops, wire. H 48 1/2 x W 52" (123.2 x 132 cm). Museum of International Folk Art, a unit of the Museum of New Mexico, Santa Fe.
Cyrek is one folk recycler whose primary medium – the removable pop-top – has disappeared, as environmentally friendly laws mandated that it be phased out of production.

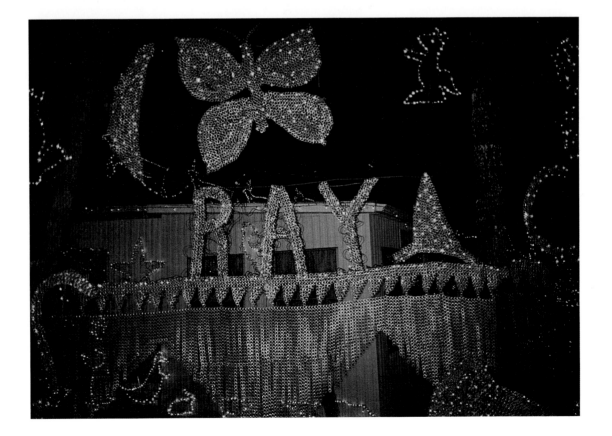

1.13
At Christmastime, Ray Cyrek's yard was filled with fanciful pop-top creations and colored lights.

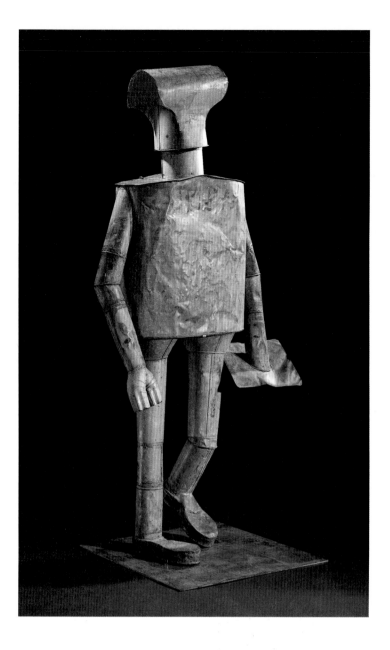

1.15

Galvanized Man. Gerald McCarthy, Ogdensburg, New York. c. 1950. Cut, bent, assembled, and soldered galvanized iron. H 78" (198 cm). National Museum of American Art, Smithsonian Institution. Gift of Herbert Waide Hemphill, Jr., and Museum Purchase made possible by Ralph Cross Johnson.

Many recyclers find artistic expression through their occupations. Gerald McCarthy made this overscaled "tin man" using scraps from his plumbing and ventilation shop.

1.16

Muffler Man. Jack King, Des Moines, Iowa. c. 1992. Automobile parts: muffler, springs, hubcap, etc. H 71" (180 cm). International Folk Art Foundation Collection, Museum of International Folk Art, Santa Fe.

Jack King, working with mechanics at his import automobile repair shop, created this muffler man to attract attention to his business.

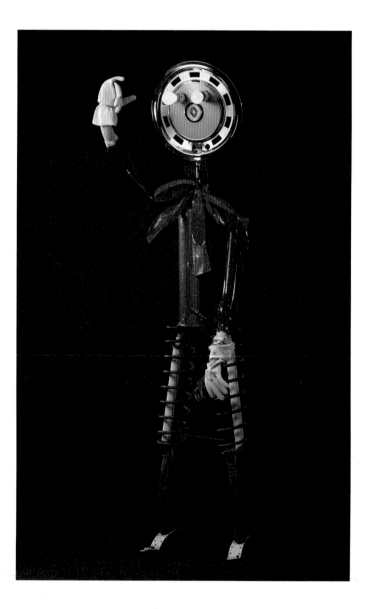

heart with an arrow piercing it (plate 1.14), and three-dimensional structures, such as a castle, a gazebo, and a windmill. A giant star loomed overhead. In the back, the entire facade of the garage was covered with interconnected pop-tops. A patio area behind the trailer was gloriously adorned with an eight-foot-high, thirty-foot-long curtain of festooned and interlinked chains.

Ray told me in disgust that the *Guinness Book of World Records* had rejected his environment as record-setting. Apparently, it is not easily measurable enough – as, for example, a several mile long chain would have been. Still, he said, "Over a million people know about this place; I know it." (Personal communication, May 1995) A former neighbor from Buffalo had heard about it up there and came down to see it – only to learn that Ray was the guy behind it. Maybe Ray was right: I heard about it from a couple of elderly RV'ers from Michigan that I met in Santa Fe.

While Ray's process and technique were his own innovations, his access to the "raw" material of his art was not accidental. Up north Ray had owned a junkyard, and upon retiring he earned additional income by collecting and recycling aluminum cans. Many other conspicuous recyclers find a voice in artistic expression by way of their occupations. And for many, their recycling is a measure of their technical and creative virtuosity.

Prime examples of this phenomenon are shop signs, such as muffler men and sheet-metal figures. One of the most well known examples of this form is Gerald McCarthy's *Galvanized Man,* which once enticed and welcomed customers to his plumbing, heating, and cooling shop in Ogdensburg, New York (plate 1.15). Creatively redefining standard metalworkers' ventilation forms into human form, the "tin man" seems like a latter-day knight engaged in anonymous battle. Such oversize figures recall nineteenth- and early-twentieth-century cigar store figures and colossi that appeared on American roadsides during the 1920s and 1930s (Hartigan, 89).

Related forms are the ubiquitous muffler men, whimsical figural signs fashioned from discarded mufflers and other car parts. Displaying the welding skills of the muffler repairman, such figures are posted in front of the establishment to attract attention, a remnant of retail marketing strategies dating to the days when American towns were filled with pictorial signs that met the needs of literate and illiterate customers alike. A muffler man now in the collections of the Museum of International Folk Art (plate 1.16) was made in 1992 by auto repairman Jack King of Des Moines, Iowa. It sports not only a hubcap head but car springs for arms, flashing red lightbulb eyes, and a festive wreath bow at the neck. Such folk forms are still relatively common in some regions of the country, the Southwest among them, and remain strongly associated with the welder's trade. They are closely allied in process if not purpose to the gates, fences, furniture, and whirligigs made of old and worn-out tools and equipment that can be found largely in ranching and agricultural areas. These, too, albeit in a subtler fashion, are evidence of the aesthetic of conspicuous recycling found across the American landscape.

Any essay on recycling in the United States would be incomplete without at least some mention of the recycled art forms found within the nation's penitentiaries. Here, prisoners are faced with the enormous stress of losing their personal identity, adjusting to a highly developed and discomforting institutional culture, detachment from their family and community, and long periods of "leisure" time. Many seek forgiveness and transcendence, experiencing grief and guilt. Some find solace in religion and some turn to making art, particularly as gifts for loved ones.

Those who do, prevented for reasons of security from having access to most materials common in the "free world" (metals in particular), make do with readily available recycled materials that reflect the scarcity of goods in their environment. The raw materials of recycled prison arts are gum or cigarette wrappers or canceled stamps (plate 1.17); toilet paper that is rolled, sometimes scorched, or made into a type of papier-mâché; articles of used or raveled clothing, such as socks; and even chewing gum. Objects made of paper wrappers encased in cellophane are perhaps the most common form: ingeniously woven bags, picture frames, crosses, baby shoes, and clock cases are fashioned using skills passed from one inmate to the next, generation by generation.

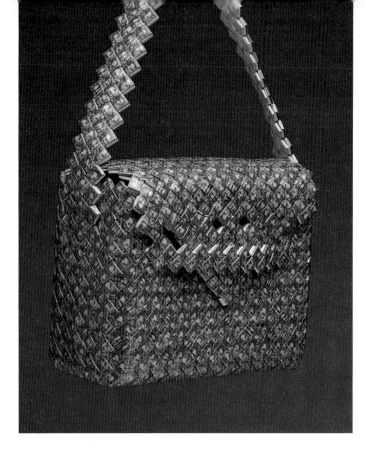

1.17

Purse. Possibly Marion Correctional Institution, Marion, Ohio. 1960s. Canceled Lincoln 4-cent postage stamps, writing paper, cotton fabric interior. H 7 1/2 x W 9" (18.2 x 22.8 cm). International Folk Art Foundation Collection, Museum of International Folk Art, Santa Fe.

Inmates who make recycled arts must get by with the few materials that are readily available to them. Woven from strips of cellophane-wrapped Lincoln stamps and writing paper, this purse may have been a gift for a loved one.

Some forms are also associated with cultural identity and pride, as in the case of the *paños,* or decorated handkerchiefs. Made by Chicano prisoners, the handkerchiefs find new life as the support medium for elaborate pen or pencil drawings that feature religious iconography such as images of the Virgin of Guadalupe and other Catholic saints; symbols of romantic love such as roses, hearts, and unicorns; and even cartoon characters (in *paños* made as gifts for children). They serve to solidify bonds of affection with family and friends as they provide relief from the inevitable boredom and alienation faced by these men and women (Greco, n.d.).

The woven paper tradition in prison arts has reached new heights in the hands of a recent, highly publicized group of would-be immigrants from China. On June 6, 1993, some 219 people swam to safety after the freighter *Golden Venture* ran aground off the coast of Rockaway Point near Lower New York Bay. The survivors, who had paid thousands of dollars each to be smuggled into the United States, were soon incarcerated in five different detention centers around the country awaiting an official determination of their status.

In the York County Prison in York, Pennsylvania, the long wait has not deterred the detainees from using their time in confinement productively. They do so by creating extraordinarily complicated constructions made from toilet papier-mâché, and rolled or folded magazine pages. The imagery of these pieces encompasses everything from dragons, carp, and Buddhist "thank-you towers," to pineapples, peacocks, and Christmas trees. But, for these refugees whose fate rests in the hands of the American federal bureaucracy, it is the American eagle which in size and scale and pure volume of production outstrips all the other motifs by far (plate 1.18). They call it the "Freedom Bird."[15]

The recycled sculptures made by the *Golden Venture* detainees have provided through sale proceeds[16] not only needed funds for the detainees' legal defense, but much-desired media attention as well. So far, the artists of the *Golden Venture* have not succeeded in gaining their freedom. But, without seeming to have missed a beat, they have succeeded in publicizing

their political plight and negotiating their cultural identity during these critical months of incarceration in a most "American" way: by capitalizing on the artistic skills of recycling as an effective strategy for survival, recognition, and personal transcendence.

As outcasts of the most literal kind, these would-be "hyphenated" Americans demonstrate that recycling still continues to find fertile ground inside our national borders, as it gives a voice to the marginalized and hope to the downtrodden. As ethnically diverse as the United States is as a nation, and as culturally different as the recyclers examined may be, all have responded to the prevailing "throwaway spirit" with a personal call to find meaning and self-expression in the very discards of our consumer culture. In so doing, they have demonstrated the ingenuity, resourcefulness, and rugged individualism that are the mainstays of American populist notions about our nation's capacity for greatness.

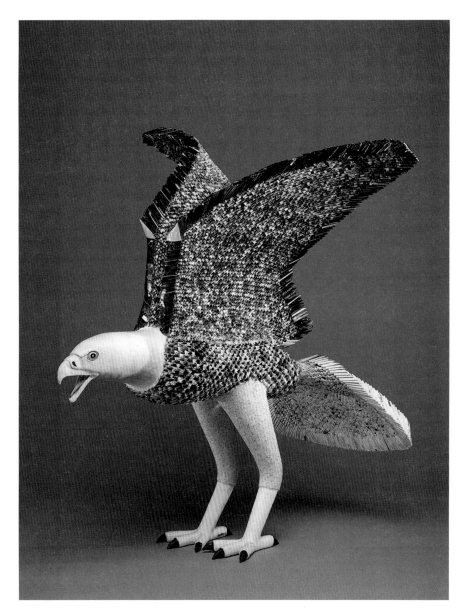

1.18

Freedom Bird. Golden Venture detainees, York County Prison, York, Pennsylvania. 1994. Woven magazine paper, toilet papier-mâché. H 31 1/2 x W 30 x L 33" (80.2 x 77 x 84 cm). International Folk Art Foundation Collection, Museum of International Folk Art, Santa Fe.

Some of the Chinese refugees who arrived illegally in the United States on the *Golden Venture,* a ship that ran aground off Rockaway Beach, New York, are currently detained at the York County Prison in Pennsylvania. Among the woven-paper constructions they create in prison are American eagles such as this one – which they call the "Freedom Bird."

Sci-Fi Machines and Bottle-Cap Kings: The Recycling Strategies of Self-Taught Artists and the Imaginary Practice of Contemporary Consumption

Joanne Cubbs and Eugene W. Metcalf, Jr.

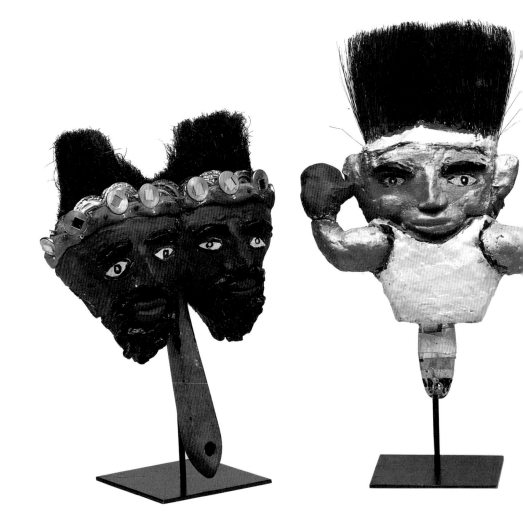

2.1

Left to right: *Twins*. 1993. *Boxer*. 1992. *Scrub-brush Head*. 1991. H 21 1/8" (53.7 cm). *Paintbrush Portrait*. 1991. Mr. Imagination, Chicago, Illinois. Paintbrush, scrub brush, bottle caps, wood putty. Collection the artist, courtesy Carl Hammer Gallery, Chicago, Illinois.

Mr. Imagination's paintbrush people are adorned with costumes made from nails, bottle caps, old car parts, buttons, and other materials he scavenges from the dumpsters, alleyways, and street corners of his urban Chicago environment.

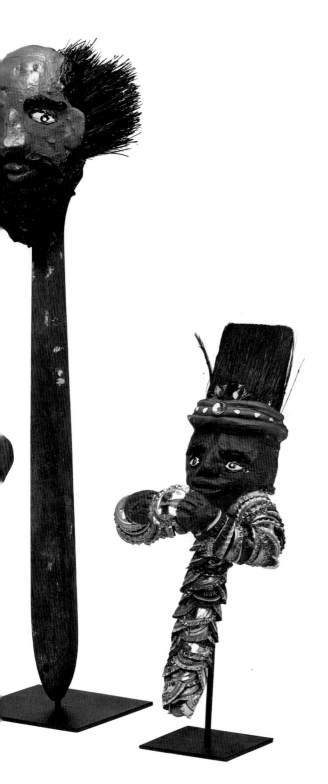

We, in the United States, live in a world of proliferating junk: cans, bottles, and newspapers; rivers of discarded motor oil and mountains of wrecked cars; broken tenement buildings and decaying urban centers – the litter of our relentless modern ambitions. Like the inhabitants of the futuristic city in the science fiction movie *Blade Runner,* we exist in the rubble of our own progress, in a hybrid world increasingly reconfigured from its own remains. Many view this rampant production, consumption, and waste as part of a larger social "crisis" and warn that we have replaced our tradition of self-restraint and social responsibility with a new ethic of excess and material gratification. Americans, they claim, have been seduced by the products of proliferating technology and dazzled by the empty promises of an endlessly consumable world. But there may be another way to view this situation. Instead of charging contemporary culture with accusations of social and moral decline, we might simply see our present preoccupations with consumption as part of an evolving cultural process that not only poses new dilemmas but also introduces new ways of experiencing and imagining our world and ourselves.

As we respond to the new conditions of contemporary life, we must rethink many of our cultural practices. More specifically, we must develop creative strategies to confront the overwhelming proliferation of our material world and its leftovers. In fact, there are already many individuals among us who are involved in the crucial task of recycling or of habitually salvaging the trash that would otherwise be thrown away. And within the latter growing group of salvagers, there are a few master-recyclers. Refashioning new visions of our world from its leavings, these *bricoleurs* transform not only objects but meanings. In particular, they use discarded things to comment reflexively back upon the cultural world from which they draw their resources.

This essay examines the work of two such individuals, who use found objects and materials in imaginative ways that may be seen as models for how to address the problems and possibilities of our increasingly cluttered world. Before recounting the particular stories of these makers, however, it is instructive to explore some of the forces that have shaped our contemporary culture.

Developments in advanced technology have been, in great part, responsible for our ability to produce more and more goods, but our society's almost unlimited productive capacity is matched, and perhaps even surpassed, by its seemingly unquenchable desire to consume: to purchase and possess, to use and display, and then to discard and purchase again. In a world of budget deficits, credit debt, and planned obsolescence, overconsumption is a national and moral duty. What one "needs" is determined by rapidly changing fashion, and personal status is gauged not only by our ability to purchase, but also by what we think we can afford to throw away.

Consumerism is a way of life in our culture. The department store, partly responsible for revolutionizing patterns of consumption in the nineteenth century, has been superseded by the mall, a key symbol of contemporary life, and a phantasmagorical, endlessly overflowing world of goods sustained by the collusion between actual and imagined needs. We have become primarily a society of consumers rather than producers, spending our time, energy, and imagination buying things rather than making them. No longer constrained by a scarcity of goods or the means to obtain them,

we now consume primarily for symbolic rather than utilitarian purposes, not merely for subsistence but for creating, reinforcing, and revising social meanings.

According to anthropologist Mary Douglas and economist Baron Isherwood, consumption is an important ritual that determines and stabilizes social meaning. In their words,
[T]he choice of goods continually creates certain patterns of discrimination, overlaying or reinforcing others. Goods are the visible parts of culture. They are arranged in vistas and hierarchies that can give play to the full range of discrimination of which the human mind is capable. The vistas are not fixed: nor are they randomly arranged. Ultimately their structures are anchored to human social purposes. (Douglas and Isherwood 1979, 65–6, 75)

Yet it is not only social values that are negotiated through the ritual process of consumption, it is the significance of each participating individual as well. Identity, the incessant process of self-creation, is also established through the activity of acquiring objects. Neither given nor fixed, the independent self is continually constructed and elaborated from the seemingly endless choices that characterize the activity of consumption; what we acquire and display around us at any given moment signifies who we are. Finally, the act of acquisition has become more than just a source of our identity as individuals; it is proof of individuality itself. In contrast to a world of real-life limitations, the universe of consumption seems to evidence our free will and our freedom to choose from among countless possibilities.

The use of objects for symbolic rather than practical purposes is just as responsible for the escalating production of goods in contemporary times as are technological advancements in mass production. As social theorist Zygmunt Bauman comments, the phenomenon of "free individuals engaged in symbolic rivalry lifts demand for the products of capitalist industry to ever higher levels, and effectively emancipates consumption from all natural limits set by the confined capacity of material or basic needs." (Bauman, 1992, 51) But it is not only the production and consumption of goods that have proliferated in our time, it is also the meanings of the objects themselves.

Emancipated from the significance attached to them by functionality, objects are now valued, reval-

ued, and endlessly transformed in a dynamic, give-and-take process of consumption. The meanings of goods are established and reestablished with each exchange. A car, for example, is a means of transportation, an engineering wonder, a status symbol, or a sexual come-on. According to Celeste Olalquiaga, this breaking down of traditional referentiality is indicative not only of "the loss of conventional boundaries between production and consumption, but also of an unprecedented mediation in our mode of consuming, which converts all elements of experience into mobile texts that can be transformed at random." In this new and expanded mode of consumption, which is believed to be a hallmark of postmodern society, commodities become signs susceptible to multiple uses and the practice of recycling becomes a quintessential activity (Olalquiaga 1992, xvii, xviii).

In many ways, recycling – or the process of borrowing, quoting, and recontextualizing objects, images, and ideas – is the best metaphor for the way in which meaning is constructed and understood in our contemporary world. This view of culture as the product of fluid and interchangeable parts, constantly recycled and recombined, is commonly held by many postmodern theorists. According to these writers, if in the past individuals experienced their surroundings as a stable and coherent field of possibilities, it now seems that our world has become a site of multitudinous, changing, and shifting experiential fragments. In contrast to a modern vision of stable social ideologies and hierarchies, Bauman argues that our society exhibits no universally binding authority and thus no intrinsic or indisputable source of connection, meaning, or truth. "Instead . . . the world [is] composed of an indefinite number of meaning-generating agencies, all relatively self-sustained and autonomous, all subject to their own respective logics." (Bauman, 35) In such a world of multiple points of departure and destination, we have lost our faith in progress and with it the belief that what we create is truly original. There is, it seems, nothing more to invent. More particularly, as our natural resources are depleted and replaced by an environment of manufactured objects, these industrial artifacts become the new raw materials from which we must produce more.

Understood in this context, recycling is a remarkably appropriate and necessary response to contem-porary, postmodern life. Acting as a kind of "semiotic broker," the recycler manipulates outworn and disconnected fragments of culture to create new meanings.[1] These discarded artifacts or "texts" are dismantled, reconnected, and reassembled by the recycler to create, as folklorist Susan Stewart has shown in her study of nonsense, a new "intertextuality" that disrupts the usual order of the world and results in new, and unprecedented, significance (Stewart 1980).

According to Stewart, nonsense is that activity "by which the world is disorganized and reorganized." (Stewart, viii) Standing in contrast to the reasonable, coherent, stable, and hierarchical world of sense, nonsense is random, arbitrary, changing, and fragmented. As a postmodern expressive strategy, recycling can be seen as a nonsense activity. A product of the intertextual relationship between the reasonable world from which it draws its materials and the nonsensical world created by their unexpected reconstruction and recombination, the mediated recycled object, like the nonsense phrase, decontextualizes and recontextualizes – and thus remakes – meaning.

By altering the organization of the everyday world, the recycler transgresses the assumptions of common sense and logic, an act which Stewart also associates with artistic activity. In this way the recycler can be seen to operate in an aesthetic domain in which the commonplace is reconceived and transformed into a new reality. In this nonsensical place, the recycler, like the artist, creates "a model for interpretation, for arranging perception, which at its profoundest point does not so much make its members 'see into the life of things' as it enables them to remake the life of things." (Stewart, 22–4)

Because recycling reshapes the world, all recycling might be said to have an aesthetic dimension, yet some recyclers more consciously assume the role of artist than others. This is not to say that many of these artist/recyclers have been schooled in the recognized academies of art. In fact, most of these individuals are "self-taught" artists who, through their day-to-day activities, have developed a special understanding of the expressive possibilities inherent in otherwise ordinary, cast-off materials.

Many self-taught artists who use recycled materials have spent their lives involved in manual trades

or physical occupations from which they later draw their artistic resources. Yet some of these artists use recycled materials not only because of occupational or economic necessity, but also because these materials can be utilized to address the most urgent social, spiritual, and political issues of our time. Through their use of salvaged materials, these artist/recyclers self-consciously exploit the multiple associations and borrowed histories inherent in found objects to attain a rich layering of meaning. As the two following case studies demonstrate, the use of recycled materials by many self-taught artists also involves them in one of the most crucial creative practices of contemporary times. Not only interested in conserving, economizing, and salvaging what we cast off, they are also concerned with reconceiving the imaginative and symbolic parameters of our culture.

Bottle-Cap Kings

Gregory Warmack is a streetwise picker of discarded goods who transforms techno-urban junk into images from an ancient, mythical time. Recently, he recounted a story that he tells to schoolchildren explaining his power to magically alter the outworn things and meanings of our world:

I was telling these kids about the time I was walking through this alley, and as I was walking all of a sudden I heard this sound going "psst." I looked back and I didn't see anything; meanwhile I kept walking. Now these kids are wondering what I was talking about. But I told them that I continued to walk, and as I was walking this time the sound got louder, and it went "PSST." So I said to the kids, "What do you think that sound was?" Some of them said, "Snake, cat, somebody calling you," I said, "No, no, no." Then, all of a sudden, a smart kid said, "It was your imagination." I said, "You are absolutely right."[2]

Warmack, who also calls himself "Mr. Imagination," is well aware of the transformative power of his vision. An artist who, throughout most of his life, has created his works from the stuff other people throw away, Warmack understands the importance of seeing beyond the commonplace. His is a world where marvels can appear in dumpsters, and treasures are to be found in alleyways. These are, for him, unpredictable places where generally held truths about the

value and meaning of things can be rearranged to reveal dazzling new possibilities. It is all a matter of what you can perceive. "I have the eye to see what [other] people cannot see," says Mr. Imagination.

Painted on a piece of cardboard, and taped to the glass in the door of an apartment building on the north side of Chicago, is an eye that serves as a kind of trademark for Mr. Imagination, or "Mr. I" as he is called by his friends. It is also a punning reference to the power of his creative vision.

At the end of the second-floor landing is another door that opens to reveal Mr. Imagination's living room. More an elaborate sculptural environment than a living space, it is crammed with hundreds of the artist's works, which cover the walls up to the ceiling and are stacked and arranged all over the floor. Dominating the room is an enormous throne, over six feet tall with a high, imposing back and wide, flat arms (plate 2.2). For a footstool, the throne uses a box, painted with large eyes and covered with bottle caps. The back of the throne is divided into two panels; the upper one contains the sculpted face of a bearded black king made of wood putty, and the lower panel features a pyramid made of old copper sheeting. At the top of the throne, as well as on the front of each arm, are four more sculpted faces of bearded black kings, wearing blue turbans instead of crowns. The rest of the throne, like the footstool, is encrusted with hundreds of bottle caps.

This throne belongs to Mr. Imagination, and it is here that he often sits when photographs are taken (plate 2.2). Wearing a hat, tie, and vest made of bottle caps, he grasps a staff that is also covered with bottle caps and surmounted by another molded head of a bearded black king. Before the camera, he gazes confidently, his distinctive, dark, full-bearded face recognizable as the model for those reproduced on this throne and staff. Artist and recycler extraordinaire, he poses among the wonders he has made, in a world created from what others could not see.

Long before Gregory Warmack became Mr. Imagination, he knew the value and potential of the things other people discard, and the development of his artistic career is tied, in many ways, to his discovery and use of various recycled materials. Born in 1948, into an African-American family from Chicago's West Side, Warmack was an early and avid collector

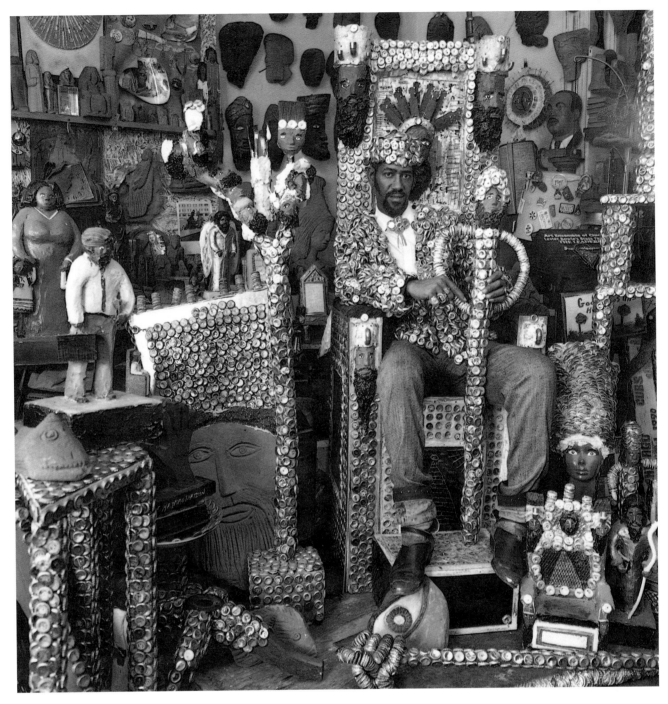

2.2
Mr. Imagination likes to pose
for pictures seated on the
grandiloquent bottle-cap-
encrusted throne that
commands a central position
in his cluttered living room.
"Other artists, when they
run out of canvas, they proba-
bly freak out. But they don't
really use what is there."

of anything that looked interesting or old. By his late teens, he had accumulated so many strange objects that his room was full, and he had to sleep under the kitchen table. Already, as a young child, he had painted on old sheets of cardboard and cut-up boxes. After leaving school, he earned a meager income by making jewelry and decorative items out of beads, shells, and trinkets which he sold in local bars and restaurants or on the streets. Finally, around 1979, Warmack made a discovery that would significantly affect his artistic career.

He noticed a truck unloading sandstone blocks that had been used in the production of steel, and gathered up some of these discards. Once at home, he rubbed the blocks together and glued the loose sand to the roof of a miniature cardboard house that he was making. Later, he found another use for these soft stones and began to carve them into the faces and figures for which he is known today. In 1983, these pieces were debuted in the first of a series of solo and group exhibitions featuring his work at Chicago's Carl Hammer Gallery and at other galleries and museums across the country.

In the late 1980s, after earning significant recognition by the art world for his sandstone carvings, Warmack discovered still another kind of cast-off material that would expand his expressive vocabulary. Given buckets of bottle caps by Lisa Stone, then director of the Carl Hammer Gallery, he proceeded to make a coat, hat, and mask that won first prize at a Halloween party. Inspired by this response, he collected more bottle caps from neighborhood bars and began using them to make and decorate canes, chairs, picture frames, sculptural figures, and all sorts of other objects.

Warmack next discovered old paintbrushes and, later, brooms. Re-created as human figures, these "paintbrush and broom people" transform bristles into hair and wooden handles into long necks. Adorning their wood-putty faces and bodies are various kinds of elaborate costuming made from nails, bottle caps, buttons, old car parts, and other found materials (plate 2.1). Although usually crafted as individual pieces, paintbrush faces have recently been incorporated into a new expressive form – imposing totem poles, standing two to ten feet in height and composed of numerous heads stacked one on top of the other.

To create his totems, Warmack sculpts wood-putty faces on tall cardboard cylinders, and then embellishes the figures with fantastic headdresses and elaborate necklaces made of bottle caps, paintbrushes, crushed aluminum cans, and other found objects. Like many of Warmack's figures, the totem heads depict his vision of characters from ancient Africa, Egypt, Meso-America, and Asia, as well as other cultures. According to Warmack, his faces represent the significance of all people from all cultural and racial backgrounds. "My art is a universal thing," he says. "I am concerned with all nationalities." In addition, his mysterious portraits of African kings and queens, and Egyptian priests and pharoahs recall the images of royal African ancestry evoked during the black consciousness movement of the late 1960s. Representing the mythic origins of African-American culture before slavery and displacement, Warmack's iconic figures seem to serve as symbols of African-American power, pride, and spiritual heritage.

According to Mr. Imagination, many of these images emerged, along with his likenesses of prehistoric creatures, towering pyramids, and other exotic iconography, from visions he experienced after a terrible incident in 1978 when he was shot and almost died. And he claims that it is only through visual expression of these images that he can convey what he saw at that time. "Sometimes I feel there is something which does not allow me to talk about the visions," says Mr. Imagination. "So I can only talk about what I have seen in my art. It all comes from this coma. I never did this Egyptian work before."

As he sits on his throne, regally posed in his bottle-cap hat, vest, and tie, Mr. Imagination, the artist-king of recyclers, is today a different person from the Gregory Warmack who began painting on cardboard and refashioning old trinkets into jewelry years before. Like the objects he makes, Mr. Imagination himself has undergone a transformative process.

Warmack first asserted his new identity as Mr. Imagination sometime between 1979 and 1981.[3] Occurring only a year or so after he was shot, this change in Warmack's persona has been seen as a consequence of his violent attack and near-death experience. But while this event was certainly significant in Warmack's life, his transformation is attributable to much more. Of particular interest in this

regard is the way in which recycling, understood as a metaphor for rebirth, has affected Mr. Imagination's perception of himself and his life. Living in a world in which the essence of all things is their fundamental mutability, Mr. Imagination views the process of perpetual change and transmutation as a model not only for his work but also for his own life development.

For example, when talking about his shooting, Warmack says,

I would like to search for the doctor who saved my life because, how many doctors who have saved lives will meet this person again? I don't know if they even save the bullets they take out. They probably just toss them away.

Understanding the power of life's transformations, Mr. Imagination not only wonders what happened to the bullets which almost killed him, but also assumes that his doctor, a recycler of life, would also wonder what happened to the people he has saved.

For Mr. Imagination, recycling is more than saving old cans so that they do not litter the streets. It is a calling connected to a higher purpose and an epistemology that organizes the way he comprehends the world and his work's place in it. "I think that everything that man makes today is important," he says. "There is something in everything." This is the difference, he believes, between his work and the work of other artists or even other artist/recyclers. "Every artist has their own job," says Mr. Imagination, "and I was chosen to do this. . . . Every now and then you will meet an artist who wants to nail bottle caps on wood, but it is more than nailing bottle caps on wood. It is a spiritual thing."

Pursuing his unusual art has, at times, required that Warmack possess unflinching belief in himself. Although he has recently received significant public and art world recognition, such acclaim was not always forthcoming. There was, for example, the derisive reaction to his salvaging of the sandstone blocks by a number of old men who congregated near the lot.

But Mr. Imagination recognized something in the blocks. According to him, mysterious, hidden faces and images "were already there in the stone." To find them, one needed only to know how to look. "That's the message that I pass along to some of my students when I teach them how to look," he says.

This strategy of investing seemingly useless objects with a hyperbolized value is common to all of Mr. Imagination's work. Opposite the bottle-cap throne in his living room is a large totem with six dark, regal faces framed by shimmering chokers and hats made of bottle caps and crushed aluminum cans. At the top of this totem sits the head of a wide-eyed, cloaked figure whose face stares out imperiously from within an opulent hood encrusted with even more bottle caps. This is the paradox of his vision that often transforms junk into the iconography of royalty. Through the alchemy of his art, he changes trash to treasures, ordinary bottle caps into fabulous jewels. "All piled up they look better than diamonds and rubies," he says. "If I could get all the bottle caps in the world, this place would be filled up with bottle caps, but they're thrown away every day. I love bottle caps. They're just like diamonds."

Although Mr. Imagination physically modifies most of the objects that he uses to make his art, he sometimes leaves them intact and merely re-presents them. In fact, with some of his more conceptual pieces, he has not altered his found objects at all, but has simply placed them in a context where their multiple meanings can be better recognized and pondered. One of the most revealing examples of this art hangs on the wall over the stairs leading up to the apartment. It is a single bottle cap in a large, gilt frame. No longer a throwaway object, or even a decorative embellishment, this unassuming artifact becomes the work of art itself. Taking on a new and unmistakable importance, the lone bottle cap represents the central idea of Mr. Imagination's work – the idea that all things have value. "Out of everything in the hallway, I like that one bottle cap because it makes my big statement," says Mr. Imagination. "It makes people stop and think. They will see that one bottle cap and remember the other bottle caps that are being tossed away every day."

Human castaways, as well as the artifactual ones, concern Mr. Imagination. Asserting that we are a society that discards and devalues people as readily as objects, his recycled art calls attention to this devaluation. In particular, Mr. Imagination believes that it is the children in our society who are often uncared for and discarded, and he has worked tirelessly in his art activities to help encourage and reclaim them. Of special interest to him are the children of Chicago's

urban ghetto with whom he has been working for many years. He holds art classes for them in vacant lots and sponsors neighborhood exhibitions of their art in community centers and empty buildings; since becoming well known, he has also accepted numerous requests to teach art at schools and child-care centers. A recent children's workshop was held in the inner-city neighborhood on Chicago's West Side where Mr. Imagination was born. During his visit, the artist and his young students searched the nearby streets and alleys for trash, which was then turned into a neighborhood art exhibition.

One of Mr. Imagination's artworks also emphasizes this concern for children. Comprised simply of two small and outworn children's chairs, one black and one white, the piece initially looks too ordinary to be significant. But this view is deceptive and emphasizes our propensity to overlook the most common, yet most important, things.

Once I put these chairs on display, it's going to make people really think. Where are the kids? What's going on with the world today? Here, just the other day, this woman set her newborn baby on the steps [and left the child behind]. Some people have babies and throw them away like they're garbage. I mean what is going on with the kids?

Mr. Imagination's central concern with the plight of children is also reflected in an interesting comment he makes about the real ecological significance of his "paintbrush people." According to Mr. Imagination, *I explained to my kids that a long time ago there was a problem with lead in the paint, and now many apartments have peeling paint. That paint was put on with a brush and now the paint is old and peeling off, but whatever happened to the brush? That brush is down in the earth somewhere, and it's not good. I feel that when I do children's workshops not all of the children are going to do something with their lives, but at least some of them will. So the children are out there like paintbrushes. And just think, where did they bury all those paintbrushes?*

Like bullets, bottle caps, and paintbrushes, children have been used and thrown away. And Mr. Imagination is interested in them all. In fact, he views his art as a kind of ministry. In his words, "Ministry runs in my family — my great aunt, my grandmother, and my great, great grandfather were all ministers. But I'm not a minister to creeds. . . . I'm a minister in my art."

Through Mr. Imagination's "art ministry," recycling is a way to save and transform not only our objects but ourselves, and salvaging found objects becomes a larger metaphor for the renewal of one's life and one's community. "My art is meant for me to share," he says. "When my mission is done, the art that I've started will go on and on. The kids will teach their kids, and it will keep going."

Sci-Fi Machines

Tom Every is also a salvager. More specifically, he is a collector of discarded machine parts and lost technologies, which he then reassembles into fantastic devices of his own invention. Transforming truckloads of industrial debris into an environment of towering metal sculptures, he has forged a tribute to the history of machine culture and a monument to the transitory wonders of the industrial age (plate 2.3).[4]

Every's sculpture environment is located in the far back of a scrapyard just south of Baraboo, Wisconsin, where the largest of his constructions – the "Forevertron" – ascends above random fields of rubble. Weighing over 300 tons, running 110 feet in length, and reaching over three stories high, this colossal sci-fi contraption is a combination spaceship, launching pad, observatory, and electrical power plant (plate 2.4). According to the elaborate, imaginary tale created by Every to explain his work, the "Forevertron" is a reproduction of the device built by a nineteenth-century inventor and scientist from Eggington, England, named Dr. Evermor. Dr. Evermor reportedly believed that the force of lightning was a divine power that came directly from God. He also thought that if he could design a machine capable of harnessing enough electromagnetic energy, he could transport himself back to the heavenly creator on a lightning force field. The Forevertron was Evermor's attempt to create such a machine.

With a bit of ironic humor, Every often expresses concern about whether his contemporary replica of Evermor's metaphysical contraption will actually work, but he does assure listeners that he has been able to find or duplicate "most of the necessary

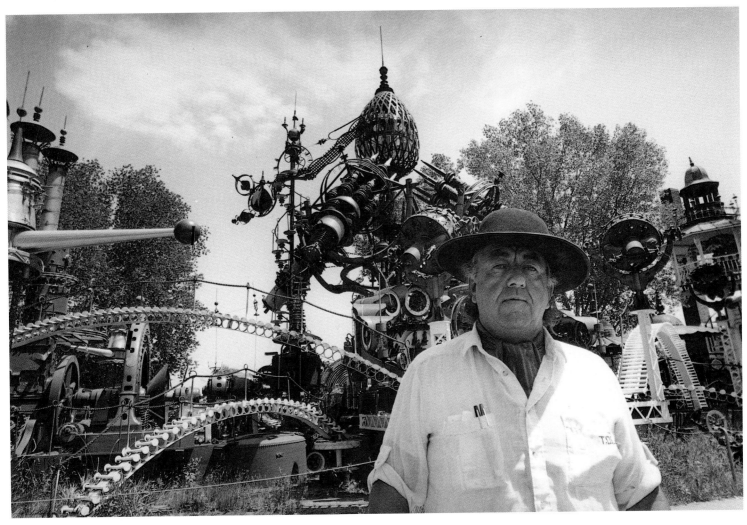

2.3
Tom Every stands in front of
his towering construction,
the Forevertron, built from
recycled industrial parts.

parts." Among these parts is a mysterious glass ball housed in a copper-wire egg, which served, according to Every, as the Doctor's space capsule. Every made his version of Evermor's spherical ship from an old globe that was originally part of a sign for a hamburger stand in Green Bay, Wisconsin. Mounted at the very top of the Forevertron structure and surrounded by three giant "spark plugs," the glass vessel sits poised for its launch into the firmament; just below it is the complex of electromagnetic gadgetry that reportedly powered the Doctor's entire experiment. Comprising this imaginary apparatus is a massive assembly of mighty "thrusters," "projectors," "exciters," "coil superchargers," and "magnetic generators," which Every constructed from an assortment of discarded fuses, boiler parts, dynamos, steam pumps, flywheels, and other real-world machines.

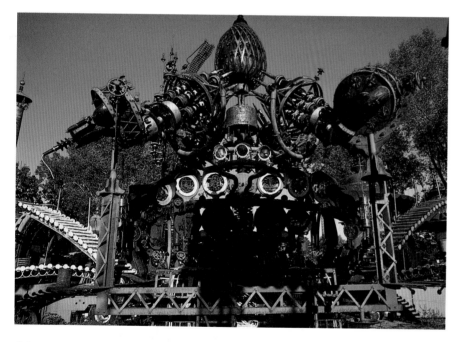

2.4

A detail of Every's Forevertron shows the space capsule "egg" and the master control panel.

At the back of the Forevertron is the "magnetic holding chamber," a make-believe storage unit for surplus energy that Every created from an enormous stainless-steel cylinder reputed by him to be the decontamination chamber used in the Apollo moon mission. To the far left of the chamber and mounted on a firetruck ladder from the 1920s, there appears a thirty-foot copper telescope that is fabricated from the wheels of old cornplanters, sheet metal, and lightning rods salvaged from old ships. According to Every, this telescope was originally constructed for Evermor's detractors who wanted to observe his flight into the heavens with their own eyes. At the other end of the Forevertron is an elevated Victorian gazebo that allegedly served as an elegant wrought-iron perch for the English royalty who attended the Doctor's notorious launching.

Secretly wired so that its machine parts blink, whiz, and whirl, the Forevertron is an animated sculpture that will one day become the central actor in an elaborate performance piece reenacting Evermor's fictional exploits. Utilizing mechanization, human performers, and special light and sound effects, it will capture the moment when the cosmic ambition of Dr. Evermor was realized and he blasted off for uncharted galaxies. According to Every, "When the machine was built and everything was set, Dr. Evermor commenced his great experiment. One by one he threw the great switches in the control center. Lights flashed, electricity buzzed and zapped, thrusters shook, and spectators gasped as Dr. Evermor was propelled to the heavens in his glass ball. And as he flew off, he cried, 'Evermor forevermore, power on.'"

In addition to the Forevertron, Every has built a series of "satellite" pieces that play supporting roles in the Evermor drama. The first of these, the "Graviton," is said by Every to alter the magnetic structure and reduce the weight of would-be space travelers so that they might fit more comfortably into Dr. Evermor's spherical glass ship. Surmounted by a wired helmet made from a chocolate pot and outfitted with a real antique fluoroscope, the piece also gives Every an opportunity to talk about William Rankin, who invented this early form of x-ray scanning machine. Another contraption, entitled "Dr. Evermor's Celestial Listening Ears," is described by Every as an "astrological"

device that searches for heavenly sounds, voices from other planets, and messages from "The High Commander" himself. To construct this extraterrestrial sensor, Every transformed a gigantic speaker from an old movie theater into a "sound collector," while for the comfort of its operators, he added an ornate, two-seater bench made from a discarded dentist's chair.

A final "satellite" piece is Every's "Overlord Master Control," reputedly the ground control or "brain center" for the Evermor project. Built to resemble an eighty-foot-tall candy jar, it is formed from a number of giant, round metal buoys employed during the 1960s to float the antimine nets at the American naval facility in Guantánamo Bay, Cuba. Surrounding the Master Control are seven "magnetic lightning cannons." These fantastic space-age armaments have been imaginatively fashioned by Every using antique fire extinguishers and genuine artifacts of military history, including cannonballs from World War I and machine-gun holders from World War II. The ornate metal wheels on the bases of the guns came from delivery carts once used in the Chicago warehouse of the Spiegel Catalog Company.

Every has been stockpiling the vast assortment of salvaged materials that constitute his sculptural creations for many years. In fact, he has been a recycler of found objects and industrial castoffs for most of his life. Born in 1938, he was, by the age of twelve, already "pulling things out of dumps, finding edge trimmings from plastics and hauling them to a blind man for weaving into rugs." "Later," Every says, "I started recycling contaminated liquid plastics, taking on large tonnages of by-products from the U.S. Rubber Plant in Stilton, Wisconsin, and making things out of their secondary materials. . . . I was also into auto salvaging and built an automobile crusher using a big piece of steel and a magnet. . . .Then finally, I started to phase into the business of industrial wrecking."

During his twenty-five years as a heavy industrial wrecker, Every dismantled obsolete power plants, bridges, textile and paper mills, cheese factories, breweries, and warehouses. But while it was his job to disassemble what modern technology had built and then abandoned, he grew weary of simply "tearing things down." Every's dismay over the continuous, wholesale destruction of outmoded industry was

rooted in his strong belief in the practical and ethical importance of recycling, and in his lifelong campaign to find a new use for the "preexisting shapes and forms" that would otherwise end up buried or on a scrap heap. In the end, he was also concerned with the loss of the social, cultural, and personal histories represented by the myriad industrial inventions that he was otherwise forced to demolish and discard.

Recombining his found machine parts into new configurations and investing them with a more fantastic purpose, Every hopes to effect a form of preservation for the countless technological curiosities that he continues to incorporate into his art. Salvaging objects that span a period from the time of the Industrial Revolution to the present, he has, in fact, created a sort of museum to the history of the machine age. Among the most important historical artifacts in Every's collection, and constituting a section of what he refers to as the "central power unit" of the Forevertron, are a number of authentic Edison bipolar dynamos deaccessioned from the Henry Ford Museum in Dearborn, Michigan. Produced by Edison himself and still exhibiting the patent dates of 1878 and 1882, these direct-current generators are joined by a series of doughnut-shaped dynamos and other antique inventions that Every displays together in order to illustrate the development of the modern electric motor.

In addition to his homage to Edison, Every's work includes other offhanded tributes to the heroes of techno-scientific progress. Found throughout his imaginary machinery, for example, are many cylinders wound with rope to imitate the real-life "Tesla Coil," which was designed by Nicola Tesla in the late 1800s as an air-core transformer for high-frequency electrical current. Creating other aesthetic parodies of scientific technology, Every has also fashioned a series of what he humorously refers to as "Faraday Stray Voltage Cages." Made of old irrigation wheels and recycled bronze wire, these giant constructions stand as heralds guarding the four sides of the Forevertron. The real "Faraday Cage" was a grounded metallic screen built by the nineteenth-century scientist Michael Faraday to protect his experiments from external electrostatic influence. Intended to parody this earlier invention, Every's creations feature large spinning

arms with blue balls and make "bug zapping" noises to simulate the sounds of stray energy. The specific purpose of his cages, says Every mischievously, is to "pick up dangerous electric and magnetic molecules coming off of the Doctor's generating devices," which, if left unattended, might eventually "alter the cell structure of his audience."

Not only concerned with commemorating the achievements of well-known inventors, Every is also interested in preserving the memory of more anonymous makers and workers. Through his recycling of old machinery, Every believes that he is saving not only the objects themselves but also the human energy that originally produced and used them. "You think, my God, what wonderful engineers we had back in those times," he says. "I have a lot of respect for them, and I feel bad when the things they made go into the scrap heap." Seeking to "capture the spirit forces of individuals from other time frames," Every finally finds in the discourse of discarded artifacts a testimony about the nature of human values, activities, and livelihoods. Recalling his dismantling of the Island Woolen Mill in Baraboo, Wisconsin, he exclaims, "You could darn near feel the spirit of the workers that used to be in the sweatshops among the big looms and bobbins."

Having been the last to witness so many objects as they became the latest casualties of rapid technological change, Every has felt a special urgency about his responsibility to save vestiges of the old industrial world that he so values and admires. Caught up in the larger cultural drama of regret and anxiety about modernism's possible demise, Every's relentless appropriation of machine culture refuses to accept the transitory nature of the modern world and its inevitable passing. Recognizing his dual role as both "disposer" and salvager, he confides, "I was part of the generation that destroyed the industrial age, but I saw magic and beauty in this stuff."

Referring to engineers, inventors, and machinists as "artists" and believing that their creations possessed an aesthetic nature, Every had no difficulty in using old machinery as the material for his art. Retiring from the salvage business to become a full-time artist in the mid-1980s, Every hoped that by elevating industrial castoffs to the status of art he might assure that these objects would be saved and valued. He also came to view his transformation of junk into art as a paradigm for the way in which we might more creatively approach the problems of our world and "see another dimension to things." According to Every, "I want to inspire people to look at things from a different perspective, without blinders and without preconceived social ideas. . . . What we are trying to accomplish here is a quadrajumping of preconceived ideas and possibilities."

To explain his creative philosophy, Every has adopted the term "imagineering," which describes his process of taking objects from the machine world that have outlived their usefulness and giving them a new imaginative function. It also describes his practice of going beyond the usual order of things to explore prospects formerly thought to be impossible. In this way, Every's use of found objects is an inherently nonsense operation in which he purposefully alters the original identity and intended purpose of his recycled materials to challenge and disrupt the agreed-upon premises of the everyday world. As Every explains, "Sometimes if you approach things too logically you can't get the job done. If people say 'What is this?' you have won already."

The found objects that Every incorporates into his work not only carry with them their own histories and meanings, they are also transported through their artistic recontextualization into the domain of the marvelous. Illuminating the "control panel" of the Forevertron with red, amber, and green lights that once signaled barges on the Mississippi River, using hand grenades to simulate the giant rivet heads of nineteenth-century construction, and transforming generators, flywheels, and other antique electrical equipment from Wisconsin power plants of the 1920s into Dr. Evermor's fantastic machinery, Every plays with the truth of history. Using authentic machines to create their fictional counterparts, he not only blurs the distinction between real and imaginative technologies but also begins to reconfigure the relationship between time and space and to transgress the usual boundaries that divide past, present, and future.

Finally, Every not only transforms the objects that he collects, but, like Mr. Imagination, he has also worked to remake his own identity. At about the

age of fifty, after decades of starting industries, running companies, and acquiring and losing fortunes, Every completely abandoned the world of everyday commerce to pursue the making of art. As if to mark his transition from businessman to artist, Every increasingly cast himself within the narrative of his own art and began to assume the enigmatic persona of his fictional character, Dr. Evermor. Today Every uses this creative alter ego as a way to entertain and mystify those who come to visit him. More important, he sees his playful ruse as an effective method of engaging the public in his imaginative world. Hoping to involve ever-increasing numbers of people in his creative enterprise, he also intends, in the near future, to incorporate his sculpture into a fanciful "art theme park."

In addition to featuring the series of sculptures that make up his "Dr. Evermor Suite," Every plans to include in his park a number of works by a real-life inventor and recycler, named Albert Melentine. Born about 1910, Melentine was a self-taught electrical genius who served as an early troubleshooter for power plants and utility companies. He also conducted his own experiments on the fuel efficiency of running diesel over electrical energy and on the possibilities of reusing automobile oil. But perhaps he is best known for the large, eccentric truck that he invented.

Built to tow big vehicles, move boulders, and transport other heavy objects, Melentine's truck started out as a bus chassis to which he added an air-cooled Franklin motor. He then hooked a generator onto the motor, mounted a winch and tow bar to the back of the chassis, and attached a 1930s Federal cab at the front. Moreover, the wiring of the truck was so unique that representatives of the General Electric Company once came to study it. Every first saw this contraption when he was in his twenties and immediately fell in love with it. Although he tried to purchase the truck at that time, the owner refused to sell. Then, recently, the vehicle surfaced again and Every quickly acquired it for his collection of mechanical wonders.

An archetypical recycler and paragon of human inventiveness, the real-life Melentine has joined the fictional Dr. Evermor to become another important figure in Every's imaginative universe. For like Dr. Evermor and Every himself, this creative tinkerer pro-vides yet another model for how we might negotiate and renegotiate our material and conceptual worlds. In Every's art theme park, Melentine will be represented by his large towing vehicle and by one of his smaller pickup trucks. Appropriate to the air of fantasy that surrounds all of his assemblages, Every wistfully describes how Melentine's pickup might be displayed: "I have been thinking about floating it in a little set of clouds followed by a trailer full of electric motors. Albert on the trail to heavenly hope, with more clouds over the top. It will be an art piece, and the best way to save that little truck."

There have always been found-object *bricoleurs,* innovative individuals who make new creations from what is at hand. Yet ours is a time when their skills and understandings are particularly instructive. Living in a disposable, waste-burdened, and socially atomized culture, we are called upon by ecological necessity to reconsider not only the manner in which we use and value things but the way we view ourselves and each other as well. In this enterprise, recycling is both a social responsibility and a way of looking at the world that helps us comprehend and reconstitute the fluid and seemingly disconnected fragments of our experience.

Mr. Imagination and Tom Every use recycling in many similar ways. Working within the strategies and framework of art making, both are committed not only to saving old objects but to imaginatively exploiting these artifacts' multiple historical and symbolic associations. Recognizing that preservation is a form of transformation, they creatively scramble and juxtapose the layered meanings of objects to present new visions of what our world is and might be.

Hacer Cosas:
Recycled Arts and the Making of
Identity in Texas-Mexican Culture

Kay Turner

This essay has a twofold purpose: on the one hand, to describe certain kinds of Mexican-American recycled arts found in Texas and, on the other, to examine these arts as indicators of the cultural style and aesthetic philosophy that energizes a *tejano* or Texas-Mexican way of living.[1] I take my title from Sra. Olga Garza, one of the people I interviewed for this project. It was she who suggested to me that for Mexican Americans in Texas recycling is just another name for *hacer cosas* – making things. Her definition seemed appropriate to the task of writing about recycled arts as they fit within a broad spectrum of things that are made, appropriated, or transformed from one means to another end in Texas-Mexican culture.

The visual topography of Mexican-American Texas is unmistakably enlivened by a certain aesthetic of objects, colors, and symbols that boldly marks homes, yards, businesses, streets, neighborhoods, and cemeteries. The density of colors and images exhilarates Mexican neighborhoods throughout south and west Texas, in small communities such as Refugio and Ozona as well as in Mexican hubs such as San Antonio and Laredo.

The sprawling west side *barrio* of San Antonio, for example, unleashes a flood of images and sensations, layers of meanings and histories that are reflected in the variety of objects and scenes found there on street corners, in front yards, and inside homes, restaurants, auto shops, bakeries, and other businesses. The playwright Luis Valdez suggests that Mexican Americans show a marked propensity toward visual communication. He claims that Mexican Americans "perceive better visually rather than literally" and he means that as a compliment, saying, "We are image-oriented, . . . [a]nd because we're image-oriented, we're also symbol-oriented. We are a very symbolic people." (Valdez 1985, 23)

Not surprisingly, many of the image-rich items that characterize Texas *barrios* are made from recycled materials – everyday industrial castoffs such as tin cans, Styrofoam containers, and tires. A cursory catalogue of recycled arts found in Mexican Texas would include brightly painted car or truck tires used as signs for car repair businesses or refashioned into objects of delight for the yard, such as planters, tree swings, decorative parrots, and swans; Christmas decorations such as huge lollipops and The Three Kings' jewels created out of Styrofoam containers; religious shrines made from old televisions, bathtubs, or junked materials such as tile chips or toys (plate 3.1); windmills and whirligigs made from soda-pop cans; airplanes and butterflies cut from scrapped tin; fencing made of pressed tin cans or bedsprings; and "muffler men" constructed from used auto parts (plate 3.2).

In *tejano* environments, recycled arts add their own messages to the heady image profusion resulting from a continuous cross-mixing of things sacred and secular, symbolic and idiosyncratic, refabricated and reused, folk and popular. A mural of Our Lady of

3.1
In San Antonio, Texas, a front-yard shrine dedicated to the Virgin of San Juan is adorned with recycled tile chips.

Guadalupe on one street corner faces a brightly painted tire hanging in the air above a shop that fixes flats. Things are positioned in multiples: not just one tire planter, but three; not just one or two cement frogs, but five or six. There is a visible sense of abundance: even in some of the poorest neighborhoods, yards and street corners exude vitality from conglomerate images. Holidays such as Christmas and Easter provide further opportunity to elaborate.

Within the family, business, community, neighborhood, and town, things cast off are recycled, recast, refurbished, recategorized to embellish the visible presence of Mexican-American life in Texas. Of course one finds the legacy of this kind of vernacular recycling in Mexico where marketplaces abound with goods made from recycled industrial materials, but in Texas, recycling is linked most often to the creation of images and symbols of identity rather than to items sold commercially.[2] Hardly any of the recycled folk arts in south Texas ever make it into the market economy, whereas right across the Rio Grande border at Reynosa, Matamoros, or Nuevo Laredo heaps of recycled objects – dustpans, lanterns, toys, etc. – are readily sold in the streets and markets. In both Mexico and Mexican Texas, the refabrication of industrial by-products often results from an economic strategy aimed at the preservation of materials and capital. On both sides of the border recycling is intimately related to a folk ideology of resourcefulness and frugality.

In the Texas-Mexican context, recycled arts are homemade, and only occasionally are they sold as a source of extra income. The Texas-Mexican version of recycled art is largely based in the family and is used primarily to decorate the home and garden for family-based celebrations such as birthdays and Christmas. It helps define tradition, ownership, and sense of place, and plays a role in affirming identity. Through artistic practice and by application of a culturally shared aesthetic code, objects of subjective value are created from things that have ceased to have objective value (plate 3.3).

Recycled arts help define a distinct Mexican-American folk aesthetic that encompasses other visual arts (both religious and secular), foodways, architecture, music, and dance.[3] Critical to any discussion of such folk expressions in Texas is the understanding

3.2
"Rudy" the Muffler Man.
Carlos Ramos and sons, Uvalde, Texas. 1994. Spray-painted car mufflers, nuts, wire, auto parts. H 78" (198 cm). International Folk Art Foundation Collection, Museum of International Folk Art, Santa Fe.

This muffler man was made by the owners of a family-run auto repair shop, using spare parts from their business. It was spray-painted with "jailhouse" stripes as a friendly spoof on a young man who worked at the shop during his probation from a drunk-driving offense.

that this state's history plays an important role in shaping the particularities of the *tejano* folk aesthetic.[4] Since the annexation of Texas by the United States in the nineteenth century, Mexicans in the state clearly have suffered a subordinate status socially, economically, and politically.[5] In the realm of culture, however, Mexicans strategically put forward their own sense of identity. Texas Mexicans used the arts not only to encode a legacy with Mexico, but also to demonstrate the strength of their difference from the Anglo-dominant culture within which they worked and lived.

In the *barrios* of south and west Texas especially, an aesthetic code developed that rather smartly and defiantly reflects *mejicanismo*, the sense of being Mexican. In the hostile setting of exploitation and oppression that characterized Mexican life in Texas for well over a century, *mejicanismo* provided an alternative and powerful sensibility, a source of pride and unity that enjoyed much of its impact through aesthetic displays. Visually speaking, *mejicanismo* translates to a highly decorative, colorful, and multi-valent aesthetic impulse; it adds flavor – visual bite – and identity to neighborhoods that have been home to Texas Mexicans for generations.

Perhaps no other form of recycled folk art is as ubiquitous in the Texas-Mexican landscape as the refabricated tire. Reinvented to accommodate a range of uses and meanings, the tire exemplifies the transformative possibilities that are embedded in a single item. It can become index, icon, or symbol (for example, a symbol of movement, but also an index of tire repair). So regularly is the recycled tire seen that its repetitive use in various contexts gives it the character of an identifying emblem for the Texas-Mexican culture.

The tire's semiotic richness underscores the kind of resourcefulness, ingenuity, and sheer artistic audacity that can transform the dumped and demeaned castoff into the praiseworthy product of the craftsman. Onetime representations of speed, of mobility, of "getting somewhere," old tires are heaped in junkyard piles at the back end of every town: mountains of motionless eyesores that can't be hidden because there are, quite simply, too many of them. These tires, removed from the vehicles that once propelled

them, seem destined only to signify that depressing denouement known as "the end of the road."

Yet in the Texas-Mexican landscape we see the rubber tire take on new life. Brightly painted – orange and white, blue and red, or yellow and black – and suspended high in the air, a rubber tire becomes a signpost for the services performed by the *vulcanizador,* he who fixes flats and thereby gives new life to old tires, keeping them off the junk heap at least awhile longer. Various tire signs, almost all of them Mexican-American by design, are seen throughout south and west Texas. They are similar to Mexican versions of this tradition, for in Mexico the signage of the *vulcanizador* is everywhere present, too. And many additional uses of the recycled tire are found there as well: shoe soles, slingshots, rubber rope, fencing, and so on.

In Texas, though, the remade tire's utilitarian strain turns playful. Cut and pulled, twisted and turned inside out, shaped and painted, the old tire realizes its potential for complete transformation in the form of decorative items mainly used to enhance front and side yards: scallop-edged, multicolored planters that look like giant sunflowers; curvaceous, white or yellow lawn swans; tree swings, sometimes shaped like ponies; and flamboyant, realistic-looking parrots, to name the most obvious (plate 3.4).

The sheer quantity of tire planters and their derivatives found in Texas-Mexican neighborhoods is remarkable. However, although some examples may exist, the tire planter is not seen widely in Mexico. Instead, the transformed tire has become in Texas a perfect Mexican-American "bicultural" object; it partakes of the tire recycling tradition in Mexico, but in a wholly different manner.[6] The tire planter is at once urban and rural, modern and pastoral. It holds the immigrant's longing and the new citizen's desire for security. The tire as a symbol of movement – including both progress and displacement – is substituted for the planter that represents home ownership and the domestic pursuit of tending one's garden. Once attached to a car, a primary symbol of modern American values, the tire becomes associated with flowers and greenery, symbols of nature's long-standing value. But the tire planter holds more than flowers. Perhaps what appears to be so attractive in

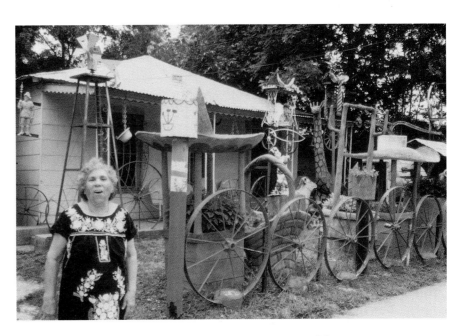

general about art made from recycled objects is most evident in the tire, in the artful transformation of a piece of black rubber into a colorful parrot or flower-like planter. We recognize the ingenuity required to transform a piece of industrial waste into something decorative that serves pastoral pleasures. A kind of paradise is regained through cleverness and a refusal to give up on the usefulness of a particular item.

Swans, Shrines, and Tire Planters: The Landscaping Arts of Texas-Mexican Identity

The transformed tire cannot be separated from the place it has in a complex array of objects that also signal the Mexican-American presence in Texas. We could investigate the phenomenon of folk recycling at several points of entry into the Mexican-American community, yet the place where I think recycling has its richest semiotic effects is in the domestic realm, especially in various arts and arrangements that decorate and modify the front yard.[7]

The yard profits from expression. It is a busy place; activities there – planting, decorating, recreation, and celebration – mark family change and growth throughout the years. The yard is an exhibition space. Objects in the yard are piled up, spread out, moved around, added and subtracted as time goes by; some things last a year, others a lifetime. Objects are placed carefully, or in other cases haphazardly, but there seems to be no hierarchy of objects or images imposed. The handmade is mixed with the mold-made; the religious is interspersed with the secular; the ephemeral is found amid the permanent; and the predictable is side by side with the idiosyncratic. And as significant is the degree to which typical American images such as a Santa Claus or a Woody Woodpecker whirligig find their place nestled against standard Mexican emblems such as a statue of the Virgin of San Juan or a plaster *sombrero* (plate 3.5).

The Mexican-American yard is a multivoiced domain; it simultaneously broadcasts a range of messages. The yard is *mezclada* (mixed) – a site of what the historian Tomás Ybarra-Frausto calls "visual biculturalism" in his suggestive claim that contemporary Chicano art enjoys the fluidity of moving back and forth between multiple aesthetic affiliations (e.g., folkloric, pre-Columbian, contemporary American).

Such fluidity allows the Chicano artist to "question and subvert totalizing notions of cultural coherence, wholeness, and fixity," the result of which is an open view of culture and identity that affirms the "possibility of making and remaking oneself from within living, changing tradition." (Ybarra-Frausto 1991, 144–5)

This affirmation is reflected in the "living, changing tradition" of the yard, a site where the choice and arrangement of objects reveals the owner's sense of identity. The yard is a strategic place for choosing to either assimilate or shun dominant values of home presentation. Objects in the yard claim ownership not only of physical space, but of the right to aesthetically mark the personal landscape with signs and symbols. As a site for "planting" symbols, metaphors, histories, and ironies, as well as plants and flowers, the yard and its art forms can be read for various meanings of Texas-Mexican life.[8]

Each yard contains individually chosen items, some of them unique, but yard art also encodes a commonality of experience and identity through its presentation of a familiar stock of objects and symbols (plate 3.6). The most regularly seen of these include statuary of the Virgin Mary (especially Our Lady of Guadalupe and the Virgin of San Juan); handmade shrines dedicated to chosen patronal saints; swans, geese, ducks, and chickens in a variety of sizes and media; tire planters; decorated wagon wheels; and handmade and store-bought whirligigs, windmills, wishing wells, and cement baskets.

Such items constitute a working repertoire of images. Most commonly they are found in the yards of established working-class or poor *barrios*, old neighborhoods whose residents have borne the pain of discrimination and deprivation, but who have made a world for themselves at home. Social conditions in Texas are better now than they were twenty years ago, but prejudice still is not a thing of the past. *Barrios* still exist as safe enclaves. There is a certain feeling of unity and cohesiveness expressed in an old neighborhood such as Lima in the west Texas town of Ozona. Yard after yard is decorated, each different, each the same. With the exception of Our Lady of Guadalupe, the patron saint of Mexico, nationalistic images such as flags or banners rarely appear.

But these yards are identifiably Mexican, both to

their owners and to outsiders who pass by. The visual code of the *barrio* is expressively *not* assimilated. Even the commonly encountered appropriation of Texas metaphors – wagon wheels and windmills – is accomplished in a Mexican way. These symbols, displayed among others within the context of a Texas-Mexican aesthetic, lose the sting of their hegemony. They are symbols of the dominant culture that have been reassigned; now they are absorbed into the democratic mix of the minority. In fact, what is remarkable about the Texas-Mexican yard is the way seemingly benign, bucolic images create affirmative markers of identity that effectively unsettle the geography of domination and segregation.

These images are derived generally from a pastoral ideal of beauty and natural harmony. But by postmodern standards they would seem to verge on kitsch. Kitsch, as Baudrillard says, "is equivalent to cliché in discourse." (Baudrillard 1990, 75) Kitsch is a hallmark of escapist, consumer society. It results in part from the industrial multiplication of ready-made objects – plastic swans and plaster saints – that can stand as nostalgic references to bygone eras or to the potency of identity or belief. Yet kitsch offers little more than a vicarious identity (Olalquiaga 1992, 36–44). On the surface, the Mexican-American yard exhibits the broad eclecticism of kitsch, its random appropriation of motifs and materials. But, in direct contrast, yard works – those same plastic swans and plaster images of the Virgin – are intimately attached to members of communities who use them as representations of cultural tradition and values. The use of pastoral and religious images claims an active relationship with the Mexican history of rural life and religious practice that is central to a lived identity in Texas. Such images are widely repeatable, cheaply available, and conventional, but when they are brought within the bounds of a Texas-Mexican yard they become intentional signs belonging to a community-based aesthetic.

The recognizability of the Mexican-American yard in Texas is underscored by differences between native Mexican and American domestic architecture and landscape design.[9] In Texas most homeowners, no matter what their nationality, inherit the suburban American yardscape, an English legacy that emphasizes a house set off by frontage and lawn. Depending on how it is maintained, exposed frontage publicly

3.5
This front-yard shrine in San Antonio's westside embodies the hybridization of sacred and secular that is characteristic of the cultural borderland of south Texas. At Christmas, the shrine's Virgin of San Juan shares space with America's most visible icon of the holiday: a plastic Santa.

reveals much about the homeowner's status. This is in direct contrast to Mexican village and town architecture where, by way of a Spanish legacy, the front doors of homes open directly onto the street, and all landscaping – plants, trees, flowers, gardens, ponds, pools, and other effects such as sculpture or family heirlooms – is enclosed within a private courtyard patio or atrium. This internal landscaping is meant for the sole enjoyment of family members and their guests. In Mexico the sacred insularity of the family is architecturally fixed in the extreme privacy of the home.

North of the border, even the smallest *barrio* house in San Antonio or Refugio is open to the street. A sense of bounded ownership is often created with chain-link fencing around the perimeters, but even this enclosure is, in effect, transparent; gardening, landscaping, and attendant decorative objects are exposed to all who pass by. The private world of the Mexican home is re-created as a publicly visible space; insularity is traded for a certain vulnerability.

The embellished Mexican-American yard is open to critique and judgment, especially in contrast to the typical Anglo yard, which is clipped and trimmed but physically empty of things that might serve as signs or symbols. Generally, the Anglo (or, more accurately, the Texas German or Texas Czech) lawn is objectless and pristine. It "says" very little visually, but in "not speaking," volumes are spoken semioti-

cally about cultural difference and its implications. The "empty" Anglo lawn symbolically sets the standard for how privilege and power are demonstrated: by withholding, by reserve, by an absence of excess, and hence, by remaining invulnerable and unknown.

This aesthetic of absence, however, is challenged by the sentient and refulgent imagery of Mexican-American yards. An aesthetic of colorful excess and abundance is flaunted in the face of prejudice that has prevented social and economic prosperity. Far from being benign, this representation of the pastoral ideal of natural wealth does not hide a certain defiance. In fact, the ultimate irony is that this ideal is achieved in part by recycling the cast-off symbols of that unattainable affluence: tires of cars they cannot afford, bathtubs in front of houses with no indoor plumbing. The mixed messages of the Texas-Mexican yard enjoy their own power to confound the monolith of social domination.

3.6
Roberto Perez's wife requested that he make these tire planters to adorn their front yard in Refugio, Texas.

In her work devoted to the politics of representation of the south Texas folk artist José Varela, Suzanne Seriff provides further proof of the potency revealed by pastoral signs in Texas-Mexican yards. Varela is a traditional ceramic sculptor who creates a remarkable range of images including Mexican symbols such as the eagle and cactus, Catholic symbols such as the Virgin of Guadalupe, and natural symbols such as flowers and butterflies. He lived for many years in D'Hanis, a small town outside San Antonio, and worked there with other Mexicans at the D'Hanis Brick Factory, owned and operated by Anglo-Germans. In fact, Varela lived directly across the street from the factory and secretly fired his sculptures in the massive kilns. In contrast to the monolithic brick factory and to the homogeneous red, rectangular objects it produced, Varela's highly visible, green yard was filled with the symbols he made that are relevant to him and his Mexican community (Seriff 1991, 146–71).

Seriff's interpretation of Varela's yard is suggestive generally for Texas-Mexican yard display. Following Hebdidge's (1979) work on subcultural style, Seriff shows that Varela's personal landscape provided a visually lush and symbolically rich Mexican counterstatement to everything the factory represented as a symbol of capitalism and Anglo domination (Seriff 1989). A confrontation that cannot or has not taken place politically or socially is waged on the level of cultural style. As Hebdidge claims, objections to oppression and hegemony can be lodged "at the profoundly superficial level of appearance: that is, at the level of signs." (Hebdidge, 17) Across the Texas landscape the subcultural style of Mexican Americans is rendered through the "superficial appearance" of signs such as shrines, swans, and wishing wells. Such "humble objects" can be appropriated to carry secret if unarticulated messages of resistance to control and subordination (Hebdidge, 18).

Celeste Olalquiaga, in her important book *Megalopolis: Contemporary Cultural Sensibilities,* comments that Latin America's take on industrialized international culture (or dual culture as we find in south Texas) "tends toward hyperrealism of uniquely parodic attributes." She suggests that this magical hyperrealism often works by inverting the image of a

colonized, subservient people into one that can laugh at "the sterile nuances of cultures with very little sense of their own self-aggrandizement." Parody is accomplished through "banalizing issues and objects either by making them literal or dramatizing their function." (Olalquiaga, 75) In Texas-Mexican yard art, elements of parody can be read in various objects. The mass-produced statue of the slumped and napping man in *serape* (cloak) and *sombrero* (hat), the so-called *mañana* Mexican, takes on a different meaning in a Texas-Mexican yard. There the dominant culture's stereotyped image of a lazy Mexican becomes simply and literally who he is: a tired *campesino*, an overworked *compadre*.

In celebratory, seasonal spectacles, hyperrealism is infused with hyperbole. Christmas, for example, the high-consumption season for the dominant culture, brings a display of huge lollipops made from recycled Styrofoam plates to a working-class *tejano* yard. Making things bigger for effect is a hallmark of Mexican holidays, but these gigantic candies do more than celebrate. Their presence can also be said to overdetermine and parody the value of sweets in an economic situation in which real food is sometimes hard to provide. The false values of American capitalism – the sugar-coated desires that invite people to be consumers first and human last – are artfully construed as a kind of holiday burlesque. The true values of home and family are enacted behind this front-yard spectacle of vicarious pleasure.

Recycled materials lend themselves to artful parody because they represent the shift of one material use to another; they bring associative meaning with them. A tire turned into a swan trades on the transformation of an industrial symbol into a pastoral one, on the power of speed and mobility tamed by the power of beauty and gracefulness. In the yard, industrial materials that represent urbanization, progress, and the exploitation of labor are recast as symbols of the higher powers of nature, family, and stability. Extrinsic commercial value is transformed into intrinsic community value.

I am not suggesting that a Styrofoam lollipop or a tire planter represents a conscious revolution. Most of the people I've talked to acknowledge the Mexican distinctiveness of their yard ornamentation, but they certainly do not voice any counterhegemonic politics in their discussion of yard design. What seems uppermost for them is a sense of beauty, a claim on the yard as a place to show ownership and family pride through landscaping in a particular way. But whether or not a political stance is voiced, this is exactly the point: that ownership and identity, a way of saying "I am here. I live here," can be asserted through vernacular aesthetics.

For example, when I stopped by to talk with Mary Molino in Gregory about the tire planters in her yard, she told me that she had always liked them. Sra. Molino could not tell me where she saw her first tire planter, but she remarked, "I've seen them around for years in my neighborhood here." When she and her husband, Roy, were able to afford a house, one of the first things she asked him to do was to make a planter for a tree she wanted to plant. He got an old tractor tire and painted it with a diamondback rattlesnake design and she put in a sapling. Twenty years later, the tree is full grown and she says, "Now, I should get him to paint [it] again, but it took the tree and I still think it's nice." Sra. Molino and her family have worked for years to perfect the beauty of their yard. This is a kind of labor that is linked to both agrarian and migrant histories for Mexicans in south and west Texas, but at home the labor of working the land out of economic necessity is transposed into an aesthetic labor of identity and enjoyment.

I have emphasized yard art as one place to look for recycled arts within the context of a highly visible Texas-Mexican aesthetic. But we should not forget that this aesthetic is also found in other places such as businesses, festival settings, churches, and cemeteries. Any of these arenas could be further investigated, but let me give only one further example of the way in which recycled art is used to demarcate and describe the Mexican experience in Texas. This is demonstrated in the most obvious and dramatic way during celebrations of All Souls' Day in early November, traditionally a family day given over to remembrance of the dead.

All over the state, *tejanos* go to their community cemeteries to clean and then brightly decorate graves of loved ones. In many places, such as Rio Grande City, La Coste, and south San Antonio, cemeteries become a temporary meeting ground for relatives

and old friends. Along with loads of freshly cut flowers and plastic ones as well, homemade decorations are seen in proliferation: recycled egg cartons are cut into flowers; old coffee cans are wrapped with tin foil and filled with chrysanthemums; and children's toys and other mementos are arranged with the flowers in front of gravestones embedded with pieces of tile or broken plates. Even the omnipresent tire is sometimes seen as part of a tribute (plate 3.7). The graves become exuberant, festive memorials proclaiming allegiance to the dead. Moreover, in south and west Texas cemeteries that were segregated until very recent times, these graves mark the visible difference between Mexican and Anglo identities: on one side the accumulated objects and blazing colors, on the other the somber gray of granite headstones. In one sense, historically speaking, this is a stark vision of acceptance and assimilation denied, but it also reveals a Mexican-American aesthetic of assumed and, yes, applauded difference.

3.7
The reuse of discards even extends to the art of grave decoration in the *mejicano* community of Texas. Here, a grave-side wreath in San Antonio's San Fernando Cemetery is made from a steel-belted radial tire that is wrapped in plastic flowers and printed with the name of the deceased along the rim.

Yard and cemetery arts, among others, have been used for years to mark a cultural geography, and just as important, they help maintain a cultural ecology, a vital network of people, places, things, and activities that ensure the evolving dynamism of Texas-Mexican life. Within the shifting circumstances of political biculturalism in Texas, these and other scenes laden with symbols and signs provoke a discourse of values, beliefs, and strategies. They are open sites of exchange between *tejanos* and others, and they thereby serve as a hedge against the erasure of identity in a sociopolitical system from which it is easy to "disappear."

Recycling and Mexican-American Style

Tejano folk arts are steeped in and arise from what Carlos Monsivais calls "*la cultura de la necesidad,*" the culture of necessity (quoted in Ybarra-Frausto, 148). Texas-Mexican recycled arts fit with other folk arts to reveal a particular aesthetic linked to complex cultural strategies of identity and survival. Certainly this style is wedded to economic necessity, but perhaps the more critical necessity is one of identity. In a recent issue of the *Journal of American Folklore* (1994), which highlights the relevance of the concept of identity as a core principle of folklore, Eliot Oring noted that in folk expression identity tends to be foregrounded in situations of conflict, where "identity is challenged or denied." (Oring 1994, 226) In fact, Henry Glassie proposes that identity is actually "a latent dimension of creative life that is made manifest by stress, particularly minority struggles." (Glassie 1994, 240)

Certainly the Texas-Mexican experience, a minority struggle that has lasted for generations, provides a rich source for elucidating idioms of identity. But these idioms, such as recycled arts, must not simply be described, they must be contextualized within a broader understanding of the aesthetic that governs them. In our catalogue essay for the 1986 exhibition *Art Among Us/Arte Entre Nosotros,* Pat Jasper and I said that this style reveals an "aesthetic of bold display" promoting a kind of distinctive aesthetic loyalty, the visual and material version of *mejican-ismo*. Further, we said that Texas-Mexican folk arts

were not mere reflections of identity, but that they in fact exemplify "the very way in which art making may constitute strategies for affirming and re-creating anew loyalties in the family, the neighborhood, and the community at large." (Turner and Jasper 1986, 10) The art of a tire planter is to be found both in the visual impact it makes as an object, and in the process of transformation – the cultural salience of remaking – it demonstrates and upholds.

In the catalogue for that same exhibition Suzanne Seriff and José Limón attempted to define further the principles at work in the bricolage methods of the Mexican-American folk artist:

What makes the Mexican-American aesthetic unique is the way in which "bits and pieces" are creatively put together to form a coherent whole. When the folk art object is created, bits and pieces are added together from a long and varied historical tradition of art forms, from the personal histories of community members, and from the resources available at the moment of creation. (Seriff and Limón 1986, 40)

Of course it is obvious that available resources are found in the leftovers of material life – the tires, the tin cans, the tile chips – but Seriff and Limón remind us of the degree to which Mexican Americans successfully appropriate bits and pieces at much more abstract compositional levels as well, such as in adaptations and transformations of musical styles. Recycled art fits within a broad folk aesthetic based in appropriation and improvisation.

"Bits and pieces" is a term suggestive of the methods whereby items from any particular domain may be transferred for further usefulness into another domain. Images, objects, and materials are constantly shifted into new contexts where they become part of a new repertoire of uses and meanings.

This kind of fluidity in the usage of images and materials suggests a general ease with recycling that reflects the diffusiveness of domestic domains. The overall economy of the Texas-Mexican home – especially poor, working-class, and middle-class homes – is based in the preservation and recirculation of goods to further extend their usefulness. But this economy is not simply materialist. It operates in conjunction with an aesthetic that allows objects and symbols to be present in, or moved in and out of various spatial

3.8
This home altar, dedicated to the Mexican folk saint El Niño Fidencio, is designed and maintained by Sra. Florentina Trujillo of San Antonio, Texas. Glass bottles, plastic jars, wrapping paper, and Christmas tinsel are a few of the objects that have been recycled from other contexts of household use to make up the personal pastiche that embodies the particular beliefs, stories, and prayers of the altar maker.

3.9
This unusual jar-shaped tire planter was made by Benito Garza and painted by his wife, Olga. Here, it sits on the front porch surrounded by the artists' nieces and nephews.

or semiotic contexts, regardless of whether or not they necessarily fit the prescribed meaning of a particular place. Diffusion of this sort signals a preference for the aesthetic of *mezclada* that results from mixing things up, from putting bits and pieces together in a way that can split a single domain or a single channel of communication into a complex aggregate of signals and meanings.

I became aware of this kind of diffusiveness years ago in my dissertation research on Texas-Mexican women's home altars, a very old and widespread form of domestic folk Catholicism (see Turner 1983, 1985, 1990). I used the term "femmage," borrowed from the feminist artist Miriam Schapiro (Meyer and Schapiro 1978), to capture the process by which women assemble personal devotional altars at home. These altars – eclectic, visually stunning, accumulative, layered with meanings and histories, both religious and familial – are put together over time in a collagelike way (plate 3.8). Items from various domains of meaning – pictures and statues of the saints, family photos, candles, flowers, knickknacks, family heirlooms, and so forth – are brought together to create a multivalent visual statement and to serve as the place where communication with the divine is effected.

Tomás Ybarra-Frausto defines the strategic sensibility that underlies this *mezclada* aesthetic as *rasquachismo*, a pervasive attitude found, he says, in all Chicano art, and that certainly summarizes the inclination toward recycling as a valued means for making art. As he suggests, *rasquachismo* is "an underdog perspective." It is "a stance rooted in resourcefulness and adaptability, yet ever mindful of aesthetics." His full definition of *rasquachismo* is worth quoting:

In an environment in which things are always on the edge of coming apart (the car, the job, the toilet), lives are held together with spit, grit, and movidas. Movidas *are whatever coping strategies one uses to gain time, to make options, to retain hope.* Rasquachismo *is a compendium of all the* movidas *deployed in immediate day-to-day living. Resilience and resourcefulness spring from making do with what is at hand* (hacer rendir las cosas). *This utilization makes for syncretism, juxtaposition, and integration.* Rasquachismo *is a sensibility attuned to mixtures and confluence. Communion is preferred over purity.*

Pulling through and making do are not guarantors of security, so things that are rasquache *possess an ephemeral quality, a sense of temporality and impermanence – here today and gone tomorrow. While things might be created using whatever is at hand, attention is always given to nuances and details. Appearance and form have precedence over function.*

In the realm of taste, to be rasquache *is to be unfettered and unrestrained, to favor the elaborate over the simple, the flamboyant over the severe. Bright colors* (chillantes) *are preferred to somber, high intensity to low, the shimmering and sparkling over the muted and subdued.* (Ybarra-Frausto, 133–4)

Following Ybarra-Frausto's lead, we come further toward an understanding of where recycled folk art fits into an aesthetic strategy of identity for Mexican Americans. Recycling is a kind of *movida*, and particularly in relation to artistic production, recycling allows ample opportunity for "unfettered and unrestrained" transformations of lifeless, inert materials into objects that convey *rasquache* exuberance. On the aesthetic level, *movidas* in Texas-Mexican folk art are generally associated with transformations that lend themselves to increasingly more outspoken objects. As I suggested earlier about the tire planter, we see in it the transformation from dreary residue, proclaiming nothing, to a colorful object that articulates aspects of Mexican identity and community.

Sr. Benito Garza and his family provide a useful model for understanding various *movidas* represented in the making of art from recycled materials. The Garza family settled in the small south Texas community of Cuero after years of migrant labor in west Texas and New Mexico. Making do and making things is something the whole family is good at. When I met them, Sr. Garza and his sons were tearing down the engine of a pickup truck, taking a break from building a small taco stand next to their house. The front of the house is decorated with an assortment of store-bought and handmade things including various creations made from old tires by Sr. and Sra. Garza.

Sr. Garza is an expert maker of tire-derived things: planters of various sizes and shapes, swans, swings

that look like horses, and so on. He started making planters out of an aesthetic sense, as he says, "I bought one from a [mejicano] in Robstown. I liked it. But then I thought, I can make it, too." He began creating his own versions of the tire planter. In fact, Sr. Garza makes a unique kind of *olla*-like planter, shaped like a jar (plate 3.9). He shares the artistic process with his wife, Olga, who is the sole painter and decorator of the tires. Sra. Garza possesses an expressionist's hand; she paints in interesting combinations of blue and pink, green and silver, and so on. Sra. Garza also makes decorative swans from recycled half-gallon milk containers. She learned by imitating her sister, who made them before her. "One day," says Sra. Garza, "I came home [from my sister's] and I just took that milk jug and made it, you know. It's not hard." Now she makes the swans as gifts for relatives and, likewise, Sr. Garza has made many decorative planters for friends and family. But in the past few years the Garzas have also used their art as a way to make a little extra money. Sra. Garza says, "I sell my little swans here. Sometimes I get an offer to carry them over to Victoria, but it's not worth the trouble."

For the Garzas, making swans, tire planters, and other things fits a larger pattern of creative self-sufficiency that operates in many aspects of their lives. At one point in our discussion of the milk jug swans, Sra. Garza asked in Spanish what the English word "recycling" means. In a serious tone her thirteen-year-old son explained that in school he had learned the importance of reusing things – tin cans, newspapers, and so on – instead of just throwing them away. She understood immediately what he meant and in response she said, "Oh, it's like *hacer cosas*. That's it." *Hacer cosas* means to make things, and in the sense she was describing, it refers to the way in which she *knew* that odds and ends are always saved for future usefulness. For Sra. Garza, the term "recycling" was understood as another name for the regular process of transforming old materials into new items by making things.

A similar way of thinking is extolled by Mary Payan, whose yard in El Paso is decorated with available materials, including a tire planter and a shrine with a handmade image of the Virgin. Sra. Payan's house burned to the ground several years ago. She was left with nothing, but together with her sons and friends "we just went ahead and remade everything, the house, this fence, and all. I'm used to it. I'm a seamstress. This is how I do, bit by bit."

These examples – and there are many others I could give as well – gloss a particular kind of strategic understanding of material means and how they may be moved around, saved, changed, transformed, or discarded. The fluidity of materials is a key *movida* in Texas-Mexican life. Nothing necessarily must remain as it is, nor must any object be bound by its primary definition of use.

The fluidity of domains and the value attached to that which is *mezclada* and *rasquache* are at the very heart of understanding the relationship between identity and the aesthetics of recycling in Mexican-American life. In a very real sense Mexican identity in America is not something *given*, it is something *made*, and this making often takes the literal form of *hacer cosas* – making things, making do, placing things, arranging things, creating things, re-creating things. Ybarra-Frausto suggests that the primary aim of the Chicano art movement is to "surmount strategies of containment by struggling to achieve self-determination on both social and aesthetic planes." (Ybarra-Frausto, 129) Folk arts made from recycled materials affirm the active level at which an aesthetic identity can be elaborated through deceptively simple artistic means. And just as much, recycled arts exemplify the ongoing project of regeneration and renewal in the Texas-Mexican community. For *tejanos,* recycling is based in a materialist urgency, but it operates metaphorically as well. Recycled arts play their part in revealing a disposition to difference that defines the legacy and viability of Texas-Mexican culture.

What Goes Around Comes Around: Temporal Cycles and Recycling in African-American Yard Work

Grey Gundaker

Bennie Lusane lives near a now-defunct Westclox factory. For some visitors to his yard, that fact alone suffices to account for the presence of so many clock faces there – tacked to a totemlike pole; marking time's passage beside a rusting license plate; encompassing the four directions on a square enclosure of chairs, pots, housewares, and lumber; forming part of a winged tribute to black manhood; and stacked like successive generations on a white marble slab that covers a waterspout (plate 4.1).[1]

But to accept this simplistic explanation for Mr. Lusane's choice in recyclables is to miss crucial connections from the four-cornered world of the compass and the clock face, to the lines and cycles of time, and to fundamental aspects of African diaspora and Afro-Christian philosophy and practice. Clocks keep time or cease to keep it; clocks are representations of particular positions in continuous, recursive motion. Bennie Lusane placed clock faces in his yard with just such ideas in mind.[2]

The principle that "what goes around comes around" endures in interpersonal, artistic, and material forms in African America.[3] On the one hand it accords with the Christian belief in God's justice and the eternal life of the soul. On the other, it parallels certain African belief systems. For example, for the Kongo people of western Angola and Zaire, ancestors of a quarter to a third of contemporary African Americans:

[T]he soul moves in time's circle as an indelible point of light and certainty. That is why the Kongo moral precept, "from humiliation stems honor" (mu diavwezwa mweti mena dianzitusu) has such depth and resonance. For according to this vision, as we die the "petty deaths" of accident and humiliation, the superior dimension to our consciousness has already distanced itself from pain in order to plan the appropriate counter-attack, the appropriate return to full assertion. And so we come back, stronger for the testing, more impressive for the return.
(Thompson 1989, 29)

This vision of rebirth and renewal finds graphic and material expression in "maps of the soul" (*dikenga*), which in the African diaspora can take the form of clock faces, compasses, spiral shells, rotary fans, whirligigs, and diagrams of solar movement (Thompson 1993, 48–55). The Kongo cosmogram encapsulates cyclical concepts with great economy as it creolizes Christian symbols like the cross and the circle. The cosmogram has no single indigenous name in the United States. Sometimes African Americans call it a diamond or star, sometimes the four corners of the world, and sometimes God's clock.[4] A narrator for the Fisk University collection of accounts of conversion experiences described encountering a "time-God" whose voice spoke from the east, the direction of the rising sun.

Some people pray and call on God as if they think He is ignorant of their needs or else asleep. But God is a time-God. I know this for He told me so. I remember one morning . . . I felt awfully burdened down so I commenced to talk to God . . . I said, "Lord, . . . looks like I have a harder time than anybody." When I said this something told me to turn around and look . . . towards the east part of the world. A voice spoke to me as plain as day but inward and said, "I am a time-God working after the counsel of my own will. In due time I will bring all things to you. Remember and cause your heart to sing."
(Rawick 1972, vol. 19, 20)

God, then, works in his own time. But through faith and revelation one can attune one's own timetable for living to God's.

4.1
Bennie Lusane, of northwest Georgia, alludes to African-American burial practices by enclosing a water faucet in his yard with a piece of white marble and clock faces. The white pipe is also a traditional grave marker.

Achieving attunement with God's time and God's will is a major preoccupation for some of the African Americans who work in, dress, or decorate their homes and yards, using recycled, handmade, and store-bought materials. It is not uncommon for elders to assume responsibility for marking time, keeping track of time in preparation for the last days, as prophesied in Revelations and Matthew 24:42–4: "Watch therefore, for ye know neither the day nor the hour wherein the Son of man cometh."

Working in this tradition, Z. B. Armstrong of Thomson, Georgia, earned a following as an artist for the sculptures he built from recycled materials painted with clock faces and timelines. These devices helped Mr. Armstrong to calibrate the relationship between the here-and-now and the unknown moment of the Apocalypse (McWillie 1990). The interplay of linear and cyclical conceptualizations of time also informs James Hampton's masterpiece, composed with recycled materials, *The Throne of the Third Heaven of the Nations Millennium General Assembly* (Gould 1987, 47–57).

The Reverend George Kornegay, a retired Methodist minister, covered the hillside around his home in Alabama with elaborate constructions made from recycled appliances, sheet metal, wheels, bottles, and stones. The overall design of the yard consists of areas that stand for the holy mountains of the Bible: Ararat, Carmel, Sinai, Calvary, etc. On the approach to Mt. Zion, site of the city of God, Mr. Kornegay chained a mirror and clocks inside a gateway so that visitors could see the faces they would show God if called to judgment at that moment.

All these works of art address overlapping themes – vision, time, clocks, cycles, history, and Revelations – that also recur in African diaspora spiritual practice in other expressive media, including music and oratory. The Reverend C. L. Franklin's famous sermon, "Watchman, What of the Night?" weaves together biblical and black folk imagery.

Isaiah . . . stood upon the lofty wall of vision, and in vision he heard the cry of frustration, the cry of oppression . . . and that cry was an inquiring cry: "Watchman, what of the night? What of the times? What time of history is this? What time of trouble is this?" For after all, history is God's big clock. For a day is but a thousand years in terms of eternity. (I wish somebody here would pray with me.) . . .

And so, . . . we inquire to the men of vision, . . . "Watchman, what of the night?" (Franklin 1989, 166–7) Phrases like "the lofty wall of vision" lend themselves to concrete form (plate 4.2). Reverend Kornegay built just such a wall for his yard-show, using *television* sets flanked on one side by silver and gold Horses of the Apocalypse (recycled rocking horses), and on the other by a white fan. Fans inscribe cycles and spirals in motion as they focus and direct the wind, the breath of God.

In African-American tradition the role of Watchman appears to be primarily a male responsibility; men of

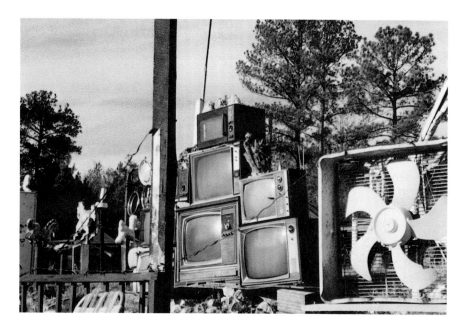

4.2
This "TV Motel," a lofty wall of (tele)vision(s), was built by the Reverend George Kornegay for the yard-show of his Alabama home. He explained that the chunks of slag on top of the TVs show signs of melting and thus are reminders of how the Creator shaped the world.

vision grapple with the question "Where in history are we?" Given their history, this question is a profound one for black Americans as much for judicial, economic, and political as for spiritual reasons. Historian Mechal Sobel has pointed out that although many enslaved people reckoned time in the African way, according to the cycle of the seasons and major events, they resented the fact that whites recorded black births and deaths, thus "'stealing' their birthdates as well as their birthrights." (Sobel 1987, 16) Timekeeping is a way to take charge of one's destiny, and timekeepers – *Watch* Men – do so not just as spiritual leaders but with a down-to-earth concern for justice in this world.[5]

John Martin, enslaved in Washington County, Mississippi, may well have been such a Watch Man, but if so his mission passed unrecognized by the white visitor to the plantation who wrote the following memoir:

He was plantation blacksmith and peg-leg carpenter during the day, but at night he turned his attention to efforts to discover perpetual motion. . . . All kinds of absurd machines sat about the blacksmith shop made of discarded pieces of iron and with them John would tinker until the small hours of the morning, hoping at any moment to discover the everlasting movement.

Defunct clocks interested this strange man and he would take them to pieces but was never able to get all the wheels back. The poor old clocks would run at ridiculous speed, but John, unperturbed, said they were all right. . . .

Along with John Martin's childish mistakes, there was a strange taste for good pictures. His cabin walls were hung with newspaper copies of paintings by the masters. There was not a trashy picture among them, and if asked why he liked them, he would answer, "I don't know. When I'm 'sleep I knows why, but when I wakes up, I done forgot." (Rawick 1977, supp. ser. 1, vol. 9, 1445–7)

A precursor of contemporary artists who work with recycled materials, John Martin explored the nature of time, technology, and motion during his meager spare time. Indeed, the results of Martin's labors may have resembled the clockwork, wind-driven machines of Harvey Low, a retired tenant farmer in the Mississippi Delta. Whirling and brightly colored, these

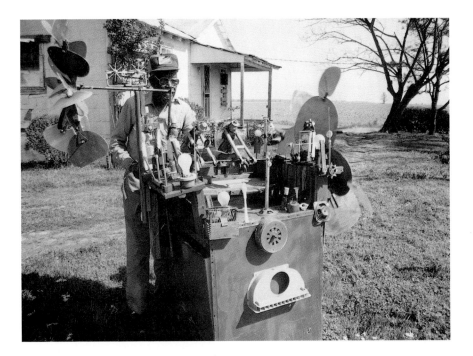

devices attracted many visitors to Mr. Low's home. Mr. Low did not own his own property; therefore, his "yard-show" was a miniaturized and portable version of what a homeowner might do on a larger scale (plate 4.3).

Because black people in the United States have historically had little say in the emergence of art institutions and market combines, it is not surprising that important genres of African-American art have taken shape in personal and domestic spaces like homes and yards. Yard-shows result when work in the yard is aesthetically replete and pitched at a high level of visibility. But such yard-shows build on a foundation of more widespread and low-key practices: "decorating" homes and burial places, "setting" fields and gardens against thieves with medicated objects like bottle-traps, and "dressing" thresholds and boundaries against intruders. Effective devices for these purposes include enclosures made from white substances such as kaolin, salt, pebbles, shells, and lime, and emblems of protective sight like the color blue, mirrors, the all-seeing eye, and television sets.[6]

Viewing yards in isolation masks their cultural foundation and casts recycled objects, like Mr. Kornegay's wall of televisions, adrift as little more than idiosyncratic, exuberant play with castoffs.

4.3
Harvey Low built this time-and-wind machine from recycled clocks and fans. In good weather he wheeled it into his front yard in the Mississippi Delta.

However, documentation indicates that recycled materials have been part of yard work at both high and low levels of visibility for at least 100 years. Interviewers searching for African survivals near Savannah, Georgia, during the Great Depression found protective plantings and charms with African antecedents. They described George Boddison of Tin City wearing a flashing crown of charms and mirrors resembling a portable bottle tree upon his head.[7] The interviewers also observed houses enclosed behind protective fences built from automobile parts, pipes, signboards, bedsprings, and scrap iron. We cannot know exactly what the makers of these yards had in mind, but we certainly can find comparable works today, for example, the tied and wrapped fence of Ruby Gilmore in Mississippi.

4.4
Materials salvaged by recycler Ruby Gilmore of Hattiesburg, Mississippi, filled her yard in November 1989. In 1991, after city officials ordered the yard cleared, Mrs. Gilmore began to store her finds behind curtains in her carport.

Mrs. Gilmore recycles as a business, setting out in her car at 4 A.M. along the routes that city garbage trucks will follow later in the day. By ten o'clock she has completed her round and unloaded the contents of a sagging car into her front yard, where she sorts aluminum cans, glass, and plastic to sell by noon at the local recycling center. On a good day she makes about three dollars. Social security and a small pension provide Mrs. Gilmore, who is in her early seventies, with enough money to live decently, if not extravagantly. But this income would not stretch to pay off the large medical bill that her grandson incurred shortly before his death. Mrs. Gilmore recycles at least partly to earn money to pay off this debt, but even without it she would probably still work. As she explained, "I've worked hard all my life. If I stopped I'd probably die."

When I first met Mrs. Gilmore her yard was completely filled with lumber, clothing, and tools (plate 4.4). About a year later a city crew stripped the yard of Mrs. Gilmore's savings and bulldozed it down to bare earth. Yet, within weeks, Mrs. Gilmore was back at work, though she now placed her newfound belongings behind curtains in her carport.

Mrs. Gilmore's major worry – and her impetus toward artistry – is fear of thieves, especially on Sundays while she attends church. She dressed her yard as a warning to intruders, twining extra layers of wire on her fence, placing a "watchdog" (a recycled Snoopy) on the carport roof, and constructing a "posted" sign on a blue-and-white-striped post. The sign reads "Post Ples Keep Out." The cross-sword on the post delivers the silent message "God sees you, so take this message seriously." A clock dial, formerly a spinner for a child's toy, underscores this message with a reminder similar to that of Mr. Kornegay's mirror, that "ye know neither the day nor the hour. . . ." It would be mortifying indeed to be interrupted by the Second Coming of Christ while stealing from the yard of an elderly widow.

Mrs. Gilmore and others like her have endured considerable hardship. But, given the coherence and persistence of African-American yard work, it still seems unwise to follow earlier researchers in treating the phenomenon of using recycled materials simply as a response to poverty. Poverty has been a fact of

life for too many African Americans; however, it cannot explain the presence of recycled materials in the yards of relatively affluent homeowners.

Sam Hogue is a retired plant foreman who enhanced his yard with variations on the themes of motion, encirclement, and enclosure. He wrapped two trees in his front yard in bright, white fabric and attached pinwheels to the trunks. Behind the house a fenced circle of statuary commemorates Mr. Hogue's late wife (plate 4.5). Several wind-catchers fashioned from recycled soda bottles and bicycle wheels spin on tall poles, pulling the gaze of visitors up so that the sky itself becomes part of the design of the yard. Purchased, recycled, and natural materials all contribute to the beauty of the yard as a whole.

In African America, as in Africa, the importance of family entwines with the spiritual and philosophical bases of existence. In the United States, making a homeplace for the family has meant making a secure place for one's past and one's ancestral memory, as well as for one's children. Although African Americans have long recognized themselves as Americans with rights and roots in this land, until recently the nation's power structure, including the legal system, has not. Slavery, Jim Crow, urban renewal programs, and all the myriad obstacles of racism have ensured that owning property and securing a home have not been easy tasks.

Gyp Packnett managed to buy land, build a house, and hold together a family in the troubled time and place made famous in Anne Moody's autobiography, *Coming of Age in Mississippi*. A retired widower whose adult children have spread across the state, Mr. Packnett now spends much of his time gardening. He lives alone with no one else to eat what he grows, yet gardening sustains Mr. Packnett's belief in the importance of tending to the earth itself.

At one corner of the garden plot in front of the house a huge cedar looms over the driveway. Mr. Packnett calls this his "Family Tree," and in its shade, facing the street, he has arranged an unusual group of chairs (plate 4.6). Clearly, the chairs aren't meant for sitting, because one seems to be in flight (it's really tied to the fence), another stands on top of a table, and the others rest on tires in such a way that they would tip would-be sitters to the ground. On

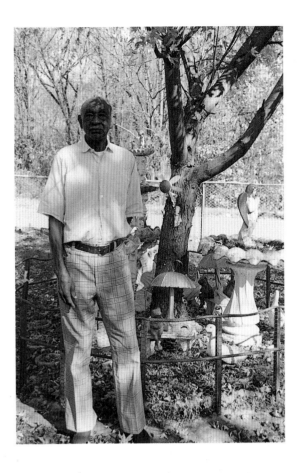

4.5
Sam Hogue, an east Tennessean, arranged this circle of statuary around a tree in his backyard as a memorial to his wife.

4.6
Gyp Packnett calls this cedar his "Family Tree." He mounted an airborne chair and wheels on the fence beside it. Special seats inside the fence suggest the Last Judgment and the enthronement of Mr. Packnett's ancestors in heaven.

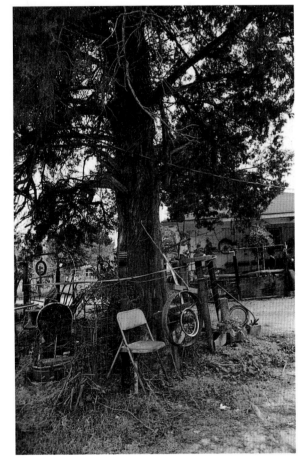

the gate to this plot Mr. Packnett mounted a wheel, which he identified as the rising/setting sun. It transforms the enclosed area from a mere vegetable bed to a model of the other world (Thompson 1993, 95).[8] In effect, the family tree is an *axis mundi* that joins earth to sky in commemoration of Mr. Packnett's ancestors. The seats on wheels surround the seat of judgment, the high seat, the throne of God. Like Mr. Kornegay and Mrs. Gilmore, Mr. Packnett has his own reasons for reminding passersby of the Last Days.

Material representations of philosophical principles in the form of the seat of judgment, God's clock, and the cycle of time serve as reminders that in due time the "chickens will all come home to roost" and injustice will rebound upon the unjust. Principles like this help to ground group identity as they fortify individuals for the challenges of life, death, and personal renewal in difficult times.

4.7
Olivia Humphrey arranged these tricycles and bicycles to show that her household is "rolling": going strong and taking trouble in stride.

The translation of philosophical principles into material form involves a flexible repertoire of puns, homonyms, material signifying, and double entendres. For example, in some yards the phrase "God's will" takes form in "God's wheel" or wheels, often elevated on a pole or tree; the words "will" and "wheel" sound much alike when spoken with a southern accent. Elevated wheels can also allude to the biblical wheel Ezekiel saw in the air and to the prayer wheel, subject of a much-recorded gospel song. In a similar way, "watchman" (guard, lookout) connects to Watch Man (timekeeper) and to objects like clocks and pocket watches. Mrs. Olivia Humphrey showed that her household was "rolling" (going strong and taking trouble in stride) by lining one side of the house with tricycles and bicycles (plate 4.7). Mr. Kornegay's wall of TV sets creates linkages between the word "television," the vacant screen/eye of the picture tube, and other forms of vision, including visionary experience. Because televisions are receivers that create a visible image from unseen signals, they are apt material metaphors for communication with spiritual powers.

Parallels between states of being of things and of souls offer richly varied expressive possibilities. For example, it's possible that Mr. Packnett viewed his enslaved ancestors as "tired" before their souls rose to sit with God. An Alabama homeowner, Edward Houston, played on the homonym sole/soul when he positioned shoe soles walking up a tree in his yard, as if ascending toward heaven.

The surrealist and anthropologist Michel Leiris wrote an especially clear account of this kind of association in his investigation of the use of Roman Catholic religious prints by practitioners of Vodou in Haiti: *Often the connection between* loa *[Vodou spirit] and saint is established because of some purely circumstantial detail and through what might be called a pun, not on words but on objects (as, for example, the lowered visor of the helmet identified as the chincloth of corpse). In order to establish such a connection, there need not exist an analogy in the content of the symbol: a superficial resemblance, fragmentary and generally accidental, seems to suffice in most cases.* (Leiris 1960, 91–2) Note that Leiris stressed the tenuousness of the iden-

tification between Catholic saints and Vodou *lwa (loa)*, which involved chance resemblances more often than fixed symbolic content. Usually only one or two details in an image served as a pivot between the worlds of Catholicism and Vodou. Yet this tenuousness actually strengthened Vodou by ensuring flexibility; if merchants ran out of one chromolithograph, another image would do.

Recycled materials have similar flexible potential. In African-American yard work they permit profound meanings to recycle through virtually whatever comes to hand. By creating new configurations out of formerly divergent components, the makers of yards establish networks of associations between objects and ideas, cuing and channeling interpretations without closing down alternative readings.

One such network of associations is, logically, the grave, the burial mound. A commonplace of recycling as a mode of expression is that objects that have "died" through being discarded are "reborn" when put to new uses. If not universal, this reasoning certainly crosses many ethnic and regional boundaries. However, although it figures in the story of recycled objects in African-American yards, it should not be allowed to obscure culturally specific associations between broken or discarded objects and the grave. These associations occur in Africa as well as the diaspora. As the anthropologist Wyatt MacGaffey points out: "Throughout West and Central Africa the rubbish heap is a metaphor for the grave, a point of contact with the world of the dead." (MacGaffey 1977, 148)

Burials are the primary conduit for recycling ancestral roots through the present and on into the heritage of the next generation. Ancestor status in West and Central Africa and the diaspora is a process as much as a state of being. As recent memory of the deceased individual fades into the generalized memory of dead forebears, the distinctness of the deceased's persona diffuses gradually into the world of souls on the other side of the water, the other side of the mirror. In the tradition of grave decoration in the African diaspora a flexible roster of material analogues – mirrors, silvery materials, whiteness, water imagery, pipe conduits, and broken vessels – bears witness to this process.[9] Ernest Ingersoll, in a frequently quoted arti-

cle, described African-American grave decoration in the late nineteenth century near Columbia, South Carolina:

When a negro dies, some article or utensil, or more than one, is thrown upon his grave; moreover it is broken . . . nearly every grave has bordering or thrown upon it a few bleached seashells. . . . Mingled with these is a most curious collection of broken crockery and glassware. On the large graves are laid broken pitchers, soap dishes, lamp chimneys, tureens, coffee cups, sirup [sic] jugs, all sorts of ornamental vases, . . . teapots, . . . plaster images, . . . glass lamps and tumblers in great number. . . . (Ingersoll 1892, 69)

Breaking objects, particularly the objects last used by the dead, was said by Africans to release the residue of the spirit of the dead from the object but, according to black southerners interviewed early in the twentieth century, was simply an old custom (Puckett 1926, 105–6). A similar motif appears in commercially produced "broken wheel" grave decorations made of Styrofoam.[10]

Breaking a vessel lets the spirit out, but in Afro-American and Caribbean performance the term "break" also relates to the point at which the spirit *enters*. In secular performance, spirit amounts to that extra something that manifests at the height of personal virtuosity; for example, in the winning moves of a break dancer competing within a circle of peers. In sacred performance like Vodou dance, cross-rhythm drumming creates a break, a kind of aural moiré effect, that marks the onset of spirit possession.[11] The break, then, is the moment when order intersects randomness and powers that are literally "out of sight" enter the performance space.

If we look across a spectrum of black expressive activity it becomes easier to appreciate how breakage links "junk" in the form of broken, discarded, and use-worn objects to the notion of circulation between material and spiritual worlds. For example, many systems of divination involve shaking and randomly distributing objects like cowries or bones. This creates a rift between past and future orders, an interstice of static in which the powers the diviner invokes can make their wishes known, directing the cowries or bones to fall into a certain, coded pattern.[12] Many African-American graves are decorated in a formal,

4.8
Gyp Packnett composed this
tribute to his late wife for
his carport. Under a spray of
roses twin mirrors are thresh-
olds to the other world and
the empty seat welcomes an
unseen presence. The childlike
doll suggests rebirth; the
shoes recall the words of a
spiritual: in heaven all God's
children have shoes.

regimented style. But where breakage occurs on
burials it also interjects a degree of randomness, dis-
rupting expectations that have been shaped by the
objects' ordinary functions and contexts of use.

According to Robert Farris Thompson, on Kongo
graves broken vessels serve as reminders that broken
objects become whole again in the other world
(Thompson and Cornet 1981, 179). But to cultural
outsiders here in the United States, broken china
and pottery merely suggest abandonment, trash, or
junk, not renewal. This impression is not entirely
misleading. For oppressed African Americans unpre-
possessing surface appearances may have been – and
may still be – a mode of protection, ensuring that
those who should not see certain things will be unable
to see even what is right under their noses, in part
because of their own biases. Further, secrecy is an
important aspect of many forms of spiritual and per-
sonal knowledge. During fieldwork I found that
commemorative areas containing objects similar to
grave decorations figured in numerous yards and that
almost without exception makers used the words
"junk" and "antique" to refer to them. Given the seri-
ousness of commemorative practices, reticence seemed
appropriate, but it also varied depending on my rela-
tionship with the maker. The functions and meanings
of commemorative areas and objects also varied widely,
depending on context and the makers' intentions.

Gyp Packnett's memorial to his late wife is one of
the most moving works of art I have ever seen (plate
4.8). It combines older African-American references
to burial – mirrors, a doll (an emblem of the soul),
and an empty seat – with contemporary elements, such
as sprays of artificial roses. The chair Mr. Packnett
relaxes in is close by. Thus he and his wife continue
to sit together in spirit, as they did in a half century
of marriage.

The practice of creating memorials and miniature
burials in yards and home interiors dates back at
least as long as black people have controlled their liv-
ing space. For example, in 1912, the novelist Effie
Graham published a purportedly fictional account of
the yard of a woman who had been born into slavery
on a plantation in Tennessee, then moved to Kansas
during Reconstruction. Note the variety of recycled
materials in the following passage:

The first impression on viewing [the yard] was that of a half-pleasing, half-offending jumble of greenery and gleaming color; of bush and vine; of vegetable and blooming flower; of kitchen ware, crockery, and defunct household furniture. A marvelous mixture it was, of African jungle, city park, and town dump. . . .

One noted . . . the unique receptacles for growing plants. Modern florists trust their treasures to the tender bosom of Mother Earth; not so Aunt June. She elevated her darlings in every conceivable manner. Marigolds bloomed in butter kits, and geraniums in punctured "deeshpans." Easter lilies were upheld by insolent punch-bowls, and johnny jump-ups were ensconced in baby buggies. . . .

The account goes on to associate the baby buggy and the white flowers growing in it with the memory of a particular dead child. Graham also described objects that together invoke the dead and their protective powers in a more general way:

Easily the most conspicuous thing in the yard, and one highly prized by Aunt June, was a mound near the gate. Here, on a rounded pile of earth, was displayed such a collection of broken chinaware and glittering, bright colored glass as has not greeted your eyes since you looked last on your old playhouse. . . . (Graham 1912, 24–6)

Graham, the white observer, obviously had a good eye for physical detail, but she seems completely unaware of the implications of what she recorded. The entire mound replicates a traditional grave; indeed, all of the objects Graham mentions in the yard can also be found in black graveyards, especially in rural areas where burials tend to remain undisturbed by lawnmowers.

The grave, then, is a break point in linear time, and a nexus in the continual cycling of life into death, flesh into spirit. A replica grave materially enacts the cycle of the cosmos by making a home for ancestors and remembered loved ones in the yard, and by establishing a threshold between worlds on the grounds of the homeplace. Living near such a grave is an assertion of rootedness that puts the moral force of the ancestors at one's back as one faces a dangerous world.

Yet, although recycled objects are key elements in actual grave decorations and yard commemorations, by no means do all recycled objects in African-American yards refer to burials. Rather, the principle of eternal renewal that informs burial traditions most forcefully also projects significance onto recycled objects used for other purposes. Junk is the emergent stuff of rebirth. As Alabama sculptor Charlie Lucas said (Lampell and Lampell 1989, 220), from his rural yard where wire and old car parts rise into monumental dinosaurs and guardian figures,

It's just castoff stuff people throw away. Like people who've been cast off, and everybody thinks they're worth nothing. I've been there. Beat up, broken, down at the bottom. But I had this dream in my head, and that made me more than a piece of junk.

The Ironies of System D

Allen F. Roberts

During a brief trip to Dakar, Senegal, to collect examples of recycled goods and develop a story line for a video production to accompany this book and its exhibition, Charlene Cerny and I visited a street of workshops near Sandaga market.[1] Carpenters were building trunks, briefcases, and other recycled wares from industrially produced scrap-metal sheeting, while other men stood about in front of their colorful displays, at the ready for customers. One of the latter young men with whom I chatted commented that in recycling, he and his colleagues work according to "System D," French slang that takes on a particularly poignant irony in its west African usage.

The "D" of this expression comes from the common exhortation *Débrouille-toi!*, from a reflexive verb which means literally "to disentangle or unravel" and figuratively "to clear up, disengage oneself, or manage."[2] A *débrouillard* is a clever soul who, with little at hand, gets along against the odds; and *Débrouille-toi!* means "Make a go of it!" "Be resourceful!" or sometimes, with more of an edge to it, "Figure it out yourself!"

A serious twist to System D in Africa is the frequency with which the majority of people are *obliged* to "manage" because salaries are not paid on time or at all, supplies run out, parts cannot be found, credit is unavailable, politics prove unstable, the weather goes haywire, and calamity strikes – as it did shortly before our visit to Dakar, when the Senegalese currency was suddenly devalued 100 percent. System D is often less a choice, then, than a necessity. And yet people in Africa do not lead mean and meaningless lives, for through the creative brilliance that *is* System D, more often than not they manage to find fulfillment and preserve their dignity, despite what

might seem from the outside to be overwhelmingly difficult circumstances. Indeed, *débrouillardise* – the ability to make do – is so essential that in some African quarters, it is felt to be divinely inspired. It is the creative courage of System D that will be celebrated here.

The young man in Dakar added that through System D, "we do things contrary to their [original] sense." His phrase, *au sens contraire,* is usually translated as "backwards," but in the young man's usage, the expression does not have the pejorative connotation that word often has, especially as it is applied to less developed countries. Rather, there is an implication of a "logic of the 'inside out'. . . of the 'turnabout,' of a continual shifting from top to bottom, from front to rear, of numerous parodies and travesties" that suggests the potential to defy established meaning (Bakhtin 1984, 11, 123).

With similar acuity, a man whom I met in Bénin later in the same trip described recycling as a *détournement,* a word derived from a French verb meaning "to change the direction of" something.

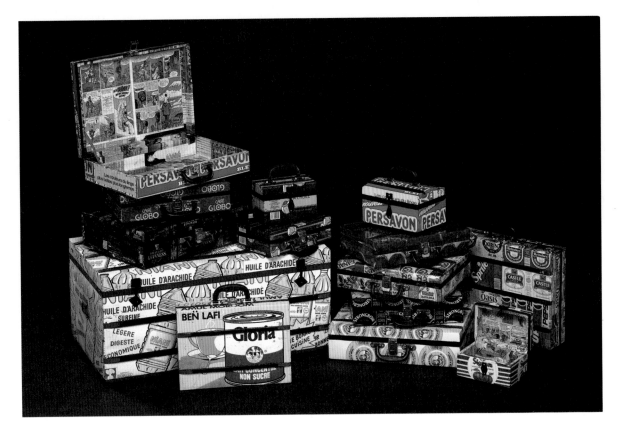

5.1
Group of Carrying Cases.
Assane Faye or N'Diamboye Ba, Dakar, Senegal. 1980–94. Misprinted sheet metal, scrap wood, manufactured hardware, newspaper. Large trunk (by N'Diamboye Ba) H 13 1/2 x W 30 3/4 x D 18 1/2" (34.2 x 78.1 x 46.9 cm). International Folk Art Foundation Collection, Museum of International Folk Art, Santa Fe.

Recycling carpenters in Dakar purchase misprinted sheet metal from a local canning factory to make trunks, briefcases, jewelry boxes, and lunch boxes. Each case capitalizes on the vivid colors and dramatic commercial designs of tins and cans for locally produced tuna fish, tomato sauce, insecticide, and assorted beverages.

Although *détournement* may be used literally in a variety of settings, in French-speaking Africa the expression almost always implies misappropriation or embezzlement (Adande 1992, 17). In developing countries where money is so extremely scarce, people are forever being victimized by those who find a way to "change the direction of" their hard-won finances for illicit personal gain. Like bribery, embezzlement is so common that people often seem to accept it as an aspect of life as they know it, but when they do, they do so with ironic wit (see Roberts 1986). Parallel and informal economies thrive in such circumstances, as does System D recycling, for it is here – and only here – that many of the basic commodities necessary to low-income households are produced (King 1977; Kasfir 1992).

As a *détournement*, recycling is a subversive diversion, a devious turning away from or inversion of what is expected (cf. Appadurai 1990, 16). In a related manner, another man in Dakar described his own recycling activities as "cheating" (*tricher* in French). When "we do things contrary to their [original] sense," as the first young man had said, meaning is upended. The ironies of System D are always a by-product of recycling in Africa. Irony has been the focus of expressive movements in the West, too. In particular, Surrealism has produced positions, texts, objects, and events that have surprising resonance with System D in contemporary Africa, and help us to better understand its very particular forms of creativity.

Chance Encounters, Ironic Collage

In his seminal essay "On Ethnographic Surrealism" (1988), James Clifford notes historical associations and a common intellectual ground between Surrealist artists and certain French ethnographers in the period between the World Wars (Roberts 1992). This was a time when dismay and disgust with the "barbarism and . . . manifest bankruptcy of the ideology of progress" that had brought the West so arrogantly into war led many to question the most fundamental assumptions of Western society. Literature was dizzied with "sensual derangements"; music and visual arts contributed to the "instability of appearances" through "aggressive incongruity"; and beauty could be characterized, in the well-known words of the

nineteenth-century poet Lautréamont, as a "chance encounter on a dissecting table of a sewing machine and an umbrella."[3]

Marcel Griaule was one of the "Surrealist ethnographers" who sought to develop a perspective that would value "fragments, curious collections, [and] unexpected juxtapositions" so as to "provoke manifestations of extraordinary realities" (Clifford 1988, 118).[4] Griaule wrote in 1930, with some exasperation, *Ethnography – it is quite tiresome to have to keep repeating this – is interested in the beautiful and the ugly, in the European sense of these absurd words. It has, however, a tendency to be suspicious of the beautiful, which is a rather rare – that is monstrous – occurrence in a civilization. Ethnography is suspicious too of itself – for it is a white science, i.e., stained with prejudices – and it will not refuse aesthetic value to an object because it is up-to-date or mass-produced.* (Cited in Clifford 1988, 131, original emphasis)

Griaule's suspicion of established authority and "meaning," and his willingness to recognize the absurdity of taken-for-granted categories and stances, assumptions, and conventions, were hallmarks of Surrealism. A similarly skeptical position has reemerged in Western postmodernist art and ethnography in our current "period of political and epistemological reevaluation in which the constructed, imposed nature of representational authority has become unusually visible and contested." (Clifford 1986, 100; Rabinow 1986, 249–50) It is the ideological motivation of the so-called Surrealist ethnographers, as opposed to those of their postmodern aftermath, that provides such an intriguing conceptual parallel to the System D of African recycling.

Let us consider the prescient passage from Griaule a bit more closely. Griaule was specifically reacting to French collectors of African art who scorned objects that they felt to be sullied by reference to the West, and so who, for instance, might "doubt the purity of a Baulé drum because the figure carved on it is holding a rifle." (Clifford 1988, 131) As Clifford writes in Griaule's voice, "If Africans choose not to imitate our high-cultural products, *tant pis!*"[5] "Too bad!" is right, but one can also turn around the focus of such an argument to consider what African artists like the Baulé drum maker may have been doing at the time

of Griaule's writing, as they are now, to use their creative talents to cope with changing circumstances of political economy. I would assert that in keeping the references of his art current, the Baulé drum maker demonstrated an ability to question definitions of worth and beauty and to juxtapose odd bits and pieces of both earlier and contemporary experience – an ability that Surrealists and postmodernists have found so vital to their respective enterprises.

A final dimension of Griaule's critique may be discerned. One can speculate that in co-opting the rifle as a potent symbol of European power, the Baulé artist was also engaging in "mimetic competition"[6] with French colonial authorities, and so making the sort of political statement that might well rankle a European art collector of the period. In other words, Western appropriation of Africa is one thing, African appropriation of the West quite another. As Bogumil Jewsiewicki has suggested,

we have obscured the invention of a West in the African imagination . . . [because] the West resists appropriation by other cultures; it has never agreed that cultural exchange goes in both directions. . . . [Yet] this invention has been at work in . . . Africa for a century. Cultural intermediaries have cannibalized the West without losing their identity . . . integrating the West into their construction of a world vision. (Jewsiewicki 1991, 139)

From this point of view, the Baulé artist may have been acting in defiance of Western hegemony. Indeed, his resistance to colonial effacement is characteristic of the *culture-building* of System D recycling in Africa today.

Culture-Building in Africa

In the last few years, art historians and anthropologists have sought to mitigate static views of contemporary African culture by demonstrating the context-specific, "processual" nature of expression, as the late Victor Turner used that term to forward a dynamic interaction with social process (Turner 1967).[7] As African artists like the Baulé drum maker seek new audiences and avenues in today's world economy, they must adapt older forms to meet new needs, or adopt and invent new objects altogether. This "culture-building," to borrow Robert Blauner's useful phrase, is a "pro-

cess . . . developing in adaptation to, and in protest against, the social experiences of the colonial situation [that] can be discerned in the group lives of most if not all culturally exploited peoples." (Discussed in Caulfield 1972, 202)[8] By no means have either the stifling effects of cultural exploitation or the resiliency of culture-building been confined to the colonial period of African history. System D is often the form such adaptation takes in contemporary Africa.

Recycling is a common form of culture-building that must be defined in the context of African political economy. In Africa, broken or worn-out objects are often transformed from purposes associated with the socioeconomic class of their first possessors, to other uses deemed more appropriate to the needs of the vast majority of people who cannot afford the luxuries enjoyed by the original owners. Objects may have a number of "lives" in this way, or, to be truer to the social processes the metaphor implies, ideas and objects can have several "careers" through the course of their "lives." (Appadurai 1990, Kopytoff 1990, M. Roberts 1994) Examples range from buckets made from tire tubes, open-wick kerosene lamps from burned-out lightbulbs, and woodstoves from defunct refrigerators.[9]

Expressive forms such as these result from bricolage, as Claude Lévi-Strauss would characterize it, a term now used so often that it has become a cliché. If one considers Lévi-Strauss's early explanation of the word, however, an oft-ignored yet relevant dimension is revealed:

In its old sense the [French] verb bricoler *applied to ball games and billiards, to hunting, shooting, and riding. It was . . . always used with reference to some extraneous movement: a ball rebounding, a dog straying or a horse swerving from its direct course to avoid an obstacle. And in our time the* bricoleur *is still someone who works with his hands and uses devious means.* (Lévi-Strauss 1966, 16)

The *bricoleur* is "devious," not as the word is sometimes used in English to connote underhandedness, but in positive reference to his or her ability and willingness to deviate from usual or "proper" – that is, conventional – courses as defined by sociohistorical circumstance. Such deviousness is precisely what recyclers in Dakar refer to as the "cheating" that is System D.

Important here is the fortuitous nature of culture-building – that is, the chance encounters that intrigued the Surrealists and which now empower African recyclers. In Africa, System D recycling depends upon recognition of potential in such unexpected opportunities. As the young man in Bénin had it, African *bricoleurs* engaged in recycling do things through *détournements* that are "contrary to their [original] sense." Such recognition takes us a step beyond where Lévi-Strauss has left his own point, however. For him, the elements of bricolage "are not raw materials but wrought products. . . . They are therefore condensed expressions of necessary relations." (Lévi-Strauss, 36) Yet if a *bricoleur* produces a "fortuitous or ironic collage" through which "the proper arrangement of cultural symbols and artifacts is constantly placed in doubt" (Clifford 1988, 132), it is precisely because the juxtaposition of such symbols and artifacts makes obvious the degree to which the "necessary relations" implied by the original object are proven not to be so necessary after all.

5.2
Wholesalers in Dakar export truckloads of these trunks to rural towns and villages throughout Senegal.

System D allows African recyclers to defy established meaning. There is a certain "victory" in the transformations of recycling, as Lisette Petit has suggested, for "the reinvented object bears a breath of contestation (a 'no' to waste, to overconsumption, [and] to the unacceptably unequal distribution of goods), but this is a nonviolent, even humorous kind of contestation." (Petit 1994, 82) While it may be said that resistance to original meanings and purposes is achieved through the ironies of System D, we must avoid romanticizing what is nonetheless a life-and-death enterprise. I would contend that in the difficult circumstances of contemporary Africa, the contestation implied by the turnabouts of System D has a hard political edge to it that, all too often, is only a short step away from desperation.

It is through the bricolage inherent in System D that contemporary African culture-builders, like Surrealists before them, play on the "aggressive incongruities" of modern life. However, there is a final irony to the expression "System D" that is relevant here; if one is to "make a go of it" *(se débrouiller)* through devious diversions of original definitions and purposes, there can be nothing systematic about "System" D. Instead, meaning is in flux; for, as Denis Hollier (1989) might remark, "meaning exists only at risk. It is never fixed, never arrested. There are no guarantees. Meaning is uninsured. Not covered." As suggested by the following case studies of System D in Senegal and Bénin, a tense mix of triumph and insecurity must result.

System D in Dakar

System D may thrive in the informal sectors of all African cities, but because of geographical and political factors, Dakar stands out as a special center for such creative activity. As the westernmost point of the African continent, Dakar has long been an important port and hub of economic activity. Its harbor serves as the first major entry point for European sea trade, and the old fortress of Gorée Island, lying just offshore, stands in mute testimony to the convenience of assembling African slaves there for the dreadful middle passage to the Americas. Since those terrible times, many thousands of French, Lebanese,

African-American, and other expatriates have settled in Dakar, making it an "African Marseilles." (R. Cruise O'Brien 1972) Growing links to New York and a burgeoning Senegalese middle class make the city one of Africa's most dynamic and cosmopolitan.

Financial institutions and factories have long been established in Dakar, where products can be assembled or fabricated and distributed throughout what used to be French West Africa. A railway links Dakar with Bamako, capital of landlocked Mali; and from there, products can be transported by road and river far into the African interior. Making so many things for so many people produces exceptional quantities of detritus – the stuff of recycling.

While the rural-urban migration common to Africa has brought people to Dakar for more than a century, the pace accelerated after Senegalese independence in 1960; and over the past fifteen to twenty years, the city's population has ballooned as people have fled the drought, famine, and more gradually worsening farming conditions of the interior (D. Cruise O'Brien 1975, 1). The informal sector of the urban economy has grown apace, and in particular, recycling has become a significant activity for a great many young people (mostly men) new to the city. New needs and opportunities have been matched by new materials available for recycling, following the worldwide proliferation of consumer goods such as tinned foods and beverages.

Triumph in the Trunk Trade

N'Diaw Niang is a kindly man who moved from Tekel, a village near Saint-Louis in northwestern Senegal, to the Medina neighborhood of Dakar in 1939. Like his father before him, Mr. Niang is a cobbler, and his workshop is still on a street dominated by shoe-making, even though he and his apprentices have been engaged in different work for many years now. One day while he was walking through the neighborhood of Old Dakar, Mr. Niang happened upon a carpenter making trunks. As is still the case today, some trunks might be purchased by urban people to store their belongings, but more of them would be bought by rural people migrating to the cities for work, to fill with cloth and other luxury goods to carry back home to the remotest corners of Senegal.

As Mr. Niang watched, the man made a frame from scrap wood to which he glued the thick paper of emptied cement bags. Because he is a cobbler, Mr. Niang knows how to draw, especially as one traces the outline of a client's foot on a piece of scrap paper to determine correct size, and he quickly sketched the trunk being made by the man he was watching. Once home, he used his diagram to try his own hand at making a similar trunk. He sold it easily and has been making trunks ever since.

Although he has retired from active carpentry, Mr. Niang has taught "perhaps 100" of his sons, grandsons, and nephews how to make trunks from recycled materials, and they maintain a thriving workshop. One nephew, an articulate man in his forties, said that he moved to Dakar in 1962 and worked for eleven years in a chemistry laboratory, but when he lost that job, he began working in his uncle's workshop and he now prefers the congenial informality of such steady work. There are few jobs in Dakar, he said, and although some of Mr. Niang's eight children and many grandchildren are teachers

5.3
Second-generation recycler Assane Faye makes briefcases, jewelry boxes, and toys from recycled materials in his Dakar workshop.

or have other professions, they have all learned how to make trunks and can always return to work in the Niang workshop. As the nephew stated, "as long as there is recycled material, they can come and work here, for there is always work to do."

More than some trunk makers we observed, the Niang family opportunistically use whatever materials happen to be available at local scrap yards: over the frames of wood scavenged from pallets and other city sources, they nail the sides of flattened cans from motor oil and industrial glue, wood veneer, and, occasionally, thick cardboard from a local bottling plant (which Mr. Niang also resells to local cobblers to make inner soles). When it is available and he can afford it, Mr. Niang purchases offprint factory-milled metal sheeting from N'Diamboye Ba, as do all other trunk-making carpenters in Dakar.

N'Diamboye Ba grew up in the 1930s in what was then the French colony of Guinea. This was a time when there were few jobs in such rural places and the great attraction was Dakar, which was emerging as the economic capital of French West Africa. Mr. Ba's elder brother was the first of the family to move to Dakar, but being from a trader's family, he found himself without readily marketable skills. He began working as a carpenter's apprentice making wooden trunks and soon sent for his brother N'Diamboye, when it seemed there would be sufficient work for them both. The two young men began making trunks from the thick paper of recycled cement bags, tacked and glued to a wooden frame.

Over the years, trunk-making technology has evolved. At one point the trunk makers noticed that leather trunks from Morocco have an outside slat that protects the sides by allowing the trunk to rest on its slats rather than its surface. Such slats also strengthen the otherwise soft sides of the trunk, and so the Ba brothers adopted this innovation. As the economy of Senegal developed, cans and other containers, oil barrels, and corrugated roofing became more readily available as scrap, and these could be scavenged and used for trunk siding. When soft drinks, beer, and other beverages began to appear in cans, the Ba brothers and other carpenters began flattening these plentiful though smaller recycled cans as colorful sheeting for the sides of their trunks. By doing so,

they discovered a second market, as the chic irony of recycling – a lawyer's briefcase, say, made from discarded Heineken beer cans – brought new clients from resident expatriates and foreign tourists.

A significant technological breakthrough for Mr. Ba and other trunk makers occurred a few years ago because of a decision made by a French firm called Carnaud Metalbox: a factory in France that had manufactured tin cans for fifty years would be modernized using advanced technology. Labor costs in France could be reduced, efficiency improved. Still, there was nothing mechanically wrong with the old machinery, and so it was disassembled and shipped from France to the company's subsidiary in Dakar, where labor costs are far less and labor intensity is promoted rather than eschewed. The Senegalese factory could produce cans for locally produced tuna fish, tomato sauce, and the like, as well as for insecticide and other substances shipped in bulk to the port of Dakar, canned there, and then exported throughout west Africa.

Introduction of the new facility brought an added benefit to the informal sector of the local economy in Dakar, for no production line is perfect, and occasionally sheets of metal are rejected at quality control after becoming jammed in the machinery or because of misprinting, misapplied rust-proofing, or incorrect soldering. While tailings are compressed and bailed for shipping to Holland, where they can be melted and recast, it is far less expensive and more practical to sell the occasionally misprinted sheets to local recyclers than it is to store and then ship them back to Europe. Colorful sheeting from Carnaud Metalbox proved a boon to the trunk-making industry.

The advantages of using a single sheet of colorfully printed metal sheeting, instead of engaging in the labor-intensive tasks of collecting and processing recycled beverage cans, were immediately recognized by Mr. Ba and his colleagues. An initial problem of how to control access to the small supply of misprinted sheeting available at the Carnaud factory was solved by the factory director who chose Mr. Ba as sole purchaser. When a sufficient number of misprinted sheets has accumulated at the factory, they are trucked to a small warehouse that Mr. Ba maintains near his home and workshop. On such a day,

people line up to purchase the sheets, and Mr. Ba serves as the middleman supplier of Carnaud sheeting for all trunks, briefcases, and other containers made in Dakar.

Mr. Ba also maintains his own large workshop, where trunks and briefcases are made. He does not usually sell these at his workshop, but instead lets them out in small lots for sale at the "artisans' village" maintained by the Senegalese government for the tourist trade, or in urban markets for purchase by rural Senegalese (plate 5.2). Trunks are also sold wholesale to merchants who take them away by the truckload to sell in smaller towns throughout Senegal. Many apprentices have worked for Mr. Ba over the years, and others he has taught have hived off to form their own workshops like one just down the street, where huge piles of colorful trunks are displayed, awaiting purchase by wholesalers. Mr. Ba explained that he wants to acknowledge the assistance given to his brother and him when they first came to Dakar, and so now that the carpenters who helped them are old and retired, Mr. Ba trains their children as his apprentices.

Assane Faye (plate 5.3) purchases metal sheeting from Mr. Ba to make briefcases and toys. He also buys beverage and other cans collected by an old man he knows; these he cuts apart and makes into toy airplanes, boats, and cars. Mr. Faye prefers to use the sheeting, because it is more quickly and easily cut into requisite sizes. The colors of the tin sheeting (especially the red of tomato paste cans and the blue of a local brand of tuna fish) are especially vivid, and the repeated logos inspire creative design. Aluminum from cans is thinner and wrinkles, making a less "smooth" product; but some tourists prefer articles made from these cans for the added irony of brands they recognize. Because the majority of Mr. Faye's products are for the tourist trade, he always makes a few briefcases, jewelry cases, lunch boxes, and other containers from recycled cans. This is sometimes out of necessity rather than choice, because he cannot always afford to buy Mr. Ba's sheeting.

Mr. Faye is an innovator, and he claims to have been the first to make European-style briefcases from recycled materials.[10] Like other trunk makers, he lines his briefcases with the pages of scavenged maga-zines and newspapers. Whereas Mr. Ba's workers appear to use such paper randomly, Mr. Faye carefully selects and positions the visual materials to increase their appeal to Western eyes. Recently he was pleased to find multiple copies of a local comic book in which recycling was a subject, and he carefully composed the lining of several briefcases to emphasize this additional irony.

Most of Mr. Faye's wares are made for and purchased by expatriates and tourists. One notable exception are the toy boats that Mr. Faye makes (plate 5.4). Although tourists still may be the primary clientele for these, Muslim men purchase them as well. Most Senegalese are devout Muslims, and as an aspect of their assiduous worship, they wear and carry talismans locally known as *gree-grees*. These are leather packets bearing scraps of paper on which the praises for and words of God are written. Such Scriptures are considered "God's secrets, shaped in silence," that provide "a pathway to His immanence

5.4
Assane Faye's toy boats are popular with devout Muslim men who keep their holy amulets in them at night.

5.5

Doors to Faye Workshop. Assane Faye, Dakar, Senegal. H 49 3/4 x W 42 x D 2 1/4" (116.5 x 98.7 x 5.2 cm). Wood, paper, metal. International Folk Art Foundation Collection, Museum of International Folk Art, Santa Fe.

Assane Faye is a recycling innovator who claims to have been the first to make European-style briefcases from recycled materials. The doors of his workshop near the Sandaga market are a patchwork of recycled materials loosely nailed, tied, and leaned together. Mr. Faye says, "it is our duty to collect little things and try to make something out of them. . . . That is how it works."

and majesty." (Bravmann 1983, 37)[11] Such sacred texts must be kept unsullied by profane and polluting situations and activities, such as lovemaking. When such a man retires to his conjugal bed, he will remove his *gree-grees,* but then the question arises of where they should be placed. Toy boats like those made from recycled cans by Mr. Faye are one answer. Boats in seaside Dakar sail upon an ocean deemed the essence of God's purity. Placing one's holy words in such a boat, then, preserves them from pollution. Thus, Mr. Faye has discovered yet another market for his recycled wares. Such are the ways of culture-building.

Like other workshops on his street adjacent to Sandaga market, Mr. Faye's includes a display of wares for sale, as well as work space. His father founded the workshop, and the building itself is a patchwork of recycled materials, so loosely nailed, tied, and leaned together that the load of additional wood, iron, and other scrap perched on the roof threatens to crash down on Mr. Faye's head (plate 5.5). His designs attract a small but steady stream of expatriate customers, including several jobbers who resell his briefcases to the "ethnic chic" markets of Europe and the Americas. Mr. Faye is an affable man who speaks serviceable French; he possesses a sizable pile of business cards from his foreign clients, and he has made a card of his own, to advertise his products. Indeed, we were not the first researchers to study and film recycling activities on Mr. Faye's street: we were shown a videotape made by a Japanese visitor, and a scrapbook of photos assembled by a French reporter.

I asked Mr. Faye what the verb *se débrouiller* and the expression "System D" mean to him. He responded, *[T]he experience of an artist is to look and see if you can't make something that will give you something back [i.e., potential profit]. For instance, if I buy a can of soda, rather than popping open the top, I can open it with a slit in the side and sip the soda out, then sell the can as a bank for coins. This is [what it means to]* se débrouiller.

Sometimes we use plywood [for the sides of our briefcases], but old empty boxes bought from Lebanese merchants are cheaper and so we make do [se débrouiller] *and use them, because we don't always have money to buy plywood; but what is*

important is that once we have covered the wood, you won't see what we made the briefcase from, and sometimes we use cardboard if that is all we can afford, but we cover it and you won't see this is what we have done to manage [se débrouiller]. *It is our duty* [devoir] *to collect little things and try to make something out of them to have something to eat – that is what we do, that is* se débrouiller. *That is how it works.*

Mr. Faye and other recyclers live life on the economic edge, with little margin. The "cheating" implicit in System D (a term suggested by Mr. Faye himself) is doubly devious, for its subversion of meaning may include outright trickery: a seemingly solid briefcase may be made of covered cardboard. The exigencies of such a lifestyle are even more clearcut in the case of Bubakar Fané, whose workshop is located in a "junkyard" of Dakar called Colobane.

Prospering in Colobane

Bubakar Fané (who prefers the nickname "Carlos") is a blacksmith from Mali. He and his men make trunks from flattened oil barrels, corrugated roofing, and other scrap in a workshop he maintains in Colobane, a junkyard that sprawls for half a mile or more, adjacent to a railroad right-of-way and under a highway bridge (plate 5.6). "Junkyard" belies local people's sense of Colobane, for the term implies a

5.6
The junkyard of Colobane in the port city of Dakar, Senegal, is a place of intense creativity, as men invent new lives for discarded objects.

finality of uselessness. *Nothing* is useless at Colobane: the expectation is that, sooner or later, *everything* will find some new purpose. Nor is Colobane a place of squalor, nor its denizens pathetic. Rather, it is a place of industriousness, albeit where hard work is extended toward the point of absurdity.

Still, Colobane does defy easy description. It possesses astounding tactility – an explosion of shreds, shards, and shrapnel. It is everything sharp, all in one place, glinting under the fierce sun. Rust reigns. Tetanus lurks. STUFF is piled such that one must wend and weave through precarious pathways, threatened by a sense that the mountain *must* fall. Colobane is T. S. Eliot's "heap of broken images, where the sun beats, / And the dead tree gives no shelter."[12] Its visual overload is matched by deafening clanging and banging as men cut through steel with cold chisels. A distant echo to Colobane's cacophony exists in some contemporary Western installation art: its piles of scrap are sense, texture, and movement arrested.

Colobane is chaos on a thin leash. It is named for a Senegalese village famous for an incident of political resistance to French colonial conquest, and "the name has been given to this place because one must be very *résistant* to work here in this *bidonville*." In French, a *résistant* is "someone who refuses to submit to the oppressor," and if those who come to Colobane are to thrive, it is only through the bravest perseverance.[13] Colobane is a tough place, full of tough people: a Senegalese friend confided that middle-class people of Dakar avoid the place as frightening, especially at night.[14] In Colobane, work is not just hard, it is frenetic, and Colobane is alive with astonishing bustle. Labor is intense, and both physically stressful and dangerous. Few choose to work in Colobane, many end up there. As one young man explained,

Life is always filled with surprises. I spent years after school without work, [and] I was without hope and did not like it; but now I am working. I am here, [and] I must be happy with what I have. I make do [je me débrouille]. *This is hard work, but I am here and perhaps something [better] will come another day. It is not wonderful work, but that is not important. I am* here.

Men in Colobane are grimy, their blackened workclothes in tatters. Laundries are located among the workshops, next to the sleeping quarters that Carlos and his fellows use during the workweek. Small restaurants run food to the men. Women occasionally appear along the sinuous paths of Colobane, their bright wraps standing out like strong songs; my guess is that one place we saw them was a brothel for these hardworking souls far from their homes in the famine-wracked outback. Yet Colobane *is* work and *does* provide a living.

Shaking hands with Carlos is like holding a horny glove. Carlos said, "Look at my hand, it is ruined!" and explained that it is so extraordinarily calloused because he has spent the last fifteen years pounding recycled corrugated roofing flat with a steel-slab hammer. Only then may it be cut into useful shapes for its next "career" as the sides of a trunk.

As a young man, Carlos spent seven years working for a man in Bamako, for which he earned less than a dollar a day. As he explained, he became impatient with his menial position, but his father told him to take courage, for one day he would "find his benefice." And truly, he has prospered in Colobane. In response to my question about the meaning of System D, Carlos responded,
I make do [je me débrouille] *in this way. I make do so that I will not steal and thereby defile* [gâter] *the names of my mother and father, because before a man can have dignity, he must work. When you have worked well, no one will say anything; . . . the policeman . . . will only leave you alone if you have done nothing bad. A troublemaker* [malfaiteur] *lacks the dignity to stand beside us, and this is why I work. Now I have a wife and five sons, all blacksmiths like me. I have sent one son to Catholic school, but I will bring him back here to learn how to be a blacksmith.*

Such devotion to work begins with sheer necessity and driving will, but does not end there. Indeed, as Carlos explained, his toil is inspired by and undertaken in the name of Sheikh Amadou Bamba, the Muslim saint (*walî* in Arabic) whose larger-than-life image adorns the wall of a building at the threshold to Colobane (plate 5.7).

As Carlos put it, "we have found in the Qu'ran that this was a man who worked hard and well, and who did things no one else had ever done: he walked on water [as the Colobane wall painting depicts]. We love him, and we are all behind him because he did everything and gave everything to us Muslims." Sheikh Bamba sanctified hard work and promoted blacksmiths like Carlos within the ranks of his movement (Monteil 1966, 186).[15] The saint oversees activities in Colobane and elsewhere in Dakar and throughout Senegal. In the shadows of a great many workshops of Colobane and near Sandaga market, Amadou Bamba's turbaned image appears as an icon, placed just behind a hardworking man to oversee, inspire, and inform his labors.

A Saint of System D

It may be sheer coincidence that the Senegalese name "Colobane" sounds a bit like "Caliban," the famously pitiable character of *The Tempest*; yet the uncanny commonalities between the place and Shakespeare's character permit an understanding of what it means to be a *résistant* in Colobane. Caliban is an archetypal, despicable "native," deformed and ugly in the view of those who would possess and colonize his island. Caliban is the soul that bourgeois people avoid on the street and consign to places like Colobane. As George Lamming has it, "Caliban 'is the excluded, that which is eternally below possibility. . . . He is seen as an occasion, a state of existence which can be appropriated and exploited.'" (Cited in Said 1993, 213)

Many writers, among them some of the great anticolonial polemicists, have built upon Shakespeare's allegory as they have sought to resist and gain escape from oppression.[16] The Calibans of this world, created by the withering arrogance of this less-than-brave new world, must (re)build their sense of themselves. As Edward Said asks, "How does a culture seeking to become independent of imperialism imagine its own past?" One way is "to be a Caliban who sheds his current servitude and physical disfigurements in the process of discovering his essential, pre-colonial self." (Said 1993, 214) This strategy underlies *résistance,* culture-building, and System D recycling in Colobane, understood and realized by Carlos and many others working there through the charisma of Sheikh Amadou Bamba.[17]

Amadou Bamba (1851–1927) was a Sufi mystic whose sacred messages would prove especially pertinent to peasant Senegal, caught up in the turn-of-the-century turmoil of transition from a political economy driven by the slave trade to one dominated by colonial occupation.[18] Sufic Islam, with its stress upon creation of strong bonds between holy men and their devotees through creation of Tarîqa "Ways" or "Brotherhoods," provided "an Islamic handbook to the production of charisma" (D. Cruise O'Brien 1988a, 4), ideology, and a structure of practice that was essential to Senegalese making a successful transition to a colonial political economy of cash-crop capitalism.

Although Sheikh Bamba was an ascetic pacifist and mystic who derided those who would engage in holy war, except as "spiritual combat" (Dumont 1975, 34), the French colonial administration found his charisma to be "surreptitiously revolutionary." They sent him into what would stretch to seven years of exile (1895–1902) in their central African colony of Gabon, followed by a second period in Mauritania (D. Cruise O'Brien 1975, 19; Monteil 1966, 164). Their hope was to diminish Sheikh Bamba's prestige and bring an end to the intolerable "state within a state" created by his avid following (Dumont 1975, 78; Monteil 1966, 167). Only later would they realize that, for Muslims, being sent into exile (especially for *seven* years – a mystically significant number) is an aspect of what subsequent authors have called "the technology of charisma." (Triaud 1988, 54) Indeed, exile echoes the Hijra, Muhammad's own flight, and so helped confirm Sheikh Bamba's status as a saint. When he was finally released, his followers are said to have cried "Our Allah returns!" (Monteil 1966, 163, 167)[19]

The exile of Amadou Bamba was accompanied by miracles that are still portrayed on the walls of buildings such as that at the threshold to Colobane. Mor Diokane, a young man working just adjacent to the painting, explained,
Sheikh Bamba was an intimate friend of Muhammad. When he was forced into exile and placed on the Europeans' ship sailing for Gabon, Sheikh Bamba minded his own business: he was respectful, devout, and pious. When it was time to pray, as we Muslims must, five times daily, he spread out his sheepskin

and knelt; but the Whites [Toubabs] would not allow this, for they did not tolerate his religion. A bird flew up to Sheikh Bamba bearing a piece of paper in its beak, with God's message, Débrouille-toi. *So Sheikh Bamba stopped the ship, laid his sheepskin on the waters, and began to pray on it. All the fish came to him for his blessing, and when the sheikh raised his head from praying, there was sand on his forehead as if he had prayed on land. When he returned to the ship, the Whites wanted to kill him but they could not. God had told Sheikh Bamba, as he had told Muhammad before him, to make do* [se débrouiller], *and so he did.*[20]

For those who would believe, these incidents were proof of the man's saintly charisma *(baraka)*, as Sheikh Bamba's own writing asserted (Monteil 1966, 177). Such marvelous acts were the foundation of the sheikh's "sacred nationalism" (D. Cruise O'Brien 1988a, 20), and they continue to inspire the anything-is-possible culture-building of Carlos and others engaged in System D recycling: if Sheikh Bamba could effect miracles, perhaps they can too, in their own small ways in day-to-day defiance of poverty.

An important aspect of the Mouride Way founded by devotees of Sheikh Bamba is his promotion of hard work,[21] as stressed in popular writing (Wade 1991, 55; Magassouba 1985, 35) and in songs sung by circles of artisans and businessmen or on the radio (D. Cruise O'Brien 1988b, 136–7). The epigram for one tract is the Sheikh's oft-repeated aphorism, "Work as though you will never die, / Pray to God as though you will die tomorrow." (P. Seck n.d., 1) *This* is the lived reality of the denizens of Colobane and other places of ceaseless toil. If, then, the sheikh's image is found at the threshold to Colobane and adorning the walls of businesses and workshops throughout Dakar and outlying Senegalese towns, one can suppose that in the saintly deeds and words of Amadou Bamba, hardworking people find purpose in life, despite the obscene difficulties of want and strife, all too common to contemporary Africa.

Colobane is a place of *résistance* that is both political and spiritual. People working there *will* persist, they *will* make do and manage *(se débrouiller)*, just as God told Sheikh Bamba he must. For people in Colobane and the recycling workshops of Dakar,

Sheikh Bamba stands for freedom through the hard work necessary to resist failure. He informs System D, for to "make do" is sanctified in the sheikh's life and writings.

Elsewhere in western Africa, contemporary African culture-builders use versions of System D to cope with the ironies and "aggressive incongruities" of modern life, but they do so in intriguingly different ways based on their own indigenous philosophies and religions, rather than on African Islam. Still, there are intriguing cross-cultural commonalities when Yoruba, Aja, and Fon peoples in the Republic of Bénin personify the ironies of System D, as people in Senegal do through Amadou Bamba. In southern Bénin,

System D is deified as Ogun, god of iron, avatar of transformation, and "Lord of the Cutting Edge." (Thompson 1983, 53)

Culture-Building in Bénin

Yoruba, Aja, and Fon peoples living in southern parts of the Republic of Bénin are closely related to their neighbors in Togo and Nigeria through language, culture, and history. This is a region of unusually dense population and thriving capitalist commerce in marketplaces that serve as the vital centers of coastal west African life. It is in African markets that many chance encounters and ironic collages are effected, in conceptual, social, and physical realms of human experience.

It seems that anything on Earth can be found in the largest markets of coastal west Africa, if one looks patiently enough. An exuberance of wares weighs down market displays to the breaking point. Markets are magnetic for their swirl of colors, from the brightest red-orange of chili peppers to the deepest green of vegetable leaves; and for their goods, from heaps of used clothing to shining displays of tinware, from alluring walls of fabric bolts to the eerily earthy textures of herbal and magical medicines. Coastal west African markets hum with conversation, clink-clank from blacksmiths' hammers, buzz with tailors' sewing machines, thud from butchers' cleavers, and pulse with the sounds of beasts' sale or slaughter.

Recycling looms large in the marketplaces of Bénin. It is here that blacksmiths and other "technology brokers" transform one thing into another, often across original cultural and historical definitions of what something was for or how it was to be used.[22] While workshops are often located in or adjacent to stalls where products are displayed, they are sometimes elsewhere altogether, whence finished goods are carried to the various markets of a region. Such is the case of Sourou Tohoessou and his family of blacksmiths living in Gbakpo, an Aja village north of Porto-Novo in southeasternmost Bénin. It is they who produce virtually all of the *assanyin* memorial sculptures sold in Ajara, Dangbo, and other markets of the region.

5.7
A wall mural at the entrance to Colobane depicts Sheikh Amadou Bamba praying on the ocean's waters. Colobane recyclers believe that just as the saint enacts miracles, so may they in transforming things – and their lives – through the hard work that Sheikh Bamba sanctified. Beneath the painting, men disassemble by hand a huge pile of motor vehicle engines.

Assanyin are umbrella-shaped metal staffs inserted in the earth or cement of tombs to honor the beloved ancestors buried there and "confirm that the dead are in reality not dead but only distant, within reach of prayer and sacrifice." (Bay 1985, 5)[23] Indeed, the bonds between living and dead are as resistant as the iron from which *assanyin* are fashioned (Adande, 6). *Assanyin* range in size from a few centimeters tall to a meter or more in height; and in elaboration from simple disks mounted on pointed shafts to highly ornamented staffs with one, two, or three tiers, each decorated with figures cut from metal standing upright on top or around the edges, or dangling from the perimeters (plate 5.8). *Assanyin* made for noble families depict proverbs, aphorisms, and "praise poems" about the deceased person's character, status, powers, and history. Simpler *assanyin* for less affluent people usually lack the "richly polysemic, . . . multiple levels of meaning" of those created for wealthy patrons (Bay, 9), and demonstrate little or no variation. Some of these latter bear the dull finish of the tin or steel from which they are made, while others are dazzlingly shiny, for they are sprayed with aluminum paint or are made from white metals like chrome. Nowadays, it appears that all *assanyin* are made from recycled materials.

Small, simple *assanyin* are made in a number of workshops in Porto-Novo and other places in southeastern Bénin. They are fashioned from cans and similar scrap collected, flattened, and cut into requisite pieces by young apprentices, and then spot-soldered by older boys or young men.[24] A preferred source of metal is powdered and condensed milk cans, the printed advertising from which can often be found on the underside of the "umbrella" form. The concentric circles common to this sort of tin accentuate the round form of the upper tier and emphasize the centering of the device upon its shaft. However, such cans are chosen as the source of metal for *assanyin* because of their shiny interiors, for the metal can be inverted so that the inner surface becomes the outer face of the "umbrella." This is done perhaps to catch the "flash of spirit" associated with the object's use, or as a more general reference to the luminosity so admired in Yoruba arts that it may have its own mystical healing qualities (Thompson 1983; idem. 1975, 38).

Larger *assanyin* are also made in these same Porto-Novo workshops, cut from the heavier grades of metal sheeting available from recycled oil barrels and other sources. These *assanyin* are rough in appearance, for their surfaces are blackened and they quickly rust. Most frequently, they are surmounted by a single, simple bird made from rolled metal of the same sort, and sometimes small iron cones dangle from the edges.

The largest and most elaborate *assanyin* appear to be the monopoly of the Gbakpo workshop, from which they are sold wholesale in lots to vendors who bring them to regional markets. For example, Mme. Gandounou sells a spectacular range of religious materials and devices, including small *assanyin* from

5.8
Umbrella-shaped *assanyin* memorial staffs, like these in a market display in Ajara, Bénin, are made from recycled metal and left black or spray-painted to increase their brilliance. Each will become a "portrait" of a loved one, on whose tomb the staff will be placed.

Porto-Novo workshops and large ones from Gbakpo, in stalls she maintains at the major markets of Ajara and Dangbo (which meet on different days of the four-day market week). She is one of three merchants specializing in these materials at the large market of Ajara (with several others carrying a few religious objects among other goods); she has much less competition and maintains a far smaller and less dramatic display at the more rural market of Dangbo. One may speculate that the number and elaboration of displays in the stalls fluctuates with more general economic conditions; displays were probably fewer and less impressive during our visit, due to the recent devaluation of Béninese currency (J. Adande, personal communication, 1994).

Assanyin made at Gbakpo range in size from being roughly the same as the largest ones made in Porto-Novo, to nearly twice as tall as any produced in those workshops. *Assanyin* sold in the stalls of women like Mme. Gandounou are cut from recycled oil barrels. Both of the round umbrella-shaped platforms are surmounted by four bird silhouettes of a signature style. At the center of the upper disk stands an even more highly stylized, three-dimensional bird. Six bangles made from thinner metal hang from the edge of the platform, and two are suspended from the tail of each bird. When the Gbakpo *assanyin* are purchased by vendors, some are sold as produced, while others are sprayed with aluminum paint and sold at a higher price.

While sitting in Mme. Gandounou's pleasantly cool, shady stall, I watched an elderly man spend a long moment looking over the display of Gbakpo *assanyin* before making a purchase of several of the tallest and shiniest ones. Once his decision was made, I asked him why he had chosen these rather than the other, smaller and less-shiny ones. He said that at first, he had decided that he would buy the unpainted ones because he did not like the way that the others were so shiny that "they can be seen from far away." He changed his mind, however, because he decided that people who saw the shiny ones would know he had spent extra money to purchase them, and that those he bought demonstrated or possessed greater *ara*.

Ara is an aesthetic and critical term from Aja and Yoruba hermeneutics, and like many such words, it proves very difficult to define, let alone translate

from one culture to another (cf. Apter 1992). *Ara* is a Yoruba word referring to invention, style, "odd fancy" (*fantaisie* in French), and fad. It is a quality of Yoruba expressive culture that underlies its "evocative power – its capacity to generate ideas, feelings, and significances that *move* audiences." (H. Drewal 1992, 187, original emphasis) One demonstrates *ara* by innovation, genius, or knack *(génie)*.[25] My hypothesis is that things and acts possess *ara,* in that this is a quality inherent to them, rather than something added by the artist. The artist's task, then, is to reveal (and perhaps release) *ara,* rather than to create it; yet his genius in doing so is recognized and appreciated. As one young man explained, "[W]e don't like to do the same thing twice. Doing something new proves that an individual exists."[26] As technology brokers, blacksmiths such as the Tohoessou family realize *ara* as they recycle materials to create flashy *assanyin*.

From Car Bumper to Ostentatious Memorial

Ara is especially evident in what my guide and interpreter Augustin Ahouanvoedo described as an *assanyin d'apparat,* that is, of "pomp, show, and ostentation" (plate 5.9). The size and beauty of such a memorial stand for one's own "size" and social stature, as well as that of the ancestor to be honored. Important people should not use the ordinary little *assanyin* sold in the market, he said. Mr. Ahouanvoedo's enunciation of the term *apparat* was so dramatic that the significance of the object was framed and dramatized. When we first visited the Tohoessou compound, he asked if I was interested in purchasing such an *assanyin*, which are only created on commission. Sourou Tohoessou, chief blacksmith of the family, suggested that he could make one from a combination of chrome car bumper and brass pipe, which he would heat and beat at his forge to produce a pleasing object. He added that in the past, fabrication of an *assanyin d'apparat* was conducted in secret, so that when it was revealed, it would be surprising and impressive (cf. H. Drewal 1988b, 84).

Both car bumpers (obtained as local scrap) and brass pipe (long imported from Europe as recycled material for African artisanal use) shine brilliantly, and are therefore appropriate for such "ceremonial"

objects, the blacksmith stated. The finished *assanyin* is polished to make it glow. It then "eats" red palm oil poured in sacrifice over it. Occasionally, a smaller *assanyin* will accompany the larger *assanyin d'apparat* as its "little witness" *(petit témoin)* and "mouth," so that the one can continue to shine radiantly and remain "very majestic" while the other "eats" the oil that renders sacred the negotiation between supplicant and ancestor. The *ara* or genius of astonishing style of such an *assanyin d'apparat* outshines that of any other, and is the way that many people wish to impress their friends and honor their ancestors, but few are able to do so.[27] The astonishment would be due to the novel juxtaposition of materials and innovative iconography, and viewers would show appreciation for the smith's realization of such *ara*.

We discussed the process of recycling at play in the production of *assanyin d'apparat* and other religious objects by the Gbakpo blacksmiths. The recuperated object must be "neutralized," Mr. Ahouanvoedo said, before it can be rendered sacred *(sacraliser)* prior to making the materials into an *assanyin*. The blacksmith has an idea of what he will make from the "profane iron" *(fer profane)* of the recuperated object; by passing the metal through his forge fire, he renders the iron sacred. Then, once an *assanyin* is created, it must be "sanctified" *(sanctifier)* in ritual, through invocations, and by sacrifice. A different final step was performed when I returned to Gbakpo to fetch the completed *assanyin d'apparat* that I had commissioned, however. I paid for it and offered another sum to purchase "gin" (locally made moonshine) as an offering to the family's ancestral spirits. The eldest blacksmith took the bottle and poured a libation to the *assanyin*, then drank some and passed the glass to the other men. Mr. Ahouanvoedo explained that this was because the *assanyin* had been made in their forge and was sacred to them, but now that I was taking it, they called upon their ancestor so that I might carry it across the ocean to a place where it would no longer be sacred but "cultural" (his word in French, chosen to refer to my intention to exhibit the object in a museum). Their sacrifice desacralized the object, so that desecration would not result from such use.

A key word in this exchange is "neutralize," as the blacksmith terminates the "life" of one object to

5.9
Assanyin (Grave Ornament).
Sourou Tohoessou, Republic of Bénin. 1994. Recycled metal (car bumper, brass pipe). Private collection.

This elaborate *assanyin* was desacralized by the makers so that it could be put to "cultural" use by a museum.

transform its substance into another. Fire is necessary for this process, and blacksmiths are masters of this conceptually as well as physically dangerous phenomenon. Iron is sacred unto itself, Mr. Ahouanvoedo explained, and "is" the god Ogun (cf. Adande, 3; H. Drewal 1989, 235).[28] Not all blacksmiths can make *assanyin,* and fewer still are able to make *assanyin d'apparat.* Such a gift comes from "a certain communion between the profession and the practitioners," Mr. Ahouanvoedo said, that is guided by Ogun. Such individuals must "live the sacred" from infancy, for they must "respect the contract" with Ogun.

We saw several of the Tohoessou children working in one of the shady shelters of the atelier, making tiny religious objects such as inch-long "handcuffs" modeled after nineteenth-century slave manacles, now used to "close" a prayer and "bind" desire. These are fashioned from recycled food and beverage cans. Such abilities come down through the generations following the "contract" with Ogun. Sourou

5.10
These *assanyin* honor the ancestors in the ruin of a deceased blacksmith's workshop in Gbakpo, Bénin.

Tohoessou's grandfather is remembered and honored for having founded the compound and workshop still in use. Several *assanyin* stand in the corner of a ruin, marking the house where the old man died. One of these is made from the colorful top of an imported enamel cooking pot, its inventive *ara* apparent (plate 5.10). The house has been allowed to fall into disrepair and offerings are no longer made to these *assanyin,* I was told, because the grandfather can see that "things have evolved" and the family has grown, in a progress honoring him. A further shrine to the grandfather stands just adjacent to Sourou Tohoessou's central forge. In a small earthen building roofed with rusty sheeting, the old man's walking stick and another *assanyin* (as well as other less obvious artifacts) stand in what is both a museum and a shrine, keeping the ancestor present in everyday affairs. The god Ogun is there, too.

An African God of Recycling

Ogun is a member of the pantheon recognized by Yoruba, Aja, Fon, and other coastal peoples of the region as what Mr. Ahouanvoedo calls their "cosmic religion."[29] Over the years, Ogun has been known as the god of hunting, iron, and warfare (Barnes 1989, 2), and as Robert Farris Thompson has described him, Ogun has been and remains "Lord of the Cutting Edge." (Thompson 1983, 53) Thompson's play of words is altogether appropriate, for while Ogun has been associated with the iron tools and weapons with which people transform their circumstances and their environment, the god is also responsible for "cutting edge" technology and thinking.

Ogun is approached with ambivalence, for his powers both create and destroy: as a "trenchant edge," Ogun cuts both ways (H. Drewal 1989, 238). Indeed, as Sandra Barnes (1989, 2–12) suggests, the origins of Ogun are found in "a *bricoleur* idiom: many available notions were pieced together into patterns that began as a concept and eventually emerged in a cult group"; and Andrew Apter finds that indeterminacy of the sort "supports shifting political relations and expresses rival political claims." (Apter, 155–6; cf. H. Drewal 1992) Such a definition sounds hauntingly like the "instability of appearances" and "aggressive incongruities" celebrated in the ironic collage of

Surrealism and, in particular, is the active vehicle for recycling through System D.

Ogun, as "Lord of the Cutting Edge," always evolves according to the complexities of contemporary circumstances. "[T]he myths and rituals of the Ogun complex served as a kind of 'ideology of progress'" (Barnes and Ben-Amos 1989, 42) that could be taken along by the thousands of Yoruba who were swept into the Atlantic slave trade. As Africans were forcibly established in the Americas, Ogun proved essential to coping with radically oppressive social change. This is true in the African-American diaspora today, too, for "no central tradition exists to check theological innovation" (Cosentino 1995), and Ogun can become whatever people need him to be.

In the African Americas, "synthetic religions" like Umbanda in Brazil, formed by "the bricolage of intellectuals, could be 'pieced' together [from] elements of the past" to create thoroughly modern forms (Ortiz 1989, 91–3) derived from African, Christian, Masonic, Native-American, and other religions. In Haitian Vodou, Ogun has become "Ogou Feray," the second word being a creolization of the French term *ferraille*, denoting "scrap iron." (Brown 1989, 71–2) In contemporary Los Angeles, Ogun is also associated with scrap iron, and the god's innovation is a "centripetal process, pushing out new forms like a jazz riff," especially at "neglected margins of official culture. . . . There we will find Ogun . . . being generated anew." (Cosentino 1995) The god's ambiguous incarnations in America lend further understanding of Ogun in Bénin.

Most blacksmiths who make *assanyin* (or conceptually and stylistically related memorials such as *asen* among Fon) maintain a shrine to Ogun (cf. Barnes and Ben-Amos, 53). In Bénin, as among Haitians and other African Americans, such an "altar is the repository of. . . history" (Brown, 72) as well as the "eyes" or "face" of the god, or more generally, a threshold to divinity (Thompson 1993, 30). Furthermore, the form of such shrines is evidence of the principle of recycling elucidated by Daniel Dawson (1994) that "if it is appropriate, we will use it."

Such assertions are manifest in the shrine to Ogun maintained by Alomadin Robert Adjovi, a blacksmith who makes *asen* memorial staffs in a workshop next to the palace of Dah Adjovi Houézé, king of the Pedah people (a Fon subgroup in Ouidah, Bénin). Scraps of iron have been collected from the various projects the blacksmith has effected over the years, or, rather, scraps of scrap iron are employed, for all the metal Mr. Adjovi uses is recycled at least twice. As he has pursued the labyrinthine paths of System D to make useful things from other things no longer needed or serviceable, the blacksmith has produced snippets that are too small or irregular for further efficient use. These nonetheless contain the "vital force" of the previous object, the iron from which it was made, and the new thing the man has produced. For such a shrine to Ogun, bits and pieces of experience are juxtaposed in a collage that *is* the vital force of Ogun himself.

For Yoruba, Aja, Fon, and related peoples of southern Bénin, *ase*, the essential life force and the power to make things happen and change, is given by God to all beings and things. *Ase* is authority and the ability to get things done; it is personified in the "driving force" of Ogun. Iron possesses *ase* in its potential to form and transform. As something iron is made, used, or invoked in religious ritual, its *ase* is increased.[30] *Ase* life force is also produced when the astonishment of *ara* is realized. Furthermore, *ara* is the perceptive, insightful "sensitivity to the need of the moment" and the "ability to adapt and change without being formally told to do so." (Abiodun et al. 1991, 28; Drewal et al. 1989, 248) *Ara* "contains the germs of change, initiative, and creativity that give dynamism to Yoruba art" (Abiodun 1990, 80–1); and in turn, the spark of *ara* increases *ase*, even as it is itself produced by *ase*. Such paradox bespeaks creative ferment. A shrine to Ogun, then, as "a synaesthetic totality" (Rubin 1974, 6), may be considered both a repository and point of generation for both *ara* and *ase*, an archive of what a blacksmith has made through his career, and a suggestion of what he may create in future.[31]

The cumulative installation of a blacksmith's shrine is created *to* Ogun, but is also *of* Ogun, for it *is* Ogun. The altar is alive as Ogun's "face" and must be nourished with offerings of palm oil, the blood of animals, gin, and other sacred or sacralizing substances (H. Drewal 1989, 241). "Power has a mouth," as Yoruba say (Drewal and Mason forthcoming); and as its mouth is fed, the vital force of *ase*

grows. Such sacrifice "revitalizes Ogun" so that the blacksmiths "may partake of that vitality and manage it safely." (M. Drewal 1989, 204) The shrine, then, is "accumulative in intent as well as . . . in aspect" (Rubin 1974, 7, 10); as it grows into "an apocalypse of iron" (Thompson 1993, 184), the shrine's particular parts become obscured in the tactile richness of its surface, even as its vital powers are concentrated and increase. Memory is merged with what is forgotten, as power and display are combined in the living altar.

Ogun is god of recycling. With all conceivable irony, Ogun is many other things as well, at the same time or separately. It is neither coincidence nor happenstance that late-nineteenth-century figures portraying Ogun were made from recycled materials (Adande, 10). The most famous of these, seized by the French at Ouidah in 1894, was a larger-than-life statue made of scrap iron from derelict ships and the newly created railroad (Adande, 10; cf. Blier 1990, 48–51). Nor should it be a surprise that several contemporary blacksmiths-turned-artists have begun to weld together figures from recycled materials (plate 5.11), which, though often comical and made for a tourist market, are informed by the vital force of Ogun (MCB 1993).

As a shrine to Ogun is assembled from bits and pieces of things that once were and will be, potential is accumulated as inspiration (in a literal sense) for the smith's future creativity. But this is the point of recycling, and the way that it plays out through the ironies of System D in contemporary Africa. Indeed, for Yoruba and related peoples, Ogun is System D, with all its paradoxes and provocations made available for contemplation and use.

What is so intriguing about recycling in Senegal, Bénin, and elsewhere in western Africa is its inventiveness. Stephen Gould suggests that people in developing countries recycle "for purposes almost comically different from original intent." (Gould 1989, 8) As Barbara Smith further asserts,
[H]uman beings have evolved as distinctly opportunistic creatures and . . . our survival, both as individuals and as a species, continues to be enhanced by our ability and inclination to reclassify objects and to "realize" and "appreciate" novel and alternative functions for them – which is also to "misuse" them and to fail to respect their presumed purposes and conventional generic classifications. (Smith 1988, 32–3)

It is the irony of this "misuse" that proves that the "necessary relations" Lévi-Strauss sought to describe are unnecessary after all. Blacksmiths and other "devious" technology brokers engage these ironies, deliberately take them on, and turn them to their own purposes as they build culture through recycling.

That Africans are aware of and enjoy such a process is apparent in vital concepts like the "principle of realization" that is *ase* and the astonishing genius that is *ara* for Yoruba peoples. Culture-builders in the workshops of Dakar or southeastern Bénin are not only as suspicious of rigid definitions as the Surrealists were, they dismiss them altogether as irrelevant to the pressing needs of their often difficult circumstances. Indeed, with aesthetic flourish, they overcome "the tyranny of 'already'" (Konate and Savane 1994, 75) in places like Colobane or at shrines to Ogun, where one arrives at the "place where the world comes to a point," *ibi sonso* in Yoruba (Thompson 1993, 147) – the same "sublime point" sought by Surrealists as "a spot on a mental mountain, where all the contraries impossibly meet." (Caws 1993, 38)[32] Such "an image . . . would be ahead of our ideas and our desires, [and] an image magnificent in its shock and its irreverence," expressing the fervent hope that "the creation of the world is not yet finished." (Simic 1993, 30) The marvelously ironic eclecticism of Ogun's "face" triumphs over the stultifying "single meaning" of established authority (cf. Bakhtin, 123).[33] "Necessary relations" can be subverted. Things can be done in ways contrary to their original sense. And so it is, over and over again, that System D carries African people through the hardest of times.

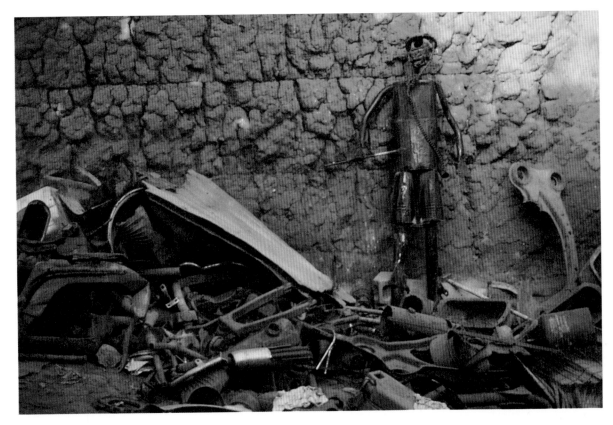

5.11
This "muffler man" made by blacksmiths-turned-artists Calixte and Théophile Dakpogan of Porto-Novo, Bénin, echoes nineteenth-century representations of the god Ogun made of iron recycled from the railway. Ogun is not only the god of iron but also the god of transformation – the act of recycling one thing into another.

Reinventing the Wheel, the Tin Can, and the Bottle Cap: Folk Recycling in Mexico

Julius S. Kassovic

The Toothbrush in the Outhouse

I threw my old toothbrush out at least three times, but it would not stay thrown away. In 1972, my wife and I had just moved to Tzintzuntzan, a small mestizo village in the high mountains of Michoacán, in central Mexico. We were beginning our anthropological fieldwork and living with a local family. Because Tzintzuntzan's folk craftsmen worked in clay and straw, I bought a nice straw wastepaper basket to put under our desk when we fixed up our room. Every few days the children in the family would take out the trash and burn it in the back yard. They were very proud of their job, and besides, it allowed them to play with fire twice a week.

A day or two after I threw away my old tooth-brush, I came into our room and found it back on my desk. I thought I had tossed it into the trash, but I mindlessly tossed it again. When it appeared on my desk again, I was seriously puzzled, but I tossed it a third time. That did it; this time it seemed to stay tossed – at least until I was out in the outhouse a few days later. By chance, I found myself peering up at the ledge between the roof and the outhouse wall. There was my toothbrush, along with a tattered tire-soled sandal, a broken lantern made from an old tin can, and some old pottery molds. I did not know what to think. It seemed a small question, in the scheme of things, but it kept nagging at me: why was the family storing trash in the outhouse?

Only much later did it finally dawn on me that I had missed a clue – ours was the only wastebasket in the house! The family itself threw very little away, and our own wastebasket was usually used only for old carbon paper and Kleenexes. With the polite reticence of the traditional villager, they did not question our profligacy. My old toothbrush was simply returned several times until they were absolutely sure I really no longer wanted it. It was then put with other objects of potential value, to wait until a use could be found for it.

As I searched for an answer to the riddle of my reappearing toothbrush, I began seeing, as if for the first time, what I had considered junk being reused all around me, and for every conceivable purpose. Roofs were being patched with old advertising signs; sandals were soled with cut-up tire treads; flower pots were often nothing more than tin cans with their tops cut out. While I had been traveling to Mexico for years, and had seen this sort of thing before, I had passed it off as just another symptom and symbol of poverty. Looking at it with fresh eyes, however, I began to realize how one person's junk can become another person's resource. What I was beginning to comprehend was a pervasive and complex system of recycling or, more specifically, refabricating used industrial products into new folk products. I was discovering the outlines of a folk process that I had never seen described before, one which was in many ways like pottery, weaving, or woodworking, but rather than using natural materials like clay, cotton,

or wood, it used previously fabricated materials like tin cans, tires, and bottle caps.

I began to photograph, buy, and document examples of "junk" being transformed into new objects. These examples, accumulated in the course of research from 1972 through 1984, number in the many hundreds, and cover all aspects of daily life. In this essay, I describe how junk was recycled on the folk level in Mexico, particularly in the villages of Tzintzuntzan and Ocumicho in Michoacán where I lived, and in Pátzcuaro, Morelia, and Guadalajara, the cities where the recycling craftsmen I studied lived. I also examine who the recyclers were and what folk recycling meant to them economically and aesthetically.

The Pervasiveness of Folk Recycling

As I began to understand the complexity of folk recycling, I started looking into it systematically. I wanted to know what kinds of junk were being recycled, how junk was refabricated into new items, where these items were being used, and who was doing the refabricating. The first and easiest thing to do was to look around me.

In our own bedroom, we had bedsheets and curtains made from flour sacks, their colorful commercial designs almost washed out and rickrack sewn around the edges for decoration. Our pillows were homemade of patchwork quilting, and the floor mat by our bed was a rectangular plastic bag with a picture of a large bird and the name "GUANOMEX" printed on the back; it had held fertilizer in its previous incarnation.

Our outhouse was a small adobe building with a very colorful patchwork-quilted curtain that served as a door. While the seat in our outhouse was simply made from an old plank, another village family refabricated theirs from an old canoe. They just turned it bottom-up, and made it into a two-holer. Old newspapers and school workbooks usually served for toilet paper, like the proverbial Sears catalogues of rural American outhouses. Sometimes more exotic sources of paper were found, such as the day we were surprised to find Sara, the mother of the family, so earnestly engaged in conversation with local missionaries that they left her piles of tracts. She told us she was not really interested, but felt sorry that on such a hot day

they were being turned away at so many doors. We found the tracts in the outhouse the next morning.

Next to the outhouse was a covered work area where the family made pottery. Because they had not strung electric wire this far from the house, they worked in the evenings by the light of *aparatos,* small kerosene-burning lamps made from tin cans, whose light was equaled or exceeded by their smoke.

In the kitchen, Sara cooked on both a wood fire and on a kerosene stove. She carried her kerosene home from the village depot in a jerry can made from a four-liter motor oil can, with a screw-close spout and soldered handles. When she made tortillas, she first soaked the corn with lime in a bucket made from a large pickled chilies can with a wire handle poked through holes punched in the sides. The griddles on which she cooked the tortillas, over the open fire, were either locally made ceramic, or steel circles cut

6.1
Miguel Peña Zavala of Tzintzuntzan, Michoacán, Mexico, brushes down his horse with a currycomb made from an oval sardine can punched with a nail to make jagged holes in the bottom.

out from junked cars and trucks. (I once bought a griddle made from the side of a bus that traveled to and from the city of Playa Azul; "Azu" was still painted across the top in the bus company's distinctive lettering.) Her kitchen implements included spatulas made from round tin-can tops riveted to metal packing strap handles, and tongs also made out of bent packing straps. A salt shaker was nothing more than an old baby food jar with holes in the lid punched by a nail.

Outside on the patio, the house's single water faucet emptied into a tub made out of a section of metal sewer pipe. Most people in Tzintzuntzan had at least one faucet, but the village pump that served these faucets occasionally broke down, making it necessary to go for water on foot. This was done by putting a pole notched at either end over one's shoulder and hanging a bucket made from a tall rectangular tin can (originally holding lard or glue) from each notch. Ocumicho, a Tarascan Indian village on the other side of the mountains, was much poorer, and in the dry season, water flow diminished to a trickle. There, where people had to go to a few public fountains or to a spring several kilometers away, carrying water long distances was a way of life. Traditionally, they had used round, thin-walled, locally made ceramic jugs to carry water. They preferred them to tin cans for storing water because, when it got hot, the ceramic was porous enough to sweat, causing evaporation that naturally cooled the water in the jugs. In addition, this low-fire pottery imparted an earthy taste to the water that people liked. Water stored in tin cans just got hotter in the sun, and tasted flat. Fragile ceramic jugs, however, could not compete with rugged tin cans for transporting water, so the water was usually collected in the metal cans and then transferred to the ceramic jugs for storage.

Because water was a precious resource in Ocumicho, people were careful to capture rainwater. They made rain gutters by cutting and fitting together tall, rectangular tin cans and drained the water off to old oil drums for storage. In poorer or less organized homes, long, thin planks were placed at angles in tin cans and ceramic pots to catch runoff from the roofs; the water flowed off the roofs and dripped onto the

planks, and then down the planks into the cans. This was less efficient than gutters, but it was cheap, easy, and caught more water than narrow-mouthed cans alone could do.

Certain industrial discards were particularly useful in village construction. The roofs of many poorer houses were made from corrugated tar paper that was nailed to a wooden framework. To keep nail heads from ripping through the tar paper, nails were driven through bottle caps, jagged edges down, to act as lock washers. Bottle caps had so many uses that storekeepers kept boxes of them for sale behind the counter, a windfall from their in-store sales of sodas and beer. When we dug a hole through our adobe bedroom wall in Tzintzuntzan to make a door to the street, the owner of the house decided to put a cement facing over the wall. Because cement does not stick to adobe, he went up to the corner store and bought a box of bottle caps and drove nails through them, jagged edges out, and then into the adobe. Hundreds of jagged bottle caps formed the lathing necessary to give the cement something to stick to. (It has now held for more than twenty years.)

Broken bottles were used everywhere in Mexico as security devices by cementing jagged fragments into the tops of fences to discourage people from climbing over. These fence tops were ablaze with multi-colored shards from whatever bottles were at hand during construction. Not surprisingly, therefore, one of the few monochrome examples I found was the line of pale green Coke bottle shards topping the security fence around a Coca-Cola bottling plant.

In Ocumicho, whole bottles were often buried, mouths down, with just their bottoms visible to make well-anchored and remarkably strong paving for walkways. Sometimes bottles were buried only partway and used as decorative borders around flowers or as short retaining walls for steps. Tin cans were less often used this way since they rusted and dented, but they were always used as flower pots. Sometimes they were painted over, but usually they were not, leaving the naturally vivid colors of various flowers to splay over a variety of commercial logos.

Milk cows, oxen, horses, and a donkey shared a small field next to the house in Tzintzuntzan, and refabricated items were used in their care. An oval

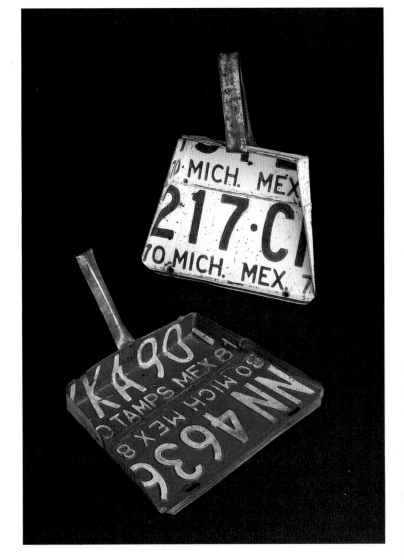

6.2

License Plate Dustpans. Maker unknown, Pátzcuaro, Michoacán, Mexico. 1970s and 1980s. License plates. Largest, W 11 1/2 x D 12 1/2" (31.9 x 29.4 cm). Collection Julius Kassovic, California.

The metal used in license plates is sturdy and provides a good material for making implements with large, flat surfaces such as dustpans. Small-time refabricators buy the license plates by the kilo from professional collectors. Dustpans and other household items are made in cottage industries and sold in markets and shops in both urban and rural areas of Mexico.

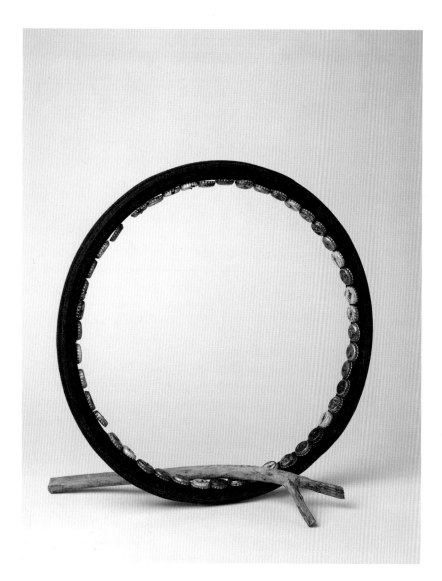

6.3

Toy Hoop and Stick. Miguel Peña Zavala, Tzintzuntzan, Michoacán, Mexico. 1972. Rubber tire beading, bottle caps, nails, wood. Hoop, Diam 20 1/2 x W 1 1/2" (52 x 4 cm). Collection Julius Kassovic, California.

Toys made from found scraps often display an economy of statement and an elegant simplicity of design. This mobile hoop was made from the beading of a used tire and decorated with colorful bottle caps nailed to the inner rim, adding color and reflection as the hoop spins down the street.

sardine can from a family picnic became a currycomb when Miguel Peña Zavala, the father of the family, punched jagged holes in the bottom with a hammer and nail (plate 6.1). He repaired his old leather oxen harness by cutting strips of rubber from a tire. He split another tire in half to make two circular troughs for his cattle and the donkey. One was placed on the ground, and the other tied to the crook of a low tree branch. In a small town near Guadalajara, I saw a more elaborate feeder of this type made to be used for pigs. It was also based on a split tire but had an oil drum mounted on top. As the pigs ate the grain out of the tire-trough, more grain automatically spilled into the circular trough from holes in the barrel's bottom.

Refabricated toys were everywhere, sometimes bought from market stalls, sometimes made by adults for children, and often made by the children themselves. Miguel cut out the bead of the tire he had used in repairing his oxen harness to make a hoop for his children to chase up and down the street; to make it more fun and colorful, he nailed multicolored bottle caps to the inner rim (plate 6.3). Other village fathers made wagons for their children from old wooden planks. Some used old water pipes for axles with wooden wheels mounted on them, others used wooden axles with roller bearings nailed into them for wheels.

Children in Tzintzuntzan smashed bottle caps into flat disks with rocks, and then made them into all sorts of toys. By carefully bending and crimping the disks, they fitted together elaborate suites of tables and chairs (plate 6.4). They made play money and game markers by bending and smashing bottle caps into various shapes and experimented with the musical and aerodynamic properties of the caps by bending and forming them into whistles or rapidly spinning them together until they hummed on a tightly wound string. They also showed me how they made slingshots using strips of rubber cut from old tire inner tubes. Sometimes they made very crude little slingshots by breaking off the narrow tops of plastic bottles and slipping a balloon over the open mouths. They then dropped a small stone through the mouth and down into the balloon, gripped the bottle neck while pulling back on the stone in the stretchy balloon, and let it fly.

Toys made from junk appeared everywhere in open markets and at fiestas, where they were sold in stalls or by itinerant peddlers. Some of the toys were cheap and simple, like twisted balloon animals that used bottle caps for weighted feet. Others were more expensive and elaborate constructions that looked just like toys from factories (plate 6.5) – whistles, guns, trucks, and dollhouse furniture – except that they were handmade out of tin cans, bottle caps, and packing straps. Push toys were made from tin cans cut and soldered into interlocking hoops that spun, or butterfly wings that flapped, when the wheels turned. In the butterfly's case, its wings were brightly painted on top, but when the wings flapped, a Pemex motor oil logo flashed from underneath. A particularly elaborately engineered toy came from the Guadalajara market. It was a small, but functioning, steam-powered boat. Inside its little tin-can cabin was a tiny boiler, powered by a homemade candle with a piece of old shoelace serving as a wick.

Refabricated items were also an integral part of the everyday commercial life of villages and towns. Out on the street in front of our house, a Tarascan Indian woman went door to door selling fish her family caught in Lake Pátzcuaro. She weighed them

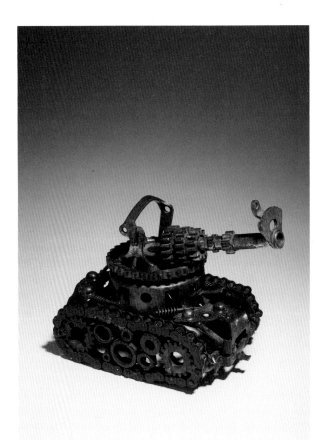

6.5

Toy Tank. Maker unknown, Mexico. c. 1980. Machine parts and bicycle chain. H 7 3/4 x W 5 1/2 x D 9" (19.5 x 13.5 x 23 cm). Collection Peter P. Cecere, Woodville, Virginia.

This sophisticated toy tank was probably made by someone who works with machines and was able to utilize discarded materials from his shop.

6.4

Miniature Toy Furniture. Miguel Zaldivar Alvarez, Tzintzuntzan, Michoacán, Mexico. 1972. Bottle caps. Chair, H 3 1/2 x W 1 1/2" (8 x 4 cm). Collection Julius Kassovic, California.

Bottle caps are a wonderful scavanged resource for toys made by and for children. In villages and *barrios* throughout Mexico, kids collect discarded

bottle caps, flatten them, and use them for play money and game chits. With only a little more skill and ingenuity, the caps can be fashioned into more complicated musical instruments, games, and miniatures, such as this doll furniture, which was made by folding the edges of the caps and fitting them together.

out in a balance-beam scale made, appropriately, from two oval sardine cans; one can held a half-kilo rock, and the other the fish to be weighed (plate 6.6). On another occasion, an itinerant tinsmith was going door to door, soldering leaky buckets and washtubs; his tool kit included a stove for heating solder that was refabricated from a can of chilies.

Recycling was so much a part of life that a particularly useful item might even be re-recycled. In Ocumicho I saw several homes where the worn-out soles of sandals, known to North Americans as "Tijuana retreads," were re-refabricated into hinges on doors and gates and nailed into place using bottle caps for lock washers. The tire tread soles had worn

6.6
This woman, from a fishing village on Lake Pátzcuaro, Michoacán, Mexico, weighs out whitefish for sale using a scale made from sardine cans.

thin and become flexible enough to be effective replacements for older leather hinges, and served as an alternative to expensive manufactured metal hinges (plate 6.7). As far as my toothbrush is concerned, however, I never did find out what happened to it, but I did come to understand that when I tossed it I was participating, however unwittingly, in something big.

The Materials of Folk Recycling

Recycling on the folk level is different from industrial recycling. Industrial recycling has tended to mean the systematic collection of industrial discards, and their reprocessing into basic materials for the production of more industrial goods. Yesterday's newspapers become tomorrow's; old beer cans become new beer cans; old tires become part of the mix for asphalt paving. Folk recycling, however, involves the reuse or, more precisely, the refabrication of industrial discards in the production of new, handmade items. Yesterday's newspapers become wallpaper; tin cans become kerosene lanterns; old tires become soles for sandals.

This is not to say that the industrial kind of recycling does not happen among folk recyclers. It does, where they participate in industrial culture. They return recyclable containers, such as soda and beer bottles, where a deposit makes this economically useful. But bottle caps, on which there is no deposit, are refabricated at the folk level.

Recycling itself is not an invention of the industrial age. People have probably been recycling as long as they have seen an advantage to using an already worked material as opposed to beginning with raw material. We can see contemporary examples of recycling nonindustrial materials that have a long history. For example, in many pottery-making villages like Tzintzuntzan and Ocumicho, kilns have no permanent caps to retain heat during firing. They are traditionally capped with layers of old potsherds. The spaces between the piled fragments allow smoke to escape, but the heat is retained by their mass. However, refabricating industrial junk is a newer phenomenon. Although the process of reuse is similar, there are several significant features that differentiate these two types of folk recycling.

The first feature is the development of industry itself. Industrial development, through the efficiency of mass production, supplies an ever-increasing quantity of products. And almost as quickly as new products are being made, old products are being junked, to be replaced by new products. The result is that the total amount of reusable material at hand has grown enormously.

In addition, the sizes of many reusable materials, such as tin cans, bottle caps, tires, and flour sacks, have been standardized for ease of production, distribution, and use. The same advantages that standardization has for industrial production are being put to good use by folk recyclers, who can depend upon regular sizes and shapes for the production of their refabrications. Many of these items already come in difficult-to-construct shapes that can be used as they are, or modified. In fact, one of the interesting characteristics of folk recycling is that the qualities of industrial discards are such that a person with no metal-working skills can attach a wire to a tin can and create a bucket that is lightweight, unbreakable, and absolutely watertight. Furthermore, the increasing availability of industrial junk has given folk recyclers easy access to many relatively high-tech materials and products never before available, such as metal alloys, plastics, and rubber compounds.

Finally, as opposed to the potter recycling his own potsherds, the industrial folk recycler often has had no previous contact with his materials. Because of the sheer increase in the volume of production, and therefore junk, a folk recycler now recycles other people's junk as well as his own. Moreover, the poor recycler may be recycling items he has never used, or could afford to use, in their original forms. Miguel, for example, who regularly recycled motor oil cans and tires, never owned a car.

Folk Recyclers at Work

Folk recyclers in Mexico operate in two fundamentally different spheres: the household and the more-or-less professional workshop. Within households, production is done by individuals, who do their work as the need arises – in the home, on the street, or in the fields. Householders work by improvising, using materials they have at hand or that are easily available to them. The motivation is a personal, and usually immediate, need. In such cases, the process of refabrication is done as a onetime job and little that is made is ever sold. This, however, does not mean that the wheel is constantly being reinvented. Over time, as in other areas of traditional life, a combination of individual inventions and communication produces a conventional body of solutions to common problems, using a commonly accessible body of recyclable materials. This means that when Miguel wanted a currycomb, he already knew about making one. He knew that an oval sardine can is easy to hold like a brush and that the jagged holes he punched in its bottom with a nail would adequately rub the

6.7
A wooden gate in Ocumicho, Michoacán, Mexico, is patched with hinges made by recycling the thin and worn soles of old sandals, which themselves were made by recycling tire treads. This is a rare example of re-recycling.

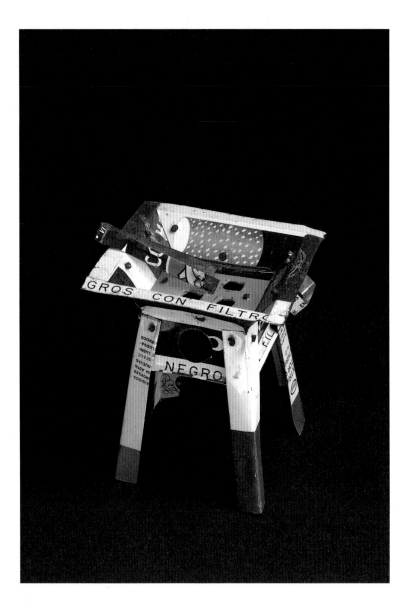

6.8

Small Charcoal Brazier with Tongs. Maker unknown, Morelia, Michoacán, Mexico. 1975. Metal advertising sign, "Quaker State" oil can, "Esso Extra" oil can. H 6 x W 5" (15 x 12.7 cm). Collection Julius Kassovic, California.

Hand-made portable charcoal braziers *(braceros)* constructed of license plates and other pieces of scrap metal are commonly used throughout Mexico.

horse clean. He also knew that all he had to do to get the necessary materials was to have lunch.

In contrast to household recyclers, workshops exist to produce and sell their refabrications. They achieve an economy of scale and complexity of production that could not reasonably occur in the home. Workshops come in all sizes, from those of the smallest part-time refabricators in isolated settlements who bring their wares to sell in village markets or to larger workshops, to very large shops with a dozen or more craftsmen, located in major cities, which sell their products from their own shops and even wholesale them to itinerant peddlers who distribute them in street markets throughout the country. In between these two extremes are small workshops in or near markets where craftsmen both refabricate and sell their products. These are usually one-person or family operations, located in towns and cities of all sizes, but not in villages, where there is not enough continuous demand to support them.

Among the smallest of the professional refabricators are those who work at it only part-time. They are often agriculturalists or have other jobs that provide their primary means of support. For them, recycling junk is a means of making extra money. Consequently, their range of products is limited, and their methods of construction are, for the most part, relatively simple. Moreover, their production is so erratic that proprietors of market stalls and workshops who buy their wares for resale often have no idea who made them. I was consistently told, "I think someone from the *ranchos* [rural hamlets] made this, but I'm not sure."

Don Salvador is a good example of the smallest part-time refabricator. Physically disabled, he lived in a one-room house in a *rancho* near Morelia. His workshop was a stool and small table in the doorway; his tool kit comprised a pair of pliers, a hammer, a glass cutter, and a screwdriver; his materials consisted primarily of the broken glass, tin cans, and metal packing straps he managed to salvage in the city. At the time I met him, his total production consisted of lanterns, alcohol stoves, trivets, and whistles, all of which he sold on the street corners of the city where he gathered his materials. This was not enough to keep him and his family financially afloat, but it supplemented the minimal farming his physical condition would allow.

Some part-time refabricators made things to order for full-time refabricators. A proprietor of one of the larger workshops in Guadalajara told me that he ordered some very cheap *braceros* (small portable charcoal braziers) that way. "They are very easy to make," he said. "The people who made them don't know how to make anything else. They're just made out of tin cans. Anybody can make them. I just don't have the time right now." He added that his own *braceros* were more difficult to make and rivet because they were made out of heavier metal like license plates, or sheet metal from wrecked cars, trucks, or buses.

Typical of the middle range of refabricating workshops were those run by Don Geraldo in Pátzcuaro and Don Luis in Morelia. Don Geraldo ran a small, three-man family shop that made only *braceros* and dustpans from old license plates (plate 6.2). He had neither the time nor the inclination to do any more types of refabrication himself. The specialized work he did involved a fairly simple process of cutting, riveting, and crimping license plates. To get involved in soldering, which is the other major joining technique used by workshop refabricators, would have involved more than it was worth to him in time to learn how to do it well and in the expense involved in setting up a more complex shop. Besides, this would have interfered with the other work done in his shop – carving wooden statues of saints, coats-of-arms, and fanciful imitations of antiques.

To get license plates, Don Geraldo often had to travel as far as Uruapan and Guadalajara, sixty and 240 miles away, respectively. He bought them by the kilo from professional collectors who sold license plates, tin cans, and other recyclables. Gasoline stations, which went through hundreds of motor oil cans of all sizes, often did a brisk business in them with the professional collectors and recyclers. Grocers were also involved in supplying materials by selling flour and rice sacks. In fact, any business that dealt with containers, or anything else acknowledged to be profitably recyclable, engaged in marketing those items.

Don Geraldo sold his *braceros* and dustpans to a few small shops in Pátzcuaro and its vicinity that dealt in refabricated goods. He also ran a stand in the marketplace which his twelve-year-old son usually tended. The sales of his *braceros* and dustpans did not bring in enough money by themselves (his carvings were sold separately to curiosity shops), so he

made periodic trips to Guadalajara to buy a variety of refabricated goods from some larger workshops in order to offer a greater selection at his own stand. His customary purchases included *aparatos*, funnels of all shapes and sizes, some with straight and some with angled or multiangled spouts, made from tin cans; kitchen utensils such as spatulas, potato peelers, deep-frying pastry molds, and tongs all constructed from metal packing straps; flour sifters and strainers made from tin cans, wire, and metal screening; large and small sprinkling cans made from tin cans; and tiny alcohol stoves made from small cans of tuna or chilies with packing strap grilles. With some of these larger workshops, Don Geraldo had informal credit arrangements, so he could afford to buy enough goods even when his personal finances were low. In addition to these items, he further diversified his inventory by selling some small, cheaply manufactured hardware items such as scissors and pocket knives, some plastic goods, and cheap plastic toys.

6.9
In his workshop stall in the Morelia market, Don Luis Algarín Nieto makes stamps for *pan dulce* (Mexican sweet breads). At his elbow is a lantern that he bought; made from glass and tin cans, it is in a style typical of Celaya, Guanajuato.

Working at a higher level of specialization was Don Luis. He was a full-time refabricator, a professional tinsmith with a workshop in the central market in Morelia where he did all of his refabricating and selling. At the time I first met him, in the late 1970s, Don Luis had been working on his own for more than twenty years. Then in his early fifties, he could only say that he started tinsmithing "years ago!" He worked for fourteen years as an apprentice to a master tinsmith who "probably learned the craft from his father." He had been in the same stall in the market for more than five years, and his fifteen-year-old son, who had left secondary school after the first year, was learning the craft. His ten-year-old son, who was still in school, helped out from time to time. Though Don Luis hoped that the younger boy would continue in school, he expected that he too would eventually learn to be a tinsmith.

Reflecting his full-time specialty, Don Luis's shop was technologically much better equipped than Don Geraldo's. His additional capability of soldering, and his use of several simple but effective bending and crimping presses, which he fabricated from heavy scrap metal, allowed his products to be more varied and complex. In fact, all the items Don Geraldo had to buy in Guadalajara to fill out his recycled inventory could have been produced in Don Luis's workshop (plate 6.9).

Don Luis's regular production included *aparatos*, funnels, and sprinkling cans made from various sizes and types of tin cans; jerry cans made from four-liter motor oil cans with spouts, handles, and bottle-cap stoppers added; sheet-metal griddles; decorative cookie cutters used to imprint designs on *pan dulce* (Mexican sweet bread) made from the resealable lids of powdered milk cans (plate 6.10); and pumps for kerosene or water made from a combination of new and recycled metal, using two "boulder-sized" marbles as valves. He also offered beads cut from tires to use in constructing oxen harnesses, or as hoop toys for children. He bought these tire beads separately from a professional collector who sold the rest of the tire body to shoemakers. The shoemakers cut them up into soles for sandals. Included in my collection is a pair made for a child, with "GOOD" emblazoned in white on the right sole, and "YEAR" on the left (plate 6.11).

As a full-time tinsmith, Don Luis did nothing but tinsmithing; in addition to refabricating junk, this included patching and mending various metal objects, custom building others, and using both junk and new metals in his work. Some of his principal nonrecycled fabrications were outsized funnels, popsicle molds, and most important, certified measures for liquids and grains that were used by food vendors in shops and markets. The production of these measures was controlled by a governmental agency, and each legal unit was licensed. "Some tinsmiths make them illegally from used metal," Don Luis said, "but I don't. They have to be from new, clean metal so you can measure milk without getting it dirty from the paint."

Besides selling from his stall in the market, Don Luis also sold to itinerant peddlers who came to his workshop to buy in quantity for a twenty percent discount. These peddlers were generally regulars. One of them had a stall in the Pátzcuaro market, but there were others who only infrequently bought from him. Peddlers like these could be found all over Mexico. It was through their activities that the products of large and centrally located workshops were spread over local areas and even all over the country. Most of the salesmen followed regular routes of fiestas and market days, such as one of Don Luis's

6.10

Decorative Stamps for Pan Dulce. Luis Algarín Nieto, Morelia, Michoacán, Mexico. 1972. "Quaker State" oil cans and tin can lids. H 1 1/2 x Diam 3 3/4" (4 x 9.5 cm) each. Collection Julius Kassovic, California.

Mexican bakeries are famous for their beautifully shaped *pan dulce,* a kind of sweet bread whose rounded surface is stamped with traditional patterns such as spirals, shells, and fans. These decorative stamps were made by a professional refabricator who specializes in making cooking utensils and other household implements. Each stamp is made from the resealable lid of a powdered milk can, with a handle on one side and a design made from strips of metal cut from a motor oil can on the other.

regulars who went to Uruapan on Monday, Pátzcuaro on Friday, and Morelia on Sunday. Most of them also sold whatever else they could acquire, especially hardware, plastics, and toys. The inventory of their offerings was similar to Don Geraldo's in Pátzcuaro, depending on who their suppliers were and what ancillary items they acquired that week.

The largest refabricating shops were similar to Don Luis's, but more complex in terms of their technology and specialized machinery. They concentrated on refabrication to the exclusion of other activities. Better equipped, these workshops were able to produce in greater volume and achieve high levels of quality and complexity. The technical capability of Don Rafael's shop near the central market in Guadalajara allowed him to produce, for example, a small kitchen strainer from a can of chilies, plastic-covered wire, and fine screening, with the perfection of an industrially produced item – no jagged edges or other faults in execution so common at the less complex levels of production.

Don Rafael could also add decorative features that could not be done in smaller shops. Storage containers made from beer cans could be made in a small shop, but in the larger ones the can was placed in an old commercial press and given a series of rippled crimps, which besides being decorative also strengthened the thin aluminum body. The same was routinely done with refabricated copies of industrially produced metal tubs, giving them the same form as the original model; the resulting products differed only in the use of recycled rather than new materials, and a lower price. The only items produced by these large workshops that were not also produced by smaller ones were constructions such as toy cars and trucks that had intricately formed metal bodies stamped out on special presses, and fairly complex mechanisms such as flour sifters.

In their technical sophistication and relatively large-scale production, some of these large refabricating enterprises began to resemble factories. The situation was complicated by their occasional, and sometimes more than occasional, use of new metals, especially in the imitation of industrial goods. There was, however, a self-drawn folk-industrial distinction: these products never crossed the line because they were marketed completely on the folk level. While stalls and shops that sold refabrications often mixed in new products, it was very rare to see refabricated objects sold in stores specializing in new products. The exception that proved this rule was the case of *grapas*, or small, beltlike metal clips used to nail electrical wiring to a wall. These were sold in hardware stores, and were usually made from new

6.11

Huarache Sandals. Maker unknown, Guadalajara, Jalisco, Mexico. 1972. "Goodyear" tire and leather. H 3 1/4 x D 7 1/4" (8 x 18.7 cm) each. Collection Julius Kassovic, California.

In Mexico, old tire tread has become the accepted material for the soles of traditional leather huarache sandals. This pair, made from the same strip of a "Goodyear" tire, was purchased in the central market (La Libertad) in Guadalajara from a stall selling hundreds of such sandals.

metal, but from time to time some hardware stores offered recycled ones as well, showing shiny metal on one side, and oil or beer labels on the other.

Tinsmiths, the refabricators of metal products, constituted the greatest number of the workshop producers simply because junked metal made up the bulk of recycled products. The other major refabricators were sandal makers, who recycled tires, and wagon makers, who recycled junked vehicles. In Mexico, on the folk level, there was no term for this kind of recycling and no category that included all the levels of refabricating. The range of activities that I studied together involved amateurs, the semiskilled, and highly skilled craftsmen. Craftsmen were distinct from casual household refabricators, but the reworking of junk did not distinguish the craftsmen from those who worked with more traditional materials. The craftsmen identified themselves as tinsmiths or shoemakers, not as folk recyclers/refabricators. They saw themselves as traditional craftsmen who merely availed themselves of the most economical and practical materials. Often they worked in both new and recycled materials, so the line was blurred both between the materials used and the products that resulted.

Form, Function, and Tradition

Refabricating junk is not merely a mechanical process; it is first and foremost a creative process. Underlying the physical changes that are made in the process of recycling is a process of conceptualization, or reconceptualization. Sometimes the desired refabricated item is very close in form and function to what already exists, such as a flower pot made from a tin can. At other times, what is conceptualized is completely different, like a delicately spoked birdcage made from strips of metal cut from many tin cans. And sometimes the refabricated item retains its original form while performing an entirely new function, as when bottle caps are placed on a patterned board and become checkers, with jagged edges up or down to indicate sides.

In order to help understand how folk recycling is done, it is useful to think of the process on a scale, with the original piece of junk on one end and a completely rebuilt object on the other. We could label these two opposite points "minimal modification" and "radical modification."

In minimal modification, little is done physically to modify the original shape or form of a piece of junk because the intended use of the resulting object does not demand greater changes. For example, a flower pot can be made out of a tin can by simply cutting out the top, which may have already been done to remove the contents.

At the other end of the scale, radical modification suggests that a piece of junk merely provides the component parts for the production of a completely new and unrelated article, such as the globe-shaped birdcage made from tin cans. The cage's thin, semi-circular bars were made by cutting four-liter oil cans apart to make flat metal sheets; these sheets were then cut into long strips, rolled lengthwise, and bent and soldered into shape.

Most folk refabrications could be placed at various points in between these two extremes, with many combining aspects of both minimal and radical modification. At the minimal end of the scale, the process of recycling is relatively easy since the modifications are simple, yet the conceptual leap from the original object may be either minimal or radical. When Sara needed a bucket, she looked for a large tin can to which she could attach a wire handle; she turned one kind of container into another. When Miguel made the sardine-can currycomb, however, he conceptualized a function completely different from the sardine can's original function as a container. Bottle-cap checkers and bottle-cap lathing are other examples of radical conceptual transformation from an original function to a recycled one.

At the radical end of the spectrum, the conceptualization is quite different. Here, junk provides only useful materials and not useful forms. In this way, license plates are cut up and made into *braceros* and dustpans, and oil cans give up their original structures to become birdcages or toy steamboats.

Because so many refabricated articles are utilitarian basics, the same items are generally refabricated from the same kinds of junk in the same manner in households and workshops all over the country. The basic designs of folk refabrications are, to a great extent, national and even international. This standard-

ization of material usage and design is most evident where the structural integrity of the original object is most preserved. It is only at the level of radical modification that significant local variations occur, because at this level the craftsmen are not limited to any basic form.

A good example of traditional design, variation, and material usage is in the production of kerosene lamps, or *aparatos*. The *aparato* was perhaps the single most common refabricated item in all of Mexico. In its basic form it is made of two pieces, a kerosene reservoir and a removable wick holder. Some *aparatos* are small, handheld models consisting of the reservoir and wick holder only, fitted with either metal finger grips or wire handles. Others are larger and often fitted with stands and provisions for multiple wicks. In their basic forms, however, they are similar to traditional candlesticks and hurricane lamps.

The variations that occur in the basic design of the *aparatos* are generally minimal. For example, a flange to catch ashes may be made out of a bottle cap or other metal, or be entirely absent. Little or no geographic difference in design can be ascertained. This is due, at least in part, to the extremely simple design of the basic *aparato* and its wide distribution. The variations that do occur seem to be less geographically specific than workshop specific. Its name, however, does change with geography; in the north of Mexico it is called a *cachimba*, in central Mexico an *aparato*, and in the south and Guatemala it is called a *candil*.

The design of *internas*, on the other hand, is geographically specific. An *interna* is nothing more than an *aparato* in a glass-enclosed box with a door and some kind of venting. Its design changes because its glass box is made by radical modification, yet the little enclosed *aparato,* closer to the minimal modification end of the spectrum, remains practically identical everywhere. In his workshop in Morelia, Michoacán, Don Luis had an *interna* from Celaya, Guanajuato. When I asked him if he made it, he said, "No, that is from Celaya. Here we make them differently; I brought that one here after visiting Celaya only as a curiosity." Similarly, examples from Tehuacán, Puebla, are quite different from both the Morelia and Celaya styles.

Aesthetics and Folk Recycling

How do recycled products fit into the Mexican folk aesthetic? Folk refabrications are produced within cultural traditions to meet not only utilitarian requirements, but a myriad of others as well. From the point of view of a craftsman like Don Luis, his chief criterion for evaluating a refabricated piece was the same as that for an item he produced from new materials: was the item well made? At the time that the pieces which form the basis of this essay were collected, craftsmen were not yet responding to a tourist market that valued the pieces precisely for the obvious industrial origin of their recycled components. These refabricators therefore did not purposely emphasize the recycled aspects of their products.

With tin cans, for example, they often worked with both the brightly printed exteriors and the shiny metal interiors in a single piece. Thus a watering can might be based on an intact motor oil or chili can for the reservoir, while the spout and handle would be cut from cans, but formed with the shiny (unprinted) side out. This is an aesthetic as well as an economic decision – the tin-can reservoir, as a minor modification, could not be reasonably turned inside out, but because the handles and spouts are radical modifications, the tinsmith had the option of showing either shiny, new-looking metal from the interior of the cans, or the painted logos. Almost all of the *internas* in my collection have their glass boxes framed in shiny metal on the outside, while their little internal kerosene reservoirs are made out of tin cans showing their labels.

Two of the few products made in Mexico at that time that boldly showed their recycled origins as part of their raison d'être were flour sack shirts and hats showing brightly printed logos. These, though, were sold almost exclusively to tourists in tourist-oriented shops. When village mothers made clothes, curtains, and sheets from flour sacks, the sacks were inevitably bleached white before they were sewn. I did find one example of obviously recycled apparel that was bought by the average Mexican, but only in the bullring. It was a paper spectator's hat, cut out of old movie posters, and was meant to be tossed into the air.

6.12

One of the streets opposite the central market of Guadalajara is dominated by store after store specializing in recycled goods. This shop is overflowing with stacks of watering cans, dustpans, griddles, jerry cans, pots, lanterns, kitchen implements, mouse traps, and other products fabricated from industrial discards.

While craftsmen stressed the sturdiness and functionality of their recycled products, the products themselves – exuberantly colorful and shiny, in familiar styles sometimes shaped by regional traditions – formed a visually integrated part of the larger aesthetic of the villages, towns, and urban neighborhoods where they were produced, purchased, and used. Workshops and stores were filled to bursting with goods, hanging in bundles from the ceiling, stacked from wall to wall, and usually spilling out into the street (plate 6.12). This colorful jumble of recycled items enlivened shops and market stalls (and attracted customers) in the same way as did stacks of sombreros, piles of chilies, and pyramids of pottery or tropical fruits.

In people's homes, these mostly utilitarian objects were found in appropriate places doing their appointed tasks, usually unobtrusively. However, on the white-washed adobe walls, flowering plants were hung in tin cans, sometimes in combination with ceramic flower pots, providing a rich mixture of colors and textures. Sometimes the tin-can flower pots were painted to conform to a color scheme their makers had in mind, but usually they were left in their natural states, mixing together various colors and designs. Sara, the producer of one of these hanging gardens, insisted that "nobody really looks at the flower pots. We look at the flowers, and see how beautiful they are. And besides, they say that flowers bloom better in metal cans." Despite her dismissal of the printed logos, her careful arrangements of these displays were harmonious with the traditional interiors of village homes.

The ability to appreciate recycled objects themselves in terms of aesthetic qualities such as design, color, reflectiveness, and form is shown most clearly in cases where the recyclers have used them to create purely decorative effects. An example would be Miguel Peña Zavala's hoop toy (plate 6.3), in which bottle caps were used for their size, uniformity, and color to create the decorative touch he had in mind. He was particularly pleased with the effect when the hoop was in motion and presented a shiny, spinning blur of color against the cobbled street. Similarly, a plain muslin dance costume in Ocumicho was decorated with dozens of bottle caps that had been smashed flat and hung by threads, like fringe. The

effect was colorful and sonorous – when the thin disks hit each other in the dance, they both flashed and tinkled like little bells. One of the most elaborate and extravagant uses of bottle caps I ever saw in Mexico was a house completely covered by a dazzling bottle-cap mosaic (plate 6.13). Bottle caps by the thousands had been carefully sorted by color and brand, and stuck into wet cement, forming long stripes and blocks of brilliant colors – yellow Squirt caps alternated with silvery Pepsi and orange Fanta.

I began to study folk recycling in Mexico because I was fascinated by the creativity displayed in the individual items I saw, and, when I began to realize that it was more than a mere scattering of temporary improvisations, I was overwhelmed by its pervasiveness. In the broadest sense, folk recycling is a way of life.

Folk recycling provides an alternate and cheaper source of goods for poor people, who are underserved by industry. Those who could not otherwise afford certain products are able to find refabricated alternatives at prices that are attainable. A hand pump provides a good example; as a manufactured item it is more than five times the cost of a refabricated product. In addition, there are products, like *aparatos* and *braceros*, which had no manufactured equivalents. At the workshop level, folk recycling has its own economy. It provides employment throughout the society, engaging people in the collection of recyclables, in the refabrication process itself, and in the distribution of products.

Folk recycling is not without its own problems. The process of refabrication is dirty and completely unregulated; the concentration of garbage and toxic wastes generated by some of the more complex workshops is cause for concern, both for the workers and for their surroundings. In addition, many of the refabricated products, particularly toys and kitchen implements, could be considered dangerous because of exposed sharp edges, lead solder, toxic paints, and other hazards.

While acknowledging these concerns, it is impossible to contemplate folk recycling in Mexico without being impressed by its scope – the number of people involved, the amount of junk reused – and its potential to enlarge and enrich the consumer base of a poor country. Through folk recycling, with a combination of tradition and innovation, poor people make their own lives easier, more comfortable, and often more beautiful.

6.13
This adobe house in rural northern Mexico was faced with a smooth covering of cement. Thousands of bottle caps, carefully chosen by color, were pushed into the wet cement as a decorative device.

Recycling in India:
Status and Economic Realities

Frank J. Korom

7.1

Paper Stick Puppets. Vinod Kumar Sharma, New Delhi, India. 1994. Magazine cutouts, sticks. H 20 3/4 x W 12 3/4" (52.7 x 32.38 cm). International Folk Art Foundation Collection, Museum of International Folk Art, Santa Fe.

Traditional stick puppets made from magazine cutouts are popular toys sold in contemporary Indian markets. Where once they might have depicted the characters of Hindu mythology, today they sport images of movie stars and modern Indian heroes from the mass media.

He had left me outside a colony of squatters' shacks, small ephemeral dwellings made from scavenged materials. This was garbage-dump architecture, its constituent parts abandoned by the affluent world outside but put to good use here. I noted packing-crate timber, rusting corrugated iron, bits of polystyrene insulating materials, lengths of piping and plastic sheeting.

The inhabitants clustered in their hovels watching expressionlessly. Then a small, bony, unshaven man stepped forward, picked up my bag and beckoned to me. I entered his home through a doorway made from an iron bed frame.

(Frater 1991, 138)

7.2

This striking example of a painted rickshaw made with recycled metal pieces is from Rajshahi, Bangladesh. The panel located between the axle and the seat depicts an idyllic country scene. It is styled from misprinted sheet metal of the type used by multinational corporations, such as Coca-Cola and others, for product labels and containers. The misprinted sheets, being of no use to the packager, are sold at a low price to middlemen, who resell them in Bangladesh's urban marketplaces.

Virtually everyone who has traveled to India has encountered recycling in one form or another and probably has marvelous stories to tell about the peculiar "social life of things" (Appadurai 1986) there.[1] My first critical encounter with reused material occurred early one brisk fall morning in 1977 on the Srinagar-Leh road. It was barely dawn and the overcrowded bus I was riding in was already an hour north out of Kargil, the halfway point on the tedious road between the two cities. Suddenly, the vehicle coughed to a clattering halt in rhythm with the snores of the sleeping passengers. Rudely awakened by shouts and curses, we all filed out. The conductor, doubling as mechanic, quickly fumbled with the hood, squinted at the engine block, and located the source of the problem: a fixture that looked like something I had never seen before. Muttering incoherently under his breath about spare parts, the trustworthy mechanic heroically began jogging back in the direction of Kargil, much to the amazement of all there.

Our savior reappeared sometime in the afternoon, huffing and puffing, with a box of what seemed to be scrap metal on his head. With the skill of a surgeon and only the barest minimum of tools, he quickly set about his task of operating on the ailing motor; half of it had been taken apart and reassembled by nightfall. To my surprise, much of the original engine was lying on the side of the dusty road, having been replaced with bits and pieces of everything from glass beads and tin cans to melted wads of rubber. Although all of the passengers on the bus had their doubts about the reliability of this makeshift patch job, we piled back into the bus, drove through the night, and reached Leh the next morning without further delay.

Stories such as this one are all too common from travelers in India and throughout South Asia. In fact, these sorts of experiences are fairly pervasive throughout much of the so-called third world, where special classes of people follow items down a predictable trail leading from production to consumption to disposal to collection to sorting to resale (Grothues 1984). These scraps are then transformed into usable objects, ultimately ending up in the possession of a patron who purchases the remade object from an artisan directly, or from a middleman, a shopkeeper, or street vendor. Such a continuous pattern of consumption, salvage, and re-creation is a vital part of

many informal sector economies (Long and Richardson 1978), working itself out not only in functional ways, but also in aesthetic and artistic ones.

In India, a "recyclical" pattern of existence has developed over a long period of time that in some sense goes back to the creation of time itself. The idea of recycling time is rooted in Hindu cosmogonic notions pertaining to the recurrent nature of manifest reality. Indeed, one could argue on a philosophical point that the whole Hindu cosmos was created and is maintained through patterns that might be defined as a "recycling" of energy. David Knipe, for example, discusses the Hindu tradition as a religious system profoundly equipped to understand the cyclically entropic sense of time and space in its

recognition that cosmic energies and elements are renewable resources, that the universe is driven by perpetual regenerations, and that in the final analysis it is a process of necessary and repeated dying that mysteriously provides new being for the world, its elements, and its inhabitants of every species. (Knipe 1993, 798–9)

Beyond such theological speculations about the nature of existence and the evolution of life, there is a very real dimension to recycling in India. On the mundane level of economic utilitarianism, under the traditional caste system the practice of reusing things was framed in terms of a strict social hierarchy mandated by Hindu law books and orthodox cultural practices. These laws stipulated the rules of interaction,

7.4

Toy Train. Vinod Kumar Sharma, New Delhi, India. 1994. Tin cans, shoe polish cans, plastic. H 9 1/2 x W 4" (17.94 x 10.16 cm). International Folk Art Foundation Collection, Museum of International Folk Art, Santa Fe.

This recycling artisan is especially fond of making small trains, trucks, and cars because they remind him of the toys he made and played with as a child. Both children and adults are drawn to Vinod's beautifully crafted locomotives, which are some of his most popular items.

7.3

Basket. Vinod Kumar Sharma, New Delhi, India. 1994. Rolled newspaper. H 3 x W 7 1/4 x D 3" (7.62 x 18.4 x 7.62 cm). International Folk Art Foundation Collection, Museum of International Folk Art, Santa Fe.

Vinod makes a number of different kinds of baskets from scavenged newspaper. The tightness of the weave and, hence, the strength of the basket depend on what he intends the container to be used for.

codes of conduct, and services that could be performed by each group within the culture. In essence, caste-based communities embodied skills that could be used to satisfy each other's needs in a reciprocal fashion. At the "head" of the hierarchy was the Brahman, who nurtured the ritualistic aspirations of the Hindu community, while the Shudra was at the "feet," performing lowly services for the higher castes. These socially inferior services included, of course, the collection and subsequent destruction or reconstruction of waste matter, a task performed solely by the poor today.[2]

In modern India, the poor continue to produce new items out of old materials largely for personal use or recirculation among impoverished groups, as they have for many generations. This is the case with a number of ordinary household items such as ovens, lamps, containers, furniture, and rag rugs (cf. Herald 1992, 184–5).[3] Even discarded plastic is collected and then melted at low heat in order to be reshaped into usable items such as storage vessels and toys.[4] Sometimes, however, recycled objects are produced intentionally for consumption by the rich, elevating specific pieces to the exalted level of "fine art."[5]

Alongside functional remade things there continues to exist a class of objects which are decorative and symbolic, as well as useful.

The Bengali traditions of *kãthā* ("quilt," cf. Kramrisch 1949; Lynton 1993) embroidery, rickshaw panel decoration (Gallagher 1992, 637–54; Kirkpatrick 1984 [plate 7.2]), and *paṭ* scroll painting (Inglis 1979; Korom 1994) are all good examples of artistically remade objects, serving a variety of purposes. Such forms are, unfortunately, beyond the scope of this essay, which is concerned mostly with industrial materials reused for the dual purpose of utility and beauty. However, these examples do clearly suggest the pervasiveness of recycling activities in India.

Today we find recyclia in numerous domains. In domestic spaces, for example, remade objects serve as functional household items (plate 7.3) as well as leisure items such as toys (plates 7.4 and 7.5). Ornamental objects, such as wall decorations and picture frames, are also common. In the occupational realm tools, containers, and even business advertisements functioning in a metafolkloric fashion are made from recycled matter.[6] Some ceremonial objects are used during special occasions, although ritualistic usages, while not unheard of,[7] are not common or preferred because of beliefs concerning the unclean environments in which recycled items are produced. This is a point I shall consider in more detail below. It is imperative to note that recycling in India does not just operate as an economic necessity or an aesthetic choice; it is also an ecological activity intended to make urban centers more habitable. Like so many countries in the so-called developing world (cf. Guibbert 1990), India is participating in a global reclamation initiated primarily by European and American scientists and activists concerned with the destiny of our planet.

It would not be difficult to imagine the political and ideological rhetoric that must be employed to discuss the transnational ramifications of global recycling and the disposal of waste, or the hegemonic manipulations of such "first world"/"third world" interactions. However, the issue I wish to raise here does not address power and knowledge relationships in any concrete sense.[8] Rather, it simply acknowledges that such discourses have an impact upon local ideas about recycling, shaping the way that some

7.5

Toy Cobra. Vinod Kumar Sharma, New Delhi, India. 1994. Electrical conduit and paint can. H 44 x W 1 x D 1" (111.76 x 2.54 x 2.54 cm). International Folk Art Foundation Collection, Museum of International Folk Art, Santa Fe.

Vinod claims to be able to make anything out of anything. Here is an elegant example of a toy sculpture that utilizes the shape and pliability of metal wire casing to create the animated likeness of a cobra.

people engaged in the process of remaking and reusing things consciously think about what it is they are doing. Economic position and caste status still persist as the major forces that shape the ways in which opinions about recycling are formulated. The positive feedback generated by foreigners about recycling forces Indian recyclers to think more reflexively about their activities.[9] Radical or alternative musings from within the recycling community on the positive nature of their trade may be limited or repressed because of the low status, economic constraints, and political under-representation of the recyclers, but they are important considerations for grasping the underlying sociological dynamics of the situation encountered by these people on a daily basis in India.

Two points are central to this essay. First, I would like to suggest that "recycling," as it is popularly understood in the United States, was not a labeled category of economic, ecological, or aesthetic practice in India for much of its precolonial history.[10] I do not mean to suggest, however, that the production of goods out of used materials did not occur.[11] On the contrary, reusing objects has always been a deeply embedded daily routine in India, a cultural practice clearly understood and demarcated along lines of status and wealth. Because of its commonplace nature as an economic necessity, the innovative reuse of everyday synthetic and natural materials for new purposes is widespread among the subaltern classes of India. However, when these same items are produced for the upper strata of Indian society, their reused nature is often concealed owing to an indigenous philosophy of purity and pollution, the dividing up of the world into clean and unclean realms.[12]

In his discussion of Indian concepts pertaining to open spaces and public places, Dipesh Chakrabarty (1991) has pointed out that garbage must be contained, kept in its place in order to keep private domains free from contamination. Mary Douglas (1984) has suggested that domains of impurity tend to be destabilizing when they encroach upon pure or clean ones. Hence, "dirt" and its by-products are not only considered to be polluting but dangerous, creating contagion by association. This partly explains the social distance that has been created to separate Hindu workers who handle polluting substances from ritu-

ally purer Hindus. Although they have always inhabited the periphery physically and symbolically, the marginalization of recyclers is much more common today because of the increase of waste in urban contexts. This attitude not only directly affects the rank of the recycling worker who collects and sorts trash for resale, but also taints the artisan who creates from waste material. Ethnographically, this is a fact, even though the juridical sage Manu is reported to have said that "the hand of an artisan is always pure."[13]

The second important point to bear in mind is that the pervasiveness of the pure (śuddha)/impure (aśuddha) dichotomy in Hindu thought has not allowed those who practice recycling – which entails scavenging and coming into contact with polluted (ucchiṣṭa) materials – to attain a rank even remotely equivalent to that of artisan castes or guilds.[14] In fact, most recyclers stand outside of the ranking system altogether, being considered "garbage pickers" (kabāḍīvālās), a lowly class of "untouchable" people who make their living from collecting and sorting the kinds of things that no other Hindu would even come near. By extension, the status of anyone else who may be involved in the trade of recyclia is affected. The artisan, then, who utilizes reused materials as a medium of expression becomes a victim of what Henry Orenstein has called external-act pollution (Orenstein 1968, 116–7).[15]

Being Creative within the Hierarchy

To illustrate these principles, I would like to explore the perspective of Vinod Kumar Sharma, a man whose unique role as an artist of recyclia defies classification because of his Brahmanical status, and who is by no means typical of "untouchable" workers in the recycling industry. Nonetheless, his industriousness is not only a testimony to his own creative potential but also to the vitality of the industry providing him with his raw materials.

Vinod is a low-income Brahman in his mid-thirties. He is also an artist. Although not trained in any of the traditional arts, he is gifted with an uncanny ability to see beauty in virtually any object. Realizing this skill early in life, he began making objects out of whatever materials were readily avail-

able in his local environment, no matter how crude, bent, wrinkled, or rusty. What was once a boyhood hobby, learned in school craft classes and from peers on the street, is now a livelihood, for Vinod has honed his artistic skills over the years. Today he proudly goes by his self-proclaimed title: Maker of Three Thousand Objects.[16]

Vinod is one of the few people in India that I know who is willing to risk his own high caste status and ritual purity for the sake of a highly personal vision. I use the term "risk" here because the spiraling process of his "downward mobility" has not been completed yet. It is rather an ongoing dialogic situation in which he must constantly negotiate both rank and identity. But even though he regrets the fact that people castigate him for working in the recycling industry, Vinod persists in his endeavors because of a strong sense of commitment to a philosophy of thriftiness and to an aesthetic of poverty in his art.

For Vinod, there is an incipient sense of empowerment through creative expression in poverty. Conversely, he views the increase of waste matter and the pervasive use of plastic as emblematic of the poverty of the postmodern world; that is, he perceives poverty not only as a decline in the quality of modern goods, but also as a degeneration of moral and ethical values resulting from consumerism and mass media. Moreover, these concerns correspond to the decay of India's traditional culture and urban landscapes. Handcrafted objects that once predominated in the realm of material culture are now dying out as synthetic, machine-made items replace them.[17] Not unlike certain European and American thinkers at the time of the Industrial Revolution, Vinod is critical of modernity.[18] While understanding the need for technological improvements and mass production, he objects to the immoral and unethical nature of development without reflection on long-term consequences. "People don't think," he says, "about how their actions will affect everyone else. They want things *now,* without even giving thought to the future!"

Vinod the thinker has been exposed to a fair amount of liberal thinking on the environment through mass media coverage of social protest against environmental damage, such as deforestation.[19] Vinod the artist creates from his own urban experience. Because he

is a product of an urban landscape himself, living in a large *bastī* (ghetto) on the outskirts of New Delhi, he can speak with authority on the subject. It is there, in the midst of squalor, that he plies his trade, using his roof as a storehouse for junk and an adjacent room as a studio. From here, he goes out into the world on a daily basis to search for cast-off items that can be transformed into useful things pleasing to the eye. By doing so, he hopes to contribute to the reclamation and beautification of his own neighborhood. His endeavors, according to one sympathizer we spoke with as we scavenged for materials on a posh street in suburban New Delhi, could lead to a trickle effect throughout the city and eventually throughout the country.[20] This seems highly improbable, given the amount of urban decay, continually increasing population, and abject poverty of slum dwellers. The goal, however, provides a constant incentive for action.

A typical day in the life of Vinod Kumar Sharma begins at dawn. It consists of visits to a number of junkyards in his neighborhood and elsewhere in the city where waste matter is sorted by kind to be either resold or disposed of. He also stops at flea markets and bazaars where a vast array of used goods are sold. With the eye of a craftsman, he skillfully picks out objects, often with a particular use in mind. One day, while strolling through the *kabāḍī bāzār* (flea market), a weekly event held in the shadow of the Red Fort in Old Delhi, Vinod searched for the cylindrical shoe polish containers that he would use as wheels for a toy truck and discarded eyeglass lenses to be used for homemade slide viewers and film projectors. On another day, he bought metal strapping tape from a crate vendor to make functional objects such as letter holders and lampshades.

Like a *bricoleur,*[21] he assembles an impressive assortment of seemingly random odds and ends that make sense only to him and transports them back to his home in burlap bags. He dumps his pile on the flat roof of his home and sorts things according to immediate or future needs. The objects that he will utilize immediately are then carried into his workroom by his young son.

There, in a small, dimly lit room shared with his other child, a mentally and physically handicapped

second son, Vinod enthusiastically goes about his work, inspired to a great extent by the boy who rests silently on a nearby rope cot. On any given day, Vinod might make paper pinwheels and puppets (plate 7.1) to sell to children of all ages at the weekly market held in front of the Hanuman Temple in downtown New Delhi. Other days he might make purely ornamental objects, inspired by his own peculiar sense of taste, to decorate the homes of relatives and friends. But because the items are all made out of recycled materials, some quite dirty or rusty, most people are wary of accepting such gifts from him. Fear of contamination creates a barrier between Vinod and other high-caste people.

As we sit on the floor of his workroom on a dusty, hot day in March, Vinod cuts a *ghī* (clarified butter) tin with crude shears to make a swan-shaped carriage, while I write notes and take pictures of the process. He sits silently cutting tin and contemplating his latest masterpiece. Suddenly he begins telling me how this line of work has affected his family and him. "People yell at me on the street," he says, "saying, 'What is a Brahman doing picking through the trash?' Even my father complains, calling me a *kabāḍīvālā*!" This is the kind of ridicule Vinod encounters even in his own neighborhood, where his identity and status are known to all. The look on his face is severe, expressing the contempt he must experience each day on the street. But he smiles in an instant and says that it matters little because he is not concerned with the opinions of others.

Vinod does, however, care about other people's attitudes toward his family, and he struggles daily with his internal conflict: loyalty to his trade or devotion to his family. Our discussions about the problematics of pollution led us to conclude that there is a definite need on the part of Indian recyclers to be concerned about the symbolic danger of contaminating others with impure substances.

Recycled Masking and Artistic Strategies

Jyotindra Jain (1992, 2–3) has suggested that the pervasiveness of the sacred distinction made in Sanskritic Hinduism between pure and impure substances and states of being has invariably affected common atti-

tudes toward recycling in the secular realm, affecting everything from the market economy to the availability and quality of everyday, household goods.[22] Since the *rich*ually pure continue to associate recyclia with the *rit*ually poor, the stigma associated with working in the recycling industry still evokes a sense of disgust in many people. "That is why," Vinod says, "commercial lamps and toys made from recycled tin must be turned inside out and freshly painted. If not, the *baṛa log* (big people) won't buy them."

The implicit assumption here is that economically advantaged people will use a well-made product crafted from recycled material so long as they are not aware of the object's social history. This is what I

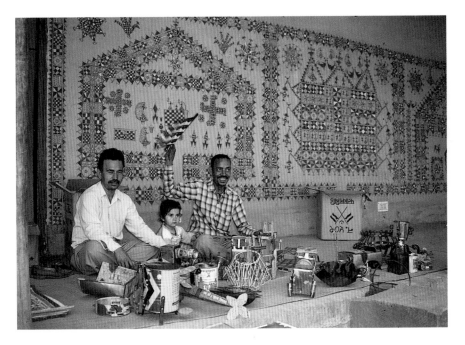

7.6
Recycling artist Vinod Kumar Sharma (waving a fan of folded cigarette packets) sits with his brother and niece amid his numerous creations on the veranda of the Crafts Museum in New Delhi. It is here that Vinod first demonstrated his art of recycling and attained some local notoriety for his scrap toys, bowls, whimsies, and other objects.

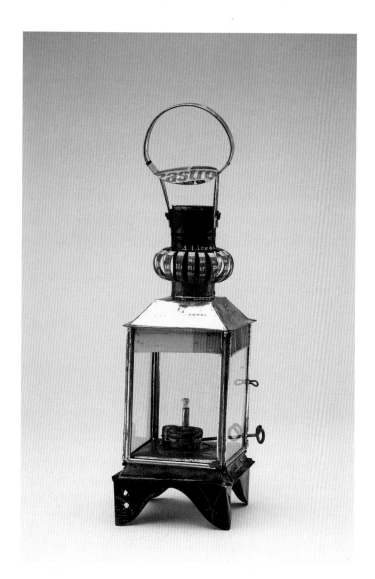

7.7

Oil Lamp. Maker unknown, West Bengal, India. 1994. Assorted sheet metal and plastic. H 13 x W 3 1/2 x D 4" (33 x 8.89 x 10.16 cm). International Folk Art Foundation Collection, Museum of International Folk Art, Santa Fe.

These lamps, standard in size and shape, come in a number of different colors and patterns, depending on the types of scrap metal and plastic that are available. Although the lamps are made in Bankura District, a considerable distance from the city, they are sold for a low price in the vicinity of the Howrah Railway Station in Calcutta.

would call "recycled masking," the deliberate hiding of a product's reused nature for commercial gain. Shopkeepers, like mass producers of commercial recyclia, thus have a vested interest in concealing the origin of the product's base materials. Indeed, when we walked through a market in the small industrial town of Badar Pur on the Grand Trunk Road near New Delhi, shopkeepers constantly denied that their goods were made of "used" materials, and when we opened a kerosene lamp to prove our point, we were cursed by the shopkeeper and sent on our way. "You see," Vinod laments despondently, "this is what I tolerate every day."

The producers of various commercial items have thus devised ways to disguise the recycled nature of their products for the purpose of mass consumption. For consumers, this translates into a false sense of security to guard them from an awareness of the used nature of the base materials. However, these implicit factors have not influenced Vinod's products, all of which clearly, exactly, and tastefully display the marks of recycled goods. As a result, he has suffered both economically and hierarchically. This negative aura, however, has not hindered his overall mood and productivity, since he remains optimistic that sooner or later people will begin to appreciate the many purposes – ecological, economic, and aesthetic – of recycling.

Vinod Kumar Sharma's life circumstances and his emergence as an artist must be viewed as an extremely extraordinary case study because of his high caste status and his conscious manipulation of the Indian recycling tradition for artistic pursuits. Nonetheless, he does share much in common with the "average" recycler in that they all demonstrate great versatility and ingenuity as an occupational group, utilizing garbage to make a living. Although he is not as impoverished as those lowest of the low who scavenge for the same materials he buys for his creations, he is not wealthy by any stretch of the imagination. However, Vinod's future as an artist seems brighter today for a number of complicated, interrelated reasons.

As the Indian government begins to realize the potential danger and destructiveness of urban squalor, officials gradually are coming to understand that cleaning up cities and industrial recycling do matter.[23] Progress in this direction is slow, however, as is evi-

denced by the widespread criticism of the government's neglect of urban decay during the recent outbreak of the plague (Friese 1994, 22–5; *India Today* 1994). But on a smaller, local level, some attention is being given to how people might participate in urban renewal.

Vinod's mission to legitimate recycling is something he pursues with the zeal of a proselytizer and the compassion of an educator. His power to bring about change in attitudes has increased in recent years because of his association with museums and educators of various sorts. Moreover, seeing the exorbitant prices fetched by recycled crafts in museum gift shops, he himself has come to realize the transformative economic power of the art market. Yet wealth and fame in the art world are not primary goals for Vinod. First and foremost is the need to train and educate people in recycling. This Vinod does when he teaches children how to make things from discarded objects during the occasional workshops he conducts under the auspices of various local government organizations in the region.

Once a featured craftsman in the open-air section of New Delhi's Crafts Museum, Vinod has even received some recognition as a folk artist. This in itself is a privileged irony, since it is well known that the Crafts Museum attempts to convey a hypothetical image of the purity of Indian craft traditions.[24] Vinod's inclusion in a living display of "traditional" craftsmen was certainly a visual anomaly and a theoretical incongruity, as he hesitatingly admitted to me, for his art was seen as substandard by some of the other participants. However, this attention also legitimated his enterprise and empowered him as an artist (plate 7.6). After all, my friendship with him would not have developed had it not been for intervening factors on the part of our mutual affiliations with museums in India and the United States.[25]

International advocacy, or "cultural diplomacy" as Brian Wallis (1994) has termed it, has also done much to raise consciousness about recycling by opening up the possibility of considering objects made from cast-off materials to be works of art. Innovators such as sanitation engineer-turned-artist Nek Chand have popularized the utilization of used materials in India because of recognition received abroad. His famous Rock Garden in Chandigarh, Punjab, is a powerful "affecting presence"[26] of recyclia. Made of broken toilet bowls and plates, potsherds, and trash, the work demonstrates the potential to transform urban landscapes. It is no coincidence, then, that Nek Chand's creation, idiosyncratic as it may be, should be situated in the heart of what Indians perceive to be a "model city." Vinod calls it a living testimony to the recycling message. The international popularity and critical acclaim of this "theme park"[27] has led to a fetishization of recyclia in certain art circles in India and abroad, which, in turn, has led to more widespread acceptance of recycled goods on the utilitarian level.

The National Institute of Design in Ahmadabad, Gujarat, has been deeply interested in propagating recycling, thereby giving the phenomenon an aura of

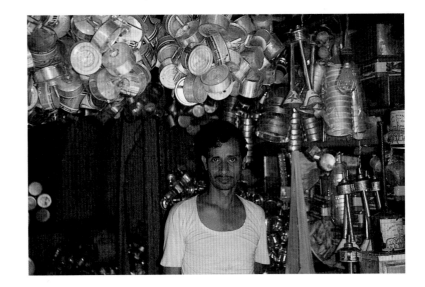

7.8
Matu Mandal is in the business of selling items made from scrap. While he carries a variety of utilitarian goods including lunch boxes, plates, cups, and utensils, his most popular item is the Bankura lamp (an example of which is shown in plate 7.7). He stands here in front of his shop, located in Bara Bazaar on the outskirts of Calcutta, West Bengal.

official sanction. The popularization of Indian recycled art is also occurring transnationally, as foreign markets are slowly being explored and exploited by more sophisticated Indian designers and experimentalists. One such designer is Dr. Anand Sarabhai, whose line of recycled items, including trunks made from tin cans and kitchen accessories made from leaves and coconut shells, are distributed worldwide by his company Eat It Private, Ltd.[28] Foreign consumption provides added prestige to recycled items not only by commodifying such objects in the transnational arena, but also by increasing their monetary value at home.[29]

There is a distinction to be made, however, between recycled art for the sake of art and remade objects produced for utilitarian purposes and economic survival.[30] The former is "controlled and ordered" recyclia, sanitized and sterilized for the consumption of art connoisseurs. But the reality remains that recycling, as we commonly understand it, is still a concept that has not received widespread acceptance in India because it is shrouded with the stigma of substance pollution. *Kabāḍīvālā*s are still scorned and ostracized, remaining economically depressed. For them, it is a way of life, a means of survival, an aspect of the "culture of poverty." (Lewis 1966) Although recycling is integral to the overall pattern of Indian life, the prevailing opinion is that it must remain marginalized and contained, lest one's purity be threatened by rampant pollution. These ideas, then, have influenced the way recycling has developed in contemporary urban India and have contributed to the maintenance of its low status.

Class, Taste, and Aesthetic Choice

How the ideology of pollution manifests itself on the street is a point worth considering in closing, and can be gauged through verbal exchanges I encountered during negotiations for the purchase of remade things. Many recycled objects made for local consumption are ingenious yet crude, functional, and cheap enough to be affordable to the economically depressed, lower-class communities. Many of these items are considered to be visually appealing within these same communities, for they are often made and distributed by people of the same caste group or neighborhood, all of whom share a common aesthetic and operate within the same social context. On the other hand, the same objects dealt with on a daily basis by the lower classes might be looked down upon by the wealthy, educated upper classes who would prefer new, shiny, and clean items. There is a great deal of truth embedded in the fact that such distinctions are found in indigenous commentaries on recycling.

Let me illustrate by using the example of the Bankura lamps (*bã̄kuṛā lampa* [plate 7.7]). Bankura lamps are made in Bankura District, West Bengal, and trucked or transported by train to Calcutta, where they make their way over the Howrah bridge on the backs of carriers who deliver them to roadside stalls in bazaars adjacent to the Hooghly River. There they are hung in bunches on the street to be purchased by the constant throng of middle-class commuters passing to and from the Howrah Railway Station. Or so I thought.

One such stall, owned by Mr. Matu Mandal (plate 7.8), is the place where I purchased my first Bankura lamp. Much to the annoyance of Mr. Mandal, I deliberated about the most interesting one for quite some time. When I finally chose the "prettiest" (*sab cheȳe sundar*), we began discussing the lamps. Meanwhile, his assistant tied a piece of twine onto the top ring of the lantern I had purchased to serve as a handle. I remarked that there must be a great demand for these lamps, but he cut me off and said, "There's a lot of poor people (*garib lok*) here." Seeing my inquisitive look, he continued by explaining that sophisticated people (*bhadra lok*) do not buy them because they are cheap, ugly, and don't work very well. I objected, pointing to the pink guarantee hung around the neck of the object that stated "Don't be fooled. Buy the one and only, world-famous Bankura lamp!" He rolled his eyes and asked me if I believed everything I read.

When I explained to him that I was purchasing this for a museum, he became embarrassed and asked why I would place a piece of junk in a museum with all of those valuable objects. I continued with my explanation of the concept of recycling and he grew more and more impatient, thinking that I had gone completely insane (*pāgal*). He even said so to his

assistant as I was leaving. Turning, I smiled and proudly held the lamp up high. They both laughed as I drifted off into the rush-hour crowd with the lantern cradled in my right arm. This amusing vignette, similarly repeated on various occasions during my collecting trip in the spring of 1994, says much about my role as an active participant in a poignant cultural encounter and the valorization of a cultural artifact through my advocacy, but it also addresses a specific class conflict within Bengali society – and by extension, Indian society at large – that shapes interpretations concerning the relative beauty and function of recycled objects. Mr. Mandal's comments epitomize the dichotomy in rich people's and poor people's attitudes.

The reactions that I received from people on the street after I left the lamp stall are further indicators to attitudes toward the infamous Bankura lamp and recycled art in general. As I intentionally moved about the city with my lamp ostentatiously displayed, I registered a wide array of responses; everything from chuckles and snickers to amazement and wonder. The chuckles and snickers came mostly from more educated (*sikhita*) and well-dressed people that I encountered on the street. As one rickshaw driver taking me through the narrow lanes of the area told me, they were laughing at my lamp. Lower-income people (i.e., members of the labor and service classes), on the other hand, commented on the design and individual character of my lamp and argued about the price I paid. I found this out when I displayed it on a table in a tea stall frequented by construction workers, road crews, beggars, and rickshaw drivers. Virtually every person who came by my table made comments about it. Eventually a crowd formed around the lamp and discussions ensued. The group concluded that it was indeed a pretty lamp, but I had paid too much for it. In essence, the lamp was more appealing, both stylistically and functionally, to the low-income labor class.

It seems that everyone in Calcutta knows of the lamps, but very few can be spotted in the homes of middle- and upper-class people who romantically refer to these lamps as quaint and rustic. Some, however, can be seen hanging on the backs of rickshaws, or dimly glowing in the lean-tos of street dwellers, most of whom have come to the city from the countryside in search of employment. What I have discovered in my search for Indian recyclia is that those who use such objects on a regular basis have developed a critical appreciation for things remade, while those who prefer new commodities often cringe at the very mention of utilizing something used before and thrown away.

The repulsion I have been referring to is deeply rooted in the ideology of pollution in India, which taints the whole recycling industry. Nevertheless, the international focus on recycling has given the whole concept and practice a new vitality. Only time will tell, however, whether those involved in the Indian recycling industry will achieve a new status as a direct result of the contemporary trend. Vinod Kumar Sharma thinks they will, for he looks forward to the day when his objects will appear in a "big book made out of old paper."

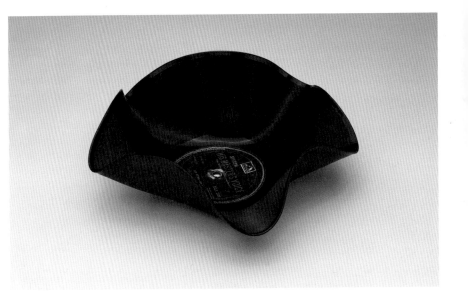

7.9

Phonograph Bowl. Vinod Kumar Sharma, New Delhi, India. 1994. Heated and bent vinyl LP record. H 3 x W 10 3/4 x D 4" (7.62 x 27.3 x 10.16 cm). International Folk Art Foundation Collection, Museum of International Folk Art, Santa Fe.

This beautifully sculpted bowl is made from a recycled phonograph record pressed in India and purchased by the artist at a flea market in the old city of Delhi. It is one in a series of ornamental bowls, baskets, and other decorative objects he has created from unlikely scrap materials.

The Beat Goes On:
Recycling and Improvisation in the Steel Bands
of Trinidad and Tobago

John Nunley

In Trinidad and West Africa, music and masquerading have been shaped by the aesthetic of improvisation and what we in the West refer to as recycling. Utilizing resources from the environment, Africans have long created musical instruments from such things as discarded animal hides, tree trunks, calabashes, gourds, and mother earth herself (used as a drum). In the context of festival, artists have produced masquerade costumes ornamented with bones, animal skins, grasses, vines, shells, and wood resin. With the development of West African urban industrial settlements, artists turned to wire, plastic flowers, empty shotgun casings, mirrors, and discarded clothing to create costumes. In turn, musicians began to recycle bottle caps, bottles, sardine cans, nails, and scrap metal in the making of instruments.

In the Caribbean region, descendants of African slaves also decorate costumes with discarded industrial materials gathered from their environment: plastic whistles, mirrors, bottle caps, plastic flowers, playing cards, rubber tires, detergent boxes, and old photographs. As in Africa, they embrace an improvisational philosophy, producing festivals that celebrate the qualities of surprise, ephemerality, and spontaneity.

Use of the available, or recycled, object also distinguishes the history of music and the development of the steel band in Trinidad and Tobago. Early in colonial times wooden barrels containing molasses and rum (produced on the sugar plantations) were recycled by African slaves for use as drums. With the eventual collapse of the sugar plantations, these barrels were in short supply for drums and were gradually replaced by bamboo, a raw material abundant in the natural surroundings. Through the introduction of industrial goods, bamboo was superseded by soda and biscuit tins until, finally, the fifty-five-gallon oil drum arrived, leading to the creation of the steel band.

Although recycling in the frame of improvisation is common in Trinidadian culture, the use of the fifty-five-gallon oil drum for making music remains one of the country's most dramatic examples of the process. Taking note of this in 1946, Trinidadian Albert Gomes remarked:

Perhaps what we ought to say of the steel band is that it offers a picturesque example of the infinite resourcefulness of the creative urge that, in this case, finds its way even through the ugly bric-a-brac of the junk-heap. (Gomes 1946)

The incorporation of urban recycled materials in the making of material culture observed by Mr. Gomes is a tribute to the resourcefulness of Africans and their descendants who settled the country, under the hostile conditions of slavery and its associated poverty.

Canboulay, *Tamboo Bamboo,* and the Rise of the Steel Drum

The invention of the steel drum has its roots in the nineteenth-century history of Trinidad and Tobago, particularly the former. As the cultures of West Africa and Europe collided, the musical traditions of both provided the foundation for the drum and its music.

A third strong cultural presence in Trinidad, the East Indians, also may have been a contributing factor to this new musical form, yet to a much lesser degree.

The French introduced many of their traditions to Trinidad, especially Carnival, which had evolved from the Roman Saturnalia and the pagan-based customs of Christianized Europeans. In the colonial era, concerts, balls, hunting parties, and grand dinners took place during the Trinidadian Carnival season, which commenced at Christmas and ended on Ash Wednesday. Music was melodic and of a delicate European nature, often played on stringed instruments. Men dressed as field slaves and women as mulattresses, in imitation of the people they controlled. While

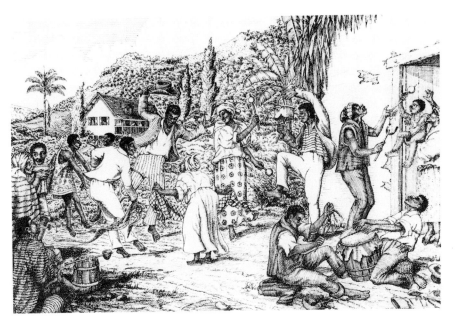

8.1

The End of the Day. 1820. Original print by Richard Bridgens. Slave crews in Trinidad celebrated the end of the workday by dancing and making music with recycled barrels and metal objects, such as tools and horseshoes.

slaves were strictly forbidden from participating in this event, domestic slaves, who worked at the big houses, were sure to have witnessed, and commented on, both the music and the masquerade (Pearse [1956] 1988, 23).

During Christmas and the end of the harvest season, slaves were allowed to celebrate with food, music, and dance. Sources also indicate that the work crew with the most production on a particular day would sing and beat percussion during the evening hours to celebrate its victory (plate 8.1). Wooden drums were made from recycled molasses and rum barrels. Beaten metal objects, such as horseshoes, established a polyrhythmic and syncopated tempo that was derived from West African drum music (Pearse 1992, 345–6). This highly percussive music stood in bold contrast to music played by Europeans during the holiday season.

8.2

Carnival in Port of Spain, Trinidad. 1888. Original print by Melton Prior for the *Illustrated London News.* In the 1880s, the Carnival tradition among freed slaves and their descendants in Trinidad was criticized and eventually curtailed by the white middle and upper classes who were offended by the noisy and flamboyant revelry.

One of the traditional sources for this African-inspired music was the worship of the *orisha* spirits, which came to Trinidad from the Yoruba and Rada of West Africa. One of the primary *orisha* deities that was patronized, from the early days of the colony, was Shango (Chango), the god of thunder (Pearse 1992, 347). People would gather in the yards and prepare for the appearance of the god, indicated by his possession of a devotee. Three *bata* or "congo" drums of different pitches, made from discarded wooden barrels with goatskin drumheads, were played during the event. The high-pitched drum established the beat for the other two. Early roots of the steel drum are also found in the tradition of Canboulay (Cannes Brulees), which originated with plantation life. When fires broke out on the sugar estates slaves used drums, conch shells, and other instruments to signal for help from other estates. Together the slaves would put out the fires and grind the damaged crop before it rotted. This occasion provided excitement and relief from the tedious nature of slave labor, and allowed slaves from different estates to meet and exchange information (Pearse 1988, 18).

After emancipation from slavery, which went into effect on August 1, 1838, the tradition of Canboulay was annually reinacted each August 1 until the 1840s, when it became part of Carnival. The emancipation dramatically changed Trinidadian society. For the first time, the freed slaves could participate in Carnival; in fact, the right to Carnival became a symbolic rite of liberation. While the newly freed took Carnival to the streets, the white planters withdrew from public, restricting their celebrations to private dwellings. Shortly after midnight on the Monday morning of Carnival, the freed slaves came together and paraded through the streets carrying torches to light the way. They danced, sang, and masqueraded to the accompaniment of drums. This phase of Carnival was referred to as Canboulay.

By the mid-1880s there were numerous written complaints about the noisy, dramatically costumed revelry of a growing Carnival tradition, which embarrassed the middle-class sensibility of style and decorum (plate 8.2). People complained about bands playing "inelegant" instruments such as a tin kettle

and a salt box (Pearse 1988, 23). The festival became increasingly criticized by the white middle and upper classes who were horrified by what they considered to be pagan sounds. As part of an effort to incorporate the freed slaves into a cultured European society and do away with the "uncivilized" traditions from the West Africans' past, the colonial government passed the Peace Preservation Act in 1883. This prohibited drumming and torch processions, effectively ending Canboulay (Stuempfle 1990, 34).[1]

However, the African descendants were not willing to give up their percussion traditions, and the spirit of Carnival found new life in the music and culture of a drum ensemble made of bamboo sticks. These instruments were allowed by the government because they fell outside the traditional notion of a drum. Known as *tamboo bamboo*, these percussive instruments were made from various sizes of bamboo to create different tones. The various forms of the *tamboo bamboo* eventually served as the prototypes for the ensemble of steel drums.

The development of *tamboo bamboo* instruments and music must be understood in the social context of patriotism among Trinidadian blacks at the turn of the century. As a result of the South African Boer War of 1899–1902, in which British soldiers fought on behalf of black Africans against the Dutch Afrikaners for a free state, for the first time the blacks of Trinidad felt an alliance with their own colonizers. This shift brought the white upper class and the black lower classes closer together, and music served as a catalyst. The black plantation singers known as Chantwell of Trinidad, forerunners of the contemporary Calypsonians, allowed English lyrics, rather than the local creole language called patois (Anthony 1989, 12–15). Concurrently, the introduction of paved roads encouraged the musicians to wear fancier costumes, which would have less chance of being soiled or damaged than they would if worn on dirt roads. The European style of these costumes went along with a more melodious European-based music. Thus, the emergence of *tamboo bamboo* music also set the stage for a new, more melodic, and more Western sound in the streets (Anthony, 12).

Eventually the *tamboo bamboo* was made in three different sizes, each creating a different sound.

The *boom*, consisting of a piece of bamboo that was five feet long and five inches in diameter, produced the bass notes. The *foule* was constructed of two sections of bamboo, each three inches thick and about a foot long. These were struck end to end to produce a middle pitch. A thin piece of bamboo of varying lengths served as the *cutter*. It was held over the shoulder and struck by a hardwood stick. This instrument produced a high-pitched counterrhythm to the *foule* and the *boom* (Stuempfle, 36–7).

Tamboo bamboo bands made their appearances for the two days of Carnival celebration. They came out in the greatest numbers after midnight on Monday morning, then known as J'Ouvert (the break of day) commonly referred to as Jouvay. This new tradition was basically a reinterpretation of the Canboulay, which had been earlier suppressed. A large band might consist of twelve *cutters*, twelve *foules*, and six *booms*. A special rhythm section within the band was composed of spoons, scrapers, and bottles that were sometimes filled with water to sustain various pitches (Stuempfle, 40–1).

One of the problems with the bamboo instruments was their limited life span. The constant pounding of the *boom* on paved roads and the striking of drums against each other strained their durability. Given this limitation, it is not surprising that musicians experimented with sturdier found materials from the Trinidadian urban environment. By the early twentieth century, *tamboo bamboo* men were employing biscuit and pitch oil tins, paint cans, and many other manufactured containers to supplement the bands' percussive sound (Stuempfle, 42). By the late 1930s, the use of such containers was widespread and by 1941 most of the *tamboo bamboo* bands had been replaced by all-metal bands.

Carlton Forde ("Lord Humbuger") and his Alexander's Ragtime Band, based in the western Trinidadian suburb of Newtown, are usually credited as being the first all-metal band. Although the year in which this band appeared is debated, its impact in the late 1930s is indisputable. According to one version of the popular story chronicling the band's all-metal origins, the band was playing on a street when a bottle broke, causing everyone to scatter, thinking that a fight was about to break out. In the

resulting chaos, a member of the band picked up a paint can from the side of the road and began to beat it. During the course of the year the band decided to abandon bamboo altogether for metal (Goddard 1991, 30–4).

Alfred Mayers, who played in Alexander's Rag-time Band, recalled that its members were well dressed and the bandmaster wore a black scissors-tail coat in imitation of a symphony conductor. All band members wore jackets and some made bow ties from discarded cardboard, another instance of using recycled materials. Forde, the conductor, claims that every member followed music sheets to play the biscuit drums, paint cans, buckets, bedposts and brassy parts of which the band was composed (Stuempfle, 36–7). Although their style of dress and conduct may be seen as a parody of Trinidad upper-class tastes, Trinidadians of all classes had come to share a taste for the classics, such as Beethoven, Bach, and Mozart. Thus, in their performances for Jouvay the band mimicked a Eurocentric musical format that, in fact,

8.3
Lawrence Mayers of Port of Spain, Trinidad, uses a cannon-ball to sink the bottom of a steel drum.

enjoyed wide cultural appeal. It was rhythm and melody and fun. This all-metal percussive music was so popular that first year at Carnival that everybody started experimenting with metal containers, generally called "pans."

Soon after the pans emerged, a number of musicians began to dent the surfaces of these metal containers to obtain different notes and they were able to play simple tunes such as "Mary Had a Little Lamb." At first the "pans" were not tuned with consistency, but by the early 1940s the musicians developed some standardization of the various forms of recycled metal instruments and their notes. A large biscuit container was known as the *cuff boom*, which was struck with a tennis ball or stick wrapped with rubber, probably from bicycle innertubes. Made from a zinc or paint can, the *tenor kittle* had three notes. The *bass kittle* or "dud up," was made from a caustic soda container. Divided into two notes, this instrument was played in counterpoint rhythms to the *kittle* and the *cuff boom* (Stuempfle, 54).

The early all-metal or steel band music was based on the *tamboo bamboo* orchestration. The *cuff boom*, the *kittle*, and the "dud up" imitated the positions of the *boom*, the *foule*, and the *cutter*, respectively; the angle iron replaced the bottle and spoon. Of critical importance was the development of a rhythm section that today is called the "engine room." This section establishes the tempo, thereby keeping the metal instruments in synchronization. Angle irons were used in the early development of this musical genre, but with the appearance of the automobile, discarded brake drums became popular. Other instruments that became part of the "engine room" included scrapers, such as spoons against graters, as well as *chac-chacs*, which are gourd rattles stemming from the African tradition (Stuempfle, 55). Also popular were two double cowbells known as the *gogo*, derived from the West African double gong known as the *agoogoo*.

In 1942, after the United States entered World War II, the colonial government in Trinidad decided to ban Carnival as a security measure. According to the late Ken Morris, a prominent costume maker in Port of Spain, the prohibition of Carnival during World War II had a positive aspect. Relieved from the pressures of competition and the business side of

Carnival, the musicians had more time to experiment with different types of metal containers (personal communication, Port of Spain, fall 1990). During this period the *ping pong* drum, made from a small oil drum, was developed as the lead instrument, replacing the *kittle*. Credited with this breakthrough is Simon Spree, who was able to produce eight notes on the bottom surface of this metal container, which was pounded out into a convex shape (Rouff 1972, 4–7, 10).

During the war, American naval bases were established on Trinidad, and U.S. Navy personnel fraternized with the local young men, teaching them basketball and other American sports (Albert Baily, personal communication, Port of Spain, Fall 1992). The youth of Trinidad frequented the American bases where thousands of fifty-five-gallon drums for storing oil were emptied. Given the high quality of the steel of these containers, people like Tony Williams, who obtained drums from the American base in Mucurapo, found that he could produce more notes with a better sound, compared with other containers (Stuempfle, 59). Later, Ellie Mannette created a *ping pong* with a fifty-five-gallon drum and, rather than busting out the bottom in a convex shape, he did the opposite, sinking the bottom of the drum inward to give the instrument a concave shape. The deeper the sink the larger the surface area on which to produce more notes. The thinner the metal from the stretching, the higher the notes. Mannette was able to obtain twenty-three notes with this newly shaped pan (Stuempfle). After Mannette's experiments, tremendous strides were made in the development of the steel drum technology and music.

Pan Technology and Recycling

The first step in the making of a pan is choosing the right drum. A fifty-five-gallon drum with eighteen-gauge steel is most preferred, for the quality of the 1.2 mm steel allows for the stretching necessary to create the notes of each pan. The drum is turned upside down so that the bottom surface, which later becomes the playing field, can be worked to create the different notes. This is accomplished by sinking the bottom of the drum with a smooth and rounded

8.4
In the Southern All-Star Band pan yard in San Fernando, Trinidad, Theodore Stephens tunes a steel drum over a recycled tire.

sledgehammer, a shot put, or a cannonball, which is the preferred method (plate 8.3). When a cannonball is used, it is dropped on the bottom surface, caught as it bounces back, and released again, until the level of concavity is reached.

After the completion of this difficult task the inner and outer notes are marked out on the surface; the lower notes at the rim are drawn with a straight edge and the smaller central notes are marked with the use of a template. Next, a nail punch and grooving hammer are used to groove the borders of each note. This step isolates the tones of the notes from each other, allowing them to vibrate independently. At this stage a backing hammer is used to flatten the surface areas of the notes within the bordering grooves. During this stage the notes are given their shape and then once again leveled and smoothed by hitting them lightly with a smoothing hammer.

The next procedure is to cut the drum to a certain height, depending on the type of pan being made. It is turned on its side, measured, and marked. The instrument is cut along the mark with an electrical jigsaw or, more commonly, with a hammer and cutlass. The drum is then tempered by being turned upside down and briefly exposed over a fire, often fueled by a discarded automobile tire. The fire pit on which the pan rests is often the recycled bottom of the drum that has been cut away. Tempering removes the tensions of the worked metal surface by reconstructing the crystal structure in the material, and

extracts the carbon content from the metal to make it more tenacious. During cooling, the metal becomes harder, yet also more flexible for final tuning.

The pan is then placed upon another recycled tire, which is set on the discarded part of the drum (plate 8.4). This is the tuning stand used in the last steps of production. First the tuner softens each note by hitting it upward from the bottom and then lowering it again. This procedure loosens up each note so that it performs independently from the surrounding notes. Next the correct pitch is obtained by hitting the note from below to raise the pitch, or from above to lower it. To create the characteristic sound of the pan, which results from a combination of overtones or what pan men refer to as "partials," each elliptically shaped note is tuned to control the vibrations along and across the note. Then holes are punched on the sides of the instrument so that it may be hung on a stand. Afterward the instrument is given a coating of chrome or zinc, using the electroplating process.

In Trinidad and Tobago the various pan instruments are classified according to the range of notes they produce. Terms that designate the ranges were borrowed from classical music: these include soprano, C soprano, alto, tenor, and baritone. The total range of a steel band begins at the bass and ends with the high note of the tenor. This allows composers to create any Western-derived form, whether European classical music or popular music from many sources.

The tenor and double tenor pans belong to the soprano and alto ranges, respectively, whereas the double second, quadrophonic, four pan, and guitar pans belong to the tenor range. The cello, tenor bass, six bass, and nine bass belong to the baritone range. The lower the range, the taller the pan and the fewer notes the instrument has. While the double second pans each have fifteen notes, providing a range of two and one half octaves, the nine bass has only three notes. The higher-pitched instruments generally carry the melody while the bass pans sustain the polyrhythms. Middle-ranging pans such as the guitar and cello play scales and chords, which lend background to the melody while helping to define the lower bass notes.

With respect to recent technological trends in the production of the instruments, there have been a few significant developments. During the mid-1980s Denzil

Fernandez invented the bore pan in which holes are punched along the grooves of the notes, forming a dotted line pattern around each note. This technique lowers the pitch of the notes so that they can be made smaller, allowing for more notes on the surface of the pan. Boring also preserves the vibrations of each note area more efficiently (Kronman, 67).

In recent years, there has been much discussion about starting a pan factory. Toward that end, drum makers have developed a standardized system whereby a lathe with a mold mounted on it can be used to sink the bottom of the drum more efficiently. Some tuners, however, believe the resulting shape is not acceptable, being too thick in the middle (Kronman, 76). While the use of stainless steel for pans, the invention of collapsible drums, and the introduction of the electrical oven for tempering have contributed to the development of the steel band, pan production and the range of instrumentation has changed little since the 1960s. Factory methods have yet to achieve the proper sounds, and it may well be that pan artists prefer the musical quality and the aesthetics of the recycled fifty-five-gallon drum.

The Steel Band and National Identity

As the old colonial regimes were dismantled in the late 1940s and '50s, there developed a great expectation among colonized peoples for new and often incompatible ideas about identity. The development of pan technology and its instrumentation made available a powerful political tool for building national identity in Trinidad and Tobago. The public celebration of Carnival resumed again after the end of World War II in 1945, creating an atmosphere that encouraged the organization of steel bands throughout the country. American films were very popular in Trinidad during this time and many steel bands adopted their names from the titles of films. For example, Casa Blanca, the Desperadoes, and the Invaders pay homage to *Casablanca, Desperadoes of Dodge City,* and *The Invaders* (Goddard, 246). These early neighborhood-based bands competed at Carnival and many had their own masquerade sections. Other bands were hired by independent masquerade companies. There was a lot of competition among the

different bands, and their encounters on the streets where often marred by violence (Terry Joseph, personal communication, Port of Spain, winter 1991).

Given the postwar economic recession, sparked by the departure of the American sailors, a street life emerged in which the steel bands played an integral part. Gambling, prostitution, and crime in general surrounded the production of the new music. The bands themselves were composed primarily of under-employed lower-class youth who hit upon the steel band as a means of subcultural expression. As a result many middle- and upper-class citizens were against the new movement. However, prominent community leaders such as Albert Gomes realized the cultural significance of pan music and pressed for establishing a government-sponsored steel band association to eliminate violence, coordinate competitions, provide financial assistance, and maintain a standard of excellence. With the help of Gomes the Steel Band Committee (soon renamed The Steel Band Association) was formed in 1950 (Goddard, 61).

The Festival of Britain of 1951 was intended as a centennial celebration of the great 1851 World's Fair in which Britain hailed its cultural and technological superiority to the world. The 1951 celebration was designed to recapture that prevailing spirit, although Britain's colonies, Trinidad and Tobago included, had come a long way toward establishing their own national and cultural identities, separate from their colonial rulers. With the pride of the steel band invention and national aspirations, Trinidadian musicians felt that steel bands should be represented at the festival. Thus, under the "Operation Britain" fundraising campaign, the Trinidad All Steel Percussion Orchestra (TASPO) was launched. Operation Britain captivated the country, bringing widespread attention to the steel band. On July 6, 1951, the eleven members of TASPO, including its leader Ellie Mannette of the Invaders, sailed out of the Port of Spain harbor while the Invaders played Manette's popular song "My Heart Cries for You" from the docks. TASPO was a great success at the Festival and the newspapers devoted much coverage to the event (Stuempfle, 149) (plate 8.5). Thus the precedent was set for government and private sponsorship of the steel band movement, which currently prevails in the 1990s.

After World War II, colonial peoples everywhere began to anticipate political independence. A new local leadership was developing in Trinidad, and it was Dr. Eric Williams who led the way. This future prime minister was very popular in postwar Trinidad. On his rise to political eminence in Port of Spain, he considered ways of establishing a national identity apart from the British. He and other Trinidadians realized the social significance of the steel bands for the future of the country. Initially steel bandsmen did not want to play a part in politics. However, Williams responded to their sentiments by saying, "I am afraid that steel bandsmen must be involved in politics because politics determines what you eat, when you eat, how you eat and if you eat." (Goddard, 79)

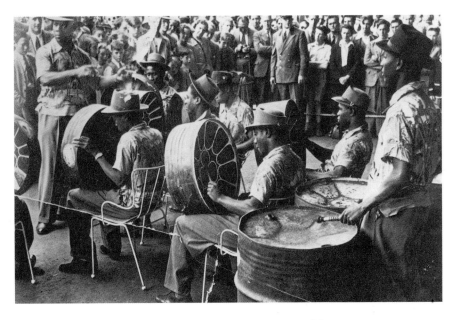

8.5
Following a successful fund-raising campaign, the Trinidad All Steel Percussion Orchestra (TASPO) was sent to London to perform at the 1951 Festival of Britain.

On August 26, 1962, independence came to Trinidad and Tobago. The occasion was highlighted by a 300-page edition of the *Trinidad Guardian,* which dedicated a large portion of the paper to stories about grassroots culture. J. D. Elder wrote an article in which he traced the roots of much of Trinidad's music to the West African *orisha* cults, especially the Ogun-Shango congo drums. Clearly he was building the case for a new nation with strong African roots. In that same issue Lennox Pierre highlighted the steel band in "From Dustbins to the Classics," which included diagrams of the instruments, a brief history of their development, and an explanation of the significance of pan music to the newly independent state. After 165 years of British rule, the country, under the People's National Movement Party (PNM) and Prime Minister Williams, set its own course with a growing sense of nationalism.

During the 1960s steel drums had achieved nearly four octaves in range, allowing the bands to play virtually anything, from classical to pop, in addition to calypso and other West Indian musical forms. Each of the bands had its group of followers who dressed in costumes for the days of Carnival. Because of the close relationship between U.S. Navymen and Trinidadians, resulting from the extensive roads the navy built, the heroic role they played in the battle against the Germans, and the money they poured into the local economy, the themes selected by the costumed groups primarily centered around the sailor. In some cases the sailor was applauded; in others, his character was tenderly lampooned. Thus "misbehaving," "drunk and disorderly," and "fancy" sailors could be seen celebrating in the streets ("Diamond" Jim Harding, personal communication, Port of Spain, fall 1990).

A national steel band competition known as "Panorama" was established in 1963, the finalists of which appeared on the stage of the Queen's Park Savannah on the Saturday prior to Monday Carnival and Jouvay. On this night the top bands, which usually included the Amoco Renegades, the Invaders, the Highlanders, the Desperadoes, Exodus, and Phase II Pan Groove, competed for the attention of thousands of supporters who packed the stands and rooted for their favorite bands until 4 A.M. With coolers of food and drinks, parties of twenty or more "limed" (celebrated), singing and dancing on the bleachers. Everything and every body moved with the beat. Panorama became a vital part of the country's national identity.

Although violence still occurred in the streets during steel band competitions of the 1960s, efforts to curb it by the Steel Band Association, the government, and private industry began to have an impact. The PNM saw the political advantage of supporting the band competitions with respect to prize money, subsidies, and the organizing of special steel band events. Local neighborhood communities began to patronize the bands. Beverage and oil companies were quick to support particular bands under the banner of patriotism and the desire to sell more of their products. In return for supplying uniforms, instruments, and paying for tuners and arrangers, the bands were expected to behave themselves, lest they embarrass their sponsors.

In the 1970s, with the emergence of electrical amplification and large and expensive sound systems, *soca* bands – playing a new type of calypso with electric guitars, trumpets, trombones, drums, and iron – began to replace steel bands on the streets of Carnival. *Soca* ensembles and their amplification systems were carried through the streets on the flatbeds of semi trucks. Although the steel band remained one of the most important national symbols, its historical moment of glory had made way for other forms that more closely reflect the economic, social, and cultural composition of contemporary Trinidadian society. Today the steel band's prominence is reserved primarily for Panorama competitions and the Steel Band Music Festival, which emphasizes the classics.

While steel bandsmen may now face difficult challenges at home, the steel band movement has become firmly anchored in the international scene. As early as 1958, the Tenth Naval District steel band of the U.S. Navy toured the United States, playing at the White House and giving the steel pan great exposure. That same year, a Trinidadian steel band played at the West Indian Festival of Arts, and another played in Senegal, West Africa, for the First Festival of Negro Arts in 1966 (Goddard, 90, 95, 160). During the 1960s, the migrations of Trinidadians and Tobagonians commenced, with the cities of New York (Brooklyn),

London, and Toronto being a few of the major destinations. The immigrants established annual Carnival festivals in the summer months, avoiding the cold winter climates of the north (Nunley 1988, 165). Where these new Carnivals appeared, so did the steel bands. Many of the key bandsmen also emigrated around this time, such as Ellie Mannette, who settled first in Brooklyn. A famous band from Scarborough, Tobago, named Our Boys moved to San Francisco and, led by Andy Narell, has received great attention in the United States.

Today steel bands perform throughout Europe, North America, and the Caribbean. The pervasiveness and global success of the steel band has masked the fact of its origin, for many people believe it to be a Haitian or Jamaican invention. Currently, Pan Trinbago, which replaced the Steel Band Association in 1971, has tried to offset this misconception through publications and education both in Trinidad and abroad.

From the 1980s to the present, steel bands have faced difficult times. With the decline of oil prices, government and business have been less generous patrons, and the competition with other musical forms has had its effect as well. To meet these challenges pan men have experimented with new combinations of instruments and smaller, more manageable group sizes.

While most steel band music is still played by the community-based band, a number of solo performers have experimented with various sounds, appropriating the melodies and rhythms of other musical traditions into their sophisticated instrumentation. These performers often arrange music for the big bands, but they remain independent. In 1990 Boogsie Sharpe performed "My Way," a song made popular by singer Frank Sinatra. The lyrics, though written by and for an entirely different ethnomusicological tradition, seem to exemplify the independently spirited steel band musician. Other performers of this kind include Ken Philmore, Earl Brooks, Ray Holman, Andy Narell, and Robert Greenidge, whose finely tuned steel drum has shared the stage with such prominent Western musicians as Taj Mahal, Barry Manilow, John Lennon, and Ringo Starr (Parks 1986, 35). The recordings of solo pan men and their groups are available at most major music outlets in audiotape

and compact disc. The contributions of these individuals have helped internationalize the music.

As the beat was carefully nourished by African slaves in early Trinidad plantation life, it was maintained and developed in the course of a complex social history of a people whose survival and identity depended on their ability to adapt to a new and challenging environment. In this West Indian setting African-descended people utilized the aesthetics of improvisation and recycling to create a new home. The steel band is yet one part of this amazing story. And, today, the beat goes on.

8.6
Double Tenor Steel Drum.
Lawrence Mayers and Kenneth Ross, Port of Spain, Trinidad. 1994. Fifty-five-gallon steel containers, each H 6 1/8 x Diam 22 7/8" (15.4 x 58 cm). International Folk Art Foundation Collection, Museum of International Folk Art, Santa Fe.

The double tenor drum, made from two oil drums, is played as one instrument. The tenor, along with other drums such as the guitar, cello, bass, kittle, and boom, comprise a steel band orchestra, which can play anything from Calypso to European classics.

CHAPTER 9

Lightbulbs, Watchbands, and Plastic Baby Dolls: Industrial Appropriations in the Corpus Christi Festival Headdresses of Highland Ecuador

Barbara Mauldin

High up in the Andean mountains of central Ecuador, costume makers engage in a form of recycling to produce ornate folk Catholic festival clothing. One of the most elaborate costumes to utilize this tradition of ornamental recycling is associated with the feast day of Corpus Christi. For this festival, dancers wear costumes featuring large headdresses decorated with a variety of discarded industrially produced objects (plate 9.1). Among these things are broken watches, clocks, combs, rulers, sunglasses, zippers, hospital syringes, automobile labels, lightbulbs, and plastic figures of animals, soldiers, muscle men, and baby dolls.

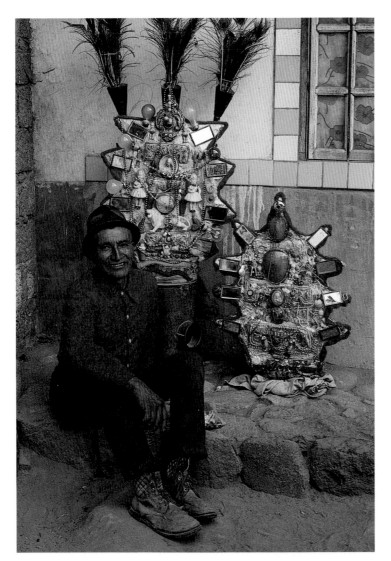

9.1
José Ignacio Criollo poses with
two of his Corpus Christi
headdresses at his home in San
Rafael (near Pujilí), Ecuador.

As discussed in the essay by Enid Schildkrout and
Donna Klumpp Pido (see pages 152–65), recycling
for adornment purposes is a practice found among
culture groups all over the world. The original func-
tions of reused objects are deconstructed into elements
of form and color, and cast-off items become "raw
materials" that are given new meaning within the
group's internal language of value, aesthetics, and
ornamentation. Some rules may guide the selection
and use of the "raw materials," but creativity and
innovation allow the costume makers to experiment
with ways to place the recycled industrial goods into
a culturally accepted context.

Although the twentieth-century objects taken from
Western culture provide new "raw materials" for the
ornamentation of Ecuadorian Corpus Christi costumes,
they relate to the kinds of things used for adornment
and religious purposes by the pre-Columbian and
colonial Andean peoples. A study of the selection pro-
cess and placement of the ornamentation by present-
day makers of the headdresses reflects a continuity of
traditional Andean aesthetic and value systems that
are now being applied to recycled industrial objects.

"Raw Materials" in Pre-Columbian and Colonial Andes

Pre-Columbian peoples in the Andean region of South
America acquired "raw materials" from the natural
surroundings to use for adornment and religious
purposes. Gold and silver metals were particularly
revered and conveyed a message of status and wealth
as well as reinforced the power of religious objects.
The underlying cultural value was the color symbol-
ism of gold and silver (yellow and white) as well as
the reflectiveness of the metal. Evidence shows that
these elements were important to Andeans as early as
800 B.C., and by the time of the Incas, after A.D. 1200,
gold was thought to represent the sun and silver the
moon. Pre-Columbian metallurgists often worked
with copper and other alloys to produce objects that
had the colors and reflective qualities of gold and sil-
ver. Even if these metal pieces incorporated very little
actual gold and silver into their composition, they
were considered to have the same value (Lechtman
1993, 252–3, 262–74). Color, shape, and reflective-

ness were also factors at play in the magical significance given to emeralds, crystals, shells, stones, and other attractive natural materials.[1]

Pre-Columbian Andean festival costumes were often made from finely woven fabrics, embroidered with gold and silver threads and ornamented with silver buttons and balls. The dancers wore various types of headdresses, often decorated with metal discs or clasps (Arriaga [1621] 1968, 49–52, 68–70). During the festivities, ancestor spirits and celestial forces were given offerings, referred to as *conopas* or *huacas,* which consisted of gold and silver pieces, emeralds, crystals, shells, stones of interesting shapes and colors, and other attractive objects found in nature. Sometimes the metal was worked into figures of men, birds, and animals. These *conopas* or *huacas* were also used as amulets by the Andean peoples and were thought to have magical powers that would contribute to the fertility of crops, animals, and families, and aid in other aspects of life (Vega [1609] 1966, 31, 76, 253; Arriaga, 52–3, 86).

After the Spanish conquest of the Andean region, European goods were viewed by the indigenous peoples as symbols of wealth and prestige. Aspects of Spanish dress began to be incorporated into Andean clothing and festival costumes (Kubler 1946, 348, 361–3; Dean 1990, 225–53). Shiny and brightly colored objects of European manufacture became a new source of "raw materials" collected by the Indian people and used as amulets or sometimes worn as adornment (Kubler, 397). A Catholic priest working in Peru in the late sixteenth century reported seeing one Indian woman wearing a piece of sealing wax, another wearing a little ball of silk, and another wearing a piece of glass (Arriaga, 28).

Corpus Christi Festival

Spanish missionaries came to the Andean region of South America in the mid-sixteenth century to convert the indigenous peoples to Catholicism. They introduced Catholic festivals as a means for teaching the Indians about the new religion. Corpus Christi feast day, which honors the Eucharist or body of Christ, was considered to be one of the most important festivals in the Catholic calendar. It was usually celebrated with an elaborate procession, and indigenous groups were forced to perform their own dances as a means to draw the "pagan" peoples into the Christian rituals (Muratorio 1981, 7–9). Late-sixteenth-century descriptions of Corpus Christi festivities in Cuzco, Peru, a neighboring region to Ecuador, indicate that male Indian groups performed pre-Columbian dances wearing their traditional festival costumes. Many Spanish authorities felt the participation of the indigenous groups in the Corpus Christi processions symbolized a rejection of their own religion and acceptance of Christianity (Vega, 1415–7; Poma de Ayala [1615] 1966, 39–41, Fig. 294). However, the floating date for the Corpus Christi feast day – sometime between late May and mid-June – coincided with the Inca solstice celebrations and the pan-Andean harvest season festivals, and thus the Indians had actually merged, or syncretized, these traditional festivities with those of Corpus Christi (Polo de Ondegardo [1571] 1916, 21–2).

As mentioned in the previous section, European-made items began to be adopted, or recycled, by the Andean peoples for religious and adornment purposes. In the late eighteenth century Italian geographer Julio Ferrario saw a Corpus Christi procession in Quito, Ecuador, in which a number of Indians performed pre-Columbian dances wearing elegantly decorated costumes, including leggings decorated with many little metal bells (Ferrario [late 18th c.] 1960, 522–3). In 1847 another European visitor, Gaetano Osculati, recorded his impressions of the Corpus Christi celebrations in Quito. He marveled at the participation of different Indian dance groups, which he distinguished by their costumes and manner of dance. He was particularly impressed by the *danzantes* from Quito and Latacunga.

[They] proceed decked out with most elegant and valuable costumes, from which hang quantities of silver coins by means of holes made directly through them. These fanatics, to show off one of these costumes, which apart from this are embroidered in gold and silver, spend in one day a year's savings, and even become slaves voluntarily for a set period of time, until the agreed is paid, and all this for the extraordinary glory of having been a danzante.
(Osculati [1847] 1960, 308–9, translated by the author)

The "glory" that motivated these indigenous dancers was actually a form of community prestige that could be attained by participating in the religious festival. Each Indian community had a hierarchical class system based on hereditary lineage and wealth. However, labor and other contributions given toward the social, political, or religious life of the village could also increase one's status. Some of these contributions came from men who belonged to Catholic brotherhoods that had been set up by the Spanish missionaries as a means for carrying out religious rituals and Catholic feast day celebrations. A great deal of prestige was gained by the *prioste,* or sponsor, and his assistants who volunteered to organize and fund each of these festivals (Kubler, 341–3, 349, 404–6). The dancers were among the men who assisted the *prioste,* and they often incurred the cost of renting the costumes on behalf of their community (Naranjo 1983, 80–1, 107–9, 112–3).

It is unclear when the tradition of renting costumes began, but its roots could go back to pre-Columbian times with certain families providing the more elaborate ceremonial costumes worn by dancers in their communities. It is likely that the family would have gained prestige and received payment in food and other goods. After the Spanish conquest of this region, the specialization of costume making evolved to meet the needs of the Catholic festival cycle, and this cottage industry was carried out by both indigenous and mestizo families. The rentable festival clothing would be refurbished and handed down through generations of the maker's family and new costumes would be made as needed. This specialization of costume making has continued into the twentieth century, although the rental fee is now generally paid in cash.[2]

Corpus Christi Festival in the Central Highlands of Ecuador

One of the groups of Indian dancers described by Osculanti as paying such a high price to rent their Corpus Christi costumes was from Latacunga, a city located south of Quito in the central highlands of Ecuador. This is a rich agricultural region stretching out between the snow-covered volcanoes known as Cotopaxi, Tungurahua, and Chimborazo. During

pre-Columbian times, the fertile area was shared by many Indian groups, distinguished by different languages. In the late fifteenth century they came under Inca rule and the whole area was converted into defined ethnic territories. Most of these groups continued to inhabit the region after the Spanish conquest of Ecuador in the early sixteenth century. Since that time the indigenous people have suffered great hardships, but many of these ethnic groups still live in this area today (Naranjo 1983, 25–9, 57–8; 1992, 31–54).

The Catholic priests who came into the central highlands region of Ecuador in the sixteenth and seventeenth centuries constructed large churches in Latacunga and smaller ones in central towns of the various Indian territories. Documents state that each church had a large plaza in front that was used for a variety of activities including processions, markets, and popular fiestas, especially those featuring bulls and *danzantes* (Zúñiga 1982, 186–7).

Corpus Christi feast day celebrations were probably introduced into this region early in the colonial period and they continued to be observed in many towns and villages into the early twentieth century (Moreno 1949, 72–4, 77, 96–116). By the 1950s, however, Catholic priests were playing a lesser role in the feast day activities and Corpus Christi dances were no longer performed in Latacunga. By the 1970s the Corpus Christi festival in the nearby town of Pujilí had converted from a religious feast day to a largely secularized event. Despite these changes, some indigenous and mestizo dance groups continue to participate in the Pujilí festivities (Muratorio, 14), and the celebrations are still carried out in some indigenous villages as part of their syncretized Corpus Christi/harvest season festivities.[3]

Corpus Christi Costumes

Over time, a distinctive type of Corpus Christi dance costume evolved in the central highlands region of Ecuador. Although variations can be seen, the basic style was shared by costume makers throughout the different Indian areas (plate 9.2). It consists of white undergarments (shirts, pantaloons, and petticoats) usually trimmed at the edges with lace or crocheting. Bibs, front aprons, and wide back aprons are worn

over these, and long panels of cloth hang down from the backs of the headdresses. These overgarments are made from shiny, colorful fabrics, often ornamented with foil. They may also have elaborate embroidery with patterns and motifs similar to those found on church vestments. Older costumes were sometimes decorated with hundreds of antique coins. Generally, the dancers wear masks, carry batons or small staffs, and tie strings of bells around their shins.

The most distinctive feature of the Corpus Christi costumes made in this region are the extremely large headpieces. These are mounted on top of felt hats that have rows of silver coins fastened across the brim. The headdresses are constructed from reeds, bent and tied to create a flat, vertical structure that extends up two to three feet above the brim of the hat. This structure is either made in the form of a simple arch or a more elaborate sunburst shape with points. Several clusters of shiny peacock feathers

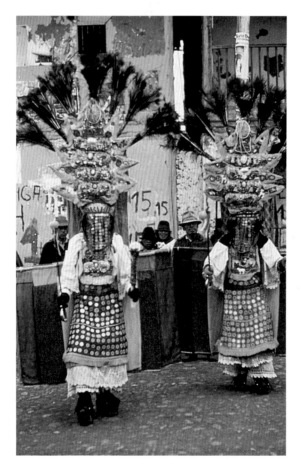

9.2
The costumes worn by these Corpus Christi dancers from San Andres Píllaro are owned by the Albán family, who have passed them down within their family for generations.

are tied to the back of the structure and extend up another two feet above the top (Muratorio, 14–9). The finished headdress can be quite heavy and difficult to dance in, which is another reason why the men who volunteer to perform gain prestige.[4]

The front surface of the headdress is the primary focal point of the outfit worn by the *danzante*. It is covered with gold or silver foil and decorated with a variety of objects, creating a rich, colorful, and shiny texture that reflects light as the dancers nod their heads. This front surface also showcases the images placed within the decoration. Costume makers from different areas of the central highlands have developed their own local styles of ornamentation, but even within a similar style each headdress is unique.[5]

The Corpus Christi costumes are highly revered by the Ecuadorians and the *danzantes* continue to take great pride in wearing them. As before, the dancers often pay the cost of renting the costume as part of their contribution to the community festival. They go to the costume makers and pick out the specific costume and headdress that appeals to them the most. This selection process is sometimes carried out in a ritual fashion and the owners may dress the dancers as part of the ceremony (Naranjo 1983, 107).

Headdresses from the Latacunga/Pujilí Area

The most elaborate style of decoration found in these Corpus Christi headdresses has been used by costume makers in the valley area extending from Latacunga to Pujilí, which was the headquarters for the Spanish colonists in the central highlands of Ecuador.[6] One of the oldest extant collections of costumes with headdresses decorated in this Latacunga/Pujilí style is owned by the Albán family in Latacunga (plate 9.3). These costumes have been passed down through many generations and, although little is remembered about their origin, some interpretive information has been retained.

One of the distinguishing features of this style of headdress is its pointed, sunburst form, which is covered on the front surface with gold foil and said to represent the sun. A stylized bird form, symbolizing an eagle, is always placed on the upper part of the center. This form is covered in gold foil and deco-

rated with strings of pearls and other jewelry. Four abstracted images of sheep, decorated in a similar fashion, are attached in a vertical line down the center. A large reliquary[7] with an image of Christ or a Catholic saint is usually placed over the bird form at the top of the headdress, along with metal chains that drape down over the surface. Other reliquaries, jewelry, cameos, and pieces of mother-of-pearl are spaced down the center and along the edges. A small figure of a dove, in plastic or metal, is usually fastened to the very top. Occasionally, a plastic figure of an animal is added to the decoration by the dancer who rents the costume. Sra. Graciela Albán, the caretaker of the costumes, refers to the ornamentation as "jewels" and stresses that the dazzling richness is an important aspect of the costume.[8]

An analysis of this formalized ornamentation suggests a syncretism of pre-Columbian and Catholic iconography and aesthetics, which is in keeping with the merging of the traditional Andean festivals and those of Corpus Christi. The sun shape of the headdress relates to the Andean reverence for the sun and the Inca solstice festival. However, it could also symbolize a Catholic monstrance, the shiny metal receptacle, framed in a sunburst motif, used to carry the Eucharist during the Corpus Christi processions.[9] The bird and sheep imagery is also significant to both traditions. The eagle was one of the most important Andean birds and was worshiped in a religious context as well as being a symbol of royalty often worn on headdresses (Dean 1990, 240–2, 247). In Catholic iconography the dove often represents the Holy Spirit. Llamas and, later, sheep or lambs were ceremonially sacrificed in Andean festivals (Vega, 86). Since early Christian times, Christ has been symbolized as a lamb, referring to his sacrifice for the sins of mankind. A reflective quality is achieved through a proliferation of gold and silver objects as well as pearls, glass, and colorful, shiny gemstones. All of these would be considered sacred materials by the Andean Indians and aesthetically appropriate to decorate festival clothing. Such lavish ornamentation, including the reliquaries and other images of Christ and Catholic saints, is also in keeping with the rich, baroque decoration found in Ecuadorian colonial churches.

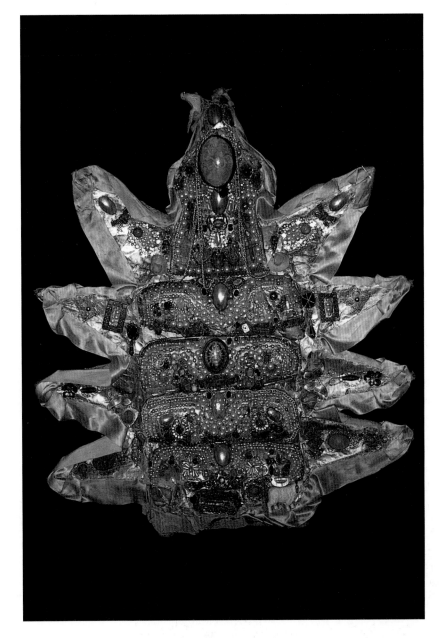

9.3

Corpus Christi Festival Headdress.
Albán Family, Latacunga, Cotopaxi, Ecuador. 19th century. Wood, fabric, foil, reliquaries, mother-of-pearl, metal chain, jewelry, porcelain, and plastic figures, etc. H 35 x W 26 1/2" (89 x 67.3 cm). Albán Family Collection, Latacunga, Ecuador.

This is one of the oldest extant Corpus Christi festival headdresses from the central highlands of Ecuador. The iconography of the imagery and the richness of the ornamentation show a blending of Andean and Catholic symbols and aesthetics.

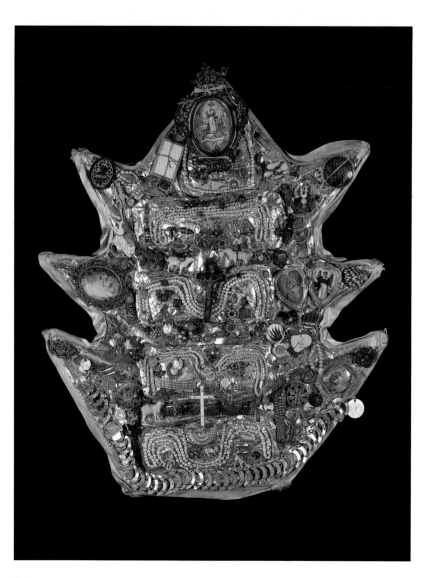

9.4

Corpus Christi Festival Headdress.
Maker unknown, Latacunga/
Pujilí area, Cotopaxi, Ecuador.
Early to mid-20th century. Wood,
fabric, foil, reliquaries, jewelry,
watchbands, sunglasses, medals,
plastic figures, etc. H 33 7/8 x
W 27 1/2" (86.1 x 70 cm). Inter-
national Folk Art Foundation
Collection, Museum of Interna-
tional Folk Art, Santa Fe.

The ornamentation of this
Corpus Christi headdress
closely follows the style seen in
nineteenth-century examples.
However, by the early twentieth
century costume makers had
begun using an assortment
of discarded metal, glass, and
plastic objects in place of the
finer "jewels" seen in the earlier
costumes.

Many of the costume makers working in the Latacunga/Pujilí area in the early to mid-twentieth century followed the formalized composition found in the Albán family headdresses (plate 9.4). However, the jewels found in the Albán headdresses were substituted with an assortment of discarded metal, glass, and plastic objects.

One of the most prominent costume makers still active in this area is José Ignacio Criollo (see plate 9.1). He is a small Indian man in his early sixties who spends most of his time farming corn, potatoes, and other crops. He and his wife, María Lorenza Jacome, live in a three-room house that also serves as their costume shop. Large clusters of yellow corn hang from the ceilings and rows of old bottles, gourds, and wooden spoons have been placed as decoration around the interior roof lines. A small foot-pedaled sewing machine sits on a table at one side of the main room, and layers of costumes made from brightly colored fabrics hang from coat hangers around the walls. Wooden masks, crowns, jewelry, and other costume pieces are stored on shelves. Trunks, full of additional costumes, are stacked in a loft in the back part of the room. The beautiful arrangement of the contents in their home is in keeping with the aesthetic sense seen in Criollo's costumes.

Sr. Criollo began making festival costumes in the late 1950s following the tradition of his deceased great-grandfather. He was inspired to start this cottage industry because many of the older costume makers were dying off and he felt it was important to carry on the tradition. He looked at his great-grandfather's costumes and figured out ways to make his own. Criollo worked on the costumes at night after he had finished his farming chores. Gradually he built up an inventory for a variety of different Catholic festivals and dancers started coming from all over the area to rent costumes from him. Although his primary job is still farming, Criollo says he has gained a great deal of prestige within his community as a costume maker. He has a keen eye and a strong sense of the indigenous aesthetic, which is reflected in his work.

The Corpus Christi dance costumes are among his most important creations and he reveres the large headdresses almost as if they were sacred objects.

Much thought goes into the ornamentation of the front surface, and he describes the process as "dressing" the headdress rather than simply decorating it. The first Corpus Christi headdresses he made in the 1950s closely followed the Albán family headdress style (plate 9.1 right). Small rectangular mirrors were sewn on each of the points. The remaining surface was heavily ornamented with shells, strings of fake pearls, images of saints, and an assortment of old costume jewelry. He attached a large object, such as a doorknob, to the top of the headdress along with light-fixture pull chains to drape over the other ornaments. As time went on and the pieces suffered wear from use he needed to refurbish the ornaments, so he added broken watchbands, old pocket knives, buttons, colored Christmas lights, metal car labels, and small metal and plastic figures of babies, soldiers, and animals.

Criollo never really looks for specific objects to use in the "dressing" of the headpiece, but when he sees things he likes being sold by the vendors in the markets, he buys them (plate 9.5). He says he is attracted to the metal pieces because they look like gold and silver and they are reflective. Although he claims no particular significance for the figures of animals, men, and children, the images reflect some of the most important elements underlying traditional Andean life.[10] Criollo readily admits to liking the shapes and colors of these plastic figures which are commonly sold in the markets as toys for kids. Some of the older, recycled objects he uses were given to him by friends and relatives, others he bought from "junk" dealers. Criollo says he prefers old objects rather than new ones because they contain part of the heart and soul of the people who used them. Recycled things, therefore, impart more meaning to the headdress.

Over time, Criollo has considered new ways to "dress" the headpieces to make them more aesthetically appealing and, in his words, "more modern." Since the mid-1970s he has been using a greater variety of recycled, industrially produced objects, many of which are larger in scale than the previous pieces. The overall effect is bolder, while retaining some aspects of his older headdress decoration (plates 9.1 left and 9.6).

He always begins the "dressing" by placing the abstract sheep forms down the center. These are ornamented with old zippers, springs, snaps, and even, in one case, a plastic ruler. Reliquaries have become harder to find so he has substituted such things as an old alarm clock, the bottom of a glass soda bottle placed over a plastic image of Christ, and a doll head placed inside a plastic ring. Metal tape measures, watchbands, glass tubes, and plastic figures fill in the remaining space in the center and along each side.

9.5
Costume maker José Ignacio Criollo is a regular visitor to the central market in Pujilí, Ecuador, where he browses for objects to use in the adornment of his Corpus Christi headdresses.

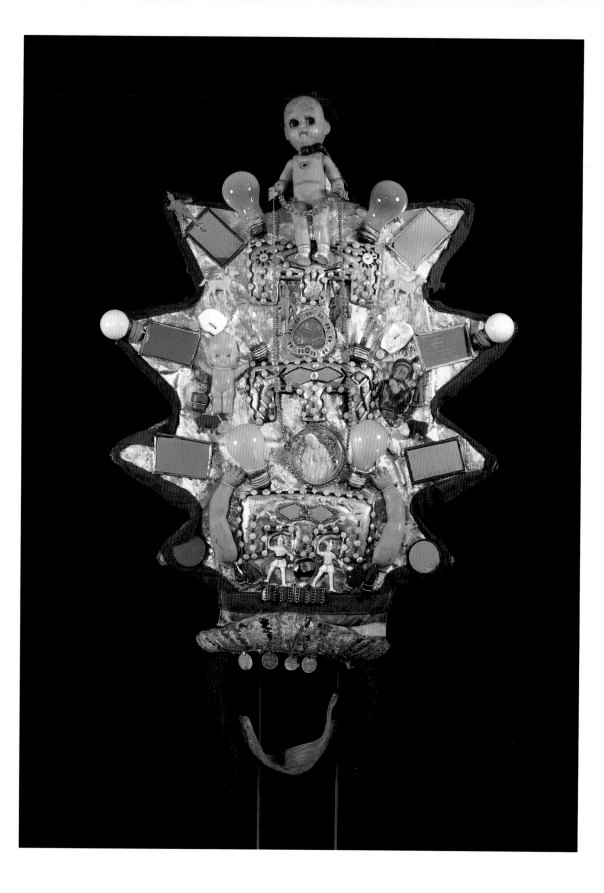

9.6
Corpus Christi Festival Headdress.
José Ignacio Criollo, San Rafael,
Cotopaxi, Ecuador. c. 1980.
Wood, fabric, foil, lightbulbs,
mirrors, glass jar, jewelry, plastic
figures, etc. H 45 1/4 x W 25 7/8"
(115 x 65.5 cm). International
Folk Art Foundation Collection,
Museum of International Folk
Art, Santa Fe.

Sr. Criollo continues to make
Corpus Christi headdresses in the
basic style of the earlier exam-
ples from the Pujilí/Latacunga
region, although the kinds of
objects used in the decoration
have changed. He is no longer
able to get the old reliquaries,
so here he has utilized a home-
made one, constructed from
the bottom of a glass jar placed
over a plastic image of Christ.

The top of the headdress is of primary importance, and Criollo generally selects something large for this spot, such as an umbrella handle or a plastic baby doll, from which he can hang chains to drape down over the rest of the ornaments. The outside edges of the headdress are "dressed" with small mirrors and old lightbulbs. Criollo has only recently gotten electricity into his home, but he began using lightbulbs on headdresses in the 1970s because of their color, shape, and reflective quality. Over the years friends from Pujilí and other towns brought him their old lightbulbs, which he keeps in a large wooden bowl. Criollo says he will continue to experiment with new ways to "dress" the Corpus Christi headdresses and five years from now they will look different from those he is making today.[11]

Other costume makers in the Latacunga/Pujilí region, such as Aurelio Vargas, have also taken the Corpus Christi headdress decoration to new dimensions (plate 9.7). One of the headdresses made by Vargas has a large, ornate picture frame covering most of the front surface. Inside is a colorful religious print and attached around the edges are porcelain angels and small plastic figures of lions, dogs, soldiers, and babies. At the top of the headdress is a smaller oval frame, containing a beer advertisement, from which hang a number of chains and ribbons. Under the large frame is a fragment from another commercial label and a series of small photographs.

Headdresses from the Mountain Villages

Indigenous costume makers living in mountain villages above Pujilí and Saquisilí have used another, less formalized, style of Corpus Christi headdress decoration.[12] Here, the headdresses are constructed in a simpler arch shape with the front surface covered in gold or silver foil (plate 9.8). The decoration is characterized by horizontal bands, usually delineated with thin strands of beads, laid out across the foil. Some of these headdresses are sparsely ornamented with a variety of objects, such as seashells, broken glass, crystals, coins, small bottles, buttons, silver earrings, broken watchbands, and pieces of broken dishware placed between the horizontal lines.

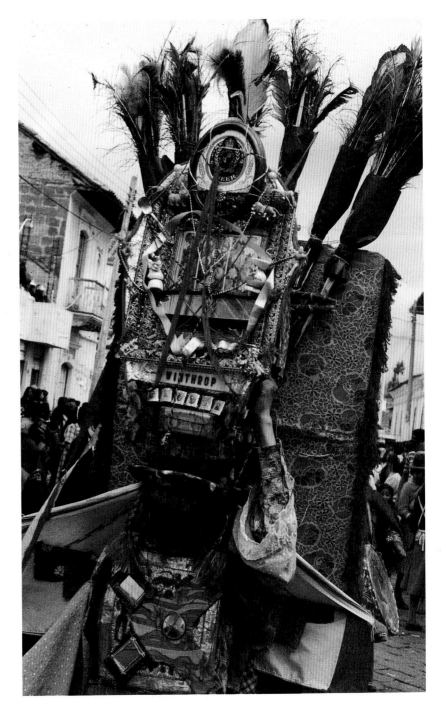

9.7
This Corpus Christi dancer is wearing a costume made by Aurelio Vargas, another Pujilí costume maker who incorporates industrial discards in his headdress design.

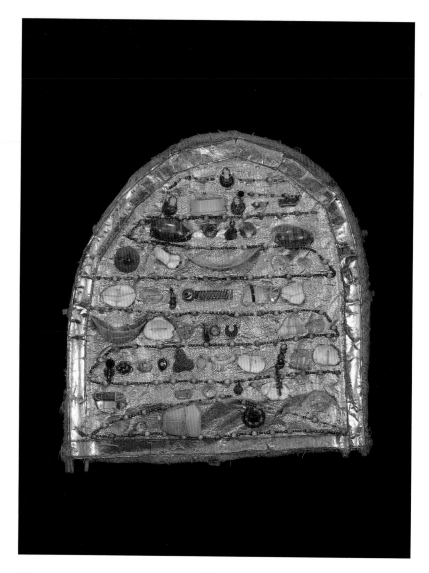

9.8

Corpus Christi Festival Headdress. Maker unknown, mountain village area above Pujilí and Saquisilí, Cotopaxi, Ecuador. Early 20th century. Wood, fabric, foil, shells, glass bottle, dishware, jewelry, watchband, etc. H 21 1/4 x W 21" (54.1 x 53.3 cm). Girard Foundation Collection, Museum of International Folk Art, Santa Fe.

Costume makers in the mountain villages of this region of Ecuador use a more simplified style of decoration for Corpus Christi headdresses. Mountain village headdresses dating from this period show the use of materials found in nature alongside industrially produced objects.

Other headdresses in this style are so densely decorated that the horizontal bands are almost indistinguishable (plate 9.9). This ornamentation contains greater quantities of the same items found on the sparser headdresses, with the addition of old rings, buckles, thimbles, small mirrors, and Catholic religious pieces such as crosses, medals, a dove, and small framed images of saints. Some of these headdresses also have plastic objects such as bicycle reflectors, forks and spoons, hair combs, and colorful figures of babies, soldiers, and a variety of animals. It seems likely that objects were continually added to older headdresses to create the desired effect. Although the overall appearance is important, each of the objects seems to have been individually selected and placed within the composition. The costume makers were obviously attracted to the assortment of metal objects and forms with interesting shapes, including many industrially produced items, and the decoration became more colorful over time as a greater variety of plastic goods was available.

The composition of the ornamentation on these arch-shaped headdresses is less formalized than seen in the sunburst-shaped headpieces, but the overall aesthetic effects and symbolic concerns are similar.

Recycling and Continuity of Andean Aesthetic and Value Systems

Pre-Columbian Andeans collected "raw materials" from their natural environment to use as ornaments, offerings, and amulets. They were attracted to specific colors, interesting shapes, and reflective surfaces. In the colonial era, shiny and brightly colored objects of European manufacture, such as metal coins, sealing wax, and glass, became a new source of "raw materials" that fit into the Andean sense of value, aesthetics, and ornamentation. With the industrial era of the late nineteenth and early twentieth centuries, more and more manufactured items became available. Costume makers creating Corpus Christi dance headdresses in the central highlands region of Ecuador have been able to draw from this increasing variety of industrial goods and to experiment with ways to place them into a culturally accepted context. The recycled objects themselves may no longer retain their

original significance but, according to Sr. Criollo, the used objects are preferred because they are thought to contain the spirits of the people who once owned them and therefore contribute to the strength and distinct quality of each headdress. The bricolage of images portraying Catholic saints and religious ornaments alongside figures of animals, children, and men also reflects the syncretized Catholic and harvest season festivities as they have evolved into the late twentieth century. Through this dynamic process of "dressing" the Corpus Christi headdresses with a widening pool of "raw materials," the costume makers are able to express their own creativity while satisfying the traditional aesthetics and values of their community.

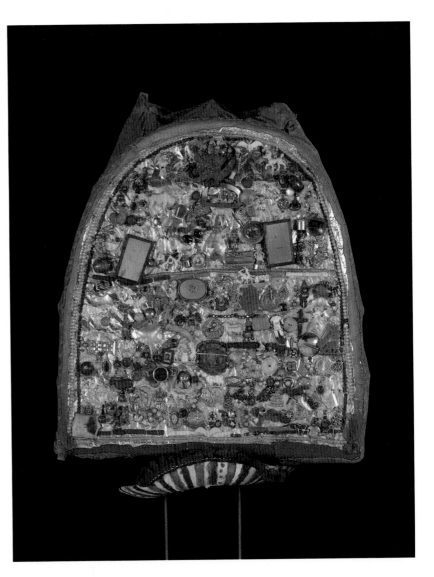

9.9

Corpus Christi Festival Headdress. Maker unknown, mountain village area above Pujilí and Saquisilí, Cotopaxi, Ecuador. Mid- to late 20th century. Wood, fabric, foil, mirrors, jewelry, bicycle reflector, pen caps, plastic figures, etc. H 23 1/4 x W 19 3/4" (59 x 50 cm). San Diego Museum of Man, San Diego.

By the mid-twentieth century, costume makers in the mountain villages of central Ecuador had more access to industrially produced goods and a variety of these objects began to appear in Corpus Christi headdress decoration.

Serendipity, Practicality, and Aesthetics: The Art of Recycling in Personal Adornment

Enid Schildkrout and Donna Klumpp Pido

When Cortés and his troops discovered hoards of gold ornaments in Mexico, they confiscated these objects of sacred and royal art for themselves. We can be sure that they did not do this because of their admiration of the workmanship or their desire to appropriate the charisma of Aztec culture. In fact, they showed a hearty disrespect for the value placed on these objects by their previous owners, and in melting them down for coinage, Cortés and his compatriots were simply recycling material from one cultural construct into another. The Aztecs would not have thought this to be an improvement; for one thing, their gold was not discarded trash.

Nevertheless, there are instructive similarities between recycling Aztec gold and recycling industrial trash. When a New Guinean wears a head ornament incorporating a mackerel tin label, and a Maasai uses a blue plastic pen cap in an armband, they are showing a similar unconcern for the meaning of these objects in the source culture. They are deconstructing the objects into elements of form, color, and material and giving them meaning in their own object language. This is intercultural recycling, and it is useful to think about the comparison of highly valued Aztec gold and postindustrial junk, since recycling did not begin with the Industrial Revolution in Europe. The transfer of objects and material from industrial sectors to newly industrializing ones is not a simple matter of appropriation and mimicry, but rather involves revaluation and redefinition of the recycled objects. Their epistomological status as "things" is called into question and they become raw materials used in a new object language.

It is all too easy to think that the people who use industrial products in novel ways either don't understand the original meanings of the objects or materials or are showing blind admiration for Western industrial culture by using its debris to cope with their own relative adversity. But both assumptions are as wrong now as they were for Cortés, who intentionally ignored Indian culture and surely did not aspire to be like the Aztecs. Leaving aside the effects on the donor culture, in this case the Aztecs who lost their treasures, what happened to the gold is exactly the same as what happens to old tires that become sandals or pen caps that are incorporated into armbands.

Ornaments, whether made from coins, Christmas tree ornaments, safety pins, or Vaseline tins used as pendants (Barry 1988, 43) are given meaning through a precise cultural grammar that uses objects in a symbolic code. Ornament is one subcategory of this object language. Objects and materials that are not defined as ornaments in one society can be appropriated into the language of ornament of another. Shape, color, texture, and symbolic resonance are all analytically separated from the whole, for the process of recycling ignores the culturally given integrity of the original object. Objects that make it to the recycling pool become raw materials because their original

10.1

Necklace. Unknown Kuna maker, San Blas Islands, Panama. c. 1985. Plastic charms, string. H 13 x W 1 3/4" (33 x 4.5 cm). Museum of International Folk Art, a unit of the Museum of New Mexico, Santa Fe.

Boxed crackers are imported to the San Blas Islands from Colombia. Often the boxes contain toy charms as prizes. Kuna women have incorporated these plastic figures into their traditional jewelry, substituting them for more traditional beads and coins.

meaning is necessarily altered, or even lost, even if they are not melted down or physically changed. Thus, recycled objects can be analyzed as a combination of two object languages: that of the first makers and users and that of the recyclers who impose their own aesthetic system on the finished product.

Members of the two groups may have little or no knowledge of each other, or the receivers may have their own ideas about the source system and may try to appropriate aspects of it, as when coins become symbols of value even though they no longer function as money. Recyclers inevitably have their own ideas about what is useful, appropriate, and beautiful. Likewise, the senders assume that even though they no longer have the objects, they understand their "true" meanings. Westerners remember with great nostalgia what a lacy white dress is for when they see a Ghanaian farmer sporting it as a smock as he hoes his fields. Irony jolts them into remembering the meaning of the wedding gown even though it is no longer a memento of their own history, an heirloom that gains value because it is laden with memories.

10.2
The Wodaabe of Niger are highly eclectic in accepting and utilizing foreign items in their traditional adornment. Items such as suitcase locks and imitation gem stones are made into decorative neck pendants by Wodaabe men.

10.3
Tunic. Unknown Wodaabe maker, Niger. Early 20th century. Fabric, buttons, safety pins. H 40 x W 24 3/4" (101.5 x 62.4 cm). International Folk Art Foundation Collection, Museum of International Folk Art, Santa Fe.

This type of tunic is worn by Wodaabe men in Niger on ceremonial occasions. The vertical band down the center of the garment has been ornamented with metal safety pins which serve no function other than decoration.

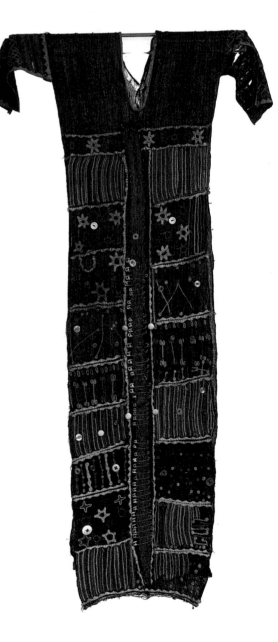

The irony and anomaly (Roberts 1992) found in recycled objects are only in the eyes of the observer who associates the objects with their now irrelevant symbolic resonance. The challenge is in understanding the new meanings of recycled objects. This requires knowledge of the language of ornament in the recyclers' culture, of the contexts in which certain things and materials can be worn, of color symbolism, and of the way in which self-decoration defines the person and his or her relationship to society. Without this information, all we can do is acknowledge the incongruity of seeing "our" things in the "wrong" context.

What do we make, for example, of the Kuna Indians in the San Blas Islands of Panama when they incorporate bright plastic charms from cracker boxes into necklaces (plate 10.1)? They have stripped them of their meaning as "collectibles" or "toys" and incorporated them into necklaces. They also use broken keys and charms sold at the racetracks in Panama City to decorate themselves with shiny tinkling forms. Recognition of the recyclia does not give us enough information to interpret them in the Kuna ornament system, but we cannot assume that the Indians have made capricious choices. If they are not being made simply to sell to tourists, then they must fit into the Kuna ornament system in some way.

To explore the complicated territory of intercultural recycling, we look first at the interplay of aesthetic codes and social contexts in various cultures. Next we discuss recycled clothing, the most ubiquitous and economically significant category of all recycling for adornment. Then we focus on several kinds of industrial materials whose overwhelming practicality has given them a prominent place in the art of ornament. Finally, we explore the relationship between aesthetics and practicality in one culture, that of the pastoral Maasai of Kenya.

The Language of Ornament

Personal adornment is a special subcategory of the language of objects, subject to very special rules. Clothing and adornment universally express aspects of a person's status in relation to others: wealth, marital or political status, gender, age, occupation, and so on. Rules – conceived as standards of propriety,

"good taste," aesthetics, ritual or sumptuary restrictions, or "fashion" – dictate who can wear what and when. There is plenty of room in the language of personal adornment for innovation and art, but as Victoria Ebin (1979, 1) so aptly points out, there is always an aesthetic space within which variation is acceptable and is regarded as "tasteful" or "chic." The person who breaks out of that space runs the risk of being defined as tasteless or even insane.

Intercultural recycling inevitably involves serendipitous innovation in the appropriation of exotic objects and materials. Sometimes the item enters its new cultural home in the interstices of the rules, in the visual and conceptual space left for personal preference and "style." But sometimes the co-optation is a perfect fit and satisfies an aesthetic or symbolic need in the receiving culture. When a Turkana man from Kenya decided to use the dappled red surface of a car's reflector to make dangles for his earrings, he made sure to cut them in a traditional Turkana shape, an elongated trapezoid. In this way he went beyond

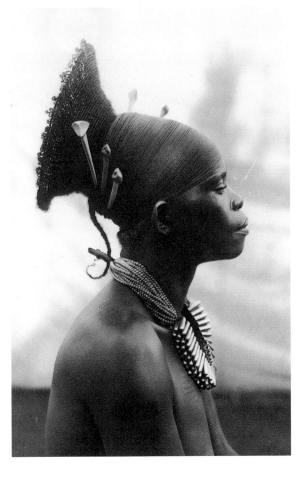

10.4
Photographed by Herbert Lang in 1913 on an expedition sponsored by the American Museum of Natural History, this Zande woman wore a necklace made of spent bullet cartridges.

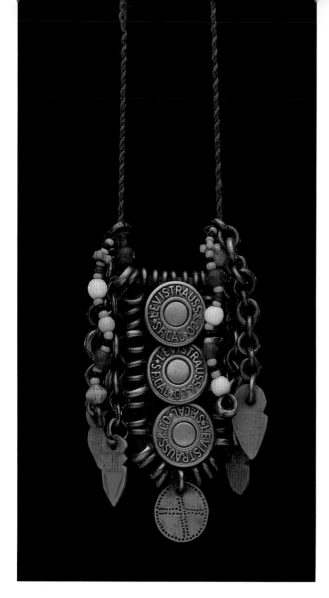

10.5

Pendant. Maker unknown, Bororo, Niger. c. 1980. Leather, glass beads, metal Levi Strauss buttons. H 2 3/4 x W 2 1/2" (7 x 6 cm). Private collection.

Used Levi Strauss blue jeans are a much sought-after commodity in many parts of the world. In Niger, West Africa, the Bororo people have also incorporated the trademark brass buttons into their own system of ornamentation.

good taste into the realm of innovative chic, but not so far afield as to discredit himself.

The reasons people adopt certain items have little to do with their original use but a great deal to do with how those things can be made to fit into a pre-existing conception of appropriate adornment. If we think of the recyclable world as a vast sea of colors, materials, objects, textures, and lusters, each culture pulls out of this pool things that will fit into its particular aesthetic, technological, economic, social, and symbolic systems. Even the most adventurous of recyclers, like the Wodaabe of Niger, who are highly eclectic in accepting and utilizing foreign items, integrate these objects into an aesthetic code of adornment that is governed by strict syntactical rules. As Angela Fisher writes: "With a real feeling for style, a love of outlandish fashion and a great sense of fun, young Wodaabe men and women search for objects in the marketplace with which they can create new and exciting ornaments." (Fisher 1984, 160) But once the odd bits of recyclia have been acquired, they still have to be assembled into jewelry and clothing (plates 10.2, 10.3). Fisher's photographs show skirts with safety pins and key charms placed in checkerboard patterns similar to the juxtaposed blocks of color in West African weavings. Whatever the reason for selecting items from the pool of recyclables, whether it is the fortuitous match with a preexisting form, color, or material, or whether it is for technological compatibility, material opportunism, labor-saving convenience, perceived need, or simply visual appeal, people confront the flotsam and jetsam of the industrialized world with a predisposition born of their own belief systems.

Whenever an item is recycled into ornament it is conceptually stripped of its former uses and meanings and repositioned within a new language of ornament specific to the receiving culture. Outside observers naturally bring assumptions about the meaning of objects when striving to understand them in new contexts. A Zande woman photographed in 1913 by Herbert Lang, on an expedition sponsored by the American Museum of Natural History, was wearing a necklace made of spent bullet cartridges (plate 10.4). Did she select these "beads" because of their shape and the fact that they were made of brass,

a highly valued material? Or was she making some kind of statement about her relationship with foreigners in general, or with Herbert Lang, who used bullets to collect specimens for the museum? One can probably assume that the layers of coins on a Palestinian bride's cap are a sign of status because coins are associated with wealth. But do brass Levi Strauss buttons serve a similar purpose for Bororo people of Niger, who use them in necklaces (plate 10.5)? Are the buttons important for their metal, their shape, their color or luster, their exotic origin, or because they come from blue jeans? To what extent are we attributing our own meanings, rather than deciphering the symbolic code of the recyclers?

Recycling always connects into a symbolic system in some way. As metaphors for power, recycled objects are often found on altars, as in Bénin (see Roberts 1992), where they are placed under the control of specialists. Children in many parts of the world wear exotic recycled objects, such as foreign coins, along with medicines made from natural materials; as medicines and talismans these objects transmit the power metaphorically represented by the object to the child. The Herero in Namibia used to don the clothes of their enemies in order to assume some of their power, and the women's "long dress" of modern-day Herero can be interpreted as an application of this idea (Hildrickson 1989).

The Wahgi man in New Guinea (plate 10.6) who sports the label from a tin of fish on the crown of his head has substituted the red paper label for a more traditional headdress made from red feathers, the red being favored because it is analogous to flowers that attract birds whose feathers are a prized form of wealth. Moreover, the relationship between flowers and birds is thought to be analogous to that between men and women. Decorations, Andrew and Marilyn Strathern write, are thought of as magically "pulling in" valuables and women (Strathern and Strathern 1971, 16). The M'ka men, from the same region, wear saucers as forehead ornaments (plate 10.7), reminiscent of the large white shell disks traditionally worn at festivals. Yet another man is depicted in an early-twentieth-century photograph wearing a shiny aluminum biscuit tin on his head. In the symbol system of this culture, large, bright, shiny ornaments

are thought to connote health, well-being, sexual attractiveness, and the approval of the ancestors, who are believed to attract further valuables to the wearer.

The saucer and the biscuit tin are substitutes for traditional valuables with which they share some syntactical correspondence: color, shape, and brightness. But substitutes have to obey strict rules. The Stratherns note that blue wool, for example, is not an acceptable substitute for blue bird plumes (Strathern and Strathern, 126). Within the ornamental syntax of the Mount Hagen region of New Guinea, the substituted objects reflect personal style and aesthetic competitiveness. Elaborate decorations are displayed at festivals at which ornament competitions are seri-

10.6
This Wahgi man from the Huli Highlands of Papua New Guinea has substituted the red paper label from a tin of fish for the red feathers traditionally used in headdresses. Red is favored because it is analogous to flowers that attract birds whose feathers are a prized form of wealth.

ous business, formerly associated with warfare and ceremonial exchange. Having the best decorations adds to the prestige of local groups and to the individuals who represent them.

What effect has the introduction of European goods had on the practice of self-adornment in New Guinea? The Stratherns reported that some Hageners were "perhaps ashamed of what they consider as wealth [particularly shells and feathers], in the face of Europeans' superior possessions." (Strathern and Strathern, 129) Not surprisingly, they have incorporated foreign elements into their ornaments, and wear them at government-sponsored festivals. By the early 1970s, imported beads sometimes replaced

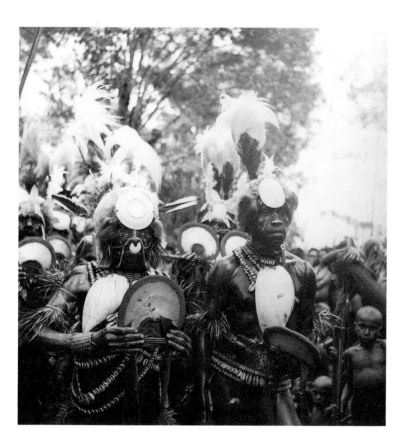

10.7
The M' ka men from the Huli Highlands of Papua New Guinea traditionally wear large white shell disks as forehead ornaments at festivals. The man on the left in this photograph has substituted a white saucer.

cowrie necklaces, and colored paper was worn for its brightness. The Stratherns described a number of other examples of this kind of recycling, such as the men placing fish-tin labels on their foreheads or cutout circlets from Player's cigarette packs on their forehead bailers. "At one *morli* dance we saw a girl wearing a City of Adelaide pennant between her breasts instead of a marsupial tail." (Strathern and Strathern, 129–30)

The syntactical rules governing the construction and use of ornament are dependent on the context in which objects are worn. In the New Guinea Highlands no decorations are worn at funerals; instead, the body of the mourner is covered with mud, wigs are discarded, and men even tear their own hair out. Some substitutes are acceptable at informal occasions, but not at the important festivals, where honoring the ancestors is important. The fish-tin labels are worn by younger men at courting parties. On these occasions, "Shreds of colored paper from tin-labels are nowadays popular as topknots. These accessories are worn for the pleasant swishing sound they make as the wearer sways his head." Ornaments "should not be too fine," for this is an event "that occurs at night, when people cannot see properly." (Strathern and Strathern, 40)

Decisions about appropriation and the use of recycled objects also depend on the context in which recycling occurs. Certain objects may be appropriated for ordinary dress and may be used to signify aspects of personal status, like blue pen caps used by Maasai elders to signify membership in particular age sets (see page 164). Other objects may be appropriated to be used in costumes for special occasions, as in the Corpus Christi festival headdresses of highland Ecuador (see Barbara Mauldin, chapter 9 in this volume). Christmas ornaments, fake pearls, upholstery fringe, plastic flowers, and mirrors – most purchased new and not strictly recycled, but analogous to recyclia in the way they are reconstituted into new ornamental assemblages – are all acceptable kinds of embellishments in the masquerade creations of Sierra Leonian artist Ajani (Vogel 1991, 22).

In most societies there are certain contexts in which breaking the rules is appropriate, or at least tolerated. It may be in precisely these contexts that new recyclia find an entry point into a culture. What

is accepted as a bizarre component of a masquerade costume on one festival occasion may subsequently become "cool" and all the rage for everyday wear. The borderline between street fashion and high fashion shifts all the time, in different ways in different places, depending upon the system of communication that diffuses "style" and upon relationships between classes, ethnic groups, and the individual and society.

Money for Old Rope

Pound for pound, the most significant recycling, from both the senders' and the receivers' viewpoints, is the global distribution of used clothing. Millions of tons of used trousers, sweaters, jackets, shirts, dresses, and underwear are sold in bales from the United States and Western Europe to Africa, Asia, the Pacific, and South America. This generates income for thousands of distributors, middlemen, and sellers. While critics of the used clothing distribution system claim that vast quantities of imported castoffs suppress the development of local clothing manufacturing industries, the fact is that most people in developing countries cannot afford new factory-made clothing, even when it is manufactured locally. When such industries are located in these countries, the clothes are usually exported to the West. The used clothes eventually come back and are sold to dealers in bales that are graded and resold. These *bruni wawo* ("dead white people's clothes," as they are sometimes called in Ghana) are distributed through small- and medium-scale market sellers and tailors who make their living sorting, reselling, and redesigning the clothing to fit current fashion. Far from suppressing a local clothing manufacturing industry, the imported secondhand clothes foster an industry in handling and retailoring them. In many parts of the world people simply could not afford to buy clothing were it not for the used clothes resold in local markets.[1]

When Africans, for example, wear secondhand imported clothes they reinterpret them into their own sense of appropriate dress. Hansen (1994) has shown how Zambians in the capital city of Lusaka continually reinterpret the way they wear this cast-off clothing. These changes in fashion bear little relationship with changing styles in the West. An urban Zambian is no more likely to dress as his or her grandparent did than a late-twentieth-century American woman is likely to wear high-button shoes or a bustle. Fashion changes everywhere, all the time, but not at the same rate and in the same way. For example, the "retro" clothing popular among adolescents in the United States in the 1990s has to conform to strict codes of fashion that index signs of status, age, gender, and even musical tastes.

In the mid-1980s Maasai elders in Kenya and Tanzania were sporting mini-length women's raincoats that American and European women wore in the late 1960s. We do not know where they all came from or where they had been between 1968 and 1985. But why does the short, A-line, cowl-collared poplin raincoat have so much appeal to Maasai men that they even take their new coats to tailors to add a colorful binding to the bottom if the coats are a bit too short? For the Maasai elder, the poplin raincoat is easier to get around in than his "traditional" blanket – itself imported from outside the culture during the colonial era. With the raincoat, he could still wear his usual short cloth, or *shuka*, tied over his shoulder, and also keep warm and carry his tobacco, money, and other small necessities in the pockets. This was a very practical advance whose time had come in Maasailand. The Maasai elder is in no way wearing Western dress. The raincoat was not a raincoat anymore, but rather an analogous garment to the blanket. Nor did the Ghanaian farmer who wore a wedding dress in any way adopt Western clothing. The white dress fit into the farmer's clothing code because its color and neckline were right; it looked something like a typical narrow-strip woven tunic popular in his area.[2]

Practicality. Or, as the Rabbi's Wife Said, "What Are All these Modern Inventions for If Not to Help Us Keep Our Traditions?"

Practicality and efficiency – the bedrock of material opportunism – operate to allow the incorporation of exotic objects and materials into new ornament systems. The industrialized world continuously provides an ever-changing range of new materials for people to use as substitutes for labor-intensive or otherwise inferior materials. Phonograph records, dishes, plastics of all kinds, tin cans, aluminum pots, innertubes,

10.8

Necklace. Maker unknown, Ghana. c. 1980. Red plastic phonograph records. H 20 x W 1/3" (51 x 0.5 cm). International Folk Art Foundation Collection, Museum of International Folk Art, Santa Fe.

Plastic – because of its availability, malleability, and multiplicity of colors – is one of the most important recycled materials in Africa and the one most widely recycled by craftspeople, especially jewelers. Red is a desirable color for adornment in Ghana, and jewelers in recent years have found red plastic phonograph records to be an excellent raw material for making necklaces.

old textiles, and an assortment of findings from buttons to zippers to key rings have relieved shoemakers, jewelers, and ornament makers of endless hours of work. Not only are new materials reworked in old forms, but new ornament industries incorporating industrial "junk" have grown up specifically for tourists, the consumers from postindustrial societies who help support people in poorer countries by repurchasing their own castoffs recycled into "ethnic" toys and ornaments.

Plastic is arguably the most important recycled material and the one most widely used by craftspeople and artists, especially jewelers.[3] Borana jewelers in northern Kenya use it as an enamel in cloisonné work. They make the cloisons, or cells, from melted cooking pots and fill them with pieces of melted plastic. The hot liquid plastic and metal can easily be filed down and polished. The result is a silvery metal ornament with colored patterns embedded in its surface.[4] Maasai men, who are not supposed to form anything (that being women's work) secretly melt lumps of plastic from discarded bottles, bowls, and jerry cans and carve them into ear pendants (Klumpp, field observation). Sheets of plastic can be cut and carved, as was done by the Turkana man who wanted a high-crested finger ring. He abandoned the tradi-

tional ivory in favor of a bright blue "gem" cut from a heavy jerry can. In many parts of Africa, necklaces and bracelets made from recycled plastic phonograph records, cut into disks with a center hole added, are made in the same way people used to string ostrich eggshell disks (plate 10.8).

Plastic jerry cans, when they are no longer useful as containers, provide a wonderful range of colors for incorporation in jewelry. Some of the plastics can be melted over a fire and fashioned into new shapes. For ear ornaments, the Maasai melt and combine plastics to form spiral patterns like candy canes or barber poles. In this way they are able to use the recycled material to fill a need for paired color arrangements and alternating colors, two in each ear. The makers of these ear sticks take advantage of the best the industrial product can offer – its pliability and saturated color – in creating ornaments that are entirely Maasai (see below).

Industrial debris is often cheaper and easier to obtain than "traditional" materials, like rare shells or ivory. Some imported materials were introduced as deliberate substitutes by Europeans who used the new items as currency and then sought to establish a demand for imports: bakelite for amber, plastic for conus shell and ivory, glass beads for seeds and shell

disks. When imported glass beads became scarce or too expensive, they were made locally by crushing and melting down old bottles. Necklaces of green, brown, and gray glass beads can be purchased in Ghana today. Glassworkers have also developed techniques of adding color to clear glass and juxtaposing ribbons and drops of different colored glass made from recycled bottles. These beads are African-made versions of the trade beads that were originally imported into Africa from Italy and Czechoslovakia.

Wakamba jewelers in Kenya used to get conus shell disks traded inland from the coast to make into pristine white earrings. When china plates came on the scene they could fashion the broken ones into similar earrings but with added decorations like blue stripes and floral patterns. Even the manufacturer's trademark became a decorative element. Later, plastic sheet brought a range of bright colors to the same kind of earring. And plastic, of course, is the obvious substitute for ivory.

Tin cans and aluminum cooking pots became useful to the Maasai because they could be cut up to make *nchili*, the shiny tinkling triangular dangles used extensively in ornament. Maasai bead workers, who have been working with imported materials since the mid-nineteenth century, have replaced leather with nylon gunny sack thread for stringing beads because it is strong, durable, and labor saving.

Sometimes exotic objects have to be taken apart and reworked to be useful. For centuries, weavers have been selectively removing threads of certain colors from European textiles and incorporating them in their own work. In Ghana, for example, the difficulties of producing a good red dye, "led to the unravelling of imported red cotton hospital blankets in order to re-weave the yarn. . . ." (Picton and Mack 1979, 30) Embroiderers in Lamu and other towns on the East African coast carefully unravel silk fabrics and use the threads to embroider complicated patterns of tiny eyelets on their skullcaps. Shopkeepers stock a variety of colors and know just how much fabric to cut for threads of the right length. The pre-cut fabric keeps the threads intact and stores it more efficiently than a spool, alleviating the need to continually cut the thread. The embroiderer can simply fold the flimsy silk cloth and carry it around in a pocket. He or she (both men and women embroider caps in East Africa) can then select the number of threads or fibers to pull off each time for the desired stitch thickness. In this case, recycling enables craftspeople greater flexibility in use of materials than would otherwise be possible.

In the 1930s, the dawn of the aluminum cooking pot marked a major watershed in ornament production. Called *sufuria* in KiSwahili, the lingua franca of East Africa, the worn-out pots provided an eminently

10.9

Belt. Unknown Okiek maker, Kenya. c. 1965. Leather, glass beads, metal chain. L 26 x W 1 1/2" (66 x 4 cm). American Museum of Natural History, New York.

Industrially produced metal chains are such a sought-after material for ornamentation in Africa that they are often purchased new – either with cash or with livestock – rather than scavenged and recycled. In this example, young Okiek men of Kenya have attached metal chain as a swishy fringe on a traditional belt.

10.10

Dress. Maker unknown, Native American. Plateau region, U.S.A. Late 19th century. Leather, glass beads, metal thimbles. H 46 1/2 x W 40" (118 x 101.5 cm). Museum of International Folk Art, a unit of the Museum of New Mexico, Santa Fe.

Native Americans often cut up tobacco cans to make tinklers to adorn their clothing, bags, and baskets. The metal makes an attractive fringe and creates a nice sound with the movement of the body. Here the maker utilized metal thimbles to achieve the same effect.

workable, soft but durable white metal that is neither too reflective nor too stiff. Unlike bits of tin from cans, aluminum sheet, when cut into simple or complex shapes for dangles and pendants, is musical when the pieces clink together. The Maasai can buy disk-shaped stainless steel sequins for their jewelry, but most people prefer the triangular *nchili* hand cut from old cooking pots.

Other ethnic groups in East Africa have recycled aluminum cooking pots by casting and forging torques, bangles, and cuffs, and as a substitute for brass and iron. Aluminum can be hammered, bent, drawn, and hot or cold forged, and requires much less effort to work than other metals. It is wonderfully lightweight and when worn constantly develops a rich silvery luster. In northern Kenya it has replaced brass among the Borana and is forged into *korema*, the beads used as dowry for married women who need a cascade of metal beads around their necks to show their status. Likewise, the Orma people of the Tana River bend, who have to wear a minimum of fourteen bangles on each arm, have switched from brass to aluminum.

While the functional meaning of an object or material in the originating culture is often lost in recycling, the aesthetic aspects of certain objects come to predominate. This kind of change can occur within a culture, as well as across cultural boundaries. People who think of buttons as closings and fastenings appreciate their decorative quality on a man's suit or their extraneous use on women's dresses or children's clothes; however, they may not be prepared for the shimmering effect of a dancing skirt or a jacket totally covered with tiny white disks of mother-of-pearl, like those of the Akamba in Kenya. When buttons are positioned as jewels in the language of ornament, they implicitly make an ironic comment on the meaning of both jewels and fasteners.

When buttons are used for ornament, they are often purchased, like beads and metal chain, and not actually recycled. The same may be true for rows of safety pins, as on the Wodaabe man's tunic (plate 10.3). Who would prefer to etch out two thousand shell disks, each seven millimeters in diameter, and drill two holes in each one when it is easier to go to a shop or market and buy ready-made buttons? The use-value of the button or safety pin has been rede-

fined. What is being transformed in this intercultural exchange is the meaning of the object, not necessarily the particular object itself.

Similarly, the chain shown on the Okiek belt from Kenya (plate 10.9) is not recycled. Such chain is highly desirable and people are willing to go to the shops and buy it with cash or livestock. The chain is familiar to Westerners as the main component of key chains and the like, but not as swishy fringes on belts. To East Africans this example is merely utilization of an eminently suitable material in the right place. As shown in the Native-American woman's hide dress with a thimble fringe from the Plateau Region (plate 10.10), or a Kenyan Kamba dance skirt with a bottle-cap fringe, items such as chains, bottle caps, buttons, and thimbles can offer fortuitous matches between manufactured objects and the technical and cultural needs of a given society.

Film canisters definitely were not designed for the many uses to which people put them. In East Africa they make wonderful lightweight substitutes for heavy wooden or ivory ear plugs worn in stretched out lobes. With film cans in their earlobes, they can carry tobacco or small coins neatly while looking stylish. They can also make money by having their picture taken by tourists.

There is, in fact, an old Maasai man who makes his living by hanging around one of the petrol stations in Namanga, a town on the Kenya-Tanzania border. He does nothing but wear a large safety pin in his pierced upper ear and rake in the shillings he gets for having his picture taken (plate 10.11). He knows that Maasai don't wear safety pin earrings, but the foreign tourists find something intriguing about his earring. In pre-punk days foreigners thought it was quite comical to wear a safety pin as an earring, and they chuckled over the old Maasai's "error." They didn't mind, of course, making Maasai beaded necklaces into picture frames to hang on their walls at home.

Despite the old man's "error," even in the eyes of his Maasai friends, the Maa-speaking peoples of East Africa do wear most of their art in the form of body ornament. But they are highly selective about which new items they adopt into the ornament language and how they treat them. They make sure that any new thing either fits in with a preexisting conception

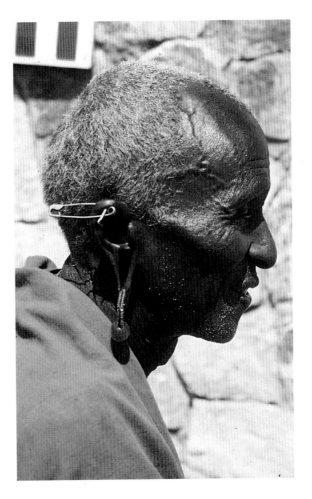

10.11
In Namanga, a town on the Kenya-Tanzania border, this Maasai elder with a safety pin through his ear attracts the attention of foreign tourists who stop to take his picture.

of how a decorated person should look, or that it can be modified to fit. The Maasai woman who placed a flashlight bulb at the center of her necklace did so because the bulb's shape was congruent with a traditional Maasai charm and the glass symbolically resonated with water in a standing pool, a highly valued resource.

Selective Recycling and the Maasai

The Maasai people of Kenya and Tanzania provide an example of a culture that both consciously and unconsciously appropriates for its use those objects and materials that fit, or can be made to fit, into their notion of what is good, true, right, proper, and beautiful. For many years the only item of Western dress imitated by Maasai in their ornaments was the wristwatch, whose form resembled a traditional bracelet and whose glassy face, like the lightbulbs, reminded them of a pool of water. The form of the watch was indigenized by using a white glass or shell button in the center surrounded by rows of brightly colored glass beads.

In Maasai thought, things are organized according to what can be called the principle of anomalous duality (Klumpp 1987). The Maasai recognize in col-

ors, objects, and people the presence of logical categories that are arranged in unequal pairs or triads. For example, in the Maasai aesthetic system, members of a pair (e.g., earrings) cannot be exactly alike. Though their sets have strong and weak members, related things correspond in a harmonious way in which the strong depend on the weak and vice versa. The Maasai see themselves as the strong member of a pair; the other member is all the other people in the world. Men and women are a pair, as are red and green, blue and orange, black and white. Black, white, and red can form a triad in which black is the strongest color. Pastoralists, farmers, and hunter/gatherers form a triad of mutually exclusive yet complementary occupational categories. Without even thinking about it, the Maasai arrange the colors they wear in ornament and in clothing according to the correct grammar and order of pairs.

Plastic, with its range of bright colors, allows the Maasai to combine contrasting colors in the right pairs – red and green, blue and orange, black and white – giving them a wider range of possibilities for

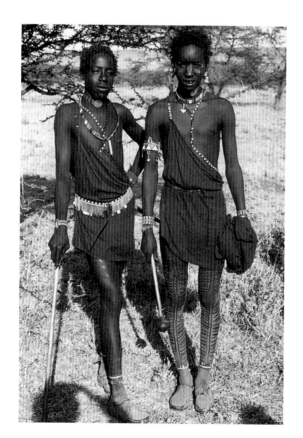

10.12
The use of the pen cap as a jewelry finding and fashion statement among the Maasai of Kenya became popular in about 1985, when members of the Ilmirisho age set began wearing pen-cap extenders on armbands and necklaces. These warriors are wearing pen-cap necklaces, belts with chain fringes, and other ornaments with plastic dividers and aluminum dangles.

expressing their own aesthetic principles with recycled material. Similarly, the metal zipper is used opportunistically in Maasai ornament because the alternating light pieces of metal and dark interstices makes an admired pattern called *keri*. The zipper is also a time and work saver because it can be sewn onto hide much more quickly than beads. Using a zipper to reinforce the eyelet in an ornament's closing makes a decorative and very strong edge. Here the zipper is not a zipper, but rather a certain kind of decorative element, fitting into the syntactical space normally occupied by alternating light and dark beads.

Clothing and adornment are extremely important to the Maasai because for them the human body is the basis for creating a uniquely personalized, yet culturally correct multimedia assemblage. For many years they have been encoding their basic ideals in color arrangements and have been telling each other who they are through the composition and style of the ornaments they wear. As early as the late nineteenth century they were recycling materials for use in their ornaments. Most notable then were the tons of wire they acquired from the railway construction crews and also purchased in the shops. Some of this wire was used as wire, whereas some of it was drawn and made into fine chain with C-shaped links. Later in this century they acquired, through trade, the chrome-plated steel or white metal twisted-link chains that are still in use today. This chain replaced that made by the blacksmiths because it was regular, more supple, shinier, and cheaper. It could be cut to any length and easily incorporated into ornaments.

Maasai ornaments often combine both recycled and nonrecycled materials: zippers, buttons, and in the case of the warrior's armband, ballpoint pen caps (plate 10.12). This armband is closed at the back by thongs from one side passing through eyelets on the other side. The closings are held in place by ballpoint pen caps drilled at the pointed end. When the pen caps are in place they protrude at the back of the wearer's arm. Such protrusions are called *ilpenyeta* and are considered very chic. They can be made from the quills of vulture feathers, but plastic pen caps provide the same shape in bright colors. The use of the pen cap as a jewelry finding and fashion statement came in about 1985, coinciding with the need for ornaments by members of the Ilmirisho age set.

As a result, pen cap extenders on armbands and necklaces will forever be associated with Ilmirisho in Maasai history.

A fortuitous correspondence of form also accounts for the adoption of the Treetops bottle as a substitute for the commonly used gourd container worn around the neck or carried over the shoulder. Treetops is a commercially made orange squash that comes in a tall glass bottle that bulges slightly at the bottom and is closed with a white plastic screw cap large enough to use as a drinking cup. Its shape is just like the long narrow gourds that the Maasai use for milk. A column of liquid does not slosh when carried. Maasai gourds also have leather caps that can double as drinking vessels obviating the need to carry an extra item that could easily get lost or dirty. Nowadays, Maasai women carry their milk in Treetops bottles.

In order to get a Treetops bottle you have to buy one and drink the sugary orange liquid inside. Treetops has become an important beverage in parts of Maasailand, especially for serving to guests. It is not clear whether or not the manufacturers designed their container to cater to a secondary-use market. Orange squash is for most people a luxury item that has to be purchased with cash, a rare commodity in rural areas. Yet people use their limited cash resources to acquire Treetops and accumulate empty bottles. These bottles can also be resold, thus recouping some of the money spent on them. Or they can be given as friendly gifts among cowives, neighbors, and friends.

For the Maasai, recycled objects are not adopted unless they conform to the symbolic code that informs the Maasai system of ornament. A Maasai baby's big egg-shaped beads are beautiful, and they also symbolize the relationship between the baby and his grandmother who gave him the beads. Babies also wear the *ilbisili*, a necklace incorporating a red gourd top, blue/black glass beads, and white cowrie shells, bringing together the triad of significant colors – red, black, and white – and the symbols for earth, heaven, and sea, respectively. The baby's necklace also includes recycled plastic in the form of a disk and other carved beads (plate 10.13).[5]

For the Maasai and others, there is nothing haphazard in the incorporation of recycled objects in ornament. As a system of symbols, ornament is utterly precise in the signals it gives regarding the wearer's ethnic affiliation, gender, age, and social and economic status, not to mention the more transient aspects of self-definition and self-presentation. Therefore, the forms, colors, textures, and materials of recycled objects used in ornament have to be deployed in a much more specific way than those used in other kinds of recycling. Ornament is too important and too finely prescribed in any culture to allow the wearer much leeway for mistakes in the symbolic messages that are transmitted to the viewer. There really are no mistakes, except in our understanding and interpretation of the process.

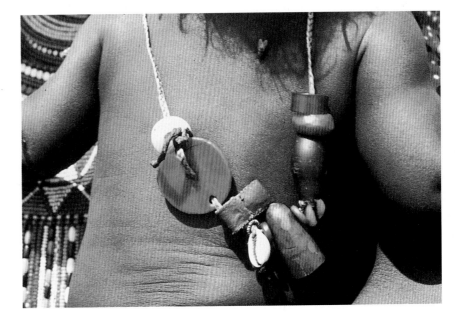

10.13
This Maasai baby is wearing an *ilbisili* necklace incorporating a red gourd top, white cowrie shells, and blue glass beads representing earth, heaven, and sea, along with recycled plastic beads and large glass beads handed down from his grandmother.

Madonna's Earrings:
Catholic Icons as Ethnic Chic

Donald J. Cosentino

For my mentors:
Pierrot Barra and Virgil Young

Quo Vadis, Domine?

Let us focus, seriously, on Madonna's jewelry. On the crucifixes suspended from Louise Ciccone's ears, or the big pop-it bead rosaries flung around her neck. How did those sacramentals make it from devotional life in Flint, Michigan, to *Time, Playboy,* and *Vanity Fair* cover girl chic (plate 11.1)? That trajectory is what we're after: appropriations and reappropriations of religious imagery, especially the crucifix, from cult object to haute couture, and back to the altar again. Vodun to *Voodoo Lounge.* The cruciform itself suggests the crossed lines of its own trajectories: Einsteinian swoops from Low to High, Pop to Folk, Sacred to Secular, and all the way around again. There is no unilinear South to North model to consider; no simple rip-off from third world hovel to Fifth Avenue vitrine. No woeful, too predictable parable of exploiter and exploited. Lessons from those earrings are really much more interesting than that.

Madonna was born into the iconic gold mine of pre-Vatican II Catholicism. So too were Andy Warhol, Andres Serrano, Robert Mapplethorpe, 6 million Haitians, and 25 million Italian-Americans, including me. A polychromatic, industrial strength world of lithographs and plastic statues, sustained by the yet more pervasive religious images of the mass media, especially movies, which brought those shoddy representations into a gaudy, if spurious, new life. No movie affected that grand translation more triumphantly than *Quo Vadis*: Christians versus Lions; epicene Nero versus the Roman fire department; Lygia, the Christian slave girl (played by demure Deborah Kerr), versus her would-be lover, the valiant but dense pagan general (played by dashing Robert Taylor). For most of the film Taylor remains a pagan, unable to understand why beauteous Lygia won't jump at his proposal to marry and settle down on the old *latifundia* in Sicily. In exasperation, he makes her a final offer she can't turn down – or so he thinks. After the wedding, he will erect a 100-foot marble cross in honor of the crucified carpenter she (perversely) worships.

Lygia was outraged, and so was I. Did this pagan brute suppose Christian imagery could be retrofitted into arcadian chic? That the crucifix, central icon of Christianity, could be recycled into lawn decor to please a simple wife, or amuse a jaded guest? I now look back in wonder at my own naïveté (and hers). The general was simply offering Lygia a gift any ordinary (i.e., pagan) Roman would surely have adored. Christians were just about the only Romans not interested in recycling foreign icons. After all, Roman temples were crammed with the statues of deities looted or copied from Greece. In fact, the entire Latin pantheon was recycled from the Greek Olympians, who, in turn, were East Mediterranean avatars of Indo-European gods, relexified and reclothed in Attic fashion.

By the time Peter and Paul arrived in the Eternal City, the range of religious artifacts available to Romans was already staggering. We know from authors as diverse as Lucretius and Apuleius that since the Punic Wars of the second and third centuries B.C., "superstitious ideas, for the greater part from abroad, spread widely among [Roman] citizens. . . . Sacrificial priests and augurs had got a hold on [them]." (Carroll 1986, 105) The urban scene they describe

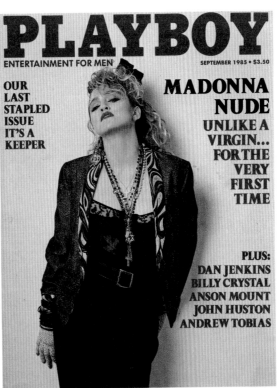

suggests a waning faith in the Olympians and a rush to recycle the votive objects of foreign gods: from Persia, carved images of Mithras's bloody tauricide; from Egypt, Osiris's severed penis; from Asia Minor, the goddess Cybele enthroned with a lion across her lap. These objects became the transcendent knick-knacks of late pagan antiquity. There is an odd resonance between their commercial allure in ancient Rome and the growing market for analogous icons of imported ecstasy in American shops on fourteenth Street in Manhattan, Melrose Avenue in L.A., or North Beach in San Francisco.

For the first three centuries A.D., it was the lower middle class, and not the slaves or landless proles of Church legend, who converted to the zealous cult of the crucified carpenter. These Christian shopkeepers and bureaucrats eschewed the ecstatic geegaws of other religions, holding out, with waning hope, for the end of the world. It was down on the *latifundia* and in the hovels of the urban poor that the prototypes of Christian iconography that have proved so enduring and popular were being made – for other gods! The truly wretched of the Empire were busy processing their images of Cybele, and flaying themselves in honor of dead and reviving gods, until they were forced to convert to Christianity at the end of the fourth century. It was the mandated conversions of this epoch, known in ecclesiastical history as the Great Transformation, which brought the wretched into the Church, along with their lurid, graphic tastes in religious arts.

As Michael Carroll notes, the crucifix is now so deeply part of Catholic tradition that it is easy to overlook its complete absence from Christian art during the first four centuries of the common era. Christ is portrayed quite often in catacomb art, but neither as crucified, nor in any other act of the Passion. Rather, He appears symbolically, as a fish; or allegorically, as a shepherd; or in favorite scenes from the New Testament (the Sermon on the Mount, the Raising of Lazarus). Only toward the end of the fifth century does the crucifix become common.[1] "The sudden appearance of this iconographic emphasis 'just happens' to coincide with the sudden influx [into] the Church of the Roman proletariat and the subsequent emergence of the Mary cult." (Carroll, 87–9)

So the Great Transformation was in fact the Great Recycling. Icons and statuary that had brought ecstatic release to the hoi polloi were now inducted into the ritual face of Christianity. Along with the crucifix, the Marian cults flourished.[2] Ceremonies

that had been observed for Cybele now shifted to Mary. Especially significant were the processions. Both Ovid and Augustine describe the "travelling statuaries" borne aloft by the *galli*, eunuch priests of Cybele, the Great Mother. They moved through the countryside with her statue, begging "small coins" from devotees in the *paeses*, or on the farms.[3]

The crucifix and the Madonna dressed in satins and carried by her believers: these are the representations of ecstasy that have proved so popular and enduring. A direct line of cultural history connects such images, already ancient in the fifth century, through various permutations, into a strange regeneration at the close of this millennium. Consider the opening scene of Fellini's *La Dolce Vita*: bikini-clad sunbathers waving to a statue of Christ being lowered from a helicopter. Or the plaster images of Mary processing from Rome to Spain to Zapopan, whose tiny Virgin is dressed in starched lace and carried in the back of a van through the villages of Jalisco, Mexico, every summer. The power of current fashion has overtaken even this plaster Madonna, who had not left Mexico for 400 years. As NAFTA's first reward, the Zapopan Virgin's summer tour now takes in East L.A. For the last two years she has been feted at Sta. Isabel on Soto Street, the high altar of the church being transformed into a faux Santería throne in her honor (plate 11.2).[4]

Material Girl

The recycling of this religious imagery is an ongoing process. Through an ingenious reappropriation of imagery devised to worship "pagan gods," the Church converted the masses of Mediterranean Europe, and then of Latin America. And now, as if to validate once again Giambattista Vico's theory of history as a waltz in three-quarter time, this same Catholic imagery is being transformed into neopagan adornment. I speak, with embarrassing literalness, of *the* Madonna of our times: *Madonna Louise Veronica Ciccone*.

Given the development of a camp sensibility in pop culture over the past forty years, Catholic icons might have undergone their own Great Transformation into boutique jewelry in the wake of the Vatican II

11.2
The Church of Sta. Isabella in East L.A. is decked out like a Santería shrine in honor of the visiting statue of Mexico's Nuestra Señora de Zapopan.

reforms of the early 1960s. But with Madonna, the transformation became a mania:

She was a parody of what she might actually have been – a dirty little Catholic girl, quite unlike her blessed namesake. Singing with torqued tongue about being like a virgin, she flaunted a raggedy-girl mixture of crucifixes and visible bras, tulle and studded leather, bared midriff and lace gloves. . . . America's stores, streets, and schoolyards swarmed with mimic Madonnas. The look even filtered into the "mad" fashion fantasies of couture copycats in Paris, notably Christian Lacroix at the house of Patou and Chanel's Karl Lagerfeld. (Gross 1986, 102)

Up until the end of the seventeenth century, her adornments would have screamed for a burning at the stake. But times, sanctions, and fashion change, and Madonna reflects all that. She has, in fact, become the Queen of Recycled Fashion, the postmodern, postcoital Virgin:

Adidas sneakers with different-color laces, nylon tracksuits in all bright colors, belts, leather caps, and gloves with fingers cut off . . . [i]t was the combination of raggamuffin . . . New Wave . . . Puerto Rican street style . . . and Catholic Church style – for there were rosaries too. "Beautiful and mysterious," she says, "something that looked like suffering." Beautiful suffering. Innocence and provocation. Madonna and Magdalene. "You know where it comes from," she says, "Catholic upbringing. I was exorcising the extremes my upbringing dwelt on. Putting them up on the wall and throwing darts at them." (Gross, 102)

Of all the gaudy elements in her pastiche, it is still the crucifix and the rosary that define Madonna's mystique:

I think I have always carried around a few rosaries with me. There was the turquoise-colored one that my grandmother had given me a long time ago. One day I decided to wear it as a necklace. I thought, "This is kind of offbeat and interesting." I mean, everything I do is sort of tongue-in-cheek. It's a strange blend – a beautiful sort of symbolism, the idea of someone suffering, which is what Jesus Christ on a crucifix stands for, and then not taking it seriously at all. Seeing it on an icon with no religiousness attached to it. It isn't a sacrilegious thing for me. I'm not saying, "This is Jesus Christ," and I'm laughing.

When I went to Catholic schools, I thought the huge crucifixes nuns wore around their necks with their habits were really beautiful. I have one like that now. I wear it sometimes but not onstage. It's too big. It might fly up in the air and hit me in the face." (Skow 1985, 78)

In her already celebrated dialogue with Norman Mailer in *Esquire*, Madonna explicitly defines the erotic appeal of her appropriated jewelry:

I do believe religion and eroticism are absolutely related. And I think my original feelings of sexuality and eroticism originated in going to church. . . . It's very sensual, and it's all about what you're not supposed to do. Everything's forbidden, and everything's behind heavy stuff – the confessional, heavy green drapes, and stained-glass windows, the rituals, the kneeling – there's something very erotic about that. After all, it's very sadomasochistic, Catholicism.

Madonna's appropriation of religious symbols is a considerable intellectual and spiritual achievement. She has gathered together incredible taboos, and made them life-affirming. "She is not a lapsed Catholic for too little," Mailer declares:

"Inter faeces et urinam, nascimur," she is always telling us, even if she never heard of Saint Odo of Cluny, but indeed it is true. "Between piss and shit we are born," as the good saint told us, and the road to heaven, if you could find it, lies by implication between the two. Madonna comes to us as a bastard descendant of the void that Andy Warhol enshrined in the ice of his technique, but how she seeks to fill that empty space with her work! (Mailer 1994, 56)

Enter the Shuppies

The heavens conjured by crucifixes, rosaries, and legions of dashboard saints inspired not only Madonna, but generations of ethnic Catholics. Michael Ventura, who grew up poor, Italian, and Catholic in Brooklyn, now writes for hip fanzines in L.A. He describes a '50s childhood shadowed and illuminated by movies, TV, and plastic crucifixes. That culture gave him a new god: the triune conflation of Elvis, Marilyn, and Jesus. And a new devil: the celluloid Dracula. As a terrified child, Ventura had only one antidote to the vampire's fangs:

a plastic, glow-in-the-dark crucifix nailed to the wall above my pillow. It glowed a sickly purplish white. Who was Jesus in my eleven-year-old world? . . . [T]he tiny figure on the rosary cross, the enormous one in church . . . a conjunction of disassociated fragments, mysterious not in themselves but because Jesus seemed inescapable, but why? It took Dracula to explain it to me. Jesus was the only thing that could save you from Dracula. That was power. You didn't have to understand him, believe in him, or even like him, but if you held up his crucifix, or nailed it above your pillow, Dracula couldn't touch you. (Ventura 1992, 8)

Madonna and Ventura represent opposite reactions to Tridentine iconography: the first, its usurpation by popular culture; the second, its continuing religious allure in the age of mass consumption. The Counter-Reformation Council of Trent (1545–63) had revalidated the sanctity of popular icons and their strategic importance in combating the radically iconoclastic Protestant heresies. The edicts of Trent opened the way to the Baroque and the Rococo, whose intensity and overstylization served to express Counter-Reformation piety. Mass production in the last century vastly increased the influence of Tridentine arts, even as it transformed them into kitsch.

Catholicism facilitates through its imagery the materialization of one of the most ungraspable of all experiences, that of the transcendence of spiritual attributes. Like kitsch, religious imagery is a mise-en-scène, a visual glossolalia that embodies otherwise impalpable qualities: mystic fervor is translated into upturned eyes, a gaping mouth, and levitation; goodness always feeds white sheep; virginity is surrounded by auras, clouds, and smiling cherubim; passion is a bleeding heart; and evil is snakes, horns, and flames. In kitsch, this dramatic quality is intensified by an overtly sentimental, melodramatic tone and by primary colors and bright, glossy surfaces (Olalquiaga 1992, 41).

Most Catholic families could (and did) own kitschy plastic crucifixes, like the one little Ventura used to scare Dracula, and Andres Serrano (another New York boy) would photograph, years later, in a glass of his urine. And the ecstasies so inspired in Ventura and in Serrano would differ only in material

representation from those enjoyed by Santa Teresa and her smiling angel (with his long golden shaft) centuries before in Toledo.

As in all folk art traditions, mass-produced manifestations of heaven can be recycled into original votive pieces. There are dashboard altars, complete with magnetized statues, stick-on holy cards, and sacred decals. Or, on a more ambitious scale, there are bathtub shrines, an art form associated especially with Italian ghettos in the northeast U.S. (plate 11.3). In this expression of piety in an industrial age, an old bathtub is upended and set into place on a brick plinth, preferably in a front-yard rose garden. The inside of the tub is painted powder blue, and fitted with a statue of the Madonna or the Sacred Heart of Jesus. The ensemble is decorated with plastic flowers to augment the natural roses.[5]

If bathtub shrines represent the flowering of Tridentine piety in the age of mechanical reproduction, then Madonna's videos, performance tours, and cello-wrapped manifesto, *SEX,* can be seen as secular appropriation of that same tradition. Her various personae, at their dark roots, attract such diverse audiences as suburban teens, gays, feminists, and urban hip-hoppers. But when Madonna appropriates kitsch into her video decor, she assumes a particular glamour for a Yuppie avant-garde who come both to jeer *and* swoon at those very religious icons most absent from their lives. These are the secular humanist Yuppies, or Shuppies, whose attitude toward the iconography of Christianity closely resembles that of Robert Taylor's Roman general in *Quo Vadis.* For them, Madonna is in fact a Shuppie icon. She is queen of a new cargo cult of spiritually charged objects. The power source of her crucifix earrings, or her rosary necklace, is as unknowable to these secular professionals as the Coke bottle falling from the sky was to the befuddled Khoisan man in *The Gods Must Be Crazy.* All either knows is the mantra of the marketplace: *If You Buy, the Gods Will Come!*

Spiritual Dressing

In her front-page article "Piety on Parade" (*New York Times,* September 5, 1993), Amy Spindler describes how quickly and relentlessly Madonna's

daring appropriations have spread beyond Catholic camp toward an ecumenical ransacking of everybody's holy clothes.

Runways, fashion advertisements and magazine layouts are rife with what could be the wardrobe at a religious summit meeting: Hare Krishna silks, hooded and rope-belted monks' robes, clerical tunics, the plain garb of the Amish and even the black gabardines of the Hasidic Jews. Nothing, it seems, is sacred. (Spindler 1993, 1)

Once again, it is the crucifix which engages Spindler's purveyors of Shuppie fashion. She quotes jewelry designer Robert Lee Morris, who is particularly fond of the cross:

We are in a period of being more humble, of spending less, of being more frugal. These crosses just emphasize that sense of self-denial. Also, there's the AIDS *crisis. Literally, we're keeping our pants up, and holding back – using our will power to control that hedonism we had in the '80s.* (Ibid.)

Other fashion designers offer more New Age rationales for their appropriation of Christian imagery. Designer Donna Karan, who uses crosses with abandon, told Spindler:

People say, "How can a nice Jewish girl do a cross?" I don't see it as a religious signature. [The spiritual aspect is only] a calming of the clothes, the antithesis of the hardness of power dressing. . . . There is an imbalance in the world, a lot of anger and fear. So when you sense that, you try to look into your spiritual self. (Ibid., 30)

And Spindler received a similar response from another arbiter of popular taste:

Calvin Klein, who pared his models down like initiates to a couture convent, and whose Eternity perfume is closed with a cross-shaped stopper, said, "I look at the robes worn by the clergy, or the pristine white shirts that choirboys wear, or the way the Amish dress, and it all comes together for me." (Ibid., 1)

Klein and Karan seem to be suggesting that the borrowed robes of religion may serve as penance for the gross consumerism of the '80s. But Katell le Bourhis, conservator-in-chief of the Musée des Arts de la Mode et du Textile at the Lourve, doubts their arguments:

Clothes that look simple and plain seem like a good

11.3
In a typical bathtub shrine, such as this example in Brooklyn, an old bathtub serves as a niche for a statue of the Sacred Heart of Jesus or the Madonna. (Photograph © Martha Cooper)

effort to respond to society in this depression. . . . But it's a misconception, because those clothes are the same price as the extravagant ones. (Ibid., 30)

Spindler also dismisses any intimations that symbols are being appropriated for more than material reasons:

While monastic dress may be a more reverential backdrop for the cross than Madonna's earlobe and torso, theologians fear that its use as a mere fashion accessory will probably have the same profane effect. (Ibid.)

Margaret R. Miles of the Harvard Divinity School concurs:

The way to discount a symbol is not to walk away from it and ignore it, but rather place it in a decorative context rather than religious context. I regret that the religious symbolism is being trivialized and secularized in this way. (Ibid.)

There is an ironic backdrop to this appropriation of the wimples and huge rosaries that fevered Madonna's young imagination. In post–Vatican II efforts at renewal, many orders abandoned their ancient habits now grown suddenly chic. For some, like the School Sisters of Notre Dame, these habits were themselves recycled versions of traditional European widows' weeds. Now the Reformed, With-It, God the Mother nuns resemble frumpy WACS,

while fashion designers capitalize on nostalgia for that lost Bells of St. Mary's look. When religious garb is still in daily use, however, recycling is not quite so easy. French designer Jean-Paul Gaultier recently accessorized his black wool suits to resemble the traditional attire worn by Hasidic Jews. When French *Vogue* staged a fashion shoot of his clothes in a Hasidic section of Brooklyn, the neighborhood went ballistic. Particularly incensing was a female model wearing one of those big Russian hats with ear flaps, and a gabardine suit. *Vogue* was no *Yentl*, and this *shiksa* was no Streisand.

Sex and Fashion

If these habits are appropriated without regard to their religious history, and if the Shuppie discussion of their semiotics is merely New Age prattle, what does motivate this odd turn in fashion? Designer John Bartlett thinks he has the answer, the same one Madonna gave Mailer: Sex. Bartlett is the creator of items such as a rope-belted monk's coat and loose orange robes inspired by the Hare Krishna. "Personally speaking, there's nothing sexier than a monk or a Hare Krishna," he said. "They're so inaccessible." (Quoted in Spindler, 30)

The critics consulted by Spindler agree with Bartlett. "On some level, these garments may be commenting on a sexual environment that for more than a decade has been dominated by the shadow of AIDS," said Nina Felshin, an independent curator and writer. *At the same time, because religious garb tends to be sexually ambiguous, as a fashion statement it continues our popular culture's questioning of fixed gender and of gender roles. As weird as it may sound, I think it is not very far removed from cross-dressing transvestism and androgyny.* (Ibid.)[6]

Dr. Valerie Steele, author of *Fashion and Eroticism* (1985), sees present fashion as continuing a nineteenth-century Parisian tradition, when hookers were expected to excite their jaded johns by wearing costumes, nun's habits and bridal dresses being the two most popular. "It's easy for us to confuse purity of line – no ruffles – with spiritual purity. No one is wearing hair shirts. Religiousness has to do with belief and behavior. This is not that. It's about a look." (Ibid.)

Of course "Spiritual Dressing" is about a "look," a look inspired in large measure by Madonna's parodic eroticism. But the lady had her own inspirations, and not all of them were spiritual, nor out of the convent. Some came out of the closet, or off the runways of the Harlem "Balls" documented so powerfully by photographer Chantal Regnault, and by filmmaker Jenny Livingston in *Paris Is Burning*. The title refers to the name of a drag queen fashion show where Black and Latino gays compete for cash prizes or trophies. At these transvestite extravaganzas, contestants are judged on their ability to impersonate the very models who display couture for social classes unaware that this subculture exists. As a parody of the high-fashion runway, the Ball is stunning proletarian performance art – except, of course, the cross-dressing is for real. In fact, *the* criterion for excellence is *realness*: the ability to "pass" – as superstar models for St. Laurent, Versace, Dior, or as video temptresses: Alexis, Crystal – it's all *Dynasty* (plate 11.4).

In the late '80s, Madonna popularized "voguing," a dance style she picked up from watching the Harlem Balls. The kids vogue when they "walk" the runways mimicking the preening gestures of their fashion and video heroines. Madonna's tribute to Ball inspiration was the No. 1 hit video "Vogue," a cleaned-up version of the lewdly powerful original. The video is a recycling of recycled style: a trip through the looking glass of American culture. "This is White America," the Ball emcee explains, *and when it comes to minorities, especially Black, we as a people, is the greatest example of behavior modification in the history of civilization. That is why, if you have the Great White Way of living, or looking, or dressing, or speaking, you is a marvel!*[7]

The irony is that for all the real style voguers inspired in White America, they experienced only simulations of realness in return.

Voodoo Chic

A cruise down Fourteenth Street in Manhattan, Melrose Avenue in L.A., or Columbus Avenue in San Francisco will confirm just how pervasive the repaganization of Tridentine art has become. In "Holy

Kitschen: Collecting Religious Junk from the Street," a chapter in her seminal book *Megalopolis*, Celeste Olalquiaga describes the Alexandrine excess of Fourteenth Street's "Inner-City Port":

Suddenly, holiness is all over the place. For $3.25 one can buy a Holiest Water Fountain in the shape of the Virgin, while plastic fans engraved with the images of your favorite holy people go for $1.95. . . . In the wake of punk crucifix earrings comes designer Henry Auvil's Sacred Heart of Jesus sweatshirt, yours for a modest eighty dollars, while scapularies, sometimes brought all the way from South America, adorn black leather jacket.[8]

During the last fifteen years a parallel market has grown on the other coast. If you're cruising for holy tchotchkes on Melrose, stop at Wackos, Zulu, the Soap Plant, or upstairs at La Luz de Jesus, where the proprietor is a Chicano Elvis impersonator named (what else?) "El Vez."

Aficionados of hand-mediated industrial arts might decide to head for the real source – the limitless recyclery of religious goods sold around the grotty Cathedral in T.J. (Tijuana). In all the churning traffic you will find the emporia for a new Catholicism whose votive objects are plucked from steerage cargo and reprocessed into items of worship for third world street religion. Laughing Buddhas from Taiwan whose transparent tummies are filled with pennies and *gris-gris*[9]; ceramic cups shaped like breasts with perforated sucking nipples; cardboard *lucha libre* (freestyle wrestling) rinks with plastic models of the deified masked wrestling heroes of Mexican TV; and Mojo Boards.[10] The last are an evolving genre of assemblage: ready-made horseshoes, holy cards, herb packets, tiny plastic Buddhas or saints, newspaper clippings, reflective tinfoil, crucifixes, rabbit feet – all shrinkwrapped onto scarlet cardboard, ready to protect your home or business.

Amazing examples of this new mojo genre are also being made by Pierrot Barra and his wife, Marie Cassise, in the Port-au-Prince iron market (plate 11.5).[11] Both Barras are Vodou priests and *bricoleurs* who create objects to attract and honor the *lwa* (Vodou spirits). Pierrot claims to be divinely inspired: "while I'm dreaming, I see mysteries, all the *lwa*; they show me a design, some face, some kind of thing,

then when I wake up, I create it."[12] As for the incredibly diverse repertoire of materials he assembles – mirrors, sequins, satins, brocades, car parts, wooden utensils, bones, horns, lithographs, and especially dolls of every sort, deconstructed and reassembled according to the dictates of the dreams – these too arrive by magic (plate 11.6). Barra never seeks any of this material. This eclectic jumble is delivered, unsolicited, by runners working out of the market, or by rumor, out of a city dump that becomes the Valley of the Broken Dolls after Christmas. *L'art trouvé* indeed, until one considers that Vodou itself is a religion *retrouvé*. As Michael Ventura has described it, "Vodou is the African aesthetic shattered, and then desperately put back together." (Ventura 1985, 113)

Third-world raiders descend on markets like T. J. and Port-au-Prince to supply boutiques in El Norte, where votive objects acquire an ironic secondary value as first-world decor (plate 11.9). Consider this promotional for the recently defunct Sacred Heart Gallery in the tourist heart of San Francisco:

11.4
As parody of high-fashion runways, the Ball is stunning proletarian performance art – except, of course, the crossdressing is for real. In fact, the criterion for excellence is REALNESS.

11.5
Pierrot Barra and Marie Cassise Barra are both Vodou priests and artists who create objects to attract and honor the Vodou deities. They are photographed here with their Mojo Board at the iron market in Port-au-Prince, Haiti.

11.6
Assembled out of doll parts, goats' horns, sequins, satin, a lithograph of *Ecce Homo*, junk jewelry, plastic spangles, and a mirror, this object was created by the Barras of Port-au-Prince to invoke the power of the fiery bull deity "Bosou Twa Kòn" (Bosou with Three Horns) through the reflective and reflexive power of the mirror.

Located in North Beach, this fun and funky shop can fill all your iconic needs. From glow in the dark Madonnas (not the one that sings), candles, and jewelry, to all manner of recycled and reconverted religious kitsch, Sacred Heart is a bizarre and good humored shopping adventure. (San Francisco Bay Guardian, November 24, 1993)

A survey of its catalogue suggests the range of "fun and funky" appropriations:
Item: Large Sacred Heart Sculpture. Industrial quality recycled tin sacred heart of Jesus frame and mirror is 22" in overall width and height and a full 5" deep. Handcrafted . . . in Mexico. $120.
Item: Glow Marias: Go back in the closet again and again. Fantastic glow-in-the-dark Virgin Marias will bring you hours upon hours of fun. Hold it to the light and dash for the closet, these ladies will illuminate the deepest of your darkest secrets. Glo Small . . . 6 in. . . . $5. Glo Big. . . 10 in. . . . $12

Sacred Heart Gallery represents only a single facet of the complex interchange of votive objects in the new urban American markets. The phenomenon stretches beyond post-Christian consumers to the practitioners of Afro-Caribbean religions, particularly Santería. John Mason, an African-American priest-scholar of the Yoruba religion, reports that Afro-Venezuelans, also living in the Bay area, are selling:
Ogun-in-the-Boot, an army boot filled with dirt, three nails and three rocks representing the orisha *Ogun. For $1200 this Ogun, and his "now you see him, now you don't" brother,* Invisible Elegba, *can protect your home from behind your door. If your problems still persist, the Afro-Venezuelans advise, then you must pay an additional $1500 to become a priestess of Yemoja and receive Odi-Up. You are taken to the beach, your clothes are torn off and you are bathed in the ocean. Then you are wrapped in a white sheet and seated on the sand encircled by blue candles that burn all through the night. At sunrise, prayers and chants can be heard as the new priest of Yemoja is presented with Odi-Up (a green plastic 7-Up bottle, half filled with ocean water, seven rocks, seven shells, a miniature statue of the Virgin of Regla, and a small crucifix). Odi-Up is accompanied by a perpetually burning blue candle.*[13]

Into the Mystic

Metropolitan Home, the interior decoration magazine for Yuppies during the years of Reagan excess, ran an article by Victoria Lautman that has become the collector's *confiteor fidei.* "Into the Mystic: The New Folk Art" reads like a pious manifesto for recycling religious art as home decor *and* shrewd capitalist investment:

The mystical world has gone mainstream, and for a new and ever-growing breed of collector-devotee, it's a feast for the eyes and soul. In an age of rampant consumerism, incomprehensible technology and growing social ills, possessing a group of handmade, one-of-a-kind, spiritually endowed objects has suddenly become tremendously comforting – a sort of security blanket for the millennium. Their wonderful, often exotic designs are aesthetically appealing, their ethnic origins serve to broaden our narrow view of the world and, while collectors can appreciate these objects as traditional folk craft without buying into the rituals and beliefs behind them, the supernatural aspect of mystical art makes it all the more intriguing. (Lautman 1989, 59)

The voices she records in support of her mystico-capitalist approach to other peoples' religious art include gallery owner Peggy Byrnes (Sonrisa/LA): "Their power is that they're visually and psychologically charged. . . . There are no connections to our spiritual roots in a slick table or a cool plate, people want things around them with emotional impact."

For psychiatrist and culture maven May Weber of the May Weber Museum of Cultural Arts in Chicago, acquisition is raised to the level of an (ersatz) religion:

Spirituality is one of the basics in human nature, and our deep-seated beliefs in magic and forces beyond our control make us respond to these objects. The more we learn about the original uses and powers of such artifacts, the more we collect them. By owning them, we feel we're tapping into their spiritual force.

Virgil Young, a bicoastal collector and dealer who pioneered the appreciation of Vodou flags as art *and* commodity, prefers to attribute their success (and his) to a more tangible religion:

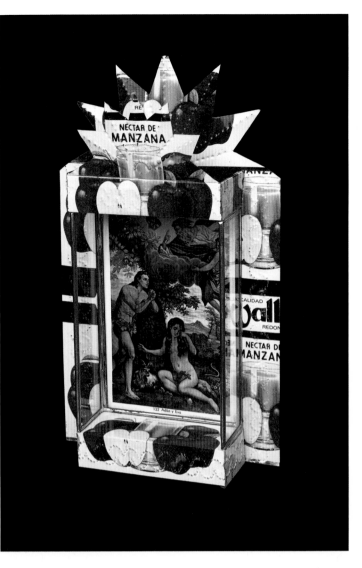

11.7

Nicho with Adam and Eve. Lee Carter, designer; made in San Miguel de Allende, Guanajuato, Mexico. 1992. Misprinted sheet metal for cans, solder, glass, chromolithograph. H 10 1/4 x W 6 3/4 x D 2" (27.3 x 17.1 x 5 cm). International Folk Art Foundation Collection, Museum of International Folk Art, Santa Fe.

Lee Carter is an American designer and wholesaler of a complete line of recycled "pop-modern-Mexican-folk-like arts and stuff" that is produced by a family of tinsmiths in Mexico and sold by folk art and craft dealers throughout the United States, Germany, and Japan. His line includes "Catholic kitsch" frames, lamps, reliquaries, sculptures, and other items made from salvaged, misprinted tin sheets stamped with Mexican beer, battery, and food can labels. This *nicho* provides a visual pun on the Adam and Eve story: a traditional chromolithograph of the apple tree in the Garden of Eden is framed in recycled tin sheets stamped with the popular logo from Jumex – Mexico's premier apple juice company.

These flags were not only visually spectacular, but also an area of folk art that hadn't gotten a lot of attention. The superstition and mystery surrounding their original purpose just made them all the more appealing. People want to think objects have some power beyond *just being great works of art, but what is* more powerful than that?

Evidently Gianni Versace feels the same, having incorporated sequined Vodou flags into the bodices of his fashion line (plate 11.8).

To refute charges that dealers in the sacred arts are really Raiders of the Third World, Professor Marilyn Houlberg of the School of the Art Institute of Chicago argues:

When we pay attention to [third world] ritual traditions, it helps to justify continuing them. . . . We have to weigh saving the art for posterity against letting things stay where they may be overlooked, even destroyed. Here, the legacy is blooming.[14]

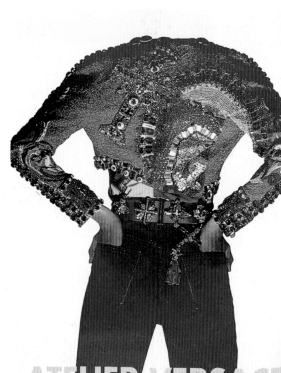

11.8
Famed fashion designer Gianni Versace transforms sequined Vodou flag imagery into high-fashioned design. (Advertisement from *Vanity Fair,* April 1991)

Recycling in the Third Degree

Celeste Olalquiaga posits three degrees of kitsch appreciation. We have recognized the first in Michael Ventura's plastic crucifix, or in those bathtub shrines. At this degree the object is referential, she argues, having no innate validity except as surrogate for its otherwordly counterpart (Olalquiaga 1994, 42). I doubt, however, that Ventura or the bathtub shrine owners would subscribe to such a dispassionate attitude toward votive objects (or sacramentals, as the Church calls them) whose affinity to heaven imbues them with material as well as spiritual significance.[15]

Votive objects sold at galleries like Sacred Heart, or patronized by the browsers of *Metropolitan Home,* have been co-opted from believers, and so constitute a second generation of recycled "neokitsch." At this level, Olalquiaga argues, the object is entirely self-referential or hyperreal (plates 11.8, 11.9). Madonna's earrings are archetypal neokitsch: the sacred suffering translated into the ironic. But, as we noted, believers also endow their sacramentals with a sense of the hyperreal, while an attitude of awe (however awkwardly expressed) often accompanies their recycling into Shuppie apartment decor or neoaltar display. The line between first- and second-degree kitsch is blurred indeed, and has grown steadily vaguer since Vatican II.

At the third, and most intense, level of sacral recycling, participation and appreciation merge into what might fairly be described as neo-Catholic votive art. As Olalquiaga eloquently states:

Third-degree religious kitsch consists in a revalorization of Catholic iconography and the accentuation of those traits that make its aesthetics unique: figurativeness, dramatization, eclecticism, visual saturation . . . its ornamental ability to cover the empty landscape of postindustrial reality with a universe of images. (Olalquiaga 1992, 50)

For Olalquiaga,

Iconography is invested with either a new or a foreign set of meanings, generating a hybrid product. This phenomenon is the outcome of the blending between Latin and North American cultures and includes both Chicano and Nuyorican artists' recovery of their heritage as well as white American artists working with the elements of this tradition. (Ibid., 47).

Perhaps the most famous (or notorious) creator of neo-Catholic art is Andres Serrano. I came away from seeing his 1990 Santa Monica show convinced that his photography could not be understood outside a continuum of religious art that stretches from Roman usurpations of the crucifix, through its propagation by missionaries in Africa, to its reemergence in the eclectic assemblages of Pierrot Barra, the jeweled, gnarly sculptures of Alison Saar, the Afro-Buddhist reliquaries of Betye Saar, the graffito-paintings of Jean-Michel Basquiat, and the sadomasochistic ritual portraits of Robert Mapplethorpe – expressors all of a pervasive neo-Catholic sensibility.

Serrano's show was dominated by his sixty-by-forty-inch Cibachrome photograph of a large, gold-yellow crucifix submerged in a reddish liquid effervescing with tiny trails of bubbles. "The image has a lush, soft-edged romanticism that suggests a larger-than-life version of the surreally golden portrayals of Christ in children's bibles," noted Cathy Curtis of the *Los Angeles Times* (June 19, 1990). It is only after reading its in-your-face title, *Piss Christ*, that you realize the crucifix is soaking in urine. As it turns out, Serrano's urine. It was the title that attracted the outrage of senatorial aesthete Alphonse D'Amato, who tore up the show's catalogue on the floor of the Senate. His solonic wrath set off a congressional attack which now threatens to destroy the National Endowment for the Arts.

Serrano might have saved himself (and the NEA) a lot of trouble by leaving *Piss Christ* untitled. But clearly this artist was concerned with establishing concrete metaphors. Neo-Catholic art has persisted in privileging the graphic and dramatic traditions of Tridentine imagery. In the late Renaissance there were the arrows skewing St. Sebastian's handsome, muscled torso. Or the Magdalene's bloodshot eyes pouring tears on pink-tipped breasts. And now it is the plastic crucifix softened in the amber glow of Serrano's piss, lending it a kind of spurious life. There is a shimmer to the molded form of the Sufferer, a diffusion into the exhausted fluid by the mutant plastic material. And the huge size of the image changes its significance. The reductive banality of a dashboard icon is transformed by this explosion into an altar piece for a cathedral no one is building.

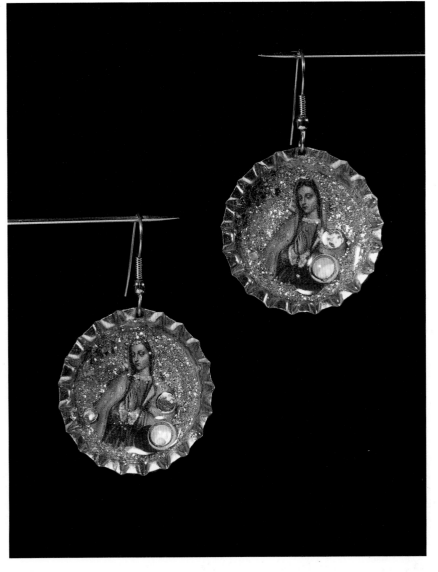

11.9

Madonna Earrings. Goldie Garcia, Albuquerque, New Mexico. 1992. Bottle caps, chromolithographs, plastic. Diam. 1 1/4" (1.3 cm). International Folk Art Foundation Collection, Museum of International Folk Art, Santa Fe.

Produced and marketed by a Hispanic craftsperson in New Mexico, these sequined dangles have become all the rage among a hip, urban clientele who respond to their "Catholic kitsch" quality.

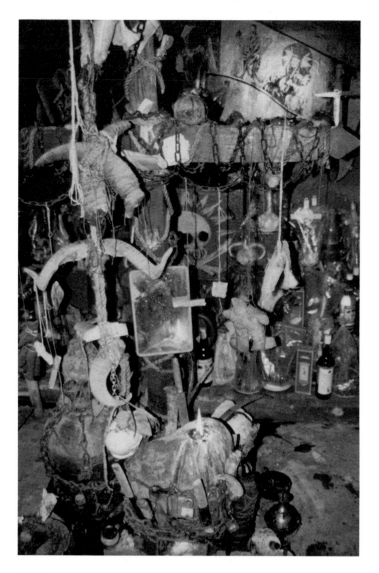

11.10
In this Port-au-Prince temple,
Vodou priest Cesar Lang re-
Kongolizes the cross, enwrap-
ping it in chains, locks, and
whip cords; embedding it with
a mirror; and embellishing it
with a skull and a doll.

Serrano is eloquent on the kind of recyclings that are reflected in his work.

If there's been a running theme throughout my work, it's this duality or contradiction between abstraction and representation, between transforming that little cross into this monumental and mysterious looking object and then making you reconsider it in another context when you read the label. . . . I've always had trouble seeing things in black and white. I'm of mixed blood. I have an African-Cuban mother and a Spanish white father. My great-grandfather was Chinese. I've always accepted this duality in myself. My work is a reflection of it.

He says *Piss Christ* illustrates the point, "First and foremost, it reflects my Catholic upbringing, and my ambivalence to that upbringing, being drawn to Christ yet resisting organized religion." (Honan 1989)

Serrano's images are many things, including scandalous. But who could *see* them and dispute their seriousness, or their power? His consonance with Afro-Caribbean votive objects is especially strong. Like the artist-priests of Vodou, Serrano wrenches Catholic images into new contexts, literally drenching them in transforming liquids. Compare his transformation of the crucifix to that effected by the Vodou priest Cesar Lang in his Port-au-Prince temple (plate 11.10). Cesar enwraps his cross in chains, locks, and whip cords; embeds it with mirrors; embellishes it with a skull and dolls. He re-Kongolizes the cross, referencing ancient African cosmographs and the missionizing of Africans in Central Africa and Hispaniola. But, especially, his encumbered cross symbolizes the ability of Vodou to recycle that whole history, and make it its own. Vodou repeats that transformation in different keys: in the crucifix set in the mystic bottle (plate 11.11), or mounted on the medicine bundle called *minkisi* in Kongo and *Kongo paquet* in Haiti.

With the Vodou priest-artists, the trajectory of my argument explodes. We are no longer talking about diffusions from Rome to New York to L.A. We are now talking about Zaire, Bénin, Haiti, Cuba, and every place with a satellite dish to catch MTV. In reality, there never were any straight lines to explain the pulsation of Roman Catholic imagery between altars and boutiques. Rather, the lines of diffusion crisscross

all over the map, back and forth since the Counter-Reformation when Catholicism became a major source for recycling votive objects. *New Mexico: Old Mexico :: Hispania: Roma*. Guadalupe in España and Nahuatl. Nuestra Señora de Guadalupe, Guadalupe tattooed on Chicano biceps, embossed on T-shirts, and imprinted on Frida Kahlo's forehead. St. Joan of Arc with black hair in the cathedral at Rheims and blond hair in the Cao Dai Pagoda in Vietnam. Jesuits bring a silver crucifix to Kongo. Kongo slaves bring a wood-and-string one to Cuba. Cubans bring a plastic crucifix to New York, where they discover Sicilians have already enshrined Jesus in a bathtub. And now Serrano photographs the crucifix in his urine, and Madonna hangs it from her ear.

If recycling is a hallmark of postmodernity, then the world has been postmodern for a very long time. From long before Lygia spurned the proposal to have a cross erected for her pleasure on that Sicilian lawn.

11.11
Crucifix in a Bottle. Maker unknown, Port-au-Prince, Haiti. 1986. H 9 1/2" (24 cm). Fowler Museum of Cultural History, University of California, Los Angeles.

The crucifix set in a mystic bottle symbolizes Vodou's ability to recycle the cultural history of Africa in Hispaniola, and to make that history its own.

The Voice in the Bottle Tree: Recycling the Spirit in the Black Atlantic World

Robert Farris Thompson

and the bottle trees threatened to speak in tongues

– Michelle Cliff, *Free Enterprise*, 1993

Recycling is an art form and a moral weapon. It is more than a matter of collecting used paper and taking it to a plant, there to be restored to pristine fiber. It is an action that responsible people encourage and enact. Yet that process can be far removed. The suburban recycler never sees, let alone shapes, the restoration of collected glass, containers, sheets of paper.

A more direct level of recycling entails tinkering with beat-up vehicles to make them run again. In many parts of the rural United States such acts immediately identify a person who is down-to-earth. Witness a father in Virginia, writing about his son-in-law, early in 1995: "like him very much – he restores old trucks, which tells me a lot." The young Virginian, bricoleur redux, puts time, love, and personality into an object until it comes alive again. Lazarus dovetails with Pygmalion.

Inspired by these matters, I talk about recycling in the Afro-Atlantic world, a dynamic zone of historically related provinces of philosophy and art, uniting cultures of west and central Africa with their creolized extensions in the Americas. Here objects of ordinary use and ordinary meaning translate, via spiritual redesignation, into realms of liberation and transcendence.

The Black Atlantic also encompasses phenomenal reverse-diffusions: the coming of jazz and son from the United States and Cuba to the west coast of Africa in the 1920s and '30s; the conquest of Dakar, Abidjan, Accra, Bamako, Cotonou, Porto-Novo, and other cities, by Afro-Cuban mambo in the '50s and New York latino salsa in the '70s; the spread of Jamaican reggae across large portions of Africa today.

Apropos of these migrations, a special relationship binds Black Atlantic material recycling to the rise of instrumentation associated with world black musical genres: jazz, rumba, and calypso. For example, as John Nunley explores in this volume, in the 1940s the fifty-five-gallon oil drum was transformed into the sounding "pans" of Afro-Trinidadian steel band music. Earlier, in Cuba, Afro-Cubans used found doors and found spoons as improvised percussion in the rumba, as Fernando Ortiz has documented.

Without question, one of the traditions characteristic of the greater Afro-Atlantic world is the spiritualization of found and recycled objects placed in yards

and upon the tomb as altar. It is a tradition that goes back to the putative "dawn" of sub-Saharan art among the foragers of the Ituri Forest in present-day Zaire and the Maluti-Drakensberg Mountains in what is now eastern South Africa.

Southern San artists of the Drakensberg "recycled" the walls of certain rock shelters. They used "found" ledges, "found" fissures in the rock, as points of emergence or disappearance for painted figures representing shamanic figures moving in trance. Breaks in the surface of the rock were "recycled" into mystic boundaries, parting a veil between this world and the next.

Just as a break in the surface of a rock emphasizes the emergence of a painted spirit in South Africa, and a break *(kasé)* in drumming occasions possession by the spirit in Haitian vodun, so a break in jazz drumming often inspires virtuosic leaps of imagination in the playing of a soloist.

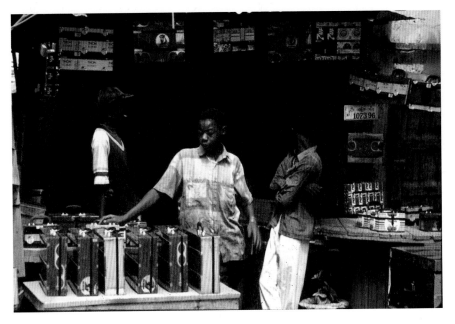

A.1
This young man in Dakar, Senegal, sells briefcases made from recycled metal sheeting to local people, expatriates, and tourists.

Extending recorded breaks on double turntables, New York hip-hop of the late 1970s and early '80s similarly intensified improvisation among young black and Latino dancers. Catching spirit from the unending breaks, the dancers themselves began to "break," and spin, and mime electrical activation.

Hip-hop is recycled record music, literally regained: two turntables play the same record, alternately cycling, so that the break-beat never stops. Dancers, correspondingly, recycle robotic motions, awkward animation from Saturday morning TV, and steals from masters of the jazz dance like James Brown.

The relationship binding recycled objects in African-American yard-shows to the structure of the jazz battery is remarkable. The link occurs in the black New Orleans "spasm band." The essentials of a spasm band include improvised instruments, Afro-percussive flair, and usage of the street as context. Jelly Roll Morton called them "spasmodic bands," alluding to their spontaneity. In any event, according to Marshall Stearns (1956, 173), the first known spasm band played New Orleans street corners in 1896. Cut to New Orleans in 1948:

The Spasm Band goes . . . down Royal Street and lingers near a crowd that looks happy. The leader gives the beat, and the washboard rhythm, from tin cans, wires, and home-made percussion instruments, begins. (Wickiser et al. 1948, 18)

A drawing illustrates the group. It shows a young black dancer in a deep, "get-down" posture, moving with playing cards attached to his torso, for luck and ostentation, and with shredded cloth at his waist and ankles (as ghost raffia) to accentuate the flash of his choreography. To his right, the spasm band percussionist makes rhythm out of recycled tin cans, wired together in different sizes to create different notes and timbres in their sounding. He also strikes a shining tin disk for flash as well as drive.

He is playing a yard-show. He is playing a portion of a bottle tree. Conversely, bottle trees, at least in some instances, protect the house with music as well as art: the sound of the bottles, striking one another in the wind, combines with flash and embottlement as a shield against all spirits. Consider Michelle Cliff's poetic evocation of the bottle-tree sound: "if the breeze from the river came up in a certain way,

and filled the spaces between bottles and branches, there might be a tune . . . lamentation or bamboula, or something in between." (Cliff 1993, 13)

The combination of different recycled metal containers in the making of New Orleans spasm band percussion parallels the wiring together of different drums, gongs, and cymbals to form the jazz battery. An eerie concordance links bottles, plates, and other objects lifted on the end of branches in the yard-show, with cymbals mounted on the ends of metal stems in jazz.

Recycling shiny metal objects for visual/melodic/percussive possibilities in jazz and spasm bands reconnects us to the Black Caribbean. Here Earl Leaf (1948, 53) photographed in Cuba the transformation of scavenged white metal cones into improvised maracas. Another attestation, from modern Haiti, raises the question as to whether the New Orleans spasm band descends in part from Haitian *rara* instrumentation, transmitted via known and documented nineteenth-century Haitian migrations to the Crescent City: "tin cans transformed into trumpets and trombones . . . rubber hose transformed into tubes. . . . Percussion in the hands of a Haitian is anything that knocks – two sticks, a hubcap, a hammer-and-leaf spring from a truck." (Davis 1985, 103)

Meanwhile, Haitians in Brooklyn and elsewhere in Black New York were rubbing a single finger across a drumhead to produce a moaning, haunting sound called glissade. Glissade traces back to an identical drumming technique in Kongo, *twíntisa*, and both would appear to relate ultimately to African friction-drum techniques of making sound.

Making an unusual sound across the round skin of a drum, *twíntisa*/glissade, plus the Puerto Rican and Afro-Cuban taste for rubbing a stick against a grooved gourd may well lie behind the rise of "scratching" in hip-hop. In this tradition, dj's recycle vinyl twelve-inch LPs into found percussion. In other words, a hip-hop dj when he "scratches . . . creates percussive sound by spinning a record backward and forwards while carefully keeping the needle in its groove." (Hager 1984, 110) Like *twíntisa*/glissade, a single finger is used. But the player pushes it backward and forward, complicating the single inward push of the Kongo/Haitian manner. In addition, the

needle as surrogate wand differs from the *güiro* stick passed over rows of grooves because, electrified, it can make percussion when moved back and forth within a single groove. These creole distinctions betray ingenuity, addressed to a new, electric mode of sound.

Beyond the realm of music, Africans and African Americans are everywhere energetically improvising material culture from industrial detritus. In Dakar and Port-au-Prince recyclers are conjuring suitcases out of salvaged metal. Matching Allen Roberts's discoveries in Dakar is evidence from the Black Republic: *kaleidoscopic Haitian suitcase[s] constructed from surplus soft drink cans [are] symbolic of an entire nation. Haiti is the place to discover how much can be done with little. Tires are turned into shoes, tin cans into trombones, mud and thatch into lovely, elegant cottages.* (Davis, 108)

Perhaps the deep meaning of suitcases improvised from found metal reflects the migratory genius of black history, blending elegance with defiance: you see us as poor, but inwardly we are rich and confident, and one day, with our tin-can luggage, we will march to glory, where worth is measured in terms of mind and spirit and belief. The cry of the recycler is the cry of Joseph Beuys: poverty cannot stop a person with a dream.

Notes

INTRODUCTION

1. In his recent book *Animals in African Art* (1995), Allen Roberts discusses the problematic nature of the ethnic term "Bushman." He correctly notes that it has been used, in South Africa and elsewhere (including the documentary satire discussed here), as a derogatory racist epithet, yet alternative terms (such as !Kung and San), which were chosen to avoid such connotations, have their own internal complications. Roberts follows the lead of archaeologists David Lewis-Williams and Thomas Dowson (1989, 8–9), who have chosen to use "Bushman" with a sensitive explanation of what they mean by the term.

2. The movie *The Gods Must Be Crazy* was produced in 1981 in Botswana and directed by Jamie Uys. The structural irony inherent in this film is that, although it is narrated from the perspective of the omniscient documentarian of Western social science, it was, in fact, produced by an African in Africa. This puts a different spin on the tongue-in-cheek fun poked at Western cinematic representations of the African "other."

3. This paradigm – the so-called natives' mistaken perception that the unannounced appearance of foreign conquerers (from Cortés to Captain Cook) or products marked a visit from their gods – has long been perpetuated by Western scholars and is the subject of a recent debate between noted anthropologists Marshall Sahlins (1995) and Gananath Obeyesekere (1994) on cultural difference and historical constructions.

4. This quote is taken from the introductory case label of a 1992–93 exhibition on recycled arts at the Hearst Museum of Anthropology at the University of California at Berkeley, curated by Ira Jacknis. The exhibit, titled "The Second Time Around: Objects Made from Recycled Materials," is one of a number of recent exhibitions and/or museum publications that explore this topic, including two stellar exhibitions that focus on metal recycling in Africa ("Fer blanc et Fildefer," 1978, Centre Pompidou in Paris; "Les Technologies adaptées et

Recuperation des Materiaux," 1988, the National Museum in Bamako, Mali); an exhibit and publication curated by Tony Hayward on the recycling arts of India (1991); an exhibit and book by Jurgen Grothues, titled *Aladins Neue Lampe: Recycling in der dritten Welt* (1988); and several recent exhibits featuring self-taught recycling artists in America (see, most notably, "Another Face of the Diamond," a 1989 exhibition on the Black Atlantic South at the INTAR Gallery in New York City; "Hello Again: Recycling for the Real World," at The Museum of the Fashion Institute of Technology in 1994–95; "Reclamation and Transformation: Three Self-Taught Chicago Artists," at the Terra Museum of American Art in 1994; "Ashe: Improvisation and Recycling in African-American Visionary Art," at the Diggs Gallery at Winston-Salem State University in 1993; and "Recycle, Reuse, Recreate," a 1994 traveling exhibition of the Arts America Program of the U.S. Information Agency). Two important exhibitions on contemporary art forms from the "third world" which featured individual pieces of recycled art include "Magiciens de la Terre," a 1979 exhibit at the Centre Pompidou, and Susan Vogel's exhibit, "Africa Explores: Twentieth-Century African Art," at the Center for African Art in New York City. Other notable publications on the topic of recycling as a folk aesthetic include Greenfield (1986), Kassovic (1983), Yoder (1991), Grothues (1988).

5. British anthropologist Anthony Forge describes a similar instance of appropriated "misuse" among the Abelam of New Guinea. In an article, titled, "Learning to See in New Guinea," Forge describes an account of how the Abelam tended to tear pages from commercial colored magazines and attach them to the matting at the bases of the facades of ceremonial houses. He writes, *In all such cases I have seen, the pages were brightly coloured, usually food advertisements of the Spam and sweet corn and honey-baked ham type. Inquiries revealed that the Abelam had no idea of what was represented but thought that with their bright colours and incomprehensibility the selected pages were likely to be European tambarans (polychro-*

matic sacred designs embodying the most powerful ancestral spirits of the tribe and covering the outside walls of the houses used for important ceremonies) and therefore powerful. (Forge 1970, 286)

6. The great theorist of America's invention of the consumer society was the Illinois-born, German-educated economist Simon N. Patten, whose key book on the subject, *The Consumption of Wealth*, was published in 1889. Daniel J. Boorstin's *The Americans: The Democratic Experience* (1973) is probably the best general account of the rise of consumer culture in America. This is an area that has produced an enormous amount of scholarship in recent years; for an important overview of the rise of consumer culture and the cultural dynamics of consumption, see Richard Wightman Fox and T. J. Jackson Lears, eds., *The Culture of Consumption* (1983).

7. For further discussion on the relationship between twentieth-century American consumer culture and art, see especially Peter Wollen (1993) and Christin Mamiya (1992); Immanuel Wallerstein's look at the modern world system (1979) also provides insights into the current epoch of economic and cultural practice. And John Tomlinson (1991) provides a critical introduction to current debates on the topic of cultural imperialism and addresses the ideological effects of imported cultural products around the world.

8. In a pointed commentary on the problems of transnational commerce, Africanist Christopher Steiner relates an interchange he witnessed between a Hausa art trader and a young European tourist in the art marketplace in Africa's Côte d'Ivoire. In this exchange, the tourist was trying to barter for a *Dan* face mask by offering his Seiko wristwatch as partial payment. Both traders were concerned about whether or not the other's treasure was truly "authentic." (Steiner 1992, 20)

9. This term was coined in the early 1970s and made popular by anthropologist Nelson Graburn to describe "the collective name for all aboriginal or native peoples whose lands fall within

the national boundaries and technobureaucratic administration of the countries of the first, second, and third worlds. As such," he continues, "they are peoples without countries of their own, peoples who are usually in the minority and without the power to direct the course of their collective lives." (1976, 1) What is important for our purposes is to emphasize that these "transnational intersections of language, labor and everyday life" (Koptiuch 1991) are as likely to be found on the streets of urban Philadelphia and East L.A., as on those of Dakar or Marrakech.

10. This question commands a central position in postcolonial literature in the social sciences and humanities on the nature and meaning of Western representation of the non-Western "other." More specifically, the targeted question involves how Westerners depict non-Westerners' response to Western contact. For excellent summaries and analyses of this literature, see especially Clifford and Marcus (1986), Clifford (1988), Fabian (1983), Minh-ha (1989), Pratt (1992), Tomlinson (1991), and Torgovnick (1990).

11. Allen Roberts has most significantly developed this notion of irony in connection with material recycling in his work on the recycling arts of Africa. His seminal article on the subject, "Chance Encounters, Ironic Collage" (1992), provided an important early framework for the editors of this volume, and has since been expanded and developed by Roberts into his essay in this volume. Corrine Kratz provides a more general cautionary note on the application of the term "irony" to this type of recyclia in her recent editorial, "Rethinking Recyclia" (1995).

12. The Compact Edition of the *Oxford English Dictionary*, New York: Oxford University Press 1982, 1484.

13. Robert Thompson's book *Rubbish Theory* (1979) is one of the earliest and most thoughtful sociological studies on this topic. Two excellent, recent explorations on this topic include Lynch (1990), and Rathje and Murphy (1992). The following section draws on Thompson's model of the socially constructed

nature of trash and its powers of transformation.

14. For an excellent recent review of the culture and politics of modern packaging, see Thomas Hine, *The Total Package* (1995).

15. See Charlene Cerny's essay (pages 30–45) for further discussion of this topic.

16. Vance Packard's books, beginning with *The Hidden Persuaders* in 1957, constituted an enormously influential criticism of American culture after World War II. *The Waste Makers* (1960) excoriated corporate policies of planned obsolescence and urged Americans to resist the pursuit of disposable commodities by retreating to simpler, quieter pleasures. For an insightful review of Packard's place in American social thought, see Daniel Horowitz's informative biography, *Vance Packard and American Social Criticism* (1994).

17. See Hine (1995, 240) for a further discussion of the landfill situation as a consequence of our mentality of wastefulness. A recent issue of *Sanctuary* (Fall 1994), the journal of the Massachusetts Audubon Society, focuses on recent attempts by resident artists to turn such landfills into parks, enviornmental art pieces, and plant and animal reserves.

18. A number of socioeconomic studies have been conducted in the last twenty years on the informal sector economies that have developed around people who make their living scavanging, sorting, and reselling urban waste in countries throughout the "third world." See Bertolini (1978), Blincow (1986), Cointreau and Gunnerson (1989–90), ENDA (1991), Gerry C. and Birkbeck (1981), Grothues (1988), Mattera (1986), Sicular (1992), Vogler (1981). Kenneth King's seminal book, *The African Artisan* (1977), directly addresses some of the most important socioeconomic issues surrounding the recuperation and transformation of urban waste and also touches on some key questions of cultural aesthetics, including issues of innovation and tradition.

19. In *Pop Art and Consumer Culture* (1992), Christin Mamiya offers an

insightful social analysis of the historical relationship between Pop art and consumer culture. Moving beyond an examination of Pop art's use of consumer imagery as subject matter, she chronicles the ways in which this art was promoted and publicized like any other consumer product. By entering into the discourse of consumer culture, she argues, Pop art ultimately deflected or absorbed social and political criticism about the socioeconomic and political systems behind this culture, thereby contributing to the legitimation of those very systems.

20. Take for example, the recent fascination with toys of recycled tin, plastic, and wire made by and for children in Africa. While there have been countless recent exhibitions, catalogues, and articles on this subject, few of them have addressed serious social, economic, cultural, or political issues related to the production and consumption of these whimsical toys. Recent exhibits include "Wire Toys from Zimbabwe" (1983) at the Bethnal Green Museum of Childhood in London; "Toys of Africa" (1993), presented by the San Francisco Airports Commission and curated by Enid Schildkrout; "Woven Trains and Beaded Planes: Technology Meets Tradition" (1993) at the Newark Museum in Newark, New Jersey. Examples of written material on the subject include Awake (1993), Harms (1979), Davison (1983), Schildkrout (1993).

21. In the current "crisis of cultural representation," which has taken place in the areas of anthropology, art history, literary criticism, history, and folklore, dozens of museum exhibitions, books, and edited collections of essays have addressed the question of folk artistic production in an age of industrialization and transnational culture contact. Beginning over twenty years ago with Nelson Graburn's seminal work *Ethnic and Tourist Arts* (1976), these inquiries have included discussions of the poetics and politics of museum display and ethnographic representation (as summarized in Clifford 1988, Karp and Levine 1991, Price 1989); catalogues and essays on mixed and hybridized art forms (e.g., Appadurai 1986, Brett 1987, 1990, Jasper and Turner 1986, Lippard 1990,

Thompson 1993, Vogel 1989); and insightful explorations of the nature of artistic expression and representation in the postmodern era (e.g., Gates 1987, Metcalf and Hall 1994, Olalquiaga 1992, Torgovnick 1990).

22. From Rushdie's *In Good Faith* (1990), as quoted in Wollen (1993, 204).

23. Anthropologist Arjun Appadurai coined the term "global ethnoscape" in a 1991 essay on the need for a transnational anthropology.

24. This term is taken from the title of Lucy Lippard's recent exploration of art in a multicultural America. The title, *Mixed Blessings,* "is an ambivalent play on the possibilities of an intercultural world that reflects not doubt about its value, but a certain anxiety about the forms it could take." (1990, 3)

CHAPTER 1

1. David M. Tucker in his *The Decline of Thrift in America* devotes an entire chapter to "The Frugal Lady," arguing that her thrift message has been ignored by feminist writers more eager to critique her perpetuation of separate sex roles. See Tucker (1991, 24–37) for an excellent summary of Hale's thrift messages.

2. For an insightful examination of American attitudes regarding waste, see Plotnicov (1980).

3. Waste, garbage, scrap, trash, and dirt all carry symbolic associations of pollution with them, see Douglas (1984).

4. Undertakers are an occupational group with a similar social standing – they serve the same function for the dead.

5. Kevin Lynch, an urban planner, offers a thought-provoking analysis of waste in America in his *Wasting Away* (1990); I am indebted to this source for much of my thinking on this subject.

6. It was in 1908 that Picasso first introduced a found object into his work – an admission ticket to the Louvre – thus sounding an ironic note characteristic of

many later twentieth-century works that utilize found objects. Marcel Duchamp's "ready-mades," Kurt Schwitters's "Merz-bilder," Joseph Cornell's "boxes," and Robert Rauschenberg's "combines" all similarly explored the expressive range of junk.

7. I would like to express my gratitude to Warren W. Wirebach of the Historical Society of Dauphin County for his able assistance in researching these pictures.

8. While one source for these jugs appears to be African-American gravesite decoration, the makers of these vessels appear to be of diverse ethnic backgrounds, and of both genders. See Hartigan (1990, 161).

9. Another interesting late Victorian recycled form, made roughly between the years 1870 and 1920, is the cigar ribbon quilt. Cf. Cozart (1987).

10. Pioneer wardrobes in the nineteenth century were also known to include underwear branded with flour mill logos and grain sack trousers. For an exhaustive study on the transformation of sack goods by American housewives, see Connolly (1992).

11. Vance Packard's *The Waste Makers* (1960) popularized this concept for a mass audience.

12. Lucy Lippard argues eloquently about this issue, particularly as regards women's "hobby art" and existing artistic hierarchies in "Making Something from Nothing," *Heresies*, 1978, 1/4: 62–5.

13. A recent exception is Tom Patterson, who begins his brief essay "Adhocism in the Post-Mainstream Era" in *Reclamation and Transformation: Three Self-Taught Chicago Artists*, by invoking Jencks and Silver's work. He notes that "the term never caught on."

14. While I would hesitate to generalize across species, it is perhaps worth noting that other species do exhibit behaviors that perform the function of calling attention to the self and making use of found materials in a decorative fashion.

One such example is the male satin bower bird, which, as part of its mating behavior, ornaments the entry to its stick "house" with a combination of artifacts and natural organic materials in hues of blue and yellow. One field photo I have seen shows a blue plastic lid, a blue Bic pen top, a blue pencil, and several blue milk lid rings as part of the array.

15. Most of the information regarding this group was generously provided by Cindy Lobach of York, Pennsylvania, and appeared in "The Golden Vision," a newsletter in support of the men and women of the *Golden Venture*.

16. I wish to acknowledge Professor Carol Burns of Bloomsburg University for bringing these sculptures to my attention and for assisting the Museum of International Folk Art in acquiring examples of this work.

CHAPTER 2

1. In his book, *Intimations of Post-modernity* (1992), 42, Zygmunt Bauman uses the term "semiotic broker" to refer to the postmodern sociologist, but it seems appropriate for the artist/recycler as well.

2. This quotation and the others in this essay are from interviews conducted by the authors with Gregory Warmack, a.k.a. Mr. Imagination, on April 24 and July 12 and 14, 1994.

3. This chronology of the development of Warmack's artistic career relies, in part, on dates presented by Tom Patterson in his article "Manifesting the World of Mr. Imagination," which appears in *Reclamation and Transformation: Three Self-Taught Chicago Artists* (1994), 35–49. This catalogue, produced with an exhibition curated by Patterson for the Terra Museum in Chicago, focuses on the work of three artist/recyclers: David Philpot, Kevin Orth, and Mr. Imagination.

4. All the information on Tom Every and his work was obtained in a series of interviews with the artist conducted by the authors from May 22 through May 25, 1994.

CHAPTER 3

1. I want to thank Suzy Seriff for her comments on earlier drafts of this essay.

2. The rising use of recycled industrial materials to create utilitarian objects and art works parallels the period after the 1910 Mexican Revolution when exploitation of natural resources and human labor began the transformation of Mexico from a rural and agricultural country to an industrial and urban one. In this period we can begin to trace the emergence of objects made from recycled materials such as rubber, tin, paper, glass, and plastic. Most likely, recycling and artisanry have been intertwined in Mexican economics and aesthetics since the very first years of industrialization there, and today Mexico continues to provide abundant examples of recycled arts. As Mexicans immigrated to the United States to work and live, recycled arts emerged in *barrios* throughout the West. The historical longevity of recycled arts in Texas can be gauged to an extent in photography before 1950. Some photos, those of south Texas home interiors taken by Russell Lee in the 1940s, for example, and others taken forty to fifty years ago to record events such as performances of *Los Pastores* (the Shepherd's Play), indicate a decorative use of available materials such as cut tin, newspaper, and so on. Historical documentation and analysis of Mexican-American recycled arts in Texas and other states requires much more attention, but some source materials can be found in Jasper and Turner (1986), Flores (1989), Seriff (1989), and Graham (1991).

3. I first became aware of the propensity for recycling in Texas-Mexican folk art traditions during my tenure in 1985–86 as cocurator of a major exhibition, *Art Among Us/Arte Entre Nosotros: Mexican-American Folk Art in San Antonio,* which was sponsored by the San Antonio Museum of Art and the Guadalupe Cultural Arts Center in cooperation with Texas Folklife Resources. For the first time, an exhibition was devoted exclusively to the distinctive nature of the ephemeral, occupational, religious, and family-produced folk art forms found in the *tejano barrios* of San Antonio and the neighboring towns. For further information see the catalogue for the exhibition (Jasper and Turner 1986) as well as catalogues for other exhibits on Texas-Mexican folk art curated by Texas Folklife Resources (Turner 1986, Turner and Jasper 1989).

4. As discussed in Seriff (1989), Dr. Américo Paredes's early organizing ideas about culture conflict in Texas border expressions (see Paredes 1971 [1958], 1976, 1977, 1978, 1993) provided the impetus for a range of studies that address the meaning of the Mexican-American folk aesthetic in Texas. Dr. José Limón situated his studies in a cultural Marxist tradition that insisted upon the political and ideological foundation of Texas-Mexican folklore as it is performed within the context of racial and class domination experienced by this population (see Limón 1973, 1977, 1981, 1983a, 1983b, 1989, 1994). Major studies that benefited from and extended the work of Paredes and Limón include, among others, Peña (1985), Flores (1989) and (1992), Seriff (1989), Montaño (1992), and Turner (1990).

5. For sources on the social and political history of Mexicans in Texas see Foley (1977) and (1990), De Leon (1982), Montejano (1987), Hinojosa (1983).

6. The making of tire planters is not an exclusively Mexican-American folk practice. In the South, various peoples including African Americans make them, but in Texas and other parts of the West the tradition is carried primarily by Mexican Americans. Among *tejanos* the fabrication method is picked up and passed on – "recycled" visually and technically – from neighborhood to neighborhood. At least in Texas, bright color and pattern seem to distinguish Mexican from African-American examples, which tend to be painted a single color, green or brown, to blend in with the yard. Although I have not undertaken a formal survey concerning the tradition, a number of people have told me that they remember tire planters in Mexican-American yards thirty years ago or more.

7. Documentation and analysis of Mexican-American material culture includes works on yard art (see, for example, Gott 1987, Kitchener 1994, Seriff 1989), cemetery art (see Turner and Jasper 1989, Gosnell and Gott 1989), home altars and other devotional arts (see Turner 1986, 1990; Heisley and MacGregor-Villarreal 1991; Griffith 1992).

8. Folklorists and other scholars have attempted to decipher "aesthetic codes" as a way of interpreting the meaning and effectiveness of particular cultural materials. This kind of semiosis is indeed relevant to the study of Mexican-American identity in Texas (see, for example, Seriff and Limón 1986, Seriff 1989, and Turner 1990). Other relevant studies are found in Hebdidge (1979), Pocius (1979), Santino (1986), Olalquiaga (1992).

9. For a detailed understanding of the history of American residential architecture, especially the Colonial British and Jeffersonian inheritance, as well as the late-nineteenth-century "home and garden" movement that inspired the provision of front lawns, see Kostof (1985), Hall (1988). On the history of early Mexican residential architecture in towns, see Kostof (1985), Crouch (1982), Herzog (1990).

CHAPTER 4

1. For another discussion of this yard see John Szwed (1992).

2. Personal interviews, May 1990.

3. Gerald L. Davis (1993) gives insights into these phrases from the perspectives of folkloristics and African-American celebrations.

4. On Kongo cosmology see MacGaffey (1986), Thompson and Cornet (1981), Thompson (1983, 103–58; 1993, 47–106); for implications of circles and wheels in African-American art see Thompson (1988); on wheeling movement, also see Stuckey (1987); on God's clock, see Gundaker (1992, 335–50).

5. "Now is the time" is also call for secular revolution and activism. The themes

of time, justice, and judgment also occur in male-dominated secular performances like Black Nationalist poetry in the 1960s and contemporary rap. During the later 1980s large watches worn around the neck were popular hip-hop accessories.

6. See Thompson (1983; 1988; 1989; 1993, 74–95) and Gundaker (1993, 1994) for discussions of the content and organizing principles of African-American yard-shows and yard work.

7. See Georgia's Writers' Project (1940, 7–22), Thompson (1983, 142–5), Thompson and Cornet (1981, 178–81).

8. Mr. Packnett explained this area when I visited him in June 1990 and June 1991.

9. On African-American burial traditions, see Nichols (1989), Thompson (1983, 132–42; 1993, 76–9), Thompson and Cornet (1981, 181–203), among others.

10. For a photo, see Connors (1989).

11. Maya Deren describes the dynamics of the "break" in relation to Vodou dance and drumming:
[Vodou] dance might be understood as a meditation of the body. . . . It is to the concentration of this physical-psychic meditation that the "break" of the maman *drum is directed.*

When the maman *"breaks," the dancers "break" with it. . . . Since the conditions of accumulating tension are so variable, the* maman *drummer . . . becomes, to some degree, arbiter of the loa's arrival; for by witholding the respite of the "break," which interrupts this concentration, he can "bring in the loa" to the head of the serviteur.* (Deren 1953, 241–2)
She goes on to explain that drummers can also create the opposite effect, using the break as a "galvanizing shock" that empties the head of the serviteur for the arrival of the loa.

12. For a variety of perspectives on divination systems see Peek (1991).

CHAPTER 5

1. A year's leave of absence as Faculty Scholar at the University of Iowa provided me with the time to conduct field research in Bénin and Senegal for this essay. I am grateful for travel stipends from the Museum of International Folk Art (MOIFA) in Santa Fe; the Midwestern Universities Consortium for International Activities (MUCIA); and the Provost and Project for Advanced Study of Art and Life in Africa (PASALA) at the University of Iowa. Sincere thanks are extended to Mapathé Kane of Best Tours Senegal who greatly facilitated research in and around Dakar in March, June, and December 1994; and to Joseph Adande, professor of African art history at the National University of Bénin, for all his assistance during research in Bénin in March 1994. Of the many Senegalese and Béninois friends who contributed to my fieldwork, special thanks to the people of the workshops I visited and to Mor Diokane, Ousmane Gueye, Augustin Ahouanvoedo, and Christian Napporn for guiding my interviews. Maurice Prangère, director of Carnaud Metalbox Senegal (Dakar), graciously granted permission to visit and photograph parts of his factory assembly line. Thanks for intellectual guidance and editorial assistance to Rowland Abiodun, Edna Bay, Sandra Barnes, Herbert Cole, Donald Cosentino, Daniel Dawson, William Dewey, Henry Drewal, Vikram Jayanti, Bogumil Jewsiewicki, John Mason, Thomas McCarthy, Daniel Moerman, John Pemberton III, Mary Nooter Roberts, Dana Rush, Chris Simon, and Janet Stanley. Finally, I am grateful to Charlene Cerny, Suzy Seriff, and the MOIFA staff for inviting me to participate in what has proven to be an extraordinarily exciting program. Any success of the present paper is due to the inspiration of these colleagues, while all shortcomings are my own. For Avery, Seth, Sidney, and Polly; and in memory of Mary Kujawski Roberts.

2. The "D" may also refer to the more colorful expression *Démerde-toi,* which means "Pull yourself out of the excrement!" Echoing the ironies of System D, Zoë Strother (1992, 150; and personal communication, 1994) reports that in

the late 1980s, Zairians spoke derisively of "Article 15" as the principle of survival. The Zairian Constitution has only fourteen articles, which are deemed to have done nothing to serve and protect ordinary people. "Article 15," then, is *"Débrouille-toi!"* – fend for yourself! In Zaire, corruption is often the result; see Cogos and Requillart (1990), the only discussion (and a brief one at that) of System D that I have found in contemporary Africanist literature; thanks to Professor Bogumil Jewsiewicki for bringing this piece to my attention.

3. Clifford (1988, 119). "Instability of appearances" is a phrase from a wall text at the Wadsworth Atheneum in Hartford, Connecticut, referring to a painting by preeminent Surrealist Salvador Dalì. "Aggressive incongruity" is a politically tinged phrase from Georges Bataille (1991, 54), a writer always on the margins of Surrealism. My paragraphs in this section are adapted from Roberts (1992), with permission of the publisher.

4. More recently, Albert de Surgy has explored commonalities among African systems of thought, Surrealist philosophy, and anthropological theory. As he suggests, "ethnologists and Surrealists were predestined to encounter each other" through their consideration of African thought (1988, 119), because of a shared sense of irony and a desire "to take the marvelous seriously," as the Belgian structuralist Luc de Heusch would have us do (1982, 8).

5. Clifford (1988, 131). A "high-cultural product" would be one that ignores any reference to anything so profane as a rifle, in favor of subjects of "sublime beauty" as defined by a Beaux-Arts tradition. The Baulé are an important ethnic group in what is now the Côte d'Ivoire, long celebrated in the West for their sculpture, which seems to resonate with a Western aesthetic.

6. "Mimetic competition" is a phrase referring to the contest of sides that mimic and emulate each other, even as they stress their supposed differences. From a lecture presented by Tobin Siebers at the University of Michigan, Ann Arbor, on January 21, 1980.

7. A brilliant example is Henry Drewal's ongoing study of "transcultural" African religious practices concerning Mami Wata, a mermaid whose head and torso are often those of a European woman, through which people "take exotic [European and Hindu] images and ideas, interpret them according to indigenous precepts, invest them with new meanings, and then re-create and represent them in new and dynamic ways to serve their own aesthetic, devotional, and social needs." (H. Drewal 1988a, 160) Equally stimulating is Herbert Cole's writing on the exuberantly constructive/deconstructive expression of Igbo peoples of Nigeria, whose arts "reflect, through time, a continuing impulse to contemporize, to incorporate the world around them at the time of building [the art] and even to anticipate the future," as when new characters such as "World Cup," "One Nigeria," and "High Court" are invented for semisacred dramas (Cole 1982, 3; Cole and Aniakor 1984, 214 and passim).

8. The more recent, related literature on "the invention of tradition" is one of the most fruitful developments in the interdisciplinary study of social process. See Hobsbawm and Ranger (1973), Wagner (1981), Mudimbe (1988 and 1994).

9. Some of the same recycled objects from Bénin are discussed in Ferera (1994). The updating and recycling of ideas (as well as objects) is a focus of Roberts (1992). On related innovation and cross-cultural synthesis in other Yoruba rituals, see M. Drewal (1992, 20).

10. Manufacture of briefcases by Mr. Faye and his colleagues in adjacent workshops is discussed in a document prepared by ENDA Tiers Monde and presented in Petit (1994, 80–1). Recycling in Dakar is discussed briefly in A. Seck (1994) and in more detail by ENDA (1990).

11. The confection and use of *gree-grees* combines the mysticism and magic common to Sufism found elsewhere in the world, with religious forms and preoccupations more typically African. For a sensitive discussion of such practices, see Monteil (1964, 137–47).

12. From "The Wasteland" by T. S. Eliot. My thanks to Vikram Jayanti for suggesting this analogy.

13. My thanks to Mapathé Kane for this insight. The original Colobane is associated with Sheikh Amadou Bamba and the Mouride Way, to be discussed below. *Résistant* in French conveys a sense of resistance, as, for example, a hardwood is resistant to termites; but it bears a more obvious political sense than its English translation. A *résistant*, "someone who refuses to submit to the oppressor," is exemplified by members of the French *Résistance* during World War II (*Nouveau Petit Larousse* 1972, 889). I shall use the French form, *résistant*, to signify the political emphasis of the word for people engaged in System D recycling. *Bidonville* is poorly translated as "shantytown," for it literally refers to houses made from flattened *bidons* or tins and barrels.

14. Most people we encountered in Colobane were open, kind, and generous. Still, Colobane is a place of alienation, and some working there are angry outcasts. One young man aggressively confronted me with the statement, "This is our ghetto. You white people make ghettos in your countries, Colobane is ours."

15. In certain west African societies such as Wolof of Senegal and Bamana of Mali (that of Carlos), blacksmiths are considered a separate guild or "caste"; their ability to master fire and transform iron into tools and weapons is mystically charged and dangerous to any who are not born into their endogamous lineages. See McNaughton (1993).

16. These include Mannoni (1990), Fanon (1967), and Retamar (1989). "Caliban" is an anagram for "cannibal," and through the character, Shakespeare made direct, demeaning reference to indigenous peoples of the Americas (Retamar 1989, 6, 8). The image has long been applied to Africans and African Americans, and internationalist writers like Roberto Retamar and Edward Said have turned the character around, rephrasing W. E. B. Du Bois's poignant question, "How does it feel to be a problem?" (cited in Said 1994, 215), in their quest for the liberty of oppressed peoples.

17. "Charisma" here refers to the Arabic concept of *baraka*, best understood as "efficient grace" and "magical power" that can be extended to others through sacred texts and practices (Dumont 1975, 20–1; D. Cruise O'Brien 1988a, 6).

18. Monteil (1966, 162), Copans (1988, 226). Sheikh Bamba and the movement he founded are subjects of a substantial literature. Good general sources are Behrman (1970) and D. Cruise O'Brien (1971); economic and ideological aspects of the Mouride movement are discussed in Copans (1988); Wade (1991) is a hagiography; Magassouba (1985) considers Mouridism in the context of Senegalese Islam; and the sheikh's theology is presented in Dumont (1975).

19. In all naïveté, the French created a sacred martyr, later lauded by Léopold Senghor as an apostle of Négritude, and by more recent politicians as one of the greatest Senegalese *résistants* (Monteil 1966, 178, 200–1; Magassouba 1985, 25) who, "1400 years after Mohammed (may His name be praised) / Re-illuminates the saintly heavens!" (Wade 1991, 52).

20. On the sheikh's miracles, see Samb (1974, 13–5), D. Cruise O'Brien (1988b, 137, 143–4).

21. For baldly political reasons, some early French writers equated such devotions to slavery and communism (Dumont 1975, 116), while later Senegalese nationalists like Senghor stressed that work for the Mourides is a "functional form of prayer."

22. "Technology broker" is a phrase that I coined in the 1980s, while serving as principal investigator for a program concerning social aspects of solar energy technology applications in developing countries, sponsored by the Lewis Research Center of the National Aeronautics and Space Administration. The term is derived from "culture broker," a concept used since the 1950s with reference to cross-cultural political nego-

tiation through which a "broker . . . manipulates, mediates, or 'processes' the information which is being transmitted between the two groups." (Steiner 1994, 154–6)

23. The orthography *assanyin* was provided by Dr. Joseph Adande. To my ear, which is admittedly altogether unpracticed in the languages of the region, the word sounded more like *asaïñ*. Assanyin among Aja are linguistically and conceptually related to *osanyin*, or "healers' staffs," among Yoruba and *asen* tomb ornaments among Fon. Because of the frequent exchange of ideas and representational forms among peoples of the region, it is difficult to know which form influenced the other, and safer to assume that a synthesis has occurred (Adande 1992, 5). The literature on *asen* tomb ornaments among Fon has been reviewed in Freyer (1993).

24. Kenneth King offers an entire chapter of his book, *African Artisan* (1977), on the production of open-wick kerosene lamps from similar recycled materials by Kenyans and, most interestingly, reports on apprenticeship in workshops where such recycling is undertaken. On the same sorts of lamps in Bénin, see Roberts (1992, 61–2), and Male (1994, 31–2).

25. This description of *ara* from Joseph Adande (personal communication 1994) accords with "creativity, innovation, novelty" given as the glossary definition by Drewal et al. (1989, 248). To date, *ara* has been discussed most directly by Cornelius Adepegba (1983), as "novelty, wonder, or new fashion." Rowland Abiodun wisely cautions use of the term "novelty" with reference to *ara*, however, suggesting that novelty be distinguished from innovation (R. Abiodun, personal communication 1994; cf. Abiodun 1990, 81). Yoruba is a tonal language and is written with diacritical marks that are dropped here and elsewhere in this text for convenience.

26. Christian Napporn, a graduate student at the National University of Bénin who worked as my research assistant, here echoes Rowland Abiodun's assertion that "in Yoruba culture it is absolutely imperative for individuals to acknowledge

each other's identity and presence. . . . To fail to greet someone is to say that he does not exist (that is, lacks *iwa* ['character' and the beauty derived from it]) and is to liken him to *igi oko*, 'the common tree in the forest.'" (1990, 85)

27. The largest *assanyin* made by the Gbakpo blacksmiths and sold by Mme. Gandounou at Ajara market cost three to four U.S. dollars apiece (depending upon one's negotiating skills), whereas the *assanyin d'apparat* we commissioned cost just over eighty dollars. Even this price was considerably lower than might have been charged, for Dr. Adande drove a hard bargain, stating that we wished to have the *assanyin* for teaching others about Béninese culture. I am grateful to Mr. Tohoessou for proving so generous. The rich zoomorphic iconography of this *assanyin d'apparat* is discussed in Roberts (1995).

28. Edna Bay (personal communication 1994) reports that in Abomey, Fon blacksmiths told her that "Gu [Ogun] was inherent in the metal when it was worked. He had to be removed so that an *asen* could contain the spirit of a person. An *asen* that I commissioned, for example, was desacralized – Gu was removed from it – before I left [Bénin] for the U.S. I was given some instruction on how to attract the spirit of my husband's mother to it. In fact, we never performed the ceremonies, so I suppose it has become a 'cultural' object." (cf. Bay 1985, 29)

29. Ogun is called "Ogu" (or perhaps "Oguñ") by Aja, "Gu" (or "Guñ") by Fon, "Ogou" in Haiti, and "Ogum" in Brazil. To avoid confusion here, the most frequently published Yoruba form "Ogun" will be used, except in quotations.

30. The concept of "vital force" as central to Yoruba philosophy is discussed in many sources, such as Drewal et al. (1989, 16 and passim), M. Drewal (1989, 203–4), H. Drewal (1989, 240–1), and Sulikowski (1993, 387–9).

31. As the late Arnold Rubin noted, through "a synaesthetic totality" such as a shrine to Ogun, "certain forms and

materials brought into conjunction and activated through appropriate procedures have the capacity to organize and concentrate energy." (1974, 6–10) Other aspects of Ogun altars in Africa and the African Americas are discussed by Thompson (1993, 180–6).

32. Certain Surrealists were aware of just such parallels, yet when the Cuban artist Wilfredo Lam created a New World Yoruba altar for the 1947 International Exposition of Surrealism in Paris, few understood the cross-cultural complexity of reference, and the installation was dismissed as overly esoteric (Galbe 1994).

33. One should not forget that Ogun's wit cuts both ways, for the god still informs violent transformation as well as that with the positive results suggested here. As Robert Thompson notes, Ogun's "force is felt whenever sharp metal penetrates soft flesh," and in such circumstances, "the laughter of Ogun is not a laughing matter." (1976, Chap. 7, 1–2) This is ominously true in pre-Aristide Haiti, where "the military-political complex has provided the primary niche for Ogou." (Brown 1989, 71)

CHAPTER 7

1. The author would like to thank Uma Dasgupta, Abhijit Ghosh, Tony Hayward, Jyotindra Jain, Vinod Kumar Sharma, Sanjay Subrahmanyam, and Anmol Vellani for their enthusiasm and comments during and after the fieldwork upon which this article is based. Thanks also to Ann G. Gold, Joyce Ice, Nora Pickens, and the editors of this volume for their remarks on earlier drafts.

2. By removing the detritus of the Brahmans and other higher castes, thereby absorbing their pollution through the elimination of contaminating agents, Shudras and "untouchables" ironically preserved the purity of the higher castes. This irony is not only at the heart of the caste system's reciprocal logic, but also the major point of contention when discussions about recycling ensue, as will be more apparent below.

3. Not much research has been done on this phenomenon in India, and no theoretical models exist. Gamst (1980) does, however, provide a viable methodology for studying what he calls "industrial ethnology," which could conceivably be adapted with modification for application in the South Asian context.

4. I gratefully acknowledge Philip Lutgendorf for this insightful observation.

5. For example, simple coconut shell *huqqah*s (water pipes) appeared in India shortly after the introduction of tobacco in the sixteenth century, but they quickly evolved into extremely elaborate objects to suit the needs of a royal class of smokers (Jain 1984). This phenomenon, following Appadurai (1986, 28), might be referred to as a "commoditization by diversion." Chow (1993, 42–3) would push this idea further to include people as well as objects. Her proposition may be necessary in some contexts, but for my purposes, it is the object's value that increases, not the maker's.

6. Dundes (1979) coined this term to refer to items of folklore and folklife that comment upon themselves. Thus, the "muffler man" signs at auto mechanics' shops in Mexico, or a paper-plate retailer's shop in Calcutta decorated on the exterior with the product for sale, work in this way.

7. See note 22.

8. As does Foucault (1972).

9. We must be cautious, however, in assuming that international ideas and political lobbying always sway the interpretations of indigenous cultures, as Williams (1990, 113) clearly points out in her discussion of the covert manipulations of cultural practices by elite members of Guyanese society.

10. In fact, it is even difficult to find vernacular equivalents for recycling. Generally speaking, there is not one term in the Sanskrit-derived languages of north India that conveys the sense intended by the English concept. One must therefore reflexively "describe" the process in order to be comprehended

by the average worker or merchant on the street. Hayward (1991), for example, uses the phrase *banī huī vastueṅ* ("made things") as a Hindi translation of the English "recycled objects." A contrived term such as this one could eventually become an acceptable standardization for the phenomenon over time. Or perhaps the English term will be adopted eventually as a vernacular word itself, as has occurred with other foreign concepts introduced into the Indian context. See, for example, Korom (1989, 77–9).

11. Perhaps I am a bit overcautious with my terminology, but I intentionally avoid using the word "recycling" here for premodern processes because of the term's strong association with industrial waste matter. There is obviously no strong evidence for postindustrial production of reused art prior to the technological advances introduced by the British (cf. Pal 1978, 1–102), but examples of "traditional" recycling abound, namely, objects either altered or reused to create new objects with different functions. With the exception of the rickshaw panels (a post-Independence development), the examples cited in this essay's introductory section would fall into this category.

12. This ritualistic dichotomy is further elaborated in the division between holy (*pavitra*) and unholy (*apavitra*) activities (Korom 1992, 54–5; Östör 1982, 22–5).

13. *nityam śuddhah kāruhastaḥ. Manusmṛti* V.129, as quoted in Pal (1978).

14. Generally speaking, most artisans were never given very much status in the caste hierarchy, even though many became wealthy because of royal patronage, etc. See Pal (1978, 120–63), Rocher (1988). Even so, their status is still much greater than that of the recyclers.

15. He defines this as action during which ego is subject to defilement by a polluting object. Orenstein's model is based on physical contact as well as symbolic categories drawn from Sanskritic texts, but they apply just as well to the kind of pollution that I refer to

here. Further, the artisan's nuclear and extended family is then also subject to what Orenstein calls "relational" pollution due to personal contact. See also his earlier comments in Orenstein (1965).

16. Although educated through the primary level, Vinod does not speak English. Yet he took the trouble to legitimize his recycling enterprise by having his letterhead printed with the following: VINOD KUMAR SHARMA, ARTIST OF CRAFT, THREE THOUSAND ITEM [*sic*] OF PAPER CRAFT & HAND MADE TOY'S [*sic*].

17. His concern is not unlike that of the contributors to a symposium on changes in traditional urban culture held at the University of Calcutta in 1956. See K. P. Chattopadhyay (1957).

18. William Morris (cf. Morton 1973) and the Arts and Crafts movement epitomize the trend, and Sharma's views parallel the British thinker's in very subtle and interesting ways which beg for future study.

19. This is not unusual, since many indigenous grassroots movements have emerged in India to rally for what Ann Gold (1994) has termed a "moral ecology."

20. I do not wish to suggest that this is not happening elsewhere, for large-scale movements in this direction have already begun in other Indian cities. The Madras Crafts Foundation, for example, is making great progress in this direction, as is the National Institute of Design in Ahmedabad. On the latter, see Chatterjee (1988).

21. The term is borrowed from Claude Lévi-Strauss. Although his structuralist thought has been heavily criticized over the years (cf. Geertz 1973; Leach 1974), the description of the *bricoleur* given in *The Savage Mind* (1969, 17) still very aptly portrays Vinod's skills:
[He] is adept at performing a number of tasks; but, unlike the engineer, he does not subordinate each of them to the availability of raw materials and tools conceived and procured for the purpose of the project. His universe of instru-

ments is closed and the rules of his game are always to make do with 'whatever is at hand', that is to say with a set of tools and materials which is always finite and is also heterogeneous because what it contains bears no relation to the current project, or indeed to any particular project, but is the contingent result of all of the occasions there have been to renew or enrich the stock or to maintain it with the remains of previous constructions or destructions.

22. This, of course, does not apply totally to the tribal stratum of Indian society, where even deities are sometimes made out of nuts and bolts, knives and forks, etc. A few exceptions in Sanskritic Hinduism do exist, however, as in the following excerpt from the Philadelphia-based *City Paper* (1994, 12) relating the discovery of a Shiva *liṅgam* made out of discarded material: "A former concrete traffic barrier dumped in a San Francisco park years ago is being worshipped as a religious shrine by pilgrims arriving from as far away as India. Hindus and New Agers alike pray, meditate and make offerings to the phallic fetish. According to park gardeners, a city worker dumped the four-foot-tall carved stone traffic barrier in Golden Gate Park, where it lay unnoticed until local Hindus saw it as a symbol of devotion to the deity Shiva." Thanks to Mary Ann Pouls for bringing this reference to my attention.

23. See, for example, Panwalkar (1990).

24. For a description of the Crafts Museum's philosophy and cultural role, see Greenough (forthcoming).

25. Ames (1990) discusses the dire need for museums to collaborate with the individuals being represented in order to facilitate dialogue and avoid misrepresentation. What is not clear is how dialogism of this sort leads to sustained empowerment beyond the duration of the exhibition. This dimension needs to be explored more fully.

26. I borrow the term from Robert Plant Armstrong (1971).

27. On the rise in popularity of theme parks in India, see Ratanani (1994).

28. His products, can be seen, for example, in the Museum of Modern Art's gift shop in New York. I thank Skye Morrison for this bit of information. This phenomenon is not confined to India in South Asia. The Bangladeshi quilt, for example, is now being marketed by Garnet Hill of New Hampshire under the sponsorship of Aid to Artisans. See the *Original Natural Fibers Catalog* (Summer 1994, 14).

29. We know this to be the case with *madhubanī* painting, a local style from Bihar in eastern India. There, the return of painters after their United States tour with the *Festival of India* led to local economic disruption and inflated prices for specific artisans' work. No author has approached this phenomenon critically yet, but see Kurin (1991) for the background.

30. The distinction would correspond loosely to Lewis Binford's (1962) *technomic* and *ideo-technic* functions, which draw attention to the division between purely utilitarian uses as opposed to ideological ones. See also Deetz (1977, 51).

CHAPTER 8

1. In this essay, I cite Stephen Stuempfle's Ph.D. dissertation, *The Steelband Movement in Trinidad and Tobago* (1990). A revised version of that work, titled *The Steelband Movement: The Forging of a National Art in Trinidad and Tobago,* has been recently published by the University of Pennsylvania Press (1995).

CHAPTER 9

1. This phenomenon is discussed in Vega ([1609] 1966, 31, 76–6) and Arriaga ([1621] 1968, 28–9). For further discussion of the role of metals and crystals in Andean cosmology, see Reichel-Dolmatoff (1981, 17–33).

2. Interview with María del Pilar Merlo de Cevallos, Director of Art, Museos del Banco Central de Ecuador, Quito, 1994. Her family has owned a costume shop near Otavalo, Ecuador, for many generations.

3. Naranjo (1983, 112–3). Although little information has been published about the details of these Corpus Christi festivals in the indigenous mountain villages in Cotopaxi, some studies have been conducted on the Salasacan Indian Corpus Christi festivals in the neighboring province of Tungurahua. See Naranjo (1992, 214–21).

4. Personal interview with Sr. Jaime Vizuete in Pujilí, 1994.

5. This information is based on my own observations. The discussion that follows focuses on two headdress styles from Cotopaxi.

6. The provenance for this style is based on interviews with the Albán family in Latacunga and Sr. Jaime Vizuete in Pujilí, 1992, 1993, and 1994.

7. Although the term "reliquary" traditionally refers to vessels and pendants that contain actual relics of the saints, in Latin America the term is used more broadly to include miniature sculptures, paintings, or prints of a saint which are placed within a small, oval frame covered with glass. See Egan (1993).

8. Personal interviews with Sra. Graciela Albán in Latacunga, 1992, 1993, and 1994.

9. Dean (1990, 219–22). Dean uses examples from Cuzco, Peru, to explain how the Andean and Catholic sun symbols were intentionally merged in colonial images depicting Corpus Christi.

10. As in pre-Columbian times, indigenous peoples in the Andean region of Peru continue to use amulet stones, carved in the shapes of animals and humans, to help increase their animals and crops as well as to prevent illness and protect the children and adults. See Egan (1991, 4–5).

11. Personal interviews with Sr. José Ignacio Criollo in San Rafael (near Pujilí), 1992, 1993, and 1994.

12. The provenance for this style of headdress decoration is based on catalogue information for headdresses in

the collection of the Museos del Banco Central in Quito, Ecuador, and interviews in 1993 with María del Pilar Merlo de Cevallos, Director of Art for the museum, and Gustoria Freire, owner of a costume shop in Saquisilí.

CHAPTER 10

1. The prevalence of used clothes and the lack of local factory-made new clothes also protects thousands of small-business people, who make new clothes from new cloth for sale to more affluent customers.

2. When one Turkana man in Kenya got married shortly after graduating from university, he artfully recycled the tassel from his mortarboard into his wedding headband.

3. This is recognized by the Guyana-born artist Tina Fung Holder, who works with safety pins and other industrial materials to make large collars and necklaces that look like Egyptian broad collars (Searle 1992).

4. A similar process has been described among the T'Boli people in the Philippines (Herald 1988).

5. While some industrial materials are readily incorporated into the symbolic code, others simply cannot be recycled because of culturally coded taboos on particular raw materials. The Maasai do not recycle bone because working with bone violates their covenant with God. Their neighbors, the Okiek, can and do recycle bone, horn, and teeth into useful objects that the Maasai may use.

CHAPTER 11

1. One of the wooden panels on the doors of the Church of S. Sabina in Rome shows a crucified Christ (dated 420 to 440). The only other crucifix that dates from this period is found carved onto a small ivory box now in the British Museum.

2. Attesting to this new devotion, Mary was declared "Mater Dei" at the Coun-

cil of Ephesus (A.D. 431); her virginity was held to be perpetual at the Council of Chalcedon (A.D. 451).

3. (Carroll 1986, 104). The processions of the galli described by the Roman commentators correspond in all significant details to processions for the Madonna which I experienced as a child in Milwaukee's Third Ward, and have later observed in Little Italies all over America, and indeed in big Italy itself.

4. Los Angeles Santero Ysamur Flores refers to Zapopan as the "Kick Ass Madonna" with a reputation for retribution if her favors are not rewarded with special devotions (conversation with author). Flores also points out that Sta. Isabella Church is made over to look like a Santería altar when Zapopan visits, another example of Christian recycling of pagan motifs.

5. Bathtub shrines are created in the very neighborhoods that sustain Veronica Leuken and her ongoing visions of the Virgin Mary at the Bayside, New York, site of the Vatican Pavilion for the 1964 World's Fair. Leuken's visions are verified by streaks of light on Polaroid images, a divinatory process folklorist Dan Wojcik has described as "Polaroids from heaven" (conversation with author).

6. This relationship between androgyny and priesthood is hardly news to the cultural anthropologist.

7. This quote, and much of the descriptive analysis of Ball phenomena, comes from Patrick Pachecho, "At the Drag Queen's Ball," Los Angeles Times, Calendar Section, August 4, 1991, 19–38.

8. Olalquiaga (1992, 38). Tony Alamo, a fiercely anti-Catholic preacher, pamphleteer, and cult leader maintains sweatshops which sew sequined images of the Sacred Heart onto leather jackets. The jackets are then merchandised at distinctly secular, and certainly non-Christian, boutiques in Beverly Hills. Alamo's Pentecostal good intentions evidently override such shameful purveying of images propagated by the "Great Harlot in Rome."

9. Through an extraordinarily complex series of cultural transfers, the figure of Buddha is now recognized as a camino of the Yoruba orisa Shango, and so finds itself on altares throughout the Afro-Latino world.

10. Tijuana religious kitsch includes portraits of Jesus with eyes that seem to move, like the one which freaked out Cheech Marin in the movie Born in East L.A.

11. Barra is one of the featured artists in Sacred Arts of Vodou, an exhibit and publication of the Fowler Museum, UCLA, 1995.

12. Personal interview, November 1994.

13. Mason (1989, 30). The distance between the proprietors of Sacred Heart and the santero merchants of Odi-Up is best measured by the prices they charge. The recycled 7-Up bottle that might effect miracles is worth fifteen hundred dollars. Glow-in-the-Dark Marias for mantel display or bedroom fun will fetch six dollars (small), twelve dollars (big). Miracles, it seems, don't make the transition from third- to first- world kitsch.

14. Houlberg's arguments echo the peculiar history of Mme. Helen Blavatsky, the Mother of Theosophy, whose mystico-gnostic patronage of Hinduism generated a revival of that religion in a period of its decline during the late decades of the Raj. Oddly missing from Lautman's potpourri of rationales for collecting alien votive objects is the simple attraction of the alien – the strange – the inexplicable.

15. See also Baudrillard's arguments on the self-sufficiency of Byzantine iconography ("Precession of the Simulacra"), or the ineffable allure of Flaubert's parrot in "Un Coeur Simple."

Bibliography

Abiodun, Rowland. "The Future of African Art Studies: An African Perspective." In *African Art Studies: The State of the Discipline*, 63–89. Washington, D.C.: National Museum of African Art, 1990.

Abiodun, Rowland, Henry Drewal, and John Pemberton III. *Yoruba Art and Aesthetics*. Zurich: The Reitberg Museum; New York: The Center for African Art, 1991.

Adande, Joseph. "Quand Gu ne fait plus couler du sang." Conference paper, "Ouidah '92." Republic of Bénin, 1992.

Adepegba, Cornelius. "Ara: The Factor of Creativity in Yoruba Art." *The Nigerian Field* 48, nos. 1–4 (1983): 53–66.

"African Toys for Free." *Awake!* 74, no. 6 (1993): 16–19.

Ames, Michael M. "Cultural Empowerment and Museums: Opening Up Anthropology through Collaboration." In *Objects of Knowledge,* Susan Pearce, ed., 158–73. London: The Athlone Press, 1990.

Anthony, Michael. *Parade of the Carnivals of Trinidad 1839–1989.* Port of Spain, Trinidad: Circle Press, 1989.

Appadurai, Arjun, ed. *The Social Life of Things: Commodities in Cultural Perspective.* New York: Cambridge University Press, 1990.

———. "Global Ethnoscapes: Notes and Queries for a Transnational Anthropology." In *Recapturing Anthropology: Working in the Present*, Richard G. Fox, ed., 163–91. Santa Fe: School of American Research, 1991.

Apter, Andrew. *Black Critics and Kings: The Hermeneutics of Power in Yoruba Society.* Chicago: University of Chicago Press, 1992.

Armstrong, Robert Plant. *The Affecting Presence: An Essay in Humanistic Anthropology.* Urbana: University of Illinois Press, 1971.

Arriaga, Father Pablo Joseph. *The Extirpation of Idolatry in Peru.* [1621]. L. Clark Keating, trans. and ed. Lexington: University of Kentucky Press, 1968.

Bakhtin, Mikhail. *Rabelais and His World.* Bloomington: Indiana University Press, 1984.

Barnes, Sandra. "Introduction: The Many Faces of Ogun." In *Africa's Ogun, Old World and New,* S. Barnes, ed., 1–26. Bloomington: Indiana University Press, 1989.

Barnes, Sandra, and Paula Girshick Ben-Amos. "Ogun, the Empire-Builder." In *Africa's Ogun, Old World and New,* S. Barnes, ed., 39–64. Bloomington: Indiana University Press, 1989.

Barrios, Greg. "Zoot Suit, The Man, The Myth, Still Lives (A Conversation with Luis Valdez)." In *Tonantzin: Chicano Arts in San Antonio* 2, no. 4 (1985): 23–5.

Barry, Iris. "Africa." In *Ethnic Jewelry,* John Mack, ed., 25–46. London: British Museum, 1988.

Bataille, Georges. "The Deviations of Nature" [1930]. In *Visions of Excess: Selected Writings, 1927–1939,* A. Stoekl, ed., 53–8. Minneapolis: University of Minnesota Press, 1991.

Baudrillard, Jean. "The Precession of the Simulacra." In *Art After Modernism,* Brian Wallis, ed. New York: The New Museum of Contemporary Art, 1984.

———. *Revenge of the Crystal: Selected Writings on the Modern Object and Its Destiny, 1968–1983.* Concord, Mass.: Pluto Press, 1990.

Bauman, Zygmunt. *Intimations of Postmodernity.* London and New York: Routledge, 1992.

Bay, Edna. *Asen: Iron Altars of the Fon People of Benin.* Atlanta: Emory University, 1985.

Beardsley, John. *Gardens of Revelation: Environments by Visionary Artists.* New York: Abbeville, 1995.

Behrman, Lucy. *Muslim Brotherhoods and Politics in Senegal.* Cambridge, Mass.: Harvard University Press, 1970.

Bertolini, G. *Rebuts ou Resources? La Socio-économie du Déchet.* Paris: Editions Entente, 1978.

Besson, Gerard, ed. *Trinidad Carnival.* Republication of *Caribbean Quarterly* 4, nos. 3–4 (1956). Port of Spain, Trinidad: Paria Publishing Co., 1988.

Besson, Gerard, and Bridget Brereton, eds., *The Book of Trinidad.* Port of Spain, Trinidad: Paria Publishing Co., 1993.

Binford, Lewis. "Archaeology as Anthropology." *American Antiquity* 28, no. 2 (1962): 217–26.

Blier, Suzanne. "King Glele of Danhomè, Part One: Divination Portraits of a Lion King and Man of Iron." *African Arts* 23, no. 4 (1990): 42–53, 93–4.

Blincow, M. "Scavengers and Recycling: A Neglected Domain of Production." *Labour, Capital and Society* 19, no. 1 (1986): 94–115.

Boorstin, Daniel J. *The Americans: The Democratic Experience.* New York: Random House, 1973.

Bravmann, René. *African Islam.* Washington, D.C.: Smithsonian Institution Press, 1983.

Brett, Guy. *Through Our Own Eyes: Popular Art and Modern History.* Philadelphia: New Society, 1987.

———. *Transcontinental: An Investigation in Reality. Nine Latin-American Artists.* London, New York: Verso, 1990.

Bronstein, Nancy. "Following the Path of Your Trash." *Faces* 7, no. 8 (Apr. 1991): 12–16.

Brown, Karen. "Systematic Remembering, Systematic Forgetting: Ogou in Haiti." In *Africa's Ogun, Old World and New,* S. Barnes, ed., 65–89. Bloomington: Indiana University Press, 1989.

Carroll, Michael. *The Cult of the Virgin Mary.* Princeton: Princeton University Press, 1986.

Caulfield, Mina. "Culture and Imperialism: Proposing a New Dialectic." In *Reinventing Anthropology,* D. Hymes, ed., 182–212. New York: Random House, 1972.

Caws, Mary. "Exquisite Essentials." In *The Return of the Cadavre Exquis*, A. Philbin,

ed., 32–40. New York: The Drawing Center, 1993.

Chakrabarty, Dipesh. "Open Space/Public Place: Garbage, Modernity, and India." *South Asia* 14, no. 1 (1991): 15–31.

Chatterjee, Ashok. "Challenges of Transition: Design and Craft in India." In *Making Things in South Asia: The Role of the Artist and Craftsman*, Michael Meister, ed., 3–9. Philadelphia: University of Pennsylvania, Dept. of South Asia Regional Studies, 1988.

Chattopadhyay, K. P., ed. *Study of Changes in Traditional Culture.* Calcutta: University of Calcutta Press, 1957.

Chow, Rey. *Writing Diaspora: Tactics of Intervention in Contemporary Cultural Studies.* Bloomington: Indiana University Press, 1993.

City Paper. "Strange Ways." 16 June (1994): 12.

Clifford, James. "On Ethnographic Allegory." In *Writing Culture: The Poetics and Politics of Ethnography,* J. Clifford and G. Marcus, eds., 98–121. Berkeley and Los Angeles: University of California Press, 1986.

———. *The Predicament of Culture: Twentieth-Century Ethnography, Literature and Art.* Cambridge: Harvard University Press, 1988.

Clifford, James, and George E. Marcus, eds. *Writing Culture: The Poetics and Politics of Ethnography.* Berkeley and Los Angeles: University of California Press, 1986.

Cogos, Emmanuel, and Hervé Requillart. "Système D et corruption en Afrique." *Passages* 33 (1990): 36–8.

Cointreau, S. J., and C. C. Gunnerson. *Recycling from Municipal Refuse: A State of the Art Review and Annotated Bibliography.* Banque Mondiale et PNUD, 1980–90.

Cole, Herbert. "Vital Arts in Northern Kenya." *African Arts* 7, no. 2 (1974): 12–23, 82.

———. *Mbari: Art and Life Among the Owerri Igbo.* Bloomington: Indiana University Press, 1982.

Cole, Herbert, and Chike Aniakor. *Igbo Arts: Community and Cosmos.* Los Angeles: Museum of Cultural History, UCLA, 1984.

Connolly, Loris. "Recycling Feed Sacks and Flour Bags: Thrifty Housewives or Marketing Success Story?" *Dress* 19 (1992): 17–35.

Connor, Cynthia. "Archaeological Analysis of African-American Mortuary Behavior." In *The Last Miles of the Way: African-American Homegoing Traditions,* Elaine

Nichols, ed., 51–5. Columbia: South Carolina State Museum, 1989.

Copans, Jean. *Les Marabouts de l'arachide.* Paris: L'Harmattan, 1988.

Cosentino, Donald. "Scrap Iron: Ogun in L.A." In *Iron and Pottery Arts in Africa,* W. Dewey, A. Roberts, and C. Roy, eds. Proceedings from the 5th and 6th Stanley Conferences on African Art, The University of Iowa, 1995.

———, ed. *The Sacred Arts of Vodou.* Los Angeles: The Fowler Museum of Cultural History, 1995.

Cozart, Dorothy. "When the Smoke Cleared." *The Quilt Digest* 5 (1987): 50–7.

Crease, Robert, and Charles Mann. "Backyard Creators of Art That Says: 'I Did It, I'm Here.'" *Smithsonian* 14, no. 5 (Aug. 1983): 82–91.

Crouch, D. P. *Spanish City Planning in North America.* Cambridge, Mass.: MIT Press, 1982.

Cruise O'Brien, Donal. *The Mourides of Senegal.* London: Oxford University Press, 1971.

———. *Saints and Politicians: Essays in the Organization of a Senegalese Peasant Society.* London: Cambridge University Press, 1975.

———. "Introduction." In *Charisma and Brotherhood in African Islam,* D. Cruise O'Brien and C. Coulon, eds., 1–31. New York: Oxford University Press, 1988a.

———. "Charisma Comes to Town: Mouride Urbanization 1945–1986." In *Charisma and Brotherhood in African Islam,* D. Cruise O'Brien and C. Coulon, eds., 135–57. New York: Oxford University Press, 1988b.

Cruise O'Brien, Rita. *White Society in Black Africa: The French of Senegal.* London: Faber, 1972.

Curtis, Cathy. "Notorious Serrano Work Provokes Questions." *Los Angeles Times,* 19 June 1990.

Davis, Gerald L. "'Will the Circle Be Unbroken?' African-American Community Celebrations and the Reification of Cultural Structures." In *Jubilation: African-American Celebrations in the Southeast,* William Wiggins, Jr., and Douglas DeNatale, eds., 51–9. Columbia: McKissick Museum, University of South Carolina, 1993.

Davison, Patricia. "Wireworks: Toys from Southern Africa." *African Arts* 16, no. 3 (1983): 50–2.

Dawson, Daniel. Lecture on the concepts behind the exhibition "Face of the Gods" at the Museum for African Art of New York, presented in "Exhibiting African Art," a seminar taught at Columbia University by Mary Nooter Roberts, 16 Feb. 1994.

Dean, Carolyn Sue. *Painted Images of Cuzco's Corpus Christi: Social Conflict and Cultural Strategy in Viceregal Peru.* Ann Arbor: UMI Research Press, 1990.

De Certeau, Michel. *The Practice of Everyday Life.* Berkeley and Los Angeles: University of California Press, 1984.

Deetz, James. *In Small Things Forgotten: The Archaeology of Early American Life.* New York: Anchor Press, 1977.

De Leon, Arnoldo. *The Tejano Community 1836–1900.* Albuquerque: University of New Mexico Press, 1982.

Deren, Maya. *Divine Horsemen: The Living Gods of Haiti.* New York: Thames and Hudson, 1953.

Douglas, Mary. *Purity and Danger: An Analysis of the Concepts of Pollution and Taboo.* London: Routledge, Chapman & Hall, 1984.

Douglas, Mary, and Baron Isherwood. *The World of Goods: Towards an Anthropology of Consumption.* New York: W. W. Norton & Co., 1979.

Drewal, Henry. "Performing the Other: Mami Wata Worship in Africa." *TDR: The Drama Review* 32, no. 2 (1988a): 160–85.

———. "Beauty and Being: Aesthetics and Ontology in Yoruba Body Art." In *Marks of Civilization: Artistic Transformations of the Human Body,* A. Rubin, ed., 83–96. Los Angeles: UCLA Museum of Cultural History, 1988b.

———. "Art or Accident: Yoruba Body Artists and Their Deity Ogun." In *Africa's Ogun, Old World and New,* S. Barnes, ed., 235–60. Bloomington: Indiana University Press, 1989.

———. "Image and Indeterminacy: Elephants and Ivory Among the Yoruba." In *Elephant: The Animal and Its Ivory,* D. Ross, ed., 186–207. Los Angeles: Fowler Museum of Cultural History, UCLA, 1992.

Drewal, Henry, John Pemberton III, and Rowland Abiodun. *Yoruba: Nine Centuries of African Art and Thought.* New York: Harry N. Abrams, Inc., and The Center for African Art, 1989.

Drewal, Margaret. "Dancing for Ogun in Yorubaland and in Brazil." In *Africa's Ogun, Old World and New,* S. Barnes, ed. 199–234. Bloomington: Indiana University Press, 1989.

———. *Yoruba Ritual: Performers, Play, Agency.* Bloomington: Indiana University Press, 1992.

Dumont, Fernand. *La pensée religieuse d'Amadou Bamba.* Dakar: Les Nouvelles Editions Africaines, 1975.

Dundes, Alan. "Metafolklore and Oral Literary Criticism." In *Readings in American Folklore*, Jan H. Brunvand, ed., 404–15. New York: W. W. Norton and Co., 1979.

Ebin, Victoria. *The Body Decorated.* London: Thames and Hudson, 1979.

———. "A la recherche de nouveaux 'poissons': Stratégies commerciales mourides par temps de crise." *Politique africaine* 45 (1992): 86–99.

Egan, Martha. *Milagros: Votive Offerings from the Americas.* Santa Fe: Museum of New Mexico Press, 1991.

———. *Relicarios: Devotional Miniatures from the Americas.* Santa Fe: Museum of New Mexico Press, 1993.

ENDA. "Des déchets et des hommes: Expériences urbaines de recyclage dans le Tiers Monde." *Environnement Africain* 8, nos. 1–2 (1990).

———. "Man and Waste: Popular Recycling Activities in the Third World." Special Issue, *African Environment* 8, nos. 29–30 (1991).

Fabian, Johannes. *Time and the Other: How Anthropology Makes Its Object.* New York: Columbia University Press, 1983.

Fanon, Frantz. *Black Skin, White Masks.* New York: Grove Press, 1967.

Fer Blanc et Fildefer. Paris: Centre Georges Pompidou, 1978.

Ferera, Lisette, ed. *Ingénieuse Afrique: Artisans de la récupération et du recyclage.* Québec: Editions Fides and Musée de la Civilisation, 1994.

Ferrario, Julio. "Las Costumbres Antiguas y Modernas de Todo los Pueblos de la América." [Late 18th c.]. In *Ecuador Visto por los Extranjeros Viajeros de los Siglos XVIII y XIX*, Humberto Toscano, ed., 515–46. Puebla: Editorial J.M. Cajica, Jr., S.A., 1960.

Fisher, Angela. *Africa Adorned.* New York: Harry N. Abrams, Inc., 1984.

Flores, Richard R. "*Los Pastores*: Performance, Poetics, and Politics in Folk Drama." Ph.D. dissertation. Austin: University of Texas, 1989.

———. "The *Corrido* and the Emergence of Texas-Mexican Social Identity." *Journal of American Folklore* 105 (1992): 166–82.

Foley, Douglas. *From Peones to Politicos: Ethnic Relations in a South Texas Town.* Austin: University of Texas, Center for Mexican-American Studies, 1977.

———. *Learning Capitalist Culture: Deep in the Heart of Tejas.* Philadelphia: University of Pennsylvania Press, 1990.

Forge, Anthony. "Learning to See in New Guinea." In *Socialization: The Approach from Social Anthropology*, Phillip Mayer, ed., 286. London, 1970.

Foucault, Michel. *Power/Knowledge.* New York: Pantheon Books, 1972.

Fox, Richard Wightman, and T. J. Jackson Lears, eds. *The Culture of Consumption: Critical Essays in American History, 1880–1980.* New York: Pantheon Books, 1983.

Franklin, C. L. *Give Me This Mountain: Life History and Selected Sermons.* Jeff Todd Titon, ed. Urbana: University of Illinois Press, 1989.

Frater, Alexander. *Chasing the Monsoon.* Calcutta: Penguin Books, 1991.

Freyer, Bryna. *Asen: Iron Altars from Ouidah, Republic of Bénin.* Washington, D.C.: National Museum of African Art, 1993.

Friese, Kai. "The Plague: How Serious Is It?" *India Today* 15 Oct. (1994): 20-31.

Galbe, Michael. "Santería at the Crossroads: African Representations in Cuba and the United States." Unpub. term paper, Columbia University, 1994.

Gallagher, Robert. *The Rickshaws of Bangladesh.* Dhaka: The University Press, Ltd., 1992.

Gamst, Frederick C. "Toward a Method of Industrial Ethnology." *Rice University Studies* 66, no. 1 (1980): 15-42.

García Canclini, Néstor. *Transforming Modernity: Popular Culture in Mexico.* Austin: University of Texas Press, 1993.

Geertz, Clifford. "The Cerebral Savage: On the Work of Claude Lévi-Strauss." In *The Interpretation of Cultures,* 345–59. New York: Basic Books, 1973.

Georgia Writers' Project. *Drums and Shadows: Survival Studies Among the Georgia Coastal Negroes.* 1940. Athens: University of Georgia Press, 1986.

Gerry, Chris, and Chris Birkbeck. "The Petty Commodity Producer in Third World Cities: Petit Bourgeois or Disguised Proletarian." In *The Petite Bourgeoisie: Comparative Studies of the Uneasy Stratum,* Frank Bechhofer and B. Elliot, eds., 121–54. New York: Macmillan, 1981.

Glassie, Henry. "On Identity." *Journal of American Folklore* 107 (1994): 231–8.

Goddard, George. *Forty Years in the Steelbands 1939–1979.* Port of Spain, Trinidad: Paria Publishing Co., 1991.

Gold, Ann G. "Sin and Rain: Moral Ecology in Rural North India." Unpub. paper presented at annual meeting of the American Academy of Religion, Washington, D.C., Nov. 1994.

Gomes, Albert. "Behind the Curtain." *Trinidad Guardian,* 16 June 1946.

Gosnell, Lynn, and Suzanne Gott. "San Fernando Cemetery: Decorations of Love and Loss in a Mexican-American Community." In *Cemeteries and Gravemarkers: Voices of American Culture,* Richard E. Meyer, ed., 217–36. Ann Arbor: University of Michigan Press, 1989.

Gott, Suzanne. "'Affective Display': The Evocation of Emotional Experience Through Foregrounded Visual Presentation." M.A. thesis. Austin: University of Texas, 1987.

Gould, Stephen J. "James Hampton's Throne and the Dual Nature of Time." *Smithsonian Studies in American Art* 1, no. 1 (1987): 47–57.

———. "From Tires to Sandals." *Natural History* 4 (1989): 8–15.

Graburn, Nelson H. H., ed. *Ethnic and Tourist Arts: Cultural Expressions of the Fourth World.* Berkeley and Los Angeles: University of California Press, 1976.

Graham, Effie. *The Passin' On Party.* Chicago: McClurg, 1912.

Graham, Joe S., ed. *Hecho En Tejas: Texas-Mexican Folk Arts and Crafts.* Denton: University of North Texas Press, 1991.

Greco, Margaret. "Arte de Corazon: Images and Objects from the Heart: A Chicano Response to the Crisis of Incarceration." In *Encuentro/Coming Together.* San Antonio: Guadalupe Cultural Arts Center, n.d.

Greenfield, Verni. *Making Do or Making Art: A Study of American Recycling.* Ann Arbor: UMI Research Press, 1986.

Greenough, Paul. "Nation, Economy, and Tradition Displayed: The Indian Crafts Museum, New Delhi." In *Modern Sites in India,* Carol Breckenridge, ed. Minneapolis: University of Minnesota Press, forthcoming.

Griffith, James S. *Beliefs and Holy Places.* Tucson: University of Arizona Press, 1992.

Gross, Michael. "Classic Madonna." *Vanity Fair* (Dec. 1986).

Grothues, Jürgen. "Recycling als Handwerk." *Archiv für Völkerkunde* 38 (1984): 103–31.

———. *Aladins Neue Lampe: Recycling in der Dritten Welt.* Munich: Trickster, 1988.

Guibbert, Jean-Jacques. "Ecologie populaire urbaine et assainissement environnemental dans le Tiers Monde." *Environnement Africain* 8, nos. 1–2 (1990): 21–50.

Gundaker, Grey. "Without Parse of Script: The Interaction of Conventional Literacy and Vernacular Practice in African-American Expressive Culture." Ph.D. dissertation. New Haven: Yale University, 1992.

———. "Tradition and Innovation in African-American Yards." *African Arts* 26, no. 2 (Apr. 1993): 58–71, 94–6.

———. "African American History, Cosmology, and the Moral Universe of Edward Houston's Yard." *Journal of Garden History* 14, no. 3 (autumn 1994): 179–201.

Hall, Michael D., and Eugene W. Metcalf, Jr., eds. *The Artist Outsider: Creativity and the Boundaries of Culture.* Washington, D.C.: Smithsonian Institution Press, 1994.

Hall, Peter. *Cities of Tomorrow.* Cambridge, Mass.: Basil Blackwell, 1988.

Hansen, Karen Tranberg. "Dealing with Used Clothing: *Salaula* and the Construction of Identity in Zambia's Third Republic." *Public Culture* 30, no. 6 (1994): 503–23.

Harms, Volker. "African Child Engineers, a Mobile Exhibition Arranged for Children by the Ubersee-Museum in Bremen, Federal Republic of Germany." *Museum* 31, no. 3 (1979): 194–96.

Hartigan, Lynda Roscoe. *Made With Passion.* Washington, D.C.: Smithsonian Institution Press, 1990.

Hayward, Tony. *Objects from India.* Southampton, England: The Winchester Gallery, 1991.

Hebdidge, Dick. *Subculture: The Meaning of Style.* London and New York: Methuen and Co., 1979.

Heisley, Michael, and Mary MacGregor-Villarreal. *More Than a Tradition: Mexican-American Nacimientos in Los Angeles.* Los Angeles: Southwest Museum, 1991.

Herald, Jacqueline. *World Crafts: A Celebration of Designs and Skills.* Asheville, N.C.: Lark Books, 1992.

Herzog, Lawrence A. *Where North Meets South: Cities, Space, and Politics on the U.S.-Mexico Border.* Austin: University of Texas Press, 1990.

Heusch, Luc de. *The Drunken King, or the Origin of the State.* Bloomington: Indiana University Press, 1982.

Hildrickson, Hildi. "The Significance of the Ovaherero Long Dress." Unpub. paper presented at the annual meeting of the American Anthropological Association, Washington, D.C., 1989.

Hine, Thomas. *The Total Package: The Evolution and Secret Meanings of Boxes, Bottles, Cans, and Tubes.* Boston: Little, Brown and Co., 1995.

Hinojosa, Gilberto. *A Borderlands Town in Transition: Laredo, 1755–1870.* College Station: Texas A & M University Press, 1983.

Hobsbawm, Eric, and Terence Ranger, eds. *The Invention of Tradition.* New York: Cambridge University Press, 1983.

Hollier, Denis. *Against Architecture: The Writings of Georges Bataille.* Cambridge, Mass.: MIT Press, 1989.

Honan, William. "A Provocative Artist's Religious Imagery." *International Herald Tribune,* 23 Aug. 1989.

Hoos, Judith, and Greg Blasdel. "Fred Smith's Concrete Park." In *Naives and Visionaries,* 53–60. New York: E. P. Dutton & Co., 1974.

Horowitz, Daniel. *Vance Packard and American Social Criticism.* Chapel Hill: University of North Carolina Press, 1994.

India Today. "Our Filthy Cities: Can We Clean Up the Mess?" 31 Oct. (1994): 36–47.

Ingersoll, Ernest. "The Decoration of Negro Graves." *Journal of American Folklore* 5 (1892): 69–70.

Inglis, Stephen. "Structural Analysis of a Bengali Folk Painting." *Journal of Indian Folkloristics* 2, nos. 3–4 (1979): 50–64.

Jain, Jyotindra. "Report on Recycling in India." Unpub. paper presented at a symposium on "Recycling as a Folk Aesthetic," Museum of International Folk Art, 1992.

Jain, Om Prakash, ed. *Sanskriti: Museum of Everyday Art.* Faridabad, India: Thomson Press, 1984.

Jasper, Pat, and Kay Turner, eds. *Arte Entre Nosotros/Art Among Us: Mexican-American Folk Art of San Antonio.* San Antonio: The San Antonio Museum Association, 1986.

Jencks, Charles, and Nathan Silver. *Adhocism: The Case for Improvisation.* Garden City, N.Y.: Anchor Press/Doubleday, 1973.

Jewsiewicki, Bogumil. "Painting in Zaire: From the Invention of the West to the Representation of Social Self." In *Africa Explores,* Susan Vogel, ed., 130–51. New York: Center for African Art, 1991.

Johnson, Don. "Bottle-Cap Fever." *Maine Antiques Digest* (Oct. 1993), 12–13.

Jules-Rosette, Benetta. *The Messages of Tourist Art.* New York: Plenum, 1984.

Karp, Ivan, and Steven D. Lavine, eds. *Exhibiting Cultures: The Poetics and Politics of Museum Display.* Washington, D.C.: Smithsonian Institution Press, 1991.

Kasfir, Sidney Littlefield. "African Art and Authenticity: A Text with a Shadow." *African Arts* 25, no. 2 (1992): 41–53, 96–7.

———. "Jua Kali: Third World Mode of Production or a New African Aesthetic?" Unpub. paper, 9th Triennial Symposium on African Art, The University of Iowa, 1992.

Kassovic, Julius Stephen. "Junk and Its Transformations." *A Report from the Center for Folk Art and Contemporary Crafts* 3, no. 1 (1983): 1–3.

King, Kenneth James. *The African Artisan: Education and the Informal Sector in Kenya.* London: Heinemann, 1977.

Kirkpatrick, Joanna. "The Painted Rickshaw as Culture Theater." *Studies in Visual Communication* 10, no. 3 (1984): 73–85.

Kitchener, Amy V. *The Holiday Yards of Florencio Morales.* Jackson: University Press of Mississippi, 1994.

Klumpp, Donna Rey. *Maasai Art and Society: Age and Sex, Time and Space, Cash and Cattle.* Ph.D. dissertation. New York: Columbia University, Teacher's College, 1987.

Klumpp, Donna Rey, and Corinne Kratz. "Aesthetics, Expertise and Ethnicity: Comparative Perspectives on Okiek and Maasai Personal Ornament." In *Being Maasai: Ethnicity and Identity in Eastern Africa,* T. Spear and R. Waller, eds., London: James Currey, 1993.

Knipe, David M. "Hinduism: Experiments in the Sacred." In *Religious Traditions of the World,* H. B. Earhart, ed., 715–846. San Francisco: Harper San Francisco, 1993.

Konate, Yacouba, and Yaya Savane. "Les artistes de la récupération à l'oeuvre." In *Ingénieuse Afrique: Artisans de la récupération et du recyclage,* L. Ferera, ed., 64–77. Québec: Editions Fides and Musée de la Civilisation, 1994.

Koptiuch, Kristin. "Third-Worlding at Home." *Social Text* 28, 9, no. 3 (1991): 87–100.

Kopytoff, Igor. "The Cultural Biography of Things: Commoditization as Process." In *The Social Life of Things,* A. Appadurai, ed., 64–91. New York: Cambridge University Press, 1990.

Korom, Frank J. "Inventing Traditions: Folklore and Nationalism as Historical Process in Bengal." In *Folklore and Historical Process,* D. Rihtman-Augustin and M. Povrzanovic, eds., 57–84. Zagreb: Institute of Folklore Research, 1989.

———. *"To Be Happy": Narrative, Ritual Play, and Leisure in an Annual Bengali Religious Festival.* Ph.D. dissertation. Philadelphia: University of Pennsylvania, 1992.

———. *"Pat* Painters of West Bengal: *Patuyas* in Transition." Unpub. paper presented at the University of Iowa Art Museum, Oct. 1994.

Kostof, Spiro. *A History of Architecture: Settings and Rituals.* New York: Oxford University Press, 1985.

Kramrisch, Stella. "Kanthas of Bengal." *Marg* 3 (1949): 18–29.

Kratz, Corrine A. "Rethinking Recyclia." *African Arts* 28, no. 3 (1995): 1, 7–12.

Kronman, Ulf. *Steel Pan Tuning, A Handbook for Steel Pan Making and Tuning.* Stockholm: Musikmuseet, 1992.

Kubler, George. "The Quechua in the Colonial World." In *Handbook of South Ameri-*

can Indians, Julian H. Steward, ed., vol. 2, 331–410. Washington, D.C.: Smithsonian Institution, Bureau of American Ethnology, 1946.

Kurin, Richard. "Cultural Conservation Through Representation: Festival of India Folklife Exhibitions at the Smithsonian Institution." In Exhibiting Cultures: The Poetics and Politics of Museum Display, Ivan Karp and Steven D. Lavine, eds., 315–43. Washington, D.C.: Smithsonian Institution Press, 1991.

Lampell, Ramona, and Millard Lampell. O Appalachia: Artists of the Southern Mountains. New York: Stewart, Tabori & Chang, 1989.

Lanham, J. Fritz. "The Result Is Made When Urban Wastes Become Public Art." Smithsonian 10, no. 10 (Jan. 1980): 86–91.

Lautman, Victoria. "Into the Mystic: The New Folk Art." Metropolitan Home (June 1989).

Leach, Edmund. Claude Lévi-Strauss. Middlesex, England: Penguin Books, 1974.

Lears, T. J. Jackson. Fables of Abundance: A Cultural History of Advertising in America. New York: Basic Books, 1994.

Lechtman, Heather. "Technologies of Power: The Andean Case." In Configurations of Power: Holistic Anthropology in Theory and Practice, John S. Henderson and Patricia J. Netherly, eds., 244–80. Ithaca: Cornell University Press, 1993.

Lévi-Strauss, Claude. The Savage Mind. Chicago: University of Chicago Press, 1966.

Lewis, Oscar. "The Culture of Poverty." Scientific American 215, no. 4 (1966): 3–9.

Limón, José E. "Stereotyping and Chicano Resistance: An Historical Dimension." Aztlan 4 (1973): 257–69.

———. "Agringado Joking in Texas-Mexican Society." New Scholar 6 (1977): 33–50.

———. "The Folk Performance of Chicano and the Cultural Limits of Political Ideology." In ". . . And Other Neighborly Names": Social Process and Cultural Image in Texas Folklore, Richard Bauman and Roger D. Abrahams, eds., 197–225. Austin: University of Texas Press, 1981.

———. "Western Marxism and Folklore: A Critical Introduction." Journal of American Folklore 97 (1983a): 337–44.

———. "Texas-Mexican Popular Music and Dancing: Some Notes on History and Symbolic Process." Latin American Music Review 4 (1983b): 229–46.

———. "Carne, Carnales, and the Carnivalesque: Bakhtinian Batos, Disorder, and Narrative Discourse." American Ethnologist 16 (1989): 471–86.

———. Dancing with the Devil: Society and Cultural Poetics in Mexican-American South Texas. Madison: University of Wisconsin Press, 1994.

Lippard, Lucy R. Mixed Blessings: New Art in a Multicultural America. New York: Pantheon Books, 1990.

Long, Norman, and Paul Richardson. "Informal Sector, Petty Commodity Production, and the Social Relations of Small-scale Enterprise." In The New Economic Anthropology, John Clammer, ed., 176–209. New York: St. Martin's Press, 1978.

Lynch, Kevin. Wasting Away: An Exploration of Waste: What It Is, How It Happens, Why We Fear It, How to Do It Well. San Francisco: Sierra Club Books, 1990.

Lynton, Linda. "Kanthas: The Embroidered Quilts of Bengal." Piecework 11, no. 1 (1994): 26–35.

MacGaffey, Wyatt. "The Black Loincloth and the Son of Nzambi Mpungu." In Forms of Folklore in Africa: Narrative, Poetic, Gnomic, Dramatic, Bernth Lindfors, ed., 144–51. Austin: University of Texas Press, 1977.

———. Religion and Society in Africa: The BaKongo of Lower Zaire. Chicago: University of Chicago Press, 1986.

Mack, John, ed. Ethnic Jewelry. London: British Museum, 1988.

Magassouba, Moriba. L'Islam au Senegal: Demain les mollahs? Paris: Éds. Karthala, 1985.

Mailer, Norman. "Interview with Madonna." Esquire (Aug. 1994).

Maison de la Culture à Bourges [MCB]. "Calixte et Théodore Dakpogan, Sculpteurs béninois." Photocopied press release and packet of newspaper clippings, Festival International des Francophonies, Limoges, France, 1993.

Male, Salia. "De l'artisan traditionnel à l'artisan de la récupération." In Ingénieuse Afrique: Artisans de la récupération et du recyclage, L. Ferera, ed., 30–44. Québec: Editions Fides for the Musée de la Civilisation, 1994.

Mamiya, Christin J. Pop Art and Consumer Culture: American Super Market. Austin: University of Texas Press, 1992.

Mannoni, Octave. Prospero and Caliban: The Psychology of Colonization. 2d ed. Ann Arbor: University of Michigan Press, 1990.

Mason, John. "Fundamentals." Unpub. paper presented at "Yoruba Vibrations" conference, University of Florida, April 1989.

Mattera, Philip. Off the Books: The Rise of the Underground Economy. London: Pluto Press, 1986.

McNaughton, Patrick. The Mande Blacksmiths: Knowledge, Power, and Art in West Africa. Bloomington: Indiana University Press, 1993.

McWillie, Judith, ed. Another Face of the Diamond: Pathways Through the Black Atlantic South. New York: INTAR, 1989.

———. Even the Deep Things of God: A Quality of Mind in Afro-Atlantic Traditional Art. Pittsburgh: Pittsburgh Center for the Arts, 1990.

Meyer, Melissa, and Miriam Schapiro. "Waste Not/Want Not: Femmage." Heresies 4 (1978): 66–9.

Minh-ha, Trinh T. Woman, Native, Other: Writing Postcoloniality and Feminism. Bloomington: Indiana University Press, 1989.

Montaño, Mario. "The History of Mexican Food Folkways of South Texas: Street Vendors, Offal Foods, and Barbacoa de Cabeza." Ph.D. dissertation. Philadelphia: University of Pennsylvania, 1992.

Monteil, Vincent. L'Islam Noir. Paris: Editions du Seuil, 1964.

———. "Esquisses Senegalaises (Wâlo – Kayor – Dyolof – Mourides – Un Visionnaire)." Initiations et Etudes Africaines vol. 21. Dakar: Institut Fondamental d'Afrique Noire, 1966.

———. The Invention of Africa. Bloomington: Indiana University Press, 1988.

———. The Idea of Africa. Minneapolis: University of Minnesota Press, 1994.

Montejano, David. Anglos and Mexicans in the Making of Texas, 1836–1986. Austin: University of Texas Press, 1987.

Moreno, Segundo Luis. Música y Danzas Autóctaonas del Ecuador/ Indigenous Music and Dances of Ecuador. Jorge Luis Pérez and C. W. Ireson, trans. Quito: Editorial Fray Jodoco Ricke, 1949.

Morton, A. L., ed. The Political Writings of William Morris. New York: International Publishers, 1973.

Motavalli, Jim. "The Real Conservatives." E: The Environmental Magazine 6, no. 4 (July/Aug. 1995): 28–35.

Muratorio, Ricardo. A Feast of Color: Corpus Christi Dance Costumes of Ecuador. Washington, D.C.: Smithsonian Institution Press, 1989.

Naranjo, Marcelo. La Cultura Popular en el Ecuador, Tomo II: Cotopaxi. Cuenca: Centro Interamericano de Artesanias y Artes Populares, 1983.

———. La Cultura Popular en el Ecuador, Tomo VII: Tungurahua. Cuenca: Centro Interamericano de Artesanias y Artes Populares, 1992.

Nunley, John. "Printed Words in Freetown Masquerades." *African Arts* 15, no. 4 (1982): 42–7.

Nunley, John W., and Judith Bettleheim. *Caribbean Festival Arts.* Seattle: University of Washington Press, 1988.

Obeyesekere, Gananath. *The Apotheosis of Captain Cook: European Myth-Making in the Pacific.* Princeton: Princeton University Press, 1994.

Ohrn, Steve, ed. *Passing Time and Traditions: Contemporary Iowa Folk Artists.* Ames: The Iowa State University Press, 1984.

Olalquiaga, Celeste. *Megalopolis: Contemporary Cultural Sensibilities.* Minneapolis: University of Minnesota Press, 1992.

Orenstein, Henry. "The Structure of Hindu Caste Values: A Preliminary Study of Hierarchy and Ritual Defilement." *Ethnology* 4, no. 1 (1965): 1–15.

————. "Toward a Grammar of Defilement in Hindu Sacred Law." In *Structure and Change in Indian Society,* Milton Singer and Bernard S. Cohn, eds., 115–31. New York: Wenner-Gren Foundation for Anthropological Research, 1968.

Oring, Elliot. "The Arts, Artifacts, and Artifices of Identity." *Journal of American Folklore* 107 (1994): 211–33.

Ortiz, Renato. "Ogun and the Umbandista Religion." In *Africa's Ogun, Old World and New,* S. Barnes, ed., 90–102. Bloomington: Indiana University Press, 1989.

Osculati, Cayetano [Gaetano]. "Quito en 1947." In *El Ecuador Visto por los Extranjeros Viajeros de los Siglos XVIII y XIX,* Humberto Toscano, ed., 297–310. Puebla: Editorial J.M. Cajica, Jr., S.A., 1960.

Östör, Akos. *Puja in Society.* Lucknow, India: Ethnographic and Folk Culture Society, 1982.

Pachecho, Patrick. "At the Drag Queen's Ball." *Los Angeles Times,* 4 Aug. 1991, calendar sect.

Packard, Vance. *The Hidden Persuaders.* Rev. ed. New York: Pocket Books, 1977 (1957).

————. *The Waste Makers.* New York: Pocket Books, 1963.

Pal, M. K. *Crafts and Craftsmen in Traditional India.* New Delhi: Kanak Publications, 1978.

Panati, Charles. *Panati's Extraordinary Origins of Everyday Things.* New York: Harper & Row, 1987.

————. *Panati's Parade of Fads, Follies, and Mania.* New York: HarperCollins, 1991.

Panwalkar, Pratima. "Processus de recyclage du plastique a Bombay." *Environnement Africain* 8, nos. 1–2 (1990): 153–7.

Paredes, Américo. *With His Pistol in His Hand: A Border Ballad and Its Hero.* 1958. Austin: University of Texas Press, 1971.

————. *A Texas-Mexican Cancionero.* Urbana: University of Illinois Press, 1976.

————. "On Ethnographic Work Among Minority Groups: A Folklorist's Perspective." *New Scholar* 6 (1977): 1–32.

————. "The Problem of Identity in a Changing Culture: Popular Expressions of Culture Conflict Along the Lower Rio Grande Border." In *Views Across the Border: The United States and Mexico,* Stanley Ross, ed., 68–94. Albuquerque: University of New Mexico Press, 1978.

————. *Folklore and Culture on the Texas-Mexican Border.* Richard Bauman, ed. Austin: University of Texas Press, 1993.

Parks, Walter. "Examination of the Role, Value, and Function of the Steel Bands in University and College Percussion Programs." Ph.D. dissertation. Houston: University of Houston, 1986.

Patten, Simon N. *The Consumption of Wealth.* Philadelphia: University of Pennsylvania, 1889.

Patterson, Tom. "Adhocism in the Post-Mainstream Era: Thoughts on Recycling, Redemption, and the Reconfiguration of the Current Art World." In *Reclamation and Transformation: Three Self-Taught Chicago Artists.* Evanston, Ill.: Terra Foundation for the Arts, 1994.

————. "Manifesting the World of Mr. Imagination." In *Reclamation and Transformation: Three Self-Taught Chicago Artists,* 35–49. Evanston, Ill.: Terra Foundation for the Arts, 1994.

Pearse, Andrew. "Carnival in Nineteenth-Century Trinidad." In *Trinidad Carnival,* Gerard Besson, ed. Republication of *Caribbean Quarterly* 4, nos. 3–4 (1956). Port of Spain, Trinidad: Paria Publishing Co., 1988.

————. "Music in Trinidad's Popular Culture." In *The Book of Trinidad,* Gerard Besson and Bridget Brereton, eds. Port of Spain, Trinidad: Paria Publishing Co., 1992.

Peek, Philip M., ed. *African Divination Systems.* Bloomington: Indiana University Press, 1991.

Peña, Manuel. *The Texas-Mexican Conjunto: History of a Working-Class Music.* Austin: University of Texas Press, 1985.

Petit, Lisette. "Le sens caché des objets 'réinventés.'" In *Ingénieuse Afrique: Artisans de la récupération et du recyclage,* L. Ferera, ed., 78–87. Québec: Editions Fides and Musée de la Civilisation, 1994.

Picton, John, and John Mack. *African Textiles.* London: British Museum, 1979.

Plotnicov, Leonard. "Resource and Waste: Current American Cultural Change." *Rice University Studies* 66, no. 1 (1980): 69–83.

Pocius, Gerald. "Holy Pictures in Newfoundland Houses: Visual Codes for Secular and Supernatural Relationships." *Laurentian University Review* 12 (1979): 101–25.

Polo de Ondegardo, Juan. "Informaciones acerca de la religión y el gobierno de los Incas . . ." [1571]. In *Colección de libros y documentos referentes a la historia del Perú,* Horacio H. Urteaga, ed., vol. 3, 3–183. Lima: Imprenta y Librería Sanmartí, 1916.

Poma de Ayala, Felipe Guamán. *La Nueva Cronica y Buen Gobierno, Pt. III.* [1615]. Coronel Luis Bustios Galvez, ed. Lima: Gráfica Industrial, 1966.

Pratt, Mary Louise. *Imperial Eyes: Travel Writing and Transculturation.* London and New York: Routledge, 1992.

Price, Sally. *Primitive Art in Civilized Places.* Chicago: University of Chicago Press, 1989.

Puckett, Newbell Niles. *Folk Beliefs of the Southern Negro.* Chapel Hill: University of North Carolina Press, 1926.

Rabinow, Paul. "Representations Are Social Facts: Modernity and Post-Modernity in Anthropology." In *Writing Culture: The Poetics and Politics of Ethnography,* J. Clifford and G. Marcus, eds., 234–61. Berkeley and Los Angeles: University of California Press, 1986.

Ratanani, Lekha. "Pleasure Islands." *India Today* 30 November (1994): 100–3.

Rathje, William, and Cullen Murphy. *Rubbish! The Archaeology of Garbage.* New York: HarperCollins, 1992.

Ravenhill, Philip. Review of "Les Technologies Adaptés et Recuperation des Materiaux." *African Arts* 22, no. 4 (19): 77.

Rawick, George P., ed. *The American Slave: A Composite Autobiography.* 19 vols. Westport: Greenwood Press, 1972.

————. *The American Slave: A Composite Autobiography.* Supp. Series I. 12 vols. Westport: Greenwood Press, 1977.

"Récupération et développement." In *Ingieneuse Afrique: Artisans de la récupération et du recyclage,* L. Ferera, ed., 10–29. Québec: Editions Fides and Musée de la Civilisation, 1994.

Reichel-Dolmatoff, G. "Things of Beauty Replete with Meaning: Metals and Crystals in Colombian Indian Cosmology." In *Sweat of the Sun, Tears of the Moon: Gold and Emerald Treasures of Colombia,* 17–33. Los Angeles: Natural History Museum of Los Angeles County, 1981.

Retamar, Roberto. *Caliban and Other Essays.* Minneapolis: University of Minnesota Press, 1989.

Roberts, Allen F. "The Comeuppance of 'Mr. Snake,' and Other Tales of Survival from Contemporary Rural Zaire." In *The Crisis in Zaire: Myths and Realities*, Nzongola-Ntalaja, ed., 113–21. Trenton: Africa World Press, 1986.

———. "Chance Encounters, Ironic Collage." *African Arts* 25, no. 2 (1992): 54–63, 97–8.

———. *Animals in African Art: From the Familiar to the Marvelous*. New York: Museum for African Art; Munich: Prestel, 1995.

Roberts, Mary Nooter. "Does an Object Have a Life?" In *Exhibitionism: Issues and Experiments in the Presentation of African Art*, M. N. Roberts and S. Vogel, eds., 36–55. New York: Museum for African Art, 1994.

Rocher, Ludo. "The Artist in Sanskrit Literature." In *Making Things in South Asia: The Role of the Artist and Craftsman*, Michael Meister, ed., 18–23. Philadelphia: University of Pennsylvania, Dept. of South Asia Regional Studies, 1988.

Rosen Seymour. *In Celebration of Ourselves*. San Francisco: Living Books, 1979.

———. "Emanuele 'Litto' Diamonte." In *Divine Disorder: Folk Art Environments of California*. Santa Clara: Triton Museum of Art, 1985.

Rouff, Anthony. *"Authentic" Facts on the Origin of the Steelband*. St. Augustine, Trinidad: Bowen's Printery, 1972.

Rubin, Arnold. *African Accumulative Sculpture: Power and Display*. New York: Pace Gallery, 1974.

Rumold, Rainer. "The Dadaist Text: Politics, Aesthetics and Alternative Cultures?" *Visible Languages* 21, nos. 3–4 (1987): 453–89.

Sagendorph, Robb. *America and Her Almanacs*. Boston: Little, Brown and Co., 1970.

Sahlins, Marshall. *How Natives Think: About Captain Cook, For Example*. Chicago: University of Chicago Press, 1995.

———. "The Economics of Development in the Pacific." *Anthropology and Aesthetics* 21 (1992): 12–26.

Said, Edward. *Le Magal de Touba*. Dakar: Editions Hilal. Seck, Amadou, 1974.

———. *Culture and Imperialism*. New York: Vintage Books, 1993.

Santino, Jack. "The Folk Assemblage of Autumn: Tradition and Creativity in Halloween Folk Art." In *Folk Art and Art Worlds*, John M. Vlach and Simon Bronner, eds., 151–69. Ann Arbor: UMI Research Press, 1986.

Schildkrout, Enid. Review of "Woven Trains and Beaded Planes: Technology Meets Tradition." *Museum Anthropology* 17, no. 1 (1993): 83–4.

Schildkrout, Enid, and Curtis A. Keim. *African Reflections: Art from Northwestern Zaire*. Seattle: University of Washington Press, 1990.

Schlesinger, Arthur M., Sr. "What Then Is the American, This New Man?" *American Historical Review* 48 (1942–43): 225–44.

Searle, Karen. "Tina Fung Holder: A Lifelong Fascination." *Ornament* 16, no. 1 (1992): 68–71.

Seck, Papa. *Naafih, Dons utiles par l'évocation du Seigneur de la Félicité*. Dakar: Lamp Fall Dabo, n.d.

Seriff, Suzanne K. "'Este Soy Yo': The Politics of Representation of a Texas-Mexican Folk Artist." Ph. D. dissertation. Austin: University of Texas, 1989.

———. "Homages in Clay: The Figural Ceramics of José Varela." In *Hecho en Tejas: Texas-Mexican Folk Arts and Crafts*, Joe S. Graham, ed., 146–71. Denton: University of North Texas Press, 1991.

———. *Snakes, Sirens, Virgins, and Devils: The Politics of Representation of a Mexican-American Folk Artist*. Philadelphia: University of Pennsylvania Press, forthcoming.

Seriff, Suzanne K., and José Limón. "Bits and Pieces: The Mexican-American Folk Aesthetic." In *Arte Entre Nosotros/Art Among Us: Mexican-American Folk Art of San Antonio*, Pat Jasper and Kay Turner, eds., 40–9. San Antonio: The San Antonio Museum Association, 1986.

Sicular, Daniel T. *Scavengers, Recyclers, and Solutions for Solid Waste Management in Indonesia*. Berkeley and Los Angeles: University of California Press, 1992.

Simic, Charles. "The Little Venus of Eskimos." In *The Return of the Cadavre Exquis*, A. Philbin, ed., 24–31. New York: The Drawing Center, 1993.

Skow, John. "Madonna Rocks the Land." *Time*, 27 May 1985.

Smith, Barbara. *Contingencies of Value: Alternative Perspectives for Critical Theory*. Cambridge, Mass.: Harvard University Press, 1988.

Sobel, Mechal. *The World They Made Together: Black and White Values in Eighteenth-Century Virginia*. Princeton: Princeton University Press, 1987.

Spindler, Amy. "Piety on Parade." *New York Times*, 5 Sept. 1993, pp. 1, 30.

Steele, Valerie. *Fashion and Eroticism*. New York: Oxford University Press, 1985.

Steiner, Christopher. "Fake Masks and Faux Modernity: The Crisis of Misrepresentation." *African Arts* 25, no. 3 (1992): 18–20.

———. *African Art in Transit*. New York: Cambridge University Press, 1994.

Stewart, Susan. *Nonsense: Aspects of Intertextuality in Folklore and Literature*. Baltimore: The Johns Hopkins University Press, 1980.

Strathern, Andrew, and Marilyn Strathern. *Self-Decoration in Mount Hagen*. London: Gerald Duckworth and Co., 1971.

Strother, Zoë. "Inventing Masks: Structures of Artistic Innovation Among the Central Pende of Zaire." Ph.D. dissertation. New Haven: Yale University, 1992.

Stuckey, Sterling. *Slave Culture: Nationalist Theory and the Foundations of Black America*. New York: Oxford University Press, 1987.

Stuempfle, Stephen. "The Steelband Movement in Trinidad and Tobago." Ph.D. dissertation. Philadelphia: University of Pennsylvania, 1990.

———. *The Steelband Movement: The Forging of a National Art in Trinidad and Tobago*. Philadelphia: University of Pennsylvania Press, 1995.

Sulikowski, Ulrike. "Eating the Flesh, Eating the Soul: Reflections on Politics, Sorcery, and *Vodun* in Contemporary Bénin." In *L'invention religieuse en Afrique*, J.-P. Chrétien, ed., 379–92. Paris: ACCT – Karthala, 1993.

Surgy, Albert de. *De l'universalité d'une forme africaine de sacrifice*. Paris: Editions du CNRS, 1988.

Szwed, John F. "Vibrational Affinities." In *The Migrations of Meaning*, Judith McWillie and Inverna Lockpez, eds., 59–67. New York: INTAR Latin American Gallery, 1992.

Thompson, Michael. *Rubbish Theory: The Creation and Destruction of Value*. New York: Oxford University Press, 1979.

Thompson, Robert Farris. "Yoruba Artistic Criticism." In *The Traditional Artist in African Societies*, W. d'Azevedo, ed., 18–61. Bloomington: Indiana University Press, 1975.

———. *Black Gods and Kings: Yoruba Art at UCLA*. Bloomington: Indiana University Press, 1976.

———. *Flash of the Spirit: African and Afro-American Art and Philosophy*. New York: Random House, 1983.

———. "The Circle and the Branch: Renascent Kongo-American Art." In *Another Face of the Diamond: Pathways Through the Black Atlantic South*. Judith McWillie, ed., 23–56. New York: INTAR Latin American Gallery, 1988.

———. "The Song that Named the Land: The Visionary Presence of African-American Art." In *Black Art: Ancestral Legacy*. Dallas: Dallas Museum of Art, 1989.

———. *Face of the Gods: Art and Altars of Africa and the African Americas*. New York: Museum for African Art; Munich: Prestel, 1993.

Thompson, Robert Farris, and Joseph Cornet. *The Four Moments of the Sun: Kongo Art in Two Worlds*. Washington, D.C.: National Gallery of Art, 1981.

Tomlinson, John. *Cultural Imperialism: A Critical Introduction*. Baltimore: The Johns Hopkins University Press, 1991.

Torgovnick, Marianna. *Gone Primitive: Savage Intellects, Modern Lives*. Chicago: University of Chicago Press, 1990.

Triaud, Jean-Louis. "*Khalwa* and the Career of Sainthood: An Interpretive Essay." In *Charisma and Brotherhood in African Islam*, D. Cruise O'Brien and C. Coulon, eds., 53–66. New York: Oxford University Press, 1988.

Tucker, David M. *The Decline of Thrift in America*. New York: Praeger, 1991.

Turner, Frederick Jackson. *The Frontier in American History*. New York: Henry Holt & Co., 1921.

Turner, Kay. "Home Altars and the Art of Devotion." In *Chicano Expressions: A New View in American Art*, Inverna Lockpez, ed., 40–8. New York: INTAR Latin American Gallery, 1986.

———. "Mexican-American Women's Home Altars: The Art of Relationship." Ph.D. dissertation. Austin: University of Texas, 1990.

Turner, Kay, and Pat Jasper. *Day of the Dead: The Tex-Mex Tradition*. San Antonio: The Guadalupe Cultural Arts Center, 1989.

Turner, Victor. *The Forest of Symbols*. Ithaca: Cornell University Press, 1970.

Van Doren, Carl. *Benjamin Franklin*. New York: Garden City Publishing Co., 1941.

Vega, Garcilaso de la. *Royal Commentaries of the Incas and a General History of Peru, Pts. I & II*. [1609]. Harold V. Livermore, trans. Austin: University of Texas Press, 1966.

Ventura, Michael. *Shadow Dancing in the U.S.A.* Los Angeles: Tarcher, 1985.

———. "The Porn Prince of Decatur Street." *L.A. Weekly*, 2 Mar. 1992.

Vogel, Susan. *Africa Explores: Twentieth-Century African Art*. New York: The Center for African Art, 1991.

Vogler, J. *Work from Waste: Recycling Waste to Create Employment*. London: Intermediate Technology Publications Limited, 1981.

Wade, Madike. *Destinée du Mouridisme*. Dakar: Côte West Dakar, 1991.

Wagner, Roy. *The Invention of Culture*. Chicago: University of Chicago Press, 1981.

Waldman, Diane. *Collage, Assemblage and the Found Object*. New York: Harry N. Abrams, Inc., 1992.

Walker Art Center. *Naives and Visionaries*. New York: E. P. Dutton & Co., 1974.

Wallerstein, Immanuel. *The Modern World System II*. Cambridge, England: Cambridge University Press, 1988.

Wallis, Brian. "Selling Nations: International Exhibitions and Cultural Diplomacy." In *Museum Culture: Histories, Discourses, Spectacles*, Daniel J. Sherman and Irit Rogoff, eds., 265–81. Minneapolis: University of Minnesota Press, 1994.

White, Peter T. "The Fascinating World of Trash." *National Geographic* 163, no. 4 (1983): 424–57.

Williams, Brackette F. "Nationalism, Traditionalism, and the Problem of Cultural Inauthenticity." In *Nationalist Ideologies and the Production of National Cultures*, Richard G. Fox, ed., 112–29. Washington, D.C.: American Anthropological Assosiation, 1990.

Wollen, Peter. *Raiding the Icebox: Reflections on Twentieth-Century Culture*. Bloomington: Indiana University Press, 1993.

Woodward, Jordie. "Ray Cyrek: 'Tops' in His Field." *Citrus Country Chronicle*, 13 Jan. 1987, p. 1C.

Ybarra-Frausto, Tomás. "Rasquachismo: A Chicano Sensibility." In *Chicano Aesthetics: Rasquachismo*. Phoenix: MARS Movimiento, 1989.

———. "The Chicano Movement/The Movement of Chicano Art." In *Exhibiting Cultures: The Poetics and Politics of Museum Display*, Ivan Karp and Steven D. Lavine, eds., 128–50. Washington, D.C.: Smithsonian Institution Press, 1991.

Yoder, Carolyn P., ed. *Faces: The Magazine About People: Special Issue on Recycling* 7, no. 8 (1991).

Zúñiga, Neptalí. *Significación de Latacunga en la Historia del Ecuador y de America, Tomo I*. Quito: Instituto Geográfico Militar, 1982.

Acknowledgments

A project of this magnitude would not have been possible without the generous support of many individuals, foundations, and institutions. A generous grant from the Lila Wallace-Reader's Digest Fund helped catapult what began simply as an idea into a full-fledged project plan. We owe the Fund, Senior Program Officer Michael Moore, as well as former Program Officer Selwyn Garraway, our first debt of gratitude. They believed in the project and supported it generously through both planning and implementation phases. Without their early support this project would not have materialized in such a timely fashion – or perhaps at all.

Once funded, our first mission was to bring together an international team of consultants to further discuss and develop the significant themes and genres of folk recycling to be explored in such an exhibit and book. We – and the project – have benefited greatly from the vision, enthusiasm, and intellectual stimulation generated by each and every one of our colleagues at that symposium: Jürgen Grothues, Marilyn Houlberg, Jyotindra Jain, Julius S. Kassovic, Deborah Mack, Roger Manley, Allen F. Roberts, Mamadou Samaké, Jehanne Teilhet-Fisk, and John Michael Vlach. Our thanks, also, to Charles and Beth Miller for their sponsorship of this event.

Subsequent financial support was generously provided by the Rockefeller Foundation and the National Endowment for the Humanities, a federal agency. These two funders – with their long-standing commitment to groundbreaking cultural projects in the humanities – provided the much-needed funding to see the project through to its conclusion. Our grants officers Tomás Ybarra-Frausto and Suzi Jones each deserve our thanks for shepherding us through the grant process and honing our concepts along the way.

The International Folk Art Foundation played a major role in facilitating this project, through not only generous grants but also other support services. To them we are most grateful. The Museum of New Mexico Foundation and the Marshall L. and Perrine D. McCune Charitable Foundation both likewise provided much-needed funds that assured the success of education and public outreach projects.

Both the exhibition and this publication were enriched by the many donors and lenders who generously agreed to share their collections with the public. We would like to acknowledge gifts to the collection from James Albright/Rare Bear Records, Florence Dibell Bartlett, Bemis Co., Diane and Sandy Besser, Inc., Peter S. Briggs, Lee Carter, Martha Cooper, Ray Cyrek, Patricia Davison, the Rick Dillingham Estate, John Fels, William Field, the Girard Foundation, Henry Glassie, Jürgen Grothues, Max and Prudence Heffron, Stephen Huyler, Jyotindra Jain, Vikram Jayanti, Raye and Dave Jonason, Joanna Kirkpatrick, Enrique Lamadrid, Tom Livesay, Mrs. Roman Martinez, Jim Miho, Eleanor Murphy, Mark Mynatt, D. B. Naik, Elisabet Olofsson, Mary Ann Pouls, Robert Ramos, Marion Rinehart, Ralph C. Rinzler, Mario Rivoli, Tom Robinson, Senaida Romero, Jacqueline and Richard Schmeal, Ira and Sylvia Seret, Kay Seriff, Richard M. Swiderski, and Lonn C. Taylor.

Those who kindly lent items from their private or corporate collections are Diane and Sandy Besser, Peter P. Cecere, Janet Cooper, Martha Cooper, Martha Egan, Goldie Garcia, William J. Gladwin, Jr., Laura Graham, the Carl Hammer Gallery (Chicago), George Hanson/Recycled Revolution, Marilyn Houlberg, Greg Johnson, Mary Kahlenberg and Robert Coffland, Julius Kassovic, Margaret C. Knapp, Diana Leonard, Helen Lucero, Mandina and Cameron MacPherson/Used Rubber USA, Mark Mainwaring and Robin Russell, Michael Malcé and Jolie Kelter, Jane Martin, Isaac Mizrahi and Company, Jean Moss, Leslie Muth Gallery (Santa Fe), Tammy Nilsen, Shelagh O'Rourke, Rudy Padilla, Susan Parrish, Robert Ramsey/Southwest Ambulance, Penny and Armin Rembe, Gail and Zachariah Rieke, Mario Rivoli, Roger Rose, Susan Skinner, Greg Warmack/"Mr. Imagination," Margot Winer, Shelly Zegart, the Four Corporation, and Mary Zwolinski.

Without the collaboration and cooperation of our colleagues in other museums and art organizations, this exhibition and publication also would not have been possible. Institutional lenders to whom we are most grateful are: American Museum of Natural History, Children's Museum of Indianapolis, Inter-

national Folk Art Foundation, Iowa Arts Council, Museum of Indian Arts and Culture (Museum of New Mexico), National Museum of American Art (Smithsonian Institution), National Museum of American History (Smithsonian Institution), National Museum of Natural History (Smithsonian Institution), Peabody Essex Museum, Peabody Museum of Archaeology and Ethnology, Phoebe Hearst Museum of Anthropology, San Diego Museum of Man, School of American Research, Spanish Colonial Arts Society, Inc., and the State Historical Society of Iowa.

Additionally, many individuals went far out of their way to assist us in the many tasks that engaged our entire team. These include academic and professional colleagues who willingly contributed their work and their expertise and also field associates who shared not only their contacts but their lives with us. They are: Graciela Albán, Peter Aleong, Arnie Anton/American Primitive Gallery, Gerard Besson, Carol Burns, Lee Carter, Roberto Granados Chavez and family, Andrew Connors, José Ignacio Criollo, Gerald Davis, Omar Diop, Assane Faye, Bonnie Grossman/Ames Gallery (Berkeley, California), Michelle Huggins-Soblers, Mapathé Kane, Enrique Lamadrid, Jaime Vizuette Lasso, Bernardino Lemus and family, Eli Leon, Frank Leto, Angel Lopez and family, Roger Manley, Ellie Mannette and Kathe George, Lawrence Mayers, María del Pilar Merlo de Cevallos, Ricardo Muratorio, Leslie Muth, Marcelo Naranjo, John Nunley, Steve Ohrn, Oscar Pyle, Judith Roberts, Polly Roberts, Seymour Rosen/SPACES, Amado Ruiz, Vinod Kumar Sharma, Elisabeth Solomon-Armour, C-C Stark, Pan Trinbago, Marcia Weber, Mary Weismantel, Arbie Williams, Dexter Yee Yick, and Shelly Zegart.

First and foremost, this project represented a team effort. Our work as co-project directors of the exhibition and editors of this volume would not have been possible without the constant support, assistance, and encouragement of the other members of the recycling project team at the Museum of New Mexico: Joyce Ice, Barbara Mauldin, and Judy Smith, who served as co-curators with us on the exhibition, locating relevant materials and most importantly applying their collective talents to creating the exhibition's interpretive scheme; Laura Temple Sullivan, Aurelia Gomez, and Hope Connors, project educators, whose commitment to interactive museum experiences informed the entire exhibition and program development process; exhibition and graphic designers extraordinaire Linda Gegick and Susan Hyde-Holmes, whose talents translated our ideas into concrete form; Judy Sellars, our trusted librarian, and Jacqueline Duke, budget and administrative wizard. Nora Pickens, project assistant, deserves our special thanks for her able assistance in the myriad details involved in coordinating a project of this scope.

Thanks also to our talented video team consisting of producer Vikram Jayanti, writer Deirdre Evans-Pritchard, director/editor Chris Simon, and museum videographer Thomas McCarthy, whose superior video case studies proved to be an essential element of the exhibition's success. Joyce Ice deserves our gratitude for coordinating this effort as executive producer for the museum.

Of the many others who have contributed their editorial or intellectual acumen to this project, we would like to extend our personal thanks to several friends, family members, and colleagues who have taken time to read, comment on, or discuss drafts of the manuscript with us: Donald Cosentino, Joanne Cubbs, Robert Cullick, Carol Dochen, Barbara Kirschenblatt-Gimblett, Frank Korom, Eugene Metcalf, Jilian Steiner Sandrock, and Nicholas Spitzer. Special thanks for keeping us on the right theoretical track go to our senior project consultants Allen Roberts and Kay Turner.

Our editor at Harry N. Abrams, Inc., Elisa Urbanelli, was a joy to work with from start to finish. Her intellectual engagement with us and our subject, her superior editing skills, and her receptive and reasoned ear are much appreciated. We were also privileged to work with such a skilled and creative designer as Judith Hudson, and to enjoy, once again, the support provided by old friends at Abrams such as Paul Gottlieb and Sam Antupit.

In addition, we were fortunate to have had a chance to work with one of the most outstanding studio photography duos we've ever encountered, John Bigelow Taylor and Dianne Dubler.

We would like to take this opportunity to express our deepest appreciation to each of the distinguished scholars who graced our book with their essays. Collaborating with them has been the most gratifying aspect of this book project for both of us. We have been not only challenged and enriched by our work with these authors, but also lucky enough to have formed many lasting friendships along the way.

Finally, to our families – Joe, Elizabeth, and Kathryn; Robert, Matthew, and Aaron – we offer you our most heartfelt thanks for the patience, encouragement, and humor with which you have honored and sustained us throughout this project. You are dearly loved.

C.C. and S.S.

Index